W9-AQD-501

Saint Peter's University Library
Withdrawn

SIENESE PAINTING OF THE TRECENTO

SIENESE PAINTING OF THE TRECENTO

by

CURT H. WEIGELT

HACKER ART BOOKS
NEW YORK
1974

First published 1930 in Florence
Reissued 1974 by
Hacker Art Books, Inc.
New York

Library of Congress Catalogue Card Number 70-143368
ISBN 0-87817-087-1

Printed in the United States of America

LIST OF PLATES

58. SIMONE MARTINI. *Half-figure of a female saint, Fresco.* Assisi, San Francesco, Lower Church, right transept.

59. SIMONE MARTINI. *Jesus reproved by his anxious parents after his return from the Temple.* Liverpool, Royal Institute of Arts.

60. SIMONE MARTINI. A. *The Bearing of the Cross.* Paris, Louvre. B. *The Crucifixion.* Antwerp, Museum.

61. SIMONE MARTINI. A. *The Deposition,* Antwerp, Museum. B. *The Entombment.* Berlin, Kaiser Friedrich Museum.

62. NICCOLÒ DI SER SOZZO TEGLIACCI. *Caleffo dell'Assunta* (1332). *Miniature on the title-page of a manuscript. Detail: The Assumption of the Virgin.* Siena, State Archives.

63. LIPPO MEMMI. *Maestà, Fresco* (1317). San Gimignano, Palazzo Pubblico.

64. LIPPO MEMMI. *Maestà, Fresco. Details:* A. *St. John the Baptist.* B. *St. John the Evangelist.* San Gimignano. Palazzo Pubblico.

65. LIPPO MEMMI. *Madonna del Popolo.* Siena, Church of the Servi.

66. LIPPO MEMMI. *Madonna and Child.* Berlin, Kaiser Friedrich Museum.

67. BARNA. *The Marriage at Cana, Fresco.* San Gimignano, Collegiata.

68. BARNA. *The Bearing of the Cross, Fresco.* San Gimignano, Collegiata.

69. BARNA. *The Crucifixion, Fresco. Detail: The Virgin falls into a swoon.* San Gimignano, Collegiata.

70. PIETRO LORENZETTI. *Madonna with the Child and Angels.* Cortona, Cathedral.

71. SCHOOL OF PIETRO LORENZETTI. *Half-figure of the Madonna with Child.* Florence, Charles Loeser Collection.

72. PIETRO LORENZETTI. *Polyptych: The Madonna and Child, with St. Donatus, St. John the Evangelist, St. John the Baptist and St. Matthew* (1320). Arezzo, Santa Maria della Pieve.

73. PIETRO LORENZETTI. *Polyptych: The Madonna and Child with St. Donatus, St. John the Evangelist, St. John the Baptist, and St. Matthew* (1320). *Detail: The Madonna and Child.* Arezzo, Santa Maria della Pieve.

74. PIETRO LORENZETTI. *Polyptych: The Madonna and Child with St. Donatus, St. John the Evangelist, St. John the Baptist and St. Matthew* (1320). *Detail: St. John the Evangelist.* Arezzo, Santa Maria della Pieve.

75. PIETRO LORENZETTI. *Four predella-pieces with scenes from the history of the Carmelite Order* (1329): A. *The Angel appears to Sobac in a dream and informs him that his son Elijah will found the Carmelite Order.* B. *Hermit-life of the Carmelite Monks at the well of Elijah.* C. *Honorius III confirms the Carmelite rules in 1227.* D. *Pope Innocent IV invests the Carmelites with a new monastic garb in 1245.* Siena, Accademia.

76. PIETRO LORENZETTI. *Predella: Pope Honorius III confirms the rules of the Carmelite Order.* Siena, Accademia.

77. PIETRO LORENZETTI. *The Crucifixion, Fresco.* Siena, San Francesco.

78. PIETRO LORENZETTI. *The Massacre of the Innocents, Fresco.* Siena, Church of the Servi.

79. PIETRO LORENZETTI. *The Beheading of John the Baptist and the Dance of Salome, Fresco.* Siena, Church of the Servi.

80. PIETRO LORENZETTI. *The Ascension of St. John the Evangelist, Fresco.* Siena, Church of the Servi.

81. PIETRO LORENZETTI. *The Madonna between St. Francis and St. John the Evangelist, Fresco.* Assisi, San Francesco, Lower Church, left transept.

82. PIETRO LORENZETTI. *The Deposition, Fresco.* Assisi, San Francesco, Lower Church, left transept.

83. PIETRO LORENZETTI. *The Crucifixion, Fresco.* Assisi, San Francesco, Lower Church, left transept.

84. PIETRO LORENZETTI. *The Crucifixion, Fresco. Detail: Christ on the Cross, with the mourning angels.* Assisi, San Francesco, Lower Church, left transept.

85. PIETRO LORENZETTI. *St. Humilitas of Faenza, with scenes from her legend* (1341). Florence, Uffizi.

86. PIETRO LORENZETTI. *St. Humilitas of Faenza with scenes from her legend. Details:* A. *The Death of St. Humilitas.* B. *St. Humilitas healing a nun.* Berlin, Kaiser Friedrich Museum.

87. PIETRO LORENZETTI. *Triptych: The Nativity of the Virgin* (1342). Siena, Opera del Duomo.

88. PIETRO LORENZETTI. *Triptych: The Nativity of the Virgin. Detail: The page brings Joachim the news of the birth of the Virgin.* Siena, Opera del Duomo.

89. SCHOOL OF PIETRO LORENZETTI. *The last Supper, Fresco.* Assisi, San Francesco, Lower Church, left transept.

90. AMBROGIO LORENZETTI. *Madonna enthroned with the Child* (1319). Vico l'Abate, near Florence, Sant'Angelo.

91. AMBROGIO LORENZETTI. *Madonna enthroned with the Child. Detail: Head of the Madonna.* Vico L'Abate near Florence, Sant'Angelo.

92. AMBROGIO LORENZETTI. *Madonna and Child.* Siena, San Francesco, Seminary.

93. AMBROGIO LORENZETTI. *Martyrdom of the Franciscans at Ceuta, Fresco.* Siena, San Francesco.

111. AMBROGIO LORENZETTI (?). *Madonna enthroned with saints and angels*. Siena, Accademia.

112. AMBROGIO LORENZETTI (?). *Polyptych. Detail: The Madonna between St. Mary Magdalen and St. Dorothea*. Siena, Accademia.

113. ANDREA VANNI. *Polyptych. The Madonna enthroned with Child and Saints* (1400). *Detail: The Madonna and Child*. Siena, Santo Stefano alla Lizza.

114. LIPPO VANNI. *Triptych* (1358). *The Madonna enthroned with saints and scenes from her legend*. Rome, SS. Sisto e Domenico.

115. LUCA DI TOMMÈ. *The Crucifixion* (1366). *Detail: Head of the Virgin*. Pisa, Museo Civico.

116. LUCA DI TOMMÈ. *Polyptych* (1367). *Madonna and Child, with St. Anna and other saints*. Siena, Accademia.

117. BARTOLO DI FREDI. *The Nativity of the Virgin, Fresco*. San Gimignano. Sant'Agostino.

118. BARTOLO DI FREDI. *The Coronation of the Virgin* (1388). Montalcino, Palazzo Comunale.

119. TADDEO DI BARTOLO. *The Adoration of the Shepherds* (1404). Siena, Church of the Servi.

120. PAOLO DI GIOVANNI FEI. *The Nativity of the Virgin*. Siena, Accademia.

The material for plate 11 was kindly placed at my disposal by M. Adolphe Stoclet, Brussels. That for plates 60b and 61a was specially prepared for me by M. Arthur Cornette, Antwerp. I take this opportunity of expressing my sincere thanks to both these gentlemen.

THE TEXT

CONTENTS

*Noi siamo per la gratia di Dio manifestatori agli uomini grossi
che non sanno lectera de le cose miracolose operate per virtu et
in virtu de la santa Fede.*

FROM THE BREVE DELL'ARTE OF 1355
OF THE SIENESE GUILD OF PAINTERS

ALTHOUGH the fourteenth century must be considered the Golden Age of
Sienese painting, any study of this period ought to begin with the Sienese
Duecento. The turn of the century cannot be taken as a limit, for in the "holy year"
of 1300, Duccio, who must be placed at the head of the school by all who aspire
to give a historical sketch of fourteenth-century painting in Siena, had already
passed his prime. And it is at least our duty to point out that what is commonly
known as "Sienese", and what Duccio succeeded in bringing to so high a per-
fection of form, can already be recognized in the paintings of the Duecento.

At that time, and even later, the artist was, in the eyes of his contemporaries, a
manual worker whose social status was determined by the guild. Like any other
master, he worked with the help of collaborators, assistants and apprentices, so that,
strictly speaking, his work can never be called personal. On the other hand the
figurative element had so strong an influence on speech that every handicraft was
termed "Art". During the period in question Art itself was dedicated almost ex-
clusively to the service of religion and the artist was so closely connected to his
period[1] that every element in his work, perhaps more readily understood in those
days than in later times, brought into relief the inner characteristics which he had
derived from his country of origin.

These characteristics are evident in the choice of subjects for pictorial repre-
sentation, and in mediaeval artistic conceptions the subject itself was practically
everything. Even during the Duecento the representation of the Madonna was the
favourite theme of the artists of the period. This cult of the Virgin created its own
very characteristic expression and confirmed what had already been proved by the
fact that the Duomo — founded in the early part of the thirteenth century — was
dedicated to the Mother of God and her Assumption. In Siena also the might and
grandeur of the state were incorporated in the construction of the cathedral, so
that it is a logical conclusion (typically mediaeval in its conception) if the Mother
of God becomes the "Advocata" and the state Her State.

The pictorial representations of the Madonna in the thirteenth century already
possessed a gentle and rather melancholy inspiration, which radiates the magic of
physical beauty, and consequently the marked and living sensuality of such pictures
becomes refined and purified until it borders on the transcendental. Though they
are still obscured by the shadow of great and severe models, we can still distin-
guish in the paintings of the Duecento this fundamental characteristic of Sienese
art, which is at one and the same time passionately worldly and ecstatically ethereal,

I

and even at this early period the painter in the construction of his pictures relied more on feeling and perception than on a careful and discriminating intelligence. The Sienese were born panel-painters, and Sienese mural painting has never been able to deny its dependence from panel-painting.

The artists have a joyful and receptive appreciation of the wealth of external appearances and strive eagerly to reproduce all that meets their eyes. Their happy and tasteful gift for ornament and decoration is only another phase of their lively artistic feeling. As early as the thirteenth century they handle coloured ornamentation with the same dexterity which they display in the treatment of the gold ground-work, the haloes, and similar accessories.

From the point of view of painting the pictorial representations of the Duecento show a remarkable appreciation of the harmonious division of the surface and a sure sense of line. In the pictures of the school of Guido da Siena the decoration of the haloes is executed in beautiful line-engraving and stippling is but sparingly used. We thus find, even at this period, a native sense of line differing from that of the Florentine school not only in technique, but also in the more careful execution.

In the fourteenth century there are, so to speak, two systems of colouring in Siena, of which one prefers light, clear tones, while the other gives us pictures in heavy, inwardly-glowing, almost melancholy colours. This second system appears to be connected with, and to draw its strength from, the Byzantine icons and illumination, while the former seems to derive from native Italian experiments, for we find it in Lucca as early as the twelfth century.

If we turn to the narrative element in the beautifully coloured Sienese "histories" of the thirteenth century, we find the Entry into Jerusalem depicted with such a living sense of reality that we are ready to overlook the conventionalisms of the models. There is, to take another instance, a Martyrdom of St. Bartholomew in which the martyr is depicted in the nude on his bed of torture, while four men, one on each leg and each arm, are stripping off the skin so that everywhere the raw flesh is exposed. In the left foreground an executioner's assistant grips the martyr's bleeding leg with both hands, so that a fifth man, crouching on the ground with his leg thrust out to obtain a better purchase, may tear away the skin with all his strength from the saint's thigh. These horrible details are related with striking realism and it is typical of Sienese painting, so rich in contrasts, that side by side with sober figures, etherealized almost to the point of transcendentalism, appear scenes in which a grim delight in the horrible is depicted in a repulsive manner.

Ever since the days of Ghiberti it has been the custom to call the style of these pictures the "Greek" or "Byzantine" manner (*maniera greca* or *bizantina*), for Byzantine painting had a large share in its formation. Native Italian elements, traditions from the antique handed down on Italian soil, and oriental artistic methods, formed a strange mixture, to which from the middle of the thirteenth century on-

wards was added the influence of northern Gothic. It would seem that the technique of mosaic art had not a little to do with the development of this Byzantinizing tendency and that certain schematic forms, such as may be seen in the modelling of the features, were derived from the conversion into line of the usages of mosaic-workers. This process may be compared with that of the insertion of gold lines in panel-painting, similar to those found in Byzantine enamelling, where they take the form of little gold ridges separating the enamelled compartments. We find these lines used as decoration in Duccio's Byzantinizing period and even later.

This mixture of Italian and Byzantine styles thus derives nearly all its means of artistic expression from the East, transforming them in such a way as to give rise to a thoroughly Italian form of art which cannot possibly be confused with the real Byzantine productions. Naturally use is also made of the excellent Byzantine technique, which is especially noticeable in the green ground employed when painting the nude. This green gradually works its way through and gives a greenish shimmer to the flesh-tints. The heritage of eastern art is also exploited in the colouring, in the form of the draperies, and in the choice of the subjects themselves. Just as practically all the Madonna-types of the thirteenth century derive from Byzantine art, so will the "histories" be related after the Byzantine manner. This style is sufficiently independent to afford artists of different races assistance in the expression of their own artistic ideas, and was an instrument which the masters of the thirteenth century knew how to use to great advantage. Such were the roots from which a mighty tree with spreading branches and thriving blossoms was to spring.

It is highly significant that the first time we hear of the young Duccio, on the occasion of his first really important commission, he is in Florence and not in Siena. On April 15th 1285 the Brotherhood of Mary, who owned a chapel in Santa Maria Novella (the last of the chapels in the choir, on the right), concluded an agreement with Duccio for the execution of a large painting of the "Madonna with the Child and other figures", a "tabula magna" as it is called in the document. We possess no documentary evidence of payments made to the master, but from what we know of the brotherhood and of their chapel it is highly probable that Duccio did actually execute this commission.

Vasari did not know of this document and praises the painting as a work of Cimabue, but an unprejudiced examination of the picture itself must inevitably lead to the conclusion that the Rucellai Madonna is a Sienese work and that it is very closely connected with Duccio.[2]

This is not the place to go further into this difficult question. From the purely historical point of view the very fact that the picture mentioned by Vasari as being by Cimabue hung close to the chapel for which Duccio was commissioned to paint his large Madonna is of the greatest significance, as is also the fact that the lower

3

border of the frame contains in a prominent position a bust of St. Peter Martyr, who founded the Brotherhood in 1243 (cf. note 6).

Plate 1 Although at a first glance this huge picture may appear rather antiquated, on account of the disproportion in size between the figure of the Virgin and those of the little kneeling angels, it nevertheless contains a new element, namely the heart-felt warmth of adoration of the Virgin, similar to that found in the *Laudi* which the members of the Brotherhood were wont to sing in praise of the Mother of Christ. The Rucellai Madonna is the first large picture inspired by this sentiment. Not only in the artistic composition, but also in the spiritual sense, the *"Donna del cielo, gloriosa madre del buon Gesù"*[3] is the central figure in the painting.

The picture is characterized by a delight in small details and in the harmony of well-divided surfaces, and we see no striving after massiveness or striking effects of outline such as are to be found in Cimabue. The technique is accurate down to the smallest detail, not free and sweeping as in the work of the Florentine artist who can never escape the influence of fresco-painting. The Sienese painter makes experiments in perspective which are far superior to anything of the sort attempted by Cimabue. Through the little Gothic arches of the throne we can see the foreshortening of the pedestal, the brocade and the extremities of the cushion on which the Virgin is seated, and in this way the picture acquires real depth. This rather uncertain sense of spacing which, side by side with highly successful attempts, also admits the most obvious contradictions, is a characteristic peculiar to Duccio.

In the Rucellai Madonna we find an almost nervous reaction to the reality of life and to the expressive power of drawing. The line is always combined with the surface in such a manner that the decorative value of the latter finds full and living expression in the line itself. Where, however, in the Rucellai Madonna the line is quite free, as in the borders of the mantles of the Virgin and the angels, we find a play of folds such as is never found in Cimabue's pictures, but which is everywhere visible in the works of Duccio.

The gold groundwork in the Rucellai Madonna is covered with a fine pattern the technique of which is clearly Sienese and at the same time Ducciesque. In view of the important function the picture was to fulfil, stippling is employed, but only
Plates 2, 6a
Plate 5 to a moderate extent. The haloes of the Madonna, of the topmost angel on the right, and of the middle angel on the left, show the beautiful Ducciesque technique, while those of the topmost and lowest angels on the left and of the middle one on the right remind us, in the conception and technique of the fillings, of Guido da Siena or his school. The painter of the Rucellai Madonna must, however, have had a
Plate 4 Florentine assistant, for the halo of the lowest angel on the right has a filling which is completely Florentine in character and technique, for instead of being executed in line-engraving the design is composed of rows of stippled points.[4]

The Rucellai Madonna should be seen by sunlight — which it is possible to direct

on to the picture from the cloisters with the aid of large mirrors — if we want to get a correct idea of its glowing, truly Sienese colouring, of the effect produced by the working-through of the green ground beneath the flesh-tints, and of the softness of the nuances in the hands and features, so typical of Sienese painting.[5] The half-figures in the medallions of the frame show, at the apex of the frame, God the Father, and also Prophets, Saints and Apostles. The last-named cannot all be identified, but where this is possible, we see that the colours of their mantles are the same as those of the Apostles in Duccio's Maestà.[6]

Even if individual characteristics revealing an acquaintance with the art of Cimabue were more numerous in the Rucellai Madonna than is actually the case, this could not influence the fundamental fact that we have to do with a picture which, though painted in Florence, is Sienese in conception, construction and feeling, and this explains the deep impression which the picture must have made on Florentine artists, for novelties always attract by their very unfamiliarity.[7]

In addition to this there are Florentine pictures which reflect this impression but differ fundamentally from the Rucellai Madonna in that their character and conception are Florentine, with more or less evident traces of Sienese influence. This is the case with the Madonna in the Gualino collection,[8] the work of a by no means insignificant painter of the Cimabue school, whose imitative, sensitive and eclectic nature was the most susceptible to the Sienese conceptions and demonstrates even more clearly than Cimabue himself the affinity of his style with that of the master of the Maddalena.

The closest relationship with the Gualino master is shown by the Madonna in the Louvre (formerly in San Francesco at Pisa), which derives both from the Rucellai Madonna and from the Trinità Madonna. The style and technique are those of the Cimabue workshop, even in such details as the ornamentation of the haloes, but are softer and have lost much of their power of expression. The influence of the master of the Maddalena is still evident, while the Sienese elements in the picture have long been recognized.[9] Even in Cimabue's Trinità Madonna we can perceive something of the Sienese charm in the heads of the angels, with their delightful alternations of attitude and poise.

The Rucellai Madonna was a fruitful source of Sienese influence on the banks of the Arno, for above all it gave the Florentines an insight into Sienese sensibility and inspiration as displayed in their rendering of facial expression.

IN OCTOBER 1285 and again in January 1286 we find Duccio once more in his native city; after this we do not hear of him again in Siena until the year 1291.[10] Apart from this the Rucellai Madonna must be closely related to Duccio, for during the last two decades of the Duecento he was the most influential painter in Siena.

One scarcely likes to compare the huge Rucellai Madonna with Duccio's little

5

Plate 10 Madonna with three Franciscans, for the latter is not much bigger than the reproduction of it given in the present volume. The affinity with the painter of the Rucellai Madonna is evident at a first glance and this in itself suffices to demonstrate the close connection of the picture in Florence with Sienese painting. The conception of the *Plate 16* kneeling Franciscans and of the Rucellai angels leads us directly to that of the Patron Saints of the City in Duccio's Maestà, for in all three cases the borders of the mantles lie upon the ground with the same easy freedom that we see in other kneeling figures in the "histories" of the Maestà.

Cimabue and his school always depicted the Infant Jesus clad in a long tunic. The more human and naturalistic tendencies of the Sienese abolished this convention, and Duccio and his school repeatedly depict the child half nude. In Siena the precocious little man, the thoughtful Saviour, the "Light of the World" in the shape of a child, becomes a real baby.

Plates 7-9 In the Madonna from Santa Cecilia in Crevole the Virgin is wearing the antiquated Byzantine coif and, as in the Rucellai Madonna and still more clearly in the Madonna with the three Franciscans, the same emphasis is laid on the gesture with which she holds the Child away from her, grasping him beneath the arm, that we see in Guido da Siena's large picture in the Palazzo Pubblico,[11] while the manner in which in the Crevole picture the Child tucks up his little leg is a further reminder of Guido's school. The Crevole Madonna is impregnated with Sienese sensibility and produces an even more antiquated effect than the Rucellai Madonna.

In the Crevole Madonna the Child Jesus is also wearing the transparent little shirt with fringed edges and a golden girdle, and clutches at the hem of his Mother's mantle where it passes across her cheek. In this we see, perhaps for the first time, a *motif* which was subsequently developed by Duccio and his school in a variety of forms. The ornamentation of the Virgin's halo is in Duccio's best style. The angels resting on the clouds reveal his manner and technique and are in perfect harmony with the style of the medallions on the frame of the Rucellai Madonna.[12]

Considered in relation with the Sienese *maniera bizantina* the modelling of the features in the Crevole Madonna is broader and the eyes are larger, and when compared with the Rucellai Madonna the style of the lineaments is seen to be slightly different. The traditional scheme of expression in the single figures is even more evident in the picture in Florence, while in the Crevole Madonna the nuances are softer and the Virgin's mouth has already that slight prominence so characteristic of Duccio's manner. The feeling for line is different only in degree and not in manner, while the variations in style are nowhere sufficient to justify the exclusion of the Rucellai Madonna from connection with the Crevole picture, any more than the fact that the flesh-tints in the latter are lighter than in the former, where the green ground is more visible.

Both the Crevole Madonna and the Rucellai picture strike us as works of great

6

artistic inspiration. Even if slight differences are perceptible in all three pictures, these may easily be attributed to the natural tendencies of a young painter who is inevitably far more susceptible to foreign influences in his earlier period than later, when familiarity with the methods of a workshop and the accumulation of mature knowledge impose narrower limits upon his artistic creation. Despite these differences there can be no doubt that all three paintings are the work of Duccio.

These pictures are the crowning achievements of the first great epoch in Sienese painting, which dates around the year 1285 and with the Rucellai Madonna did not, as is generally supposed, open the doors of Florence to Sienese painting, but merely served to strengthen the Sienese influence which already existed there. We see this influence in the school of the Master of the Maddalena, and it is a tangible element in the work of the great Cimabue himself. It would be no exaggeration to say that the soft and gentle hands of Giotto's Madonna from the Ognissanti are derived from the Rucellai Madonna, and this is not the only trace of Sienese influence in the first real Maestà in the history of Florentine painting.

In Duccio's later years his colouring and technique show more affinity to Byzantine art than do those of Guido da Siena's school. The Crevole and Rucellai Madonnas may legitimately be regarded as improved versions of the Madonna del Voto (Siena, Duomo), which is the work of an artist of Guido's school, but the *Plate 12* triptych in London and the Madonna in the Stoclet collection are much more *Plate 11* nearly related to pure Byzantine icons, while on the other hand still later pictures, such as the Madonna in Perugia and that in the Accademia at Siena (No. 28), and *Plates 13-14* above all the Maestà itself, contain elements which are obviously in relation with *Plate 17* Duccio's first period as embodied by the Rucellai Madonna. The only possible conclusion is, therefore, that in the last decade of the thirteenth century Duccio must have come into direct contact with pure Byzantine art. As a return to Byzantine models is everywhere noticeable about this period, even in sculpture, it is highly probable that Duccio fell under the influence of this last Byzantine movement.

It is not surprising that about the same time the Gothic element began to assert itself in Duccio's art, even in the representation of the Madonna, with the introduc- *Plates 11, 12* tion of the Gothic veil in the Virgin's head-dress, which imparts a piquant element to the iconography of such pictures. This veil becomes a veritable toy for the Infant Jesus and the timid reaching after the border of his Mother's mantle, as represented *Plate 7* for the first time in the Crevole Madonna, finds its real scope in the Brussels picture. The arrangement of the folds and the abundance of the drapery in the triptych in London show an increasing tendency towards Gothic, while the greater breadth of the metacarpus and the long, thin fingers are a survival of the influence of Byzantine icons, as is also the fact that the hovering angels and the Child have again become smaller in proportion to the Virgin.

The slight variation in the lineaments of the Madonna, giving greater strength

Plate 11 to the plastic form of the features, is perhaps a similar survival. In the Stoclet picture a dreamy inspiration is given to the picture by the manner in which the Virgin's figure appears above the parapet, shown in perspective, as though she were standing framed in a window, while the divine sweetness of her countenance, tinged with a gentle melancholy as she gazes upon the playful Child, produces an enchanting and mysterious effect against the gold groundwork.

IN a later group of Madonnas we see a gradual diminution in the Byzantine characteristics of the Virgin's features, and a return towards the ideals of the artist's first

Plate 13 great period. In the beautiful Perugia Madonna, the restoration of which has given us another single-handed work of the master, we see a revival of the Crevole Madonna[13], and a comparison with this latter picture enables us to appreciate the great improvement in the artist's feeling for the *ensemble* and for spacing. Despite the Byzantine gold threading the figure of the Madonna has ceased to be a flat silhouette. The figures have room to move in and the narrow frame seems to emphasize the plastic relief. Instead of two angels, as in the Crevole Madonna, we now have six, an anticipation of the angels round the throne in the Maestà.

Towards the end of the century a marked change in composition begins to make itself felt.[14] The tendency towards the multi-panelled Gothic composition was consummated in Duccio's workshop. This new form of composition, Gothic in its conception, was later amplified by the addition of elaborate frame-decoration o foliage, finials and pinnacles. The round arch maintains its sway in the interior of

Plate 15 the picture. A good example of the most ornamental form of medium-sized altarpiece is the beautiful polyptych painted by Duccio's workshop.

Plate 14 The half-figure Madonna with saints shows the new type of composition in a still simple form. To Duccio himself we can only ascribe with certainty the figure of the Virgin, though it is difficult to believe that a splendid piece of painting like the pluvial of St. Augustine can be by any other hand but his. The picture must have been painted under the master's personal direction and the self-consciousness with which the saints stand round the Madonna in Guido's pictures has been developed so as to give unity to this silent group of earnest men gathered round the Divine Mother. The figures seem bathed in the soft atmosphere of a gentle piety, so delicate and caressing that it might have been wafted from another world.

The half-clothed Child, with his little mantle slipping down from his shoulders,

Plate 15 is a new development of the theme of the master's early works, which in the polyptych, that is to say only a short time before the Maestà, attains a grandeur of composition and a depth of conception which make us regret all the more the damage suffered by the middle portion of this picture, only a part of which is the work of the master himself.

The early part of the thirteenth century gave us frontal Madonnas seated upon a heavy throne, the *Sedes Sapientiae*, and while in the middle of the century the practice of depicting the Madonna seated sideways necessarily led to an oblique position of the wooden throne, the new conceptions brought with them a return to the frontal position with a view to greater effect. For this reason the massive stone throne, adorned with Cosmato work, in the Maestà faces direct towards the front, and the Madonna herself is only very slightly inclined towards the left. The old stiff severity has disappeared, giving way to a human dignity and a solemnity of pose which in its perfect freedom results in a miracle of artistic attainment, for the Virgin and the Infant Jesus, while losing nothing of their divinity, yet appear to us as a real Mother and Child. This transformation, which was not confined to Siena but was common to all Central Italy, is more than a historical event in the development of artistic conception; it is a chapter in the history of the spirit and of the soul, in the realization of which Duccio played an important part.

On June 9th 1311, when the great painting of the Maestà was carried in solemn *Plate 16* procession from the workshop to the cathedral, to the accompaniment of music and amidst the customary animation of red-letter days,[15] the Madonna ascended her throne and took possession of the city in the religious sense of the word. Four years later she was enthroned in the temporal sense when Simone Martini, in paint- *Plate 36* ing his Madonna for the Hall of the Grand Council, invested the Virgin with all the outward symbols of royal rank, thus making her a real sovereign. This may seem to us nowadays a pleasing and sublime invention, but to the people of that time it was absolute reality.[16]

Duccio's style was firmly rooted in that of the native masters of the thirteenth century, but he used tradition as every really great artist uses it, that is to say as an aid to the development of his own creative powers.

It would be very instructive to trace this process in Duccio's various pictures and to this end one ought to choose those scenes which for centuries had provided subjects for pictorial representation, so that the artist approached them with a certain reluctance to effect any considerable change in the traditional methods. Duccio's Annunciation and his Nativity show clearly that he followed the usual models established by Guido da Siena and his school, as preserved for us in the altar-piece of St. Peter in the Accademia at Siena (No. 15). This altar-piece is the strongest proof of Duccio's dependence from the traditions of Guido's school; many of the figures have a charm which might well have been the work of Duccio in his younger days.

The relationship to Byzantine art in these pictures was evidently only indirect, whereas in other pictures we see traces of the artist's direct contact with oriental icons. This is clearly seen in the iconography of the Transfiguration in the National Gallery, London, and in the three panels of the Temptation. When compared with

9

the light, thin colouring of the altar-piece of St. Peter, Duccio's deep and glowing colours are novel and surprising, and are perhaps the strongest proof of his Byzantinizing tendencies; on the other hand we see elsewhere a return to the lighter system of colouring, as, for instance, in the panel of Judas selling his Master.

The older painters were wont to place their figures or groups in the midst of buildings or in a framework of landscape, with a view to obtaining a rough unity of plane, but Duccio gives a new development to these accessories, unobtrusive but full of new ideas. Examples of this are the Jesus framed in the dark doorway in *Plate 21* the Washing of Feet, the maid in front of the archway in the Denial in the Court, and the magnificent angel, thrown into relief by the mountain mass behind him, in the scene of the three Maries at the Sepulchre.

As a rule he clothes his figures in the raiment handed down by antique tradition and consisting of a long-sleeved tunic and a mantle thrown over the shoulders. The mantles of Jesus and the Virgin have a gold border, a northern Gothic feature already found in Duccio's precursors, but in Duccio developed on Byzantine lines. The arrangement of these borders is certainly used in the Maestà as a means of giving greater relief to the figures and the likewise Byzantine gold threading is made to serve the same purpose.[17]

Plates 16-19 In the Madonna enthroned of the Maestà the importance of the picture called for a large number of figures, which are crowded together in rows one behind the other. The effect of this arrangement, however, is not very great, and in this assembly of saints Duccio adopts a more superficial division of the pictorial plane which relies on the rows of gold haloes for its decorative effect. It is in this that consists the close affinity of the Maestà with the Rucellai Madonna, for the latter picture, despite the difference of theme, also required a looser composition.

The improvement in Duccio's feeling for form is striking and is also seen in the draperies, which are thicker in texture and fall in heavier folds. The arrangement of the latter differs but little from the Rucellai Madonna and taut lines at sharp angles to one another still prevail. In the women saints, St. Agnes and St. Catherine, *Plate 20* Gothic influence makes itself felt in the abundance of drapery (in addition to the Gothic style of the garments), in the drooping, pointed edges, and in the slight inclination of the whole figure. The graceful play of folds as seen in the Rucellai Madonna assumes a more earnest character in the Virgin of the Maestà; the golden border on the Virgin's mantle in the latter picture is closely related to the Rucellai Madonna in its gentle motion, though the rhythm is less marked.

Duccio devoted more attention than any other artist of his period to the problems of perspective in pictorial representation. He constructs the architectural or landscape settings separately and the episodes which take place, or the figures set, therein are not conceived at the same time, but are, one might say, fitted in afterwards. Their spatial relation to one another is considered apart from the setting.

In the episodes of the story of the Passion, we find real interiors, as in the Last Supper, the Washing of Feet, and the Last Address, and in the scene in which *Plate 21* Christ is brought before Annas. In the room in the Last Supper, the scene of which is the same as that of the two following episodes, the large coffers of the ceiling are supported by brackets in addition to the side walls, and not until the Trial before Annas do we find an unbroken ceiling with small coffers, such as is also found in the palace of Caiaphas. This series of episodes, from the Marriage at Cana to the Annunciation of her death to the Virgin, is like a mirror reflecting the various stages in the presentation of the interior.

These pictures represent the first appearance in western painting of the setting considered as an entity, that is to say the real interior. Duccio is guided by his observation of reality and conceives the interior as part of an ever-changing whole, capable of unlimited development.

The system of rules which we may call Duccio's perspective, as seen in the houses of Caiaphas, Herod and Pilate, is a kind of parallel perspective. In the Washing of Feet Duccio depicts the centrally-constructed room with converging vanishing lines. The only part of the picture constructed upon one vanishing point is the centre compartment of the coffered ceiling lying between the two brackets; this vanishing point is situated almost exactly in the middle of the sculptured ornament which Duccio, perhaps with a view to indicating it, has placed in the upper part of the middle wall-panel. The vanishing lines of the lateral compartments intersect approximately on a perpendicular drawn through this ornament. Duccio includes the ground plane in the perspective construction of this room, a type of construction which has been called the "vanishing axis system" on account of the perpendicular on which it is based. It is not until the last pictures of the Maestà that he contrives to construct a two-compartment interior approximately upon one centre of vision. In the Annunciation of her death to the Virgin the doorway is included in the perspective system.[18]

Duccio's importance as an exponent of the theories of perspective extends far beyond Siena. The germs of the new feeling for space, and of the artistic means of representing it, already existed in the older painting, in the *maniera bizantina*, but it appears as if contact with northern sculpture, which came by way of the thirteenth-century Italian sculpture, was necessary before the new conceptions could attain fundamental and fruitful maturity. The following period turned for enlightenment to Duccio rather than to Giotto, for although Duccio is far less simple than Giotto, he yet presented what he had to teach in an easier form, probably because in his art the new elements are directly combined with the old. Thus we find that the Sienese masters who came after him were not alone in following the new paths which Duccio had been the first to point out; the whole of Italian painting, and even that of northern Europe, was influenced by his example.

We should get but an incomplete idea of Duccio's feeling for space if we were to limit ourselves to an examination of his perspective. The whole of Duccio's pictorial conception is dominated by a notion of space which takes a particular pleasure in *Plate 22* reality. The most famous example of Duccio's power of creation is his Entry into Jerusalem. Although the picture is not constructed on any perspective system, it yet affords a striking proof of Duccio's notions of space. It is a thoroughly Sienese picture in every way, for both the vivid narration and the vivacity of spatial effect are to be found in that other Entry into Jerusalem, painted by Guido's school, of which I have spoken above.

Plate 21 The Denial in the court of the high priest's palace is very curious in its arrangement of the setting. The action takes place in the foreground. The little window with its Gothic biforium — reminding us of the Gothic windows in the throne of the Rucellai Madonna — through which we can discern the winding stairs and the half-opened door through which Jesus was led into the presence of Annas, forms the connecting link between the two scenes and gives them spatial unity.

Street-scenes like the Healing of the Blind Men, so successful in the general effect of their spatial conception, made a great impression on such painters as Simone and the Lorenzetti. Even when Duccio deliberately returns to symbolism, as in the Temptation on the Mount, he depicts the "Kingdoms of the World" as little battlemented towns, girt around with walls, which we look down upon from above. The tall, gabled houses are crowded together and dominated by church spires and the main fabric of the cathedral. We look down from a height upon the steep, paved streets and our imagination is almost tempted to penetrate beneath the gloom of the city gate and wander along the lonely lanes, for these symbols are seen and depicted as visions of a real world.

We are quite justified in speaking of landscape in connection with Duccio. The *Plate 22* gap between the Flight into Egypt and the Entry into Jerusalem is a wide one, but whereas in the latter the general tone is one of festive rejoicing, tempered only by the restrained dignity of Christ and his disciples in such a way as to render all the pathos of the solemn event, in the Christ praying in the garden of Gethsemane the landscape is presented as a sombre, almost gloomy elegy.

Plate 23 This picture must be counted among the greatest productions of the master, who has here given us a picture which is in perfect harmony with his temperament. The figures no longer move in front of the landscape as they do in the Flight into Egypt, but have become an essential part of the setting, while the eye is carried by stages into the depths of the background. The gold groundwork loses its figurative character and becomes a glowing, dusky sky, lit by the setting sun, against which the bushy tops of the trees stand out black as the shades of night. The stern, mournful aspect of the landscape and the passionate nature of the episode combine in perfect harmony to produce the tragic atmosphere.[19] Another

great example of Duccio's talent is found in the landscape of the "*Noli me tangere*", *Plate 29*
the striking pathos of which seems to grow out of the spiritual significance of this
mysterious encounter, while in the placing of the figures Duccio adheres strictly to
iconographic tradition.[20]

His observation of nature is precise but is nevertheless based on the traditional
pictorial conceptions, as is revealed by his manner of representing the rocks. The
landscape of the Entry into Jerusalem is modelled on some *motif* from his native
town, but we are unable to identify any particular gate of the city.[21] Overhanging
balconies with wooden supports such as are found in Duccio's Christ and the
Woman of Samaria may still be seen in Siena today, and the same may be said of
the little closed balconies of the Entry and the Healing of the Blind Men. The
open, curved balcony looking on to the street in the latter picture is likewise copied
from the architecture of the period and the Sienese painters who came after Duccio
copied it in their turn from him. Although it can hardly be maintained that in the
settings of his pictures Duccio started from an immediate and consistent observa-
tion of nature and of reality, it is nevertheless true that he enriched them with a
keen perception of his surroundings, even in small details, while in the superposed
architectural settings we find a striking reminder of the stages of the Mysteries.

The artists of Duccio's time knew little more of the painting of undraped figures
than what it was necessary to depict in the Massacre of the Innocents, the Baptism
of Christ, or the Crucifixion, but Duccio's nudes in this Crucifixion, while they may *Plate 24*
owe much to Niccolò Pisano or to northern Gothic ivories, undoubtedly show a
degree of anatomical knowledge which is the fruit of careful observation of the
human form.

The secret of Duccio's power of expression lies not so much in the external action
as in the inspiration of the movements, or, to put it more clearly, in the gestures.
There are numerous examples of this in his paintings, even when, as in the Denial
in the Court, the gestures indicate nothing but a commonplace everyday occurrence.
Duccio's talent for identifying himself with the feelings of his figures is unrivalled,
and his lack of passion is more than compensated by his tenderness and depth of
feeling. While Giotto strives stiffly and sometimes coarsely after heroic effects, the
gentler temperament of Duccio aims at something more human and simple, and
consequently, while Giotto always remains the son of a Tuscan peasant, Duccio is
rather the well-educated townsman taught by a careful upbringing to eschew all
vulgarity and bluntness. The crowding-together of Duccio's groups seems at a first
glance to be rather antiquated, but this troop-like effect is relieved by the lively
participation of the single figures in the action of the picture, and they are thus
transformed into a living crowd, reflecting as in a faceted mirror the different phases *Plate 21*
of the action. A notable example of this is the right-hand group of the Crucifixion.

In the group of women in the Crucifixion Duccio depicts the Virgin as she sinks

13

*Plate 25*gently to the ground in a swoon, gazing upwards with unspeakable tenderness at the dead body of her Son upon the Cross. The spiritualization in this group is carried to such a point of fervent grandeur that it borders upon heroic pathos, but the pathos of a tender humanity, which even in the pangs of grief does not lose its self-control. The mysterious curves of the gold border on the Virgin's mantle are like a linear transcription of her spiritual emotion.[22] In the Deposition the Virgin reco-

*Plate 27*vers the body of her beloved Son and Duccio depicts this recovery with a delicate tenderness which seems to breathe the gentle self-deception of a mother's heart. It is no mere chance that the straightening of the golden border of the mantle is here a linear token of an ardent longing, in contrast to the drooping folds of the Crucifixion, which seem to symbolize the anxious flutterings of a torn heart.

Duccio's mastery of his art is equally evident in another, very different, scene:
*Plates 26, 28*Peter denying the Lord for the second time; while in the Maries at the Sepulchre he employs linear tradition with graphic effect in the regal figures of the three women, whose attitudes and dignified gestures betray their agitation, while their grief and suffering are reflected in the raising of the eyebrows and by the mouths,
*Plate 29*tightly shut in the effort to repress their sobs. In the *Noli me tangere* we feel that the secret of Duccio's innovation lies in the perfect unity between action and setting, the setting itself having been freed from all trace of symbolism.

Tradition had handed down from ancient times certain elements of "continuous" representation, which consisted in depicting several scenes in the same picture, with consequent repetition of the principal figures, as Duccio has done in his Christ's Agony in the Garden of Gethsemane, in the Nativity and in the Flight into Egypt.[23] Even in the *maniera bizantina* we notice attempts to give fuller development to this system by conforming the arrangement of the different episodes to the actual course of events, thus giving a logical sequence to the whole narration. This process is seen in the side panels of the magnificent Madonna formerly in San Martino and now in the Museo Civico at Pisa, where the legend of Joachim and Anna is depicted in ten little pictures, ranging from the Refusal of Joachim's Sacrifice to the Presentation of the Virgin in the Temple.[24]

This continuous representation was further developed by Duccio. In the first predella there is something resembling unity of place in his manner of representing the Adoration of the Magi in front of the same cave, before which a lightly-built stable is placed, as that seen in the Nativity. The chief figures, not only the Virgin
*Plate 16*and Jesus but also the Apostles, are clothed in the same colours in both pictures and for the Apostles Duccio follows the same system as in the half-figures on the front. The same process is used in depicting persons whose importance in his narrative Duccio wishes to emphasize, for instance the three grey-haired Pharisees who from the Betrayal to the scene of Pilate washing his hands, and even in the subsequent episodes, are the heart and soul of the conspiracy against Christ.[25]

Later on Duccio entirely abolishes the spatial limits between two scenes and unites the two settings in such a way that a certain degree of unity of place and unity of time is attained. The Denial in the court of the high-priest's palace and the Trial *Plate 21*
before Annas are intended as happening at the same time, while the second and third Denials of St. Peter are represented as simultaneous with the Trial before Caiaphas. In this way a unique effect of narrative contrast is attained.

The adherence to the same type of countenance and to the same colours for the drapery, together with what we may well be allowed to call the unities of time and place, helps to concentrate the episodes depicted, thus tending towards the attainment of unity of action. We must therefore consider the whole Maestà in connection with its narrative composition.

In addition to the episodes actually represented, those which are omitted have a certain significance, for the narrative power of any artist is mainly revealed by his choice of scenes, and in this Duccio is guided by a definite purpose. The order of the episodes in both predellas of the Maestà is rather uncertain and Duccio seems to have been rather averse to altering the traditional iconographic order.

In the paintings on the back the fact that four scenes are thrown into greater *Plate 21*
relief by their larger dimensions gives unity and emphasis to the whole, which is thus divided into four sections, each of which is complete from a narrative point of view. The first begins with the rejoicings of the Entry, quickly transformed into a tender elegy with the scenes of the Last Supper; the tragic knot is tied with the Betrayal of Judas, followed, after the brief pause of the Agony in the Garden, by the inevitable consequences of his treachery in the Arrest. The second section opens with the brief interlude of the Denial and in the following scenes the narrative is carried on with ever-increasing rapidity to the Trial before Pilate. Pilate sends the Saviour to Herod and we breathe again an atmosphere of hope which even the Flagellation and the Crown of Thorns do not dispel. This third section closes with the Bearing of the Cross. In the exquisite Crucifixion the tragic tension reaches its highest point and at the same time its solution; conceived and depicted as a historical event and as an actual occurrence, the Crucifixion is likewise a symbol.

The last section begins with the Deposition, in an atmosphere of tender sorrow; the dark, tragic note again changes to one of elegy, sustained in the anxiety of the three Maries at the Sepulchre, becoming assurance and certainty in the radiant countenance of the Angel on the tomb. And just as the narrative began with the Entry of the Saviour into Jerusalem, so does it close with the Christ of the Resurrection, in pilgrim's garb, making his way, unrecognized by the two disciples, towards another of Jerusalem's gates, towards that of Emmaus. The march of events seems to die away in a soft adagio, like the steps of the three pilgrims as they wend their way towards the twilit city. In its narration and its composition this picture is the transition to the upper row of paintings, which are devoted to the

other appearances of Our Lord after his Resurrection and reach their definite conclusion with the Feast of Pentecost.

It is difficult to see any valid reason for finding fault with Duccio on the ground that, between the Trial before Annas and Pilate washing his hands, he has spared the spectator not one single episode of the Path to Calvary, for it is precisely in this succession of scenes that he has given a magnificent demonstration of his power of dramatic narration. We can understand Duccio and his ideas only if we consider him as a narrator in the sense of the term contained in the quotation which I have placed at the commencement of this book.

Duccio loves inserting narrative details into his work; he likes to raise the tone of the story and then let it fall in a sorrowful chant, only to rise again. He envelops the course of events with an abundance of tender conceptions, which help to broaden and diversify the action, so that the stream of his poem flows smoothly before our eyes. Like a true elegiac he veils each incident in the atmosphere of a lingering pathos, but gives his pictures so great an affinity to nature that they form a charming contrast to this underlying impression. The broad stream of his narrative is but an epic approach to reality, striving to bring the succession of events ever nearer to a reality which has been and can be experienced. Thus did Duccio prepare the soil from which his great successors were to reap so fruitful a harvest.

VASARI, whose Life of Duccio scarcely reveals any first-hand knowledge of the master's works, tells us that Duccio also worked in Pisa, Lucca and Pistoia as well as in Florence. In Pisa the art of Duccio made a lasting impression; the Madonna in the Schiff collection there, which was originally in San Francesco at Lucca, is the work of Duccio's school.[26] In Pistoia all trace of his work has vanished.

Plate 13 Of Duccio's influence in Perugia Vasari says nothing. Even before Duccio's time there were links between Siena and Perugia, as Vigoroso was a native of that city. In 1319 the mediocre Meo da Siena was living in Perugia; he came from Duccio's school, had a great success there and through his followers dominated the painting of Perugia during the first half of the fourteenth century.[27]

That Duccio had a workshop is proved by certain pictures which so closely mirror his style that it is impossible to ascribe them to followers or imitators.[28] These followers have little importance in the history of Sienese painting and its development, but are interesting as an aid to the study of Duccio's own works.

Plate 30 We shall first mention a painter who combines Duccio's earlier and later styles and takes his name from the Madonna enthroned in the church of San Salvatore at Badia a Isola near Colle di Val d'Elsa. The picture must have been painted only a few years after Duccio's Maestà. The marble throne with inlaid mosaic-work is taken from Duccio's masterpiece, but modified in the manner of the Rucellai Madonna, and the relationship to Duccio's early work is also seen in the draughtsman-

16

ship of the picture and in the types of the Child and angels. In this picture, as in the fragment of an older Madonna now in the Archiepiscopal Museum at Utrecht, the artist preserves, together with other characteristics of the *maniera bizantina*, the Byzantine coif beneath the mantle of the Virgin drawn up over her head.[29]

An artist of the first quality is the Master of the Madonna in Città di Castello, who appears to have become associated with Duccio's workshop about the beginning of the last decade of the thirteenth century. His earliest picture is perhaps the much-damaged Madonna in the Ny-Carlsberg Glyptothek at Copenhagen, which reveals an artist who, while deriving originally from the Sienese *maniera bizantina* of the latter half of the Duecento, came under Duccio's powerful sway and was able by his vigorous modelling to give the master's tender charm a solemn, grandiose character, so that in his other early picture, the Madonna from San Michele in Crevole (Siena, Opera del Duomo), Duccio's soft melancholy is transformed into a sentiment of magnificently restrained sorrow. A later picture of his, the five-panelled altar-piece in the Accademia at Siena (No. 33 of the 1903 catalogue) shows a still further diminution of the harsh character seen in the linear drawing and draperies of the *maniera bizantina*, and a softening of the impressive severity which produces an unforgettable effect in the Madonna from San Michele in Crevole. The Madonna in the Pinacoteca at Città di Castello proves that the master continued to follow Duccio's later style. The Maestà was for him a landmark, as it was for all the artists of Duccio's circle. The frequent, more or less free, repetitions of the Maestà are an eloquent testimony of the great influence which this picture exercised on the art of the period.[30]

Plate 31

Of all Duccio's pupils there is one who must have drawn his determinative impressions from the master's middle period. Segna di Buonaventura has not only faithfully preserved Duccio's Byzantine style but he has turned the tender, rather passive, sensibility of the master's Madonnas into a tearful sentimentality which is sometimes peevish and sometimes merely stupid. Of the work of Segna, who must have been considerably younger than Duccio, only four signed pictures have come down to us: a Maestà in the Collegiata at Castiglion Fiorentino; four arbitrarily reassembled fragments of an altar-piece; a triptych in the Metropolitan Museum at New York, and a Crucifix in the Russian Historical Museum at Moscow. In addition to these there is a large Crucifix in the Badia SS. Fiora e Lucilla at Arezzo, which though unsigned is probably the work of Segna, who appears as witness in a document of that abbey dated 1319. If the "Madonna delle Grazie" in the cathedral at Massa Marittima is really by him, this would be a valuable aid to the study of his development, for we may safely relate to this painting a document which states that work on the picture was interrupted in 1316.[31]

Plates 32, 33

Some of Segna's pictures are modelled on Duccio's middle period, while others owe their progress to the master's later style. His Madonna in Castiglion Fioren-

tino must be called a free repetition of the Maestà and was probably painted a few years after Duccio's masterpiece, as the throne shows, even in its details, the increasing influence of Gothic forms; the picture appears nevertheless to have been one of Segna's first works. Although the prime source of his development was Duccio, he owes much to his contemporary Ugolino and was not altogether indifferent to the work of Pietro Lorenzetti. Segna's son Niccolò opened a workshop in 1331 and has left us a Crucifix, signed and dated 1345 (Siena, Accademia, No. 46).[32]

From the point of view of painting Ugolino was the most delicate of all Duccio's followers. We have no documentary evidence on his account, but in the eighteenth century Padre Della Valle was able to decipher and transmit to us the signature: UGOLINO DE SENIS ME PINXIT, on the polyptych which was formerly on the high altar in Santa Croce in Florence, but which at that period had already been removed from the church to the monastery. The middle panel of the picture, which bore the above-mentioned signature, represented the Madonna enthroned with the Child, and has since disappeared. As far as we can judge the painting

Plates 34, 35

must have been in seven parts, of which the Kaiser Friedrich Museum in Berlin possesses three large half-figures of the Apostles Peter, Paul and John the Baptist, and two predella-pieces, representing the Flagellation and the Entombment, while the Arrest, Deposition and Resurrection, together with other fragments, are in the National Gallery in London. A few other fragments are to be seen in private collections in England.[33] The florid Gothic form of this altar-piece is not the only reason for assigning it to about the end of the third decade, for years after Duccio's death it still remains faithful to the master's style and retains the form created by him. In the predella-pieces Ugolino follows the corresponding compositions of the Maestà. Ugolino is a typical imitator; painstaking, delicate in his draughtsmanship, and gifted with excellent taste and accuracy in finishing off a composition. Considered independently of other artists he is a capable painter, and the accuracy, precision and beauty of his drawing impart to his St. Peter a masculine gravity, to his St. Paul something of the severity of that soldier of God. He can scarcely be called a precursor of Pietro Lorenzetti, but he was capable of understanding that artist, and many of Simone's pictures also left a deep impression upon him.

Through Ugolino the traditions of Duccio's workshop were carried on right to the end of the Golden Age of Sienese painting, for his pupils remained true to their master and were incapable of exploiting for their own benefit the great changes which were taking place in Sienese art. All of them survived by many years the great master Duccio, who died in 1319.[34]

NONE OF the great successors can really be called a pupil of Duccio, although all of them are deeply indebted to him and Simone Martini more than any of the

Plates 36-38

others. We have no very early works by Simone. The fact that in 1315 he was

entrusted with an important commission by the state proves that at that time he was already considered a great artist. The execution of this work reveals the hand of a master, for it is a clever transformation of Duccio's Maestà, although painted only a few years later than the model. Despite the free rendering this great fresco proves that Simone derived from Duccio.

In his panel-paintings this is even clearer, for we see the same technique and the same colouring, even if the latter is somewhat richer and more vigorous, while the same workshop customs are visible in the decoration of the haloes, despite the *Plate 40* finer execution. That Simone was more closely related to his great precursor in panel-painting than in his frescoes is not surprising, for he must have studied the *buon fresco* in the workshop of another master: the relationship to Duccio is thus not the only feature in the development of Simone's art.[35]

Simone's frescoes show how much he fell under the sway of the new Gothic movement which had conquered the whole of Europe. As he grows older he abandons himself more and more to the charm of the "modern" style and this hinders to a certain extent his development. From a historical point of view he did little to further the solution of the essential problems of art which occupied the attention of all the really great painters of his time, even though they might have only an approximate idea of these problems rather than a complete comprehension. It says a great deal for Ghiberti's artistic insight that, despite his great admiration for Simone, he maintains in the face of popular opinion that Ambrogio Lorenzetti, and not Simone, was the greatest painter of Siena.[36]

If we compare Duccio's masterpiece with the Maestà painted by Simone in 1315, we can see the great progress made by Sienese painting in the brief space of four years. The main features of Duccio's composition are repeated and there is scarce- *Plate 36* ly any alteration in the arrangement and choice of the principal saints. But the grave and solemn compactness of Duccio becomes freer and, one might almost say, airier, while the artist makes a great effort to attain depth of space by arranging the saints and angels in rows placed at an angle to the plane of the picture, giving further relief to the hindermost rows by the frequent intersections. Three steps mark the different levels on which the figures stand.

Simone contrives to isolate the Madonna not only spatially, but also in the spiritual sense. The Virgin is seated upon a raised Gothic throne, of elaborate and graceful construction, while the draperies have the typical abundance of Gothic art. Duccio's perennial grandeur has been transformed by Simone into the atmosphere of an audience in the Heavenly Court, in which strict attention is paid to rank and office, and etiquette may on no account be infringed. On all sides we see dignified and handsome figures, whose correct and conscious gestures are the hall-mark of their noble birth and of their careful upbringing and culture. Very curious is the solemn Child, who seems as if he were giving an audience and grasps

19

in his hand a scroll on which is written: "Diligite iustitiam, qui iudicatis terram", the first verse of the Book of the Wisdom of Solomon — "Love righteousness, ye that be judges of the earth" as the translation has it. The baskets of the kneeling angels are full of roses and lilies and the words of the Virgin, inscribed on the middle step of the throne, seem like an acceptation of this homage, for they begin: "The flowers of the angels, the roses and lilies with which the meadows of heaven are bespangled, are not more pleasing to me than righteous resolutions..." Like the following lines on the lowest step they are an exhortation to good government, and the scene thus becomes symbolical. The fresco is in the former Council Chamber of the Republic of Siena, of which the real ruler was held to be the Madonna herself, who thus presided at every sitting.[37] The symbolical element is also dominant in the wide, painted frame, decorated, like that of the Rucellai Madonna, with medallions.

Plate 98 Simone's Maestà with its inscription from the Book of Wisdom is a preface to the frescoes in the adjoining Sala dei Nove, which Ambrogio Lorenzetti endowed with a wealth of reference to mediaeval wisdom and philosophy.

Unfortunately this first real "Maestà della Madonna" is now little more than a ruin, but although the details can no longer be properly judged, the style of the master is still clearly visible. Simone has little feeling for figures in the mass and for this reason the organic elements, and the standing and kneeling postures are a little uncertain. His depth of inner feeling is especially noticeable in the countenances and in the spiritual expression. He attires his figures in fine raiment, which becomes more and more sumptuous and elaborate as his art develops, with a consequent weakening in the modelling of the figures themselves.

Simone's strong leaning towards Gothic conceptions and the courtly elements in his Maestà lead us to the conclusion that before the year 1315 he must have spent some time at a princely court, the life and manners of which were based on French culture and custom. The Naples picture is a proof that he subsequently worked for the court of Anjou in that city. An ordinance issued by King Robert of Anjou, dated July 23rd 1317, provides for the payment to a certain Cavaliere Simone Martini of an annual pension, and modern opinion is rightly inclined to connect this document with Simone.[38] In any case it is impossible to exclude a sojourn of Simone in Naples, for the only explanation of the influence of his art in that city is that he must have had a workshop there.

Plates 39, 40 The Naples picture represents St. Louis of Toulouse placing the crown on the head of Robert of Anjou, who went to a lot of trouble and expense to obtain the canonization of this elder brother of his, who, a great-nephew of St. Louis IX of France, became Archbishop of Toulouse and died at the early age of 24 in 1290. The canonization was finally granted in 1317 by Pope John XXII. The picture had considerable significance from the political point of view, as the legitimacy of Robert's claim to the throne had been disputed, but is consecrated in the picture

by the hand of his saintly brother. It is therefore probable that the king ordered the picture immediately after the Pope had finally given his consent to the canonization and we may safely date it in the year 1317 or 1318.

Although the picture is in a very bad state of preservation, it gives us a good idea of Simone's exceptional talent as a painter. The Saint wears a magnificent red pluvial, fastened by a costly monile, over his Franciscan cowl. The broad edging is decorated, like the mitre, with the colours of the house of Anjou and its crest consisting of a lily, which also appears in the engraving of the gold groundwork. St. Louis is grasping the crozier in a stately manner and holds the crown above the head of the kneeling king with an elegant gesture. A comparison with the tomb of King Robert in Santa Chiara shows us the similarity of the features. Above the saint's head two angels hover, supporting the crown above his archbishop's mitre. The whole picture is purposely given an atmosphere of regal pomp, in the costliness of the draperies, the wealth of ornamentation, the beauty of the inlaid footstool, and the magnificence of the eastern carpet spread upon the floor.

When compared with the 1315 Maestà, this picture seems impregnated with Gothic elements, although it retains the old trapezoidal shape. The poor modelling of the figures and of the limbs beneath the abundant draperies is more than compensated by the magnificence of the *ensemble*.[39] This official painting of St. Louis reveals Simone as a painter who was at the same time a courtier, and it is impossible to imagine him as being other than a man of refined culture. It is quite likely that the verses on the Maestà were written by Simone himself, for we know that he was later a friend of Petrarch, and may safely assume that the poet did not honour him with his friendship merely because he was a great painter, but that he also appreciated the man of high culture.

THE CHRONICLE of the monastery of St. Catherine in Pisa furnishes ample proofs *Plate 41* of Simone's activity in that city in 1319, for we read that the seven-panelled polyptych of the Madonna with the Child and saints was placed in position on the high altar of Santa Caterina in the year 1320.[40] This altar-piece has recently been reconstructed on its old site and the fragments formerly in the Museo Civico have been replaced by copies.[41] It is a large work, in form very much like the polyptych from Duccio's workshop but with the addition of a predella, while it is more Gothic in *Plate 15* the emphasis given to the perpendiculars, although it still keeps strictly to the round arch. The picture is in a bad state of preservation and the quality of the painting on the whole very uneven, though that of the predella-pieces is excellent. The participation of the workshop is responsible for the apparent inferiority to the St. Louis picture and also for the fact that it seems more antiquated and nearer to Duccio. The principal pictures, even that of the Madonna, follow the older style, while that of St. Mary Magdalen shows marked Gothic influence in the drawing and the

ST. PETER'S COLLEGE LIBRARY
JERSEY CITY, NJ

Plate 41 b drapery, and this is even more the case with the finely-drawn figure of St. Lucy.
 The fact that Simone soon after received another large order, likewise from a
 Dominican monastery, seems to point to some inner connection. In 1320, at the
 request of Trasmondo, Bishop of Sovana, a member of the Orvieto family of the
 Monaldeschi, he painted an altar-piece in seven parts for the high altar of San
 Domenico in Orvieto. The form of the picture is simpler than that of the altar-
Plate 42 piece in Pisa.⁴² The centre-piece is a very beautiful and accurate piece of work,
 especially in the decoration of the nimbi, but we notice at once that the linea-
 ments of the Child and the form of his hands have become heavier and that the
 Magdalen, when compared with the corresponding panel in Pisa, shows a more
 Gothic tranquillity in the play of the folds and in the run of the borders of the
 mantle, a remark which may also be applied to the respective Madonnas. The
 increasing Gothicization is apparent not so much in the fact that Simone depicts
 his saints for the first time beneath fairly narrow, pointed arches with Gothic tre-
 foils, as in the circumstance that the panels are higher and narrower and the half-
 figures stand out more clearly from the edge of the frame than is the case in Pisa.
 The affinity of style cannot be denied and the two pictures are undoubtedly very
 close to each other as regards date. In Orvieto, as in Pisa, the participation of the
 workshop is very perceptible.
Plate 43 There was formerly in the Opera del Duomo at Orvieto another altar-piece in
 five parts, now in the Gardner collection, Boston. In this picture the participation
 of the workshop is again clear, more so in the wing panels than in the centre-piece.⁴³
 The manner in which Simone invests Duccio's models with new forms and con-
 ceptions is beautiful and at the same time striking. A silent procession of gentle
 figures, their faces slightly tinged with sorrow, his Madonnas and saints pass be-
 fore the pious spectator. The striving towards a loftier representation of mankind
 induces the painter to borrow a dignified charm and conscious ease of gesture from
 the well-bred circles which he frequented. A definite conception of beauty raised
 to the loftiest heights surrounds these gentle women and silent pensive men with
 a blend of pure, glowing colours and with the warmth of an artistic sensuality
 which displays itself in the gold-embroidered draperies, in the magnificence of the
 diadems, in the smooth curves of the drawing and in the careful refinement of an
 eminent pictorial technique.⁴⁴

BETWEEN 1320 and 1330 the Sienese archives furnish us with documentary evi-
dence about Simone nearly every year. In 1324 he married Giovanna, the sister
of Lippo Memmi, and in 1328 he was paid for the fresco in the Hall of the Grand
Council. In this same year Guidoriccio accomplished the feat of arms to celebrate
which the state ordered a portrait of the condottiero to be painted. Since 1326
Guidoriccio had been commander-in-chief of the Sienese forces and in 1328 he

gained a victory over Castruccio Castracani, thereby capturing the town of Montemassi. The general is depicted on the field of battle; on the right is the Sienese *Plates 44, 45* camp with the tents of the commander and of his officers, with the Balzana fluttering in the wind; on the left the battlemented town of Montemassi upon a rocky hill. The sturdy figure of the condottiero, clad in a coat of mail, is sitting well down in the saddle and the horse proceeds at a walking pace, snorting and chewing the bit. In front of him the general holds his marshal's staff and his rather fleshy countenance has an energetic chin and an expressive mouth; the atmosphere is one of danger and adventure. What some consider as a defect of this painting, namely, that the horseman and the background are not in harmony, gives it a peculiar character of unreality, and the fact that wherever the eye turns, not a living being, not a horse nor a man, is to be seen amidst all these fields and roads, huts, tents and battlements, except the solitary rider, produces an almost eerie effect. This fresco is the oldest existing example of those monumental equestrian likenesses with which the Italian republics were wont to honour their condottieri. 45

Simone's most celebrated picture, the Annunciation in the Uffizi bears his and *Plates 46-48* Lippo Memmi's names and the date 1333. In the Gospel we read of Mary after the angelic greeting that "when she saw him, she was troubled at his saying, and cast in her mind what manner of salutation this should be". In the picture the Virgin drops her prayer-book with an almost pained gesture, gathers her dark blue mantle about her and turns away, raising her slender shoulders as if shuddering, arching her delicate eyebrows as if in pain. She seems almost to be a lady of breeding offended by an unseemly word. The archangel Gabriel is a striking contrast to the inner restraint and outward calm of the noble Virgin. Fresh and vivacious, his wings and garments still rustling after his flight, he kneels before her, holding a sprig of olive in his left hand and raising his delicate right hand to accompany with his forefinger the words which issue from his half-opened lips; and the "fear not" with the principal words of his message are inserted in golden letters on the narrow border of his stole. Over the whole scene Simone has lavished an incredible wealth of charm and beauty. The golden brocade of the archangel's raiment with its dim shadows, the fluttering mantle, the wings with their plumage, the embroidery on the back of the throne, the inlays of the throne itself, all are miracles of painting. Perhaps no more beautiful picture has ever been painted, no more divine scene ever enveloped in such an atmosphere of enchanting, fairy-like etherealism. 46

This picture marks an important stage in the history of Sienese painting and of Italian painting in general, for the spirit of Siena and the conceptions of northern Gothic here appear in perfect counterpoise, united without a trace of contradiction with those reminiscences of the voluptuous pomp of painting which the Sienese had retained from their contact with eastern art and developed in their own peculiar manner. A spiritual unity was thus attained which even today is so strikingly

23

manifest that we are deeply impressed by the strength and purity of these mediaeval conceptions. The influence of the picture was considerable even at that time while later it became extraordinary, not only in Siena.[47]

ALTHOUGH there are numerous outward signs of the transformation of Simone's style, many elements in his artistic development still remain uncertain. A proof of this is the fact that even so extensive a series of frescoes as that of the life of St. Martin in the lower church of San Francesco at Assisi is sometimes attributed to the third, and sometimes to the fourth, decade of the fourteenth century.

In any case it is certain that the frescoes were painted after 1317, because St. Louis of Toulouse is depicted in the soffit of the entrance-archway to the chapel. It would be going too far if we were to accept the assertion that the chapel must have been painted after 1333, that is to say about the middle of the fourth decade.[48] The chapel is dedicated to the memory of the head of the Franciscan order, Cardinal Gentile Partino da Montefiore, whose name and arms are to be seen in the stained-glass windows both in the chapel of St. Martin and in the opposite chapel formerly dedicated to St. Louis of France.[49] The dedication picture in the chapel of St. Martin, above the entrance, confirms its foundation by Cardinal Gentile, who died at Lucca in 1312 and whose mortal remains were transferred to Assisi in the same year.

Like Duccio, Simone did not attempt until comparatively late in his career the pictorial representation of a connected series of ideas. He has left us two series of pictures representing "histories", both older than the frescoes in the chapel of St. Martin. These are the predella of the Coronation at Naples and a picture dedicated to the Blessed Agostino Novello, unsigned and probably painted about the end of the third decade of the century.

Plates 49, 50

The Naples predella gives rise to certain observations which are important both for the painting in Sant'Agostino and for the frescoes of St. Martin, for they serve to reveal the inner connection between these pictures. Although in the predella the settings of the various episodes are almost entirely confined to comparatively small interiors and Gothic architectural details are lacking, while for each of the episodes it is easy to trace a model in the work of Duccio, it is nevertheless surprising that the five scenes are conceived as regards their settings in relation to the centre-piece, that is to say that the spatial arrangement is common to all five scenes, in that a spectator standing in front of the central picture sees the pictures on the right and left in increasing perspective foreshortening.

A glance at the Agostino picture is sufficient to show that it is intended to be seen from one point and that Simone has learned how to represent several spatial layers placed one behind the other. In these pictures, and especially in the scene representing the child which has fallen from the balcony, we see that the time

24

will soon be ripe for the production of scenes of city life such as Ambrogio Loren-
zetti's "Good Regiment". On the other hand the good effects of Duccio's teaching *Plate 100*
are also apparent in the richness of the architectural setting and in the diversity
of the representation of space. A picture such as the Miraculous Resurrection of
the child which has fallen out of its cradle, where the child is seen below, restored
to health and carrying a votive candle to the church, would not have been pos-
sible without Duccio's Denial of St. Peter. *Plate 21*

Both the frescoed walls in the chapel of St. Martin are arranged, as regards per-
spective, in the manner described above, while the fifth history, placed above, is
conceived as a central composition. In the details the spatial composition is more
elaborate than in the painting in Sant'Agostino. The typically Sienese delight in
glimpses of interiors or through archways, and in the overlapping of figures and
other details, is again evident, while in scenes such as Valentinian humbling him- *Plate 53*
self before the Saint we find the same balcony-architecture as in Duccio's Healing
of the Blind Men, but in a more elaborate form. The weakest effect from the point
of view of perspective is produced by the Appearance of Christ (No. 2) in which
the workshop obviously had a greater share than in the other pictures. The fres-
coes have sadly deteriorated, but the unity and conciseness of the whole scheme
of decoration, which receives ample lighting from the beautiful windows, makes a
deep impression even at the present day. In no part of the Basilica of St. Francis,
abounding as it does in important works of art, do we feel ourselves so close to the
light of a great genius.[50]

On the left wall we see the noble saint, mounted upon a white charger, before
the gates of Amiens, dividing his mantle with his sword that he may cover the
nakedness of the shivering beggar, who is none other than Christ in disguise. Jesus
appears to the young saint in a dream, showing the severed portion of the mantle
to the angels. In the third picture, on the right wall, Simone has depicted the knight-
ing of the saint in strict conformity with the ceremonial of the period; the emperor
Julian in person girds on the young knight's sword, while a servant buckles on *Plate 51*
his spurs. Martin is wearing an elegant garland of flowers in his hair. The two ser-
vants of the emperor personify the only occupations worthy of a knight, feats of
arms and the chase. On the right of the picture we see musicians and singers. The *Plate 52*
mouth of the flute-player and the hands of the mandoline-players are represented
with perfect accuracy of observation. The servants and the musicians are clad in
two-coloured garments in the fashion of the period and not a single detail has been
overlooked. The action is fitted together to form a soft and pleasantly-animated
picture, which breathes the atmosphere of a time long since passed away, out of
which the humility of the pious knight gleams like a beautiful flower of heaven.

The invasion of Gaul by the barbarians compelled the Emperor Julian to take
defensive measures, and to this end he increased the pay of his officers, among

25

whom was St. Martin. Simone depicts the emperor sitting before his tent, while St. Martin holds a cross in front of him and accompanies with the animated play of the fingers of his raised right hand the words with which he refuses to follow the emperor to the war and declares that he will go out, alone and unarmed, to face and conquer the enemy with the aid of the crucifix. The landscape has scarcely any depth, for Simone concentrates all his sense of space on the perspective construction of the architecture.

With the following picture, which has suffered great deterioration, the narrative is carried over on to the left-hand wall, and in it we see St. Martin, who in the meantime has become bishop of Tours, raising a child from the dead. With the Mass of St. Martin we return to the right-hand wall but this fresco also has been grievously damaged; the "history" next to it shows Valentinian humbling himself before the saint. According to the legend the emperor had forbidden the saint access to his palace and had caused all the doors to be shut to keep him out; but an angel appeared to St. Martin and ordered him to go to the palace, into which he penetrated *Plate 53* without hindrance until he reached the throne; the irate emperor refused to rise from his throne to greet St. Martin, whereupon the throne burst into flames. Thus warned by Heaven, Valentinian threw himself penitently at the feet of the saint. The humble and at the same time passionate emperor is one of Simone's most beautiful creations, especially in the abruptness of the movement and the inner depth of feeling. The elaborate architecture, carefully constructed with a view to perspective, despite the narrow dimensions of the setting, surrounds the well-conceived scene with an impression of vastness, of lofty balconies, silent halls and peaceful courtyards, such as phantasy may well conceive an imperial palace to possess.

In the next compartment we see the Death of St. Martin. The saint lies stretched on the floor of the room, upon a rough bed of ashes; at the head of the deathbed a bearded, grey-haired priest is reading the prayers for the dying; on his left is a cleric with a burning taper and on his right an acolyte with the holy-water basin and the *aspergillum*. Behind the priest a group of clerics and laymen express their grief with sorrowful gestures. Of all those present only a choir-boy and a cleric, kneeling at the foot of the bed, gaze upwards with an expression of wonder and watch the saint's soul being carried up to heaven by four singing angels. The dead saint is surrounded on every side by the varied aspects of grief; nearly every one of the spectators receives an impressive characterization, from the snub-nosed choir-boy to the refined, thin faces of the two noblemen. Simone has even remembered that on such funereal occasions the priest must wear a black stole.

Plate 54 In the Dream we see St. Ambrose, wrapped in his chasuble, asleep upon his episcopal chair, a striking depiction of complete relaxation. The worthy prelate is a long away from himself for he is sleeping in Milan and in his dreams is celebrating the obsequies of St. Martin in Tours. We shall have to wait till Michael An-

26

gelo's Jeremiah in the Sistine chapel before we find so perfect an embodiment of self-absorption. A kneeling deacon gazes humbly but insistently at the slumbering bishop while another deacon enters and lays his hand with a cautious gesture on the shoulder of St. Ambrose.

In the last picture, representing the Obsequies, we see St. Ambrose celebrating *Plate 55* the funeral mass for St. Martin and receiving the ritual kiss on the hand as he gives back the censer. He is wearing the black stole and the archbishop's pall. Many of Simone's figures in this picture are the same that we saw in the Death of St. Martin, including the two noblemen on the left, now clad in the robes of some brotherhood, with their hoods drawn over their heads, ready to lift up the bier and carry it to its last resting-place. A cleric bears the crucifix which is carried in front of the funeral procession; the foremost of the two choir-boys is busying himself with the wax which drips from his taper, while in the background two cler- *Plate 56* ics are singing heartily, with that pleasing reality which is so striking in all these frescoes. As in the Death of St. Martin, the setting, although constructed with the most minute care as regards perspective, is out of all proportion to the number of figures and to the space they would have needed to move about in.

If we examine these frescoes in the order in which they were painted, that is to say from bottom to top and in the reverse way to the course of the story, we see how Simone adapted himself to the conditions of mural painting. The settings increase in depth, the number of figures is gradually reduced, the figures themselves become larger as his feeling for form increases, the style becomes broader. It is possible that one of Simone's brothers, Donato, may have been among his assistants, but as no signed work of his has come down to us, there is nothing to be gained by ascribing to Donato the chief share in the Christ appearing to the Saint in a dream, the fresco in which the participation of assistants is most evident.[51] The St. Martin frescoes, considered as a whole, show a certain irregularity in conception and execution, which cannot be adequately explained as being merely due to the participation of assistants, but appears to be a result of Simone's finding himself faced with a task of dimensions larger than those to which he was accustomed, although he was not without previous experience in mural painting.

A close examination of the frescoes, following the course of the story, proves that the narrative element is stronger than a first glance might have led us to believe. It is true that there is no great passionate crisis, but nevertheless a steady stream of spiritual realization leads from one picture to the other, and the gentle piety of St. Martin is presented in each picture under a different aspect, against a background of lifelike humanity in the secondary figures, who do in a natural and consciously calm manner exactly what it is their place to do. The restraint and inner moderation are an embodiment of the Gothic conception of mankind, which conceals the inner emotions beneath the veil of external composure and of elegant gesture.

27

The remaining decoration of the chapel is also filled with this spirit, for it is based upon the elaborate Gothic conceptions of ornamentation and architecture. The beautiful picture of the kneeling founder receiving St. Martin's benediction, the splendid half-figures of saints in the jambs of the three windows,[52] and lastly the eight standing figures of saints in the soffit of the entrance-archway are all imbued with the same spirit. Simone conceives his Gothic niches from a spatial *Plate 57* point of view. His Magdalen is thoroughly Gothic in conception and in the abundance of the drapery, while she holds the pyx with the elegance with which a young lady of the court might offer a costly casket, and, with a gesture typical of the women of the nobility holds up her dress with thumb and forefinger, just as St. Catherine, who was also of royal blood, gathers up the upper part of her dress beneath her arm. Elizabeth after the fashion of the time places her delicate fingers on the edge of her mantle and is in dress and demeanour a typical lady of the court, just as St. Louis, the king, and St. Louis of Toulouse are typical saintly princes.

The painting of this chapel was not the last work which Simone executed in Assisi, for we find him again in the right transept of the lower church in a row of half-figures painted on the wall near the former altar of St. Elizabeth, on the right near the entrance to the St. Nicholas chapel.[53] These pictures are in a bad state of preservation, especially the fresco of the Madonna between the two princely saints. Although little wider than a *paliotto* the effect is that of a panel and the impression is further heightened by the rich gilding, especially in the gorgeous picture of Elizabeth, who appears as the middle figure of the five saints on the left in the same dress that we see on the entrance-archway to the chapel of St. Martin. Despite the participation of pupils the style of these figures is similar to that of the last pictures in the chapel of St. Martin, for instance, the saints on the jambs of the windows or in the soffit of the entrance-archway, and it is hard to believe *Plate 58* that any other than Simone can have conceived and painted a figure like the so-called St. Clara, who modestly drops her eyes, and, while she reveals her ancient lineage in her noble oval countenance and pure features, still remains a saint in whom the worldly elements are in some strange way transfigured: distant like a lady of high degree, humble like the most lowly servant of the Lord.

The art of Simone, so full of all the pomp of worldly power, seems as far from the self-inflicted poverty of St. Francis as a king is from a beggar. A mighty prince of the church had ordered the painting of the chapel, so that the sanctuary of his order might appear as rich and brilliant as possible. The frescoes round the altar of St. Elizabeth, the Hungarian princess and Margravine of Thuringia, are full of reminiscences of courtly life. This princess was beloved of the Franciscans, for she was one of the first princesses to enter the third order. All this may seem little more than worldly vanity, proud of its protectors in high places, but Simone's frescoes are imbued with so pure a spirit and with a piety so natural, that even

28

this regal pomp is brought to serve the Almighty and his saints. And even with Simone we feel something of the Franciscan spirit, for did not the Poverello regard the glories of this world as a reflection of the mightier Glory of God?

As SIMONE's work in Assisi kept him busy during the years which preceded and followed the middle of the fourth decade, he can have spent but little time in his native city before he set out in 1339 for the court of Benedict XII at Avignon. It was probably that lover of art Cardinal Iacopo de' Stefaneschi who was the cause of Simone's being summoned to Avignon, in order that the greatest painter in Italy since the death of Giotto might have a share in the important undertakings which resulted from Benedict's great building activities.[54]

Only one dated panel-picture is left which shows us the painter's style during the last years of his life in Avignon. This is the Presentation, in which the twelve year old Jesus is depicted listening to his Mother's anxious question: "Son, why *Plate 59* hast thou thus dealt with us?"[55] The Virgin speaks with the dignified, almost severe calm of a woman of the upper classes and the austerity of her gestures emphasizes the earnestness of her words. The fine, fair-haired boy stands before her with folded arms, in that attitude of respect which good custom prescribes in the presence of one's elders. The setting is architecturally as little defined as in the great Annunciation and this gives the picture an abstract charm. In the combined motion of bending and turning of the body no picture of Simone's reveals so much Gothic *élan* as does his Joseph in this Presentation. Immediate contact with the old refined French culture intensified his joy in the animated movement of Gothic figures, but even so he did not sacrifice his Italian restraint to this new influence.

The little altar-piece in Antwerp — signed on the frame but undated; a por- *Plates 60, 61* tion of the picture is in the Louvre and another fragment in Berlin — must have been painted during Simone's Avignon years. The artistic and technical delicacy of execution which we find in these miniature pictures is on the same exceptionally high level as in the Liverpool picture. The number and the small dimensions of the figures have influenced the choice of types and the draperies are less Gothic in tendency, but the weeping St. John who stands on one side in the Entomb- *Plates 61 b* ment is very near to the little Jesus in Liverpool in the Gothic arrangement of the drapery. From the point of view of style there can be no objection to dating the picture round about 1342.

The contradictions which have to be explained are of another kind. Simone, the painter of suppressed emotions, for whom the moderation imposed by inner self-control appeared as the expression of a higher humanity, in these four scenes of the Passion of Christ transports the spectator into a veritable whirlwind of vehement emotion. Evidently direct contact with northern Gothic was indispensable before such inner forces could find expression in painting.

29

The artist relates the Passion with the conciseness of a cycle but at the same time with a wealth of connecting details which prove how great an influence Duccio's gift of narration had had upon his art. The emotions of the soul find expression in the painting of this sublime and sacred story.[56]

Simone envelops the sublime incidents of the Passion with a living animation which seems based on actual experience. Everything is translated into movement, which forms the connecting link between one scene and the other and gives a certain uniformity of action to the four episodes. Duccio's epical aspirations have been correctly interpreted and one might even say that the teacher's intentions have here found fulfilment for the first time. Some of the secondary episodes have almost the same strength and significance as the principal event and in this way narrative depth is attained. All the pictures are pervaded by the voice of pain *Plate 60b* and sorrow, which breaks out like a tempest in the great final scene. Unity of action is maintained throughout and care is taken to distinguish the various personages by giving them in each of the scenes the same draperies, the same colours and the same features; but this striving after uniformity does not prevent the painter from devoting some of his attention to delicate accessories, as, for example, in *Plate 61a* the Blind Man who is healed in the Crucifixion,[57] the woman in the Deposition who, overcome with grief, holds the bloodstained nails in her hands covered by *Plate 61b* her cloak, the two girls who fall weeping into each other's arms in the background of the Entombment. New versions of traditional gestures are also found such as the throwing-up of the arms in despair, or the St. John standing on one side, his whole frame shaken by sobs, a symphonic expression of a soul racked by pain.

The foreshortening of the faces in order to depict the bending of the head or the raising of the eyes, which Simone had only attempted to represent at Assisi, is diligently practised in the Antwerp altar-piece and brings about a noteworthy change in the direction of vision in his pictures. He pays less attention to questions of space and devotes all his care to the expression of inner emotion. In these thoroughly Sienese pictures we see the painter adapt in his own way certain of Giotto's themes, and this is particularly interesting in the Entombment, where to Duccio's composition he has added the sitting figures in the foreground with their backs towards the spectator.

Since 1337 Petrarch had been living at Vaucluse near Avignon and it would appear that Simone's sojourn in Avignon brought him for the first time into contact with the poet, who mentions the painter several times and refers to him in the two well-known sonnets.[58] The portrait which Simone painted of Laura has disappeared, but we still possess a document proving the friendly relations between Petrarch and Simone. This is the illuminated title-page of the Virgil manuscript which originally formed part of the poet's library, and Simone's authorship is attested by the two rhymed hexameters beneath the painting. The manuscript

30

is now in the Ambrosiana at Milan and the miniature is believed to represent Servius revealing Virgil to Aeneas, while the landscape background is a reference to the Georgics and the Bucolics. Simone's hand is very evident in the figures of Virgil and the two knights, yet this title-page seems to have been completely overlooked in later times.[59] Despite the great beauty of this miniature, it does not give us a sufficient idea of Simone's talent in the art of illumination, which must have been considerable, for from his school came the two greatest Sienese miniaturists, Niccolò di Ser Sozzo Tegliacci and the Master of the St. George Codex.[60]

THE LITTLE altar-piece in Antwerp serves in a certain degree to supplement our knowledge of Simone's illumination as do also the works of the two artists mentioned above; in fact the miniatures in the St. George Codex at the Vatican were long attributed to Simone himself. We have only one signed miniature by Niccolò, the Assumption of the Virgin and the Miracle of the Girdle, in the Caleffo *Plate 62* d'Assunta, painted about 1332. It is a work of unrivalled delicacy of execution and feeling. The influence of this great master of miniature was widespread and lasting, but we have no other manuscript which can safely be ascribed to him, although many of the codices at San Gimignano closely resemble his work.[61]

The master of the St. George Codex takes his name from the *Missorium libri et sancti Georgii martyris historia* of the Vatican Library, commissioned by Cardinal Iacopo de' Stefaneschi who himself compiled this history of the patron saint of his church. Among the not very numerous miniatures we find one representing St. George killing the dragon, which was very probably inspired by Simone's fresco in Notre-Dame-des-Doms at Avignon. The beauty of the colouring, the delicate draughtsmanship, the keen sense of observation make these miniatures worthy to rank among the finest productions of Italian illumination. One or two excerpts, unfortunately much damaged, from another manuscript, in the Print Room at Berlin, show the same delicate execution and animated charm of conception which are typical of Simone. Among the numerous panel-paintings which as a result of recent investigations may safely be ascribed to Simone, the distinctive features of good miniature-painting are again perceptible.[62]

Simone's brother-in-law, Lippo Memmi, may originally have come from Simone's workshop, for in his Maestà painted in 1317 he copies Simone's fresco and already shows his artistic dependence from this master. In this badly-preserved fresco, which underwent a first restoration as early as 1467 at the hands of Benozzo Gozzoli, the types of heads have little in common with the signed works of Lippo. Although Benozzo also touched up the signature, there is no valid ground for doubting its authenticity, but we should not base our opinion of Lippo on the peculiar characteristics displayed in this fresco. The gentle animation of the model *Plates 63, 64* has been turned into a stiff and soulless regularity, the Gothic elements have be-

come scanty and coarse; Simone is seen through the eyes of a *petit bourgeois*. Lippo's relationship to his brother-in-law appears in a more favourable light in his panel-paintings; faithfulness to Simone, who taught him all that he was capable of learning, distinguishes all his work, and this is the secret of those delightful little Madonnas which seem to become more charming and more inspired in

Plate 65 inverse proportion to their size. Even a beautiful picture like the Madonna del Popolo in the church of the Servi, corresponding in style to Simone in the first years of the third decade of the century, lacks both the artistic merit and the

Plate 66 charm of inspiration which we find in the little picture in Berlin, painted some time later. Of his signed pictures the Madonna enthroned at Altenburg is the latest in date and one of the most beautiful. A safe ascription to Lippo is the half-figure Madonna formerly in Montepulciano and now in the Accademia at Siena (No. 595), which in its calm dignity is as good an example of Lippo's mature period as the Madonna and Child formerly in the Benson collection in London. When Lippo

Plate 46 worked in collaboration with his brother-in-law, as in the Uffizi Annunciation, he submitted completely to Simone's artistic criteria. The wing panels representing St. Ansanus and St. Julia are generally attributed to Lippo's own hand, as they are weaker than the main picture and the colouring is duller.[63] That Lippo at a later date was entrusted with the execution of other frescoes is proved by the fragments, certainly his work, of a Madonna enthroned, to be seen in the cloisters of San Domenico at Siena.

Even if the painter of the episodes from the Life of Christ in the Collegiata at San Gimignano was not a direct pupil of Simone, he must certainly be considered as related to Simone's school. Ghiberti calls him Barna, and Vasari relates that he was killed by a fall from the scaffolding in 1381, before the frescoes were finished and when he was still a young man, and that the frescoes were completed by his pupil Giovanni d'Asciano. This tragic story was the object of a certain mistrust[64] even at a comparatively early period and it is generally recognized that Vasari's date must in any case be wrong, as the frescoes cannot have been painted later than the middle of the century and were probably painted earlier.

It is very remarkable how this successor of Simone keeps to his master's early style, avoiding Simone's Gothic elegance and with his coarse but energetic temperament converting Duccio's simple grandeur into an expressive and effective fresco style. It is very difficult to detect any trace of his having been acquainted with the Lorenzetti, but he must have known Giotto's frescoes in the Arena at Padua, for, to take an instance, in his Annunciation he copies the listening woman with the distaff whom we see in the Annunciation to Anna. Simone's exaltation of movement becomes vehement, and almost violent, in Barna, and the latter's truly Sienese love of reality suggests to him an abundance of new details, while the older characteristics are reproduced with new and almost boorish force. His phy-

32

siognomies show great variety of expression and he deliberately places the mild head of the Saviour among the coarse and angry faces of the spectators in the Bearing of the Cross but also shows that he is able to depict the Virgin with a noble *Plates 68, 69* and tender countenance. With his happy sense of space he constructs clear and lucidly-arranged pictures, displaying such a complete mastery of his means that even so large a composition as the Marriage at Cana is completely successful and *Plate 67* the miracle of the wine is shown in the most natural manner. These frescoes are undoubtedly the work of a young painter, still striving towards the realization of his aims, none of whose subsequent works are known with certainty to have been preserved to us.

The design and conception of the mural paintings in the Collegiata are certainly due to one painter, but for their execution it is impossible not to admit at least two different hands. A comparison of the Raising of Lazarus with the Marriage at Cana suffices to show the difference of style. In the history of Sienese painting these pictures have but a secondary importance.[65]

The mention of these pupils does not by any means exhaust the subject of Simone's influence, which in Siena alone outlived the end of the century and left lasting traces in those foreign cities in which he worked. His sojourn in Naples was specially fruitful, for Neapolitan painting of the fourteenth century reveals his influence to a marked degree. And this is also true of Neapolitan illumination. In Pisa the lesser artists drew nourishment for their mediocre talent from the fruitful source of his art and Simone's influence is very clear in the work of Francesco Traini. It is the same at Orvieto, and the whole of Umbria also lies within the sphere of Simone's artistic domain. In Florence his influence seems to have been merely transitory, and less perceptible about the middle of the century than towards the end, for Lorenzo Monaco, who came from Simone's native city, combined in his own work and renewed those Sienese influences which after Giotto's death had brought new life into Florentine art, which after the disappearance of that great master had run to seed. Donato accompanied Simone when he went to Avignon and three years after his death Lippo Memmi and Tederigo were still working in that city, where Matteo da Viterbo helped to preserve the memory of Simone, while the French artists of Provence undoubtedly owe much to these Sienese artists. The City of the Popes conferred upon Sienese painting in the person of Simone a world-wide renown, so that we meet with traces of Sienese influence in Bohemia, Hungary, Cologne, Paris and in Catalonia. It is true that Simone owed much to Franco-Gothic culture, but it is also true that he repaid his debt with interest through the influence he exercised, both directly and indirectly, on the formation of the new French panel-painting, and even in the domain of illumination, in which French art, as in sculpture and in architecture, had been the model for the whole of Europe. The cult of realism, the animation and richness of its concep-

33

tions of space, its glowing colour and good, solid technique, these were the qualities to which Sienese painting owed its international renown and the aristocratic Simone was the painter who paved the way for its world-wide diffusion.[66]

SIMONE's derivation from Duccio was clearly visible from the beginning despite the uncertainty of his early period, and the same may be said of Pietro Lorenzetti, generally assumed to have been older than his brother Ambrogio because the first documentary evidence about him dates from an earlier year (1306). In Pietro's altar-piece in the Pieve at Arezzo (1320), we find the artist already in full possession of his powers, but this magnificent picture was certainly painted after the Madonna enthroned in the cathedral at Cortona, an interesting picture in that it proves the decisive influence of Duccio on Pietro's early years. In the latter Madonna Pietro modelled himself mainly upon the Maestà, but the heads of the angels show traces of Duccio's less Byzantinized manner, as exemplified in the Rucellai Madonna. The haloes are entirely executed in line-engraving, and whereas Duccio in his small Madonna-pictures accentuates the relationship between Mother and Child by depicting the Virgin gazing tenderly down upon the infant Jesus, in Pietro's work this conception is developed until it becomes an intimate, smiling conversation between the Mother and the vivacious little Child.[67]

Plate 72

Plate 70

Plates 1-6

Plate 11

The undecided element in this early picture has not entirely disappeared in the altar-piece at Arezzo but the latter picture is nevertheless a masterpiece. The attribution of the picture to Pietro is confirmed by a document dated April 17th 1320, in which Guido Tarlati, Bishop of Arezzo, entrusts Pietro with the painting of the altar-piece.[68] The figures of the side panels are enveloped in the atmosphere of Ducciesque feeling and the form of the altar-piece is not the only trace of Duccio's influence, for the figures of John the Baptist and St. Matthew have the same haggard type of countenance and the same low foreheads which were likewise adopted by Ambrogio. Although in this picture there is scarcely any trace of Gothic elegance as interpreted by Simone — St. John the Evangelist has an even more antique appearance than in the work of Duccio — the Gothic influence is nevertheless evident in the manner in which the figures stand out from the frame. The very conciseness with which the figures are placed in the setting produces an effect of suppressed internal force and it is this which gives to Pietro's pictures their weight and grandeur. Despite the fact that in the middle picture the solidity of the figure of the Virgin lies more in the intentions of the painter than in the actual realization, the heroic dignity of the figure nevertheless reaches a height of plastic expression which reminds us of Giovanni Pisano's imposing Madonnas.

Plate 72

Plate 15

Plate 74

Plate 73

In the polyptych in the Pieve Pietro has created an Annunciation which in its depth of conception and inner tension is a clear indication of the paths which he will follow in the course of his later development. If we compare Pietro's Annun-

34

ciation with the versions of the same theme by Simone and Ambrogio, we cannot *Plates 46, 109*
fail to be struck by the remarkable wealth of means which Sienese painting had
at its disposal. The beautiful Assumption of the Virgin in the space beneath the
pinnacle is also deserving of attention for it shows the importance which this
theme had attained in Sienese art.

There is a passage in the above-mentioned document which may be taken as
meaning that by 1320 Pietro had already been away from his native city for sev-
eral years, though it does not prove whether he had resided in Arezzo during
the whole of his period of absence. It is, however, certain that he resided for some
years in Arezzo, probably at a later period, for Vasari praises the frescoes with
which Pietro had adorned the tribuna of the Pieve. These contained twelve "his-
tories" from the Legend of the Virgin with life-size figures, and Vasari singles out
for special praise the Assumption of the Virgin in the vaulting of the conch, describ-
ing it in such detail that we may conceive the Ovile Master's Assumption (Siena,
Accademia, No. 61) as an abridged version of this composition, adapted to meet
the necessities of panel-painting.[69] This cycle of frescoes is the most comprehensive
work by Pietro of which we know.

The beautiful Madonna in the Loeser collection does not attain the same high *Plate 71*
quality of painting as the 1320 picture and differs considerably from it in the types
of figures, while the technique of the haloes is not in accordance with Pietro's
custom at that period. In fact this picture is nothing but a good production of
the workshop, painted at a later date. The manner in which the Child lays his
left hand upon his knee is one of those coarse, commonplace characteristics not
infrequent in the works of Pietro and his school.[70]

THE FEW notices which have come down to us concerning Pietro speak of works
painted in 1326, which have since disappeared, and it is not until 1329 that we
obtain a definite clue to a certain attribution: the altar-piece for the Carmelites
in Siena. The middle panel of this picture is, as Dewald has recently proved, the
Madonna enthroned with St. Nicholas, Elijah and angels, now in the church of
Sant'Ansano a Dofana, on the Arbia. This picture, the splendid colouring of which
is still preserved, shows the Virgin enthroned with the Child and four angels, who
stand behind the throne, while in the foreground on either side are the two saints.
The Madonna is sitting in a dignified attitude, looking straight towards the front,
and the vivacious Child turns towards Elijah, the founder of the Carmelite order.[71]
Of the predella only four panels, representing episodes in the history of the order *Plates 75, 76*
and now preserved in the Accademia at Siena, are known to us, but they enable
us to conclude that the perspective construction of the whole predella was similar
to that of Simone's Coronation in Naples. The Dream, showing Sobac slumber-
ing in the alcove, beneath the familiar arched balcony, is cleverly constructed and

is a proof of Pietro's keen interest in problems of perspective. The last two pieces are magnificent in their representation of space, and despite the similarity of subject, the setting of the panel representing the Pope investing the Carmelites with *Plate 75d* a new monastic garb is depicted in quite a different manner, while the frequent intersections of the arches and vaulting give the scene a different aspect. We are reminded of Giotto's "Appearance of St. Francis to St. Anthony at Arles" in Santa Croce, for whereas figures seen from behind are seldom found in Duccio, who studiously avoids them in his Last Supper, Giotto makes frequent use of them in the Arena frescoes. In these animated little pictures Pietro proves himself to be a born narrator with a warm sense of colour and a keen observation of nature.

ALTHOUGH the whole series of frescoes in Santa Maria della Pieve at Arezzo has been lost, there are other mural paintings still extant which enable us to form a good idea of Pietro as a painter in fresco. There can scarcely be any doubt that *Plates 83, 84* the large and magnificent Crucifixion at Assisi was painted towards the end of his career, and that the share of the workshop in the execution of the picture was relatively unimportant. The style of the painting is an immediate prelude to the *Plate 89* episodes from the Passion of Christ on the barrel-vaulting, which must, however, be attributed to his school. The frescoes on the entrance-wall of the Orsini chapel, *Plate 82* representing the Deposition, the Entombment, Christ in Limbo and the Resurrection, are anterior to the Crucifixion, while the two frescoes of the Madonna, *Plate 81* one of them over the tomb of Napoleone Orsini and the other beneath the Crucifixion, must have been the first works which Pietro painted in Assisi.

To express such observations in terms of years is not easy. The Crucifixion cannot *Plate 87* have been painted before 1342, the date on the Nativity of the Virgin in the Opera del Duomo at Siena; in fact, it is far more likely that it was painted a few years later. The four episodes from the Passion on the traverse-wall closely resemble in *Plate 77* style the Crucifixion of the Bandinelli chapel in San Francesco at Siena, which is usually assumed to date from the year 1331. The inexpressive polyptych of 1332 does not help us very much.[72] In 1333 Pietro painted a Madonna above the "new portal" of Siena cathedral, while in 1335 he and Ambrogio signed and dated the frescoes on the façade of the Ospedale della Scala which according to Vasari represented the Presentation of the Virgin in the Temple and her Marriage.[73] In the same year Pietro received his first payment for the altar-piece of St. Savinus, which had been ordered for the cathedral; we learn on this occasion that Pietro knew no Latin, for a "Maestro Ciecho de la gramatica" translated the legend of St. Savinus into Italian for his benefit, an interesting proof of the importance which at that time was attached to knowledge of the written sources of pictorial representation. In 1337 we have certain proof that Pietro was in Siena. To sum up, from the date of the altar-piece for the Carmelites (1329) until 1337 we have, at

comparatively short intervals, a series of notices which prove his presence in his native city, so that we may safely attribute the frescoes in San Francesco at Siena to this period, probably about 1334-35. We should therefore in all probability be fairly near the mark if we attributed the Story of the Passion on the entrance-wall of the Orsini chapel in the lower basilica at Assisi to the years 1337-39, in which years it is very probable that Pietro was not in Siena, as Ambrogio alone signed the great series of frescoes in the Palazzo Pubblico. The two Madonna frescoes in the lower church would thus date from about the end of the third decade.

The Madonna beneath the Crucifixion seems to be the older of these two As- *Plate 81* sisi frescoes. The *motif* and the more tranquil play of the folds are reminiscent of the Arezzo polyptych. The relationship between Mother and Child is equally charming in both pictures; the Madonna gazes provokingly into the Child's eyes, and at the same time points backwards towards St. Francis. This gesture with the thumb is no novelty, for we find it again in St. John the Baptist in the Arezzo pic- *Plate 72* ture. Nowadays such a gesture seems a little coarse, and it is worthy of note that we do not find it in the works of the aristocratic Simone.[74]

In the Orsini chapel fresco, under an architectural setting of arcades decorated with Cosmato inlays, we see the half-figure of the Madonna with the Child, with St. Francis on the right and John the Baptist on the left. Behind the still rather flat, pointed arches of the stone triforium, the perspective of which is based on the broad middle aperture, the three half-figures appear upon a gold groundwork. The Virgin glances across at St. Francis who raises his hand with a graceful gesture in order to show the stigmata, while the playful Child tries to attract his Mother's attention. John the Baptist is the familiar, lean prophet of the wilderness whose shrunken limbs emerge from his raiment of camel's hair. The "Vox clamantis in deserto" on his scroll heightens the contrast between him and the gentle, mild figure of the Poverello. This figure of the Baptist is a translation into terms of "western" art of the ascetic but inwardly active Byzantine ideal.

The crucifixion in the Bandinelli chapel, which was formerly in the chapter *Plate 77* hall of the convent, may be called the zenith of Pietro's artistic creation, despite the fact that it suffered grievous damage during the removal of the whitewash and that the standing figures below the cross have been cut off above the knees. Pietro here attains a wonderful harmony of feeling, a grandeur and dignity in the representation of the emotions, qualities which in their conciseness are at the root of the deep impression produced by this fresco. The lineaments are powerfully drawn and full of expression, while those of the Virgin are beautiful in their gentle charm. Duccio's conception of the fainting Mary is here repeated in a new and striking manner and no other painter has succeeded in representing with such simple means the touching, despairing grief of St. John. Jesus seems to have just died and the powerfully-drawn body, with the pronounced cavity above the hips

37

and the ribs showing beneath the skin, seems numbed by pain. With the fluttering angels round the cross the passion of grief bursts forth, and a shudder of pain seems to issue from the strips of cloud. The decorative and rather mechanical arrangement of these angels gives dignity and severity to the whole.

Plates 78-80 The frescoes in Santa Maria dei Servi are in themselves of the greatest importance, but they must also be considered in relation to the Crucifixion in San Francesco. In one of the choir-chapels we find the Massacre of the Innocents and in another the Dance of Salome and the Ascension of St. John the Evangelist; there are also a few remains of the general scheme of decoration of this chapel in which Pietro's style can still be clearly recognized. All three frescoes have been rescued from beneath a layer of whitewash. The Massacre of the Innocents is the best-preserved of the three and is particularly noteworthy in its representation of the city. The mothers and their children have been driven by a troop of horsemen into an inner courtyard of the royal palace and in this way the old-fashioned concentration of the tragic scene is, perhaps intentionally, explained. The features of the women are in Pietro's early manner, the lower part of their faces being rather broad. Despite the novelty and possibilities of the scene, the action lacks Pietro's energy, and we can hardly believe that the artist who in 1329 had handled a similar subject with *Plate 75a* such consummate skill can have been guilty of so glaring an error in perspective as the door and steps on the left. The fact that so sparing a use is made of figures with their backs to the spectator is a further reminiscence of Pietro's early style. The fresco must therefore be anterior to the Crucifixion and although it cannot be denied that Pietro had something to do with the work, his personal share in the painting cannot have been great.

Plate 79 In the mural painting of the Dance of Salome we are immediately struck by the grandiose architectural conception, the ample spacing, and the animation which the painter has given to the whole setting. Giotto's fresco in Santa Croce served as model for the banqueting-scene but the painter has introduced a realistic freedom into the remainder of the picture by depicting Herodias seated expectantly on the balcony above, while Salome herself, after the dance, carries up the head of the Baptist on the charger and consigns it to her mother. Although the picture is today little more than a ruin, it is difficult to arrive at any other conclusion than that Pietro himself is mainly responsible for it. The picture could scarcely have exercised so lasting an influence if it had not been the work of a recognized great master. The balcony architecture with figures placed thereon, so frequent in Sienese painting during the latter part of the fourteenth century has its beginnings here, while the beheading of the Baptist at the window of the prison served as a model for Giovanni di Paolo.[75] This fresco, and with it the whole chapel, was perhaps painted a short time before the Crucifixion in San Francesco.

Plate 80 The effectiveness of the Ascension of St. John the Evangelist is marred by the gaps

and by the feeble attempts at restoration. The arrangement of the figures is free and light, the movement is rhythmical and the relationship between figures and architecture natural and unconstrained. A comparison with Giotto's fresco in Santa Croce, which served as model, is interesting not only for the recognition of the differences between the manner of Florence and that of Siena, but also as showing the progress made by painting in the interval between the two pictures. Nearly all the faces in the picture have been disfigured by restoration, but the noble countenance of Drusiana has been less spoilt than the rest and is very similar to that of the Virgin in the Bandinelli chapel Crucifixion, which may also be said of the whole fresco, especially as regards the maturity of style.

The pictures on the entrance-wall of the Orsini chapel in the lower church at Assisi were certainly painted after the Bandinelli chapel Crucifixion and the most likely date would be towards the end of the fourth decade. In the Deposition there *Plate 82* is but little trace of the participation of pupils, which on the other hand is more noticeable in certain figures of the Entombment, while the Christ in Limbo and the Resurrection appear to be mainly the work of the studio.[76] Pietro develops Duccio's model with striking energy. The only addition is the Magdalen standing at the foot of the cross, a figure introduced by Giotto in his Arena Crucifixion, but which does not appear until much later in Sienese versions of the theme, while *Plates 60b, 27* this is the first time we find it in the Deposition. The painter shows an unrivalled tenderness in the manner in which he depicts the dead, tortured body of Christ lying limply across Joseph's knees, the head hanging down and the hair streaming out. With feverish haste Nicodemus strives to extract the nail from the pierced foot. The blood has run down from the *suppedaneum* on to the rocky ground and to the right of the cross we see a little pool of congealed blood formed by the dripping and splashing from the wound in the hand. The composition rises in heavy curves, as if bent beneath the burden of sorrow, and the surfaces of the drooping garments seem to fit into the *ensemble* like blocks of stone. The picture reveals a power of spiritual inspiration which is far superior to that of the Crucifixion in Siena and strives to reach an ever higher level. Pietro does not relate a "history"; he gives us something which is greater than mere narration, but which still retains the form of an exquisitely human picture.

As compared with the Crucifixion Pietro's style has undergone a change which corresponds to the inner significance of the theme. The features are thinner and sharper with expressions of inwardly-burning passion which are little removed from grimaces. The line is harder and in the treatment of the hair almost like wire. The heavy draperies fall in long, regular folds, broken where they touch the ground by sharp angles. That the tender conception of the picture does not suffer through this change is seen in the manner in which St. John supports the body and in the frightened countenance of the second Mary.

39

WE ARE now approaching the end of the fourth decade of the century and to this stage in Pietro's career belong the Madonna in the Uffizi and the altar-piece of St. Humilitas. The date on the first picture cannot be read otherwise than as 1340. The peculiar features of Pietro's style about this time are clearly recognizable in the longer faces and the sharper drawing of the outlines and hair, in the substantiality of the figure of the Virgin with its silhouette growing gradually broader as the eye descends, in the simple, heavy style of the draperies, in the type of the Child, very similar to the little Mary in the Nativity of the Virgin, and also in the technique of the haloes — to mention only the most important points. The disappearance of the transparent veil so characteristic of the earlier pictures and the fact that the Virgin once more has her mantle drawn up over her head, reveal another return towards the older, Byzantinizing tradition, which is also apparent, in the increasing use of gold threading as an ornament for the draperies. The picture is not one of Pietro's greatest creations, but nevertheless this radiant symphony of blue, grey and gold produces an effect which it is not easy to forget.[77]

Plates 85, 86 The date of the St. Humilitas altar-piece has been the subject of much discussion. Even if the date of 1341 is not absolutely certain, a critical examination of the style proves that this painting is very close to the Uffizi Madonna. The draughtsmanship is rather hard and the colours are roughly applied, while the conception of space and the perspective lack the clear firmness which distinguishes the Carmelite predellas, and the poverty of the architectural setting is noticeable. The legend is so charmingly related and contains such an abundance of expressive details that we feel ourselves under the influence of Pietro's art of narration.[78]

Plate 87 In the Nativity of the Virgin we possess Pietro's most important panel-painting. The admiration which the later artists of the fourteenth century and those of the fifteenth had for this picture gives us some idea of the impression it must have created when it was painted. Every subsequent version of the subject in Siena is based on Pietro's model. Since the days of the Carmelite predellas his work has not been lacking in representations of homely interiors, so that we are able to follow his progress step by step until we reach this great culmination of his art. In the Nativity of the Virgin he contrives to give community of perspective to the centre and right-hand panels of the great triptych, while in the left-hand panel he leads the eye into another and much deeper room; and though the perspectives of the two rooms are seen with different eyes, he yet manages to relate that of the left-hand panel to the perspective of the bedroom, which is constructed on one vanishing point even down to the pattern of the flooring, the coverlet of the bed and the mouldings. It is true, however, that of the vanishing lines in the foreground of the left-hand panel only a few lead to the vanishing point of the centre panel, while others run approximately to the latter's axis. These observations show how keen was Pietro's interest in the problem of perspective.

The scene is laid in the house of a well-to-do man, with a beautiful, arcaded courtyard very similar to that of the Palazzo Pubblico at Siena. A close examination of the construction of the house reveals many homely details. The grey-haired St. Anna, sturdily and broadly built, raises her right leg in most unceremonious fashion beneath her flowing robe, in order that she may rest her hand upon her knee. The mother of the new-born child is receiving visitors, for a lady, holding a beautiful fan, sits by the side of the bed, while another has seated herself upon the floor in the foreground to help the maid wash the tiny Mary. The elegant damsel carrying the jug of strengthening wine is depicted in the act of drawing back the finely-woven cloths which cover and conceal the presents contained in the maid's basket. The graceful body of the new-born babe emits rays of heavenly light. Meanwhile the aged Joachim has been waiting anxiously in the other room, until *Plate 88* at length a page comes to bring him the joyful news. The old man leans expectantly forward, looking into the boy's eyes as if he wanted to test the truth of his statements. His companion, a bald-headed man with a carefully-trimmed black beard, gazes out of the picture in an attitude of pensive indifference.

The atmosphere of the "happy event" which permeates this picture does not lend itself to any representation of tragic tension. This scene, in which a motherly woman, smiling gently, bends over the charming child, is far removed from the spiritual agitation of the Deposition at Assisi. All the same the two works are so similar in style that we cannot be very far wrong if we attribute the Orsini chapel frescoes to about the same period as this Nativity of the Virgin.[79]

In the same year in which this picture was painted Pietro, according to a document which has come down to us, purchased a piece of land for Cola and Martino, the sons of Tino di Camaino, to whom a couple of years later he and his wife Giovanna sold some land. This latter notice, dated 1344, is the last news we have of Pietro. It is thus possible that he went to Assisi about that time. We do not even know in what year he died, and that he fell a victim to the plague of 1348 is nothing but a supposition, although it is probably not far from the truth.

Despite the complete lack of documentary evidence, there is little doubt that the painting of the left transept of the lower church was undertaken in accordance with a uniform plan, and that the work was entrusted to Pietro. The frescoes in the barrel-vaulting must be assigned to a later date. The earliest date which can be admitted for the latter paintings is 1342, for it is in Ambrogio's Presentation *Plate 106* in the Temple that we see for the first time the almost excessively decorative architecture which characterizes the frescoes in the barrel-vaulting. In Ambrogio's picture small winged and draped figures carry a garland of flowers on the wall of the Temple of Solomon, but in Assisi they become undraped genii, large and *Plate 89* sturdy children who play about amidst the capitals and mouldings. The difference in such details is so marked that the only possible conclusion is that the scenes

41

from the Entry into Jerusalem down to the Bearing of the Cross must have been painted a considerable number of years after the year 1342, for it is hard to conceive of such mural paintings being executed earlier. Considerations of this nature tend to strengthen the supposition that Pietro must have died, or left Assisi for good, during or immediately after the execution of the Crucifixion, leaving the completion of the frescoes in the left transept to his pupils.

Plate 83, 21

Plate 100

Plate 84

The Crucifixion still produces a great and striking effect. The thickly-peopled scene derives originally from Duccio but has imbibed something of the spirit of Ambrogio, who has given us in his scenes of city life so vivid a representation of everyday happenings. Pietro's painting is a historical episode, but his Christ dominates so completely the seething crowd that the crucified Saviour with the group of delicately arranged angels becomes the decorative expression of the artistic symbol. The loss of the centre-piece deprives the picture of much of its perspective effectiveness.

Pietro made remarkable efforts to give depth to his *ensemble* and organize the swirling movement by frequent changes of direction in the line of vision. Below on the right we see the rumps of three horses with their riders; the horses paw the ground and lash their tails. Other horsemen ride towards them, while in the background we catch glimpses of the heads of still more horses and even the soldier striking at the legs of the wicked thief is mounted. In contrast to this confusion of horses and horsemen, of soldiers and upward-gazing spectators, the left half of the picture produces an impression of comparative calm. Longinus rides up with his companion, their horses shown in profile, and raises a protesting arm and hand with the same impressive gesture as at Siena. In the foreground, beneath the cross of the good thief, is the magnificent group round the fainting Virgin, whose drooping head is supported by one of the Maries, while the other, seen from behind, receives her in her arms. St. John gazes sorrowfully upon the scene. Above, the swarm of angels round the Cross give vent to their heart-rending chorus of lamentation, with all the passion of which Pietro is capable.

In his desire to give to the historical event a more modern realism, the painter makes frequent use of the dresses of his period, while horsemen and soldiers are clad in a rich selection of the military uniforms of the fourteenth century. The abundant, stirring colouring heightens the effect of the vigorous action which characterizes the scene. The drawing is not distinguished by that incisive clearness to which we are accustomed in Pietro's work, and in places its vigour of movement and action become rather lifeless. The composition cannot be attributed to any other hand than Pietro's and his participation in the execution must also be considered as certain, for, to take an example, the group round the Virgin must have been painted by Pietro himself. [80]

The wall by the window was probably the next to be painted, that is to say that the next pictures in order of date were the Stigmata and the Death of Judas. This

42

hypothesis is confirmed by the similarity of style between the picture of St. Francis and the big Crucifixion. The scenes from the Entry to the Bearing of the Cross, on the barrel-vaulting, would thus come last. A close examination of these pictures, which are not without merit, shows that they must have been the work of several artists. The weakness of the architectural perspective in the Entry strikes the eye at once when compared with that of the Washing of Feet, while the thickset, compact figures of the latter and of the Flagellation are in marked contrast to the more slender ones of the Entry; in the Last Supper softer types prevail. In these scenes the architectural decoration, which with Ambrogio had reached an advanced stage of perfection is further developed in accordance with Pietro's conceptions, and is distinguished by two features, the growth of interest in the antique and a conception of decoration which indicates a close relationship to illumination. The naked genii are a good example of the former characteristic, as is also the almost archaeological precision with which Roman armour is imitated in the Flagellation. In the ornamentation we find antique masks, foliage and fillings. We are led to assume a close relationship with miniature-painting, because small figures are found on and about the architectural setting which cannot deny their derivation from the whimsical fancies of illumination.

The vivacity of the representation almost oversteps the limits of the master's fine sense of moderation and taste. The story of the Passion is pervaded by a coarse atmosphere which reveals the absence of Pietro's lofty manner of thinking. In the Washing of Feet, however, the projecting alcove of the window is used to give a curious spatial and compositional character to the picture, while the new development and arrangement of the old *motif* of the round table in the Last Supper *Plate 89* reveals an unusual originality of invention, which must have excited admiration even at the time, for we find it retained in the German painting of the following century.[81] Jesus is seen handing the sop to the traitor and the "One of you" causes general dismay, especially in Thomas and Philip who are seated in the foreground. The grey-haired Andrew gazes sorrowfully across the table at Judas, while Peter in dismay carries his hand to his cheek. Two of the servants discuss the terrible news and the third, who has run out into the kitchen, relates it, pointing with his thumb, to the cook who is drying a dish before the hearth. A purring cat warms itself in front of the fire and a little dog is licking a plate. In the sky we see the moon and the stars.

The remaining frescoes are likewise rich in original and vivaciously depicted *motifs*. In the Flagellation, in the upper part of the picture, we see a woman and a child sitting at a window resembling a balcony. She gazes complacently at a monkey which the boy is holding on a chain, allowing it to walk along the breastwork. The figures are perspectively reduced in size. The little scene reminds us of Herodias sitting on the balcony and silently awaiting the outcome of her schemings.

43

These frescoes are so true to life that we may well say that the world is shown by means of excerpts from real life, and it is no mere chance if the example of Duccio is everywhere visible.

OUR STUDY of Pietro's life-work has given us a picture of a great creative personality.[82] His real teacher was Duccio and it is only in his early works that he is slightly influenced by Simone, who was approximately of the same age as Pietro. Pietro gives further development to the great conceptions of his master, giving them a fuller and deeper significance with the passion of his own temperament and bringing them ever nearer to the light of that joy in nature which was at the very heart of the Sienese character. He succeeded in bringing the narrative art of Duccio to that point of maturity which the painting of monumental frescoes demanded. His relationship to Giotto had little decisive influence on his artistic development. His efforts to solve the problems of space and perspective were genuine and of the utmost importance for the subsequent development of painting. Pietro's attitude towards Gothic is hesitating and he seems to return deliberately towards the old traditions of Siena, affirming in this way the value and significance of the Byzantinizing tendencies.

We know very little of his activity outside his native city. Cortona and Arezzo, Pistoia, Florence, Assisi and Umbria, in addition to the *terra di Siena*, all come within the radius of his artistic influence, but nevertheless it would appear that he spent the major part of his life in Siena.

This is not the place to investigate all the ramifications of Pietro's influence. We have already seen how much Duccio's pupils and successors were able to learn from him. This was evident in Ugolino, and even more so in the so-called Ugolino Lorenzetti. The art of Pietro and Ambrogio penetrated in particularly noteworthy fashion into Sienese illumination, and is especially visible in the miniatures of Lippo Vanni, while many of the masters who followed Tegliacci show undoubted traces of the influence of the two Lorenzetti.

Of all Sienese painters the nearest to Pietro is the "Master of the Madonna in San Pietro a Ovile". Perhaps the most valuable and fruitful outcome of Dewald's investigations has been that he was able to show the correct relationship between a whole group of Pietro's pictures and the work of the Ovile Master, thus enabling us to obtain a clearer view of Pietro's work. The close relationship between him and the Ovile Master is very similar to that existing between Matteo di Giovanni and Guidoccio Cozzarelli, and it is no mere chance if the Ovile Master reminds us of Simone, for the former represents the connecting link between the traditions of Pietro's school and the art of Simone. It is very probable that Pietro's Madonna in the Uffizi served as a model for one of his early pictures, the Madonna enthroned in the Accademia at Siena (No. 76). The Madonna enthroned in San Pietro a

44

Ovile, from which this master takes his name, derives from Pietro's 1329 Madonna, but was painted subsequently to the above-mentioned Madonna in the Accademia. The other Madonna enthroned in the Accademia (No. 80) is a much Gothicized and enriched version of No. 76. The angels crowded together behind the throne with their claw-like hands, which produce a particularly unpleasant effect in No. 76, show the mediocrity of the artist. In the same way the imposing composition of the Assumption (No. 61), probably the latest of the series, is not his own invention but is modelled upon a previous creation of Pietro.[83] Everything tends to confirm the supposition that the Ovile Master first began his work towards the end of Pietro's career and that he outlived the middle of the century by a goodly number of years. The step from him to the so-called Ugolino Lorenzetti is a short one, and the proofs are numerous. The Ovile Master is one of those eclectics who were so typical of Sienese art, the best features in whose works are due not to themselves but to others, for it was only the good schooling they had received which enabled them to paint pictures which are not lacking in a certain importance for the history of art.

WE ARE better supplied with documentary evidence about Ambrogio's life than we are about Pietro's, but the value of these notices from the point of view of the history of art is not great.[84] The first mention of Ambrogio occurs in the year 1324, the last in 1347. A very necessary light was thrown on the painter's early period when De Nicola discovered the Madonna in Vico l'Abate, which bears the date 1319.[85] The picture is unsigned but shows clearly all the characteristics of Ambrogio's art. In this picture a first-rate artist asserts his own peculiar talent. Ambrogio presents us with a highly original version of the well-known theme by depicting the sturdy, restless child in a semi-recumbent position, with the Virgin holding him in a very decided fashion. It would be wrong to call the Virgin antiquated on account of the frontal attitude, for the picture was painted during those very years in which all who aspired towards an effect of dignity were returning to the frontal position. Ambrogio is a master of clear and simple outline and in this picture he combines the plastic element with softness of line in a manner which is very far removed from Giotto's ideas of figure-painting.

Plate 90

The Madonna in Vico is as Sienese as can be, even down to the ornamentation on the borders of the Virgin's mantle, the Ducciesque technique of the haloes, executed in line-engraving, and the green groundwork which has worked its way through to the surface. The close connection with Duccio is particularly evident in the countenance of the Madonna, which also shows a certain affinity to Pietro in the stylization of the features. The sturdy child with its rather turgid outlines and large dark eyes, a type also found in Duccio, reminds us of the Master of the Madonna in Città di Castello, whose Madonnas have the finely-curved eyelids to

Plates 91, 20
Plate 73

Plate 31

45

which Ambrogio in Vico l'Abate imparts something of his own more tender expression. The art of Ambrogio is therefore an entirely Sienese product, and as a painter he is very close to Pietro, which does not mean that he was his pupil in the strict sense of the word.

Ambrogio's efforts to attain clearness and strength of outline are seconded by a delight in ornamentation which sets off the simplicity and breadth of his compositions. His independence of spirit is eloquently demonstrated by his admiration for the great old models of his native city at a period when others had fallen

Plate 8

under the spell of Gothic art. Not only does he restore the Byzantine coif to a place of honour but he also recalls the early Sienese painting in the angular folds of the border of the Virgin's mantle around her forehead and temples. Beneath the coif he lets the lobes of the ears appear, decorating them with large gold pendants.[86] The Byzantine coif, the pendants on the ears, and to a certain degree the

Plate 93

flat eyebrows and the narrow lids, all tend to give the head an oriental character which seems as if it must have been due to direct observation from life, and this almost tempts us to advance the hypothesis that Ambrogio had been in the East.

The fact that this Madonna was painted for Tolano, a village in the neighbourhood of Florence and not very far from Vico l'Abate, has led many critics to conclude that about that time Ambrogio must have made a prolonged stay in Florence. We know already that he was inscribed in the rolls of the Florentine painters' guild, but this bare piece of information left a considerable margin as regards the date. Rowley has recently stated that he can prove that Ambrogio's name was inscribed in the rolls before 1327,[87] which would serve to confirm the above conclusion, and we may safely assume that during the years which Simone spent at Pisa and Orvieto, and Pietro at Arezzo, Ambrogio was living in Florence. As regards the length of his stay in the latter city we know nothing, but we have documentary proof that in 1324 he was still in Siena. According to Cinelli the altar-piece in San Procolo at Florence was dated 1332, and Richa describes it as representing the Madonna and Child between St. Proculus and St. Nicholas. De Nicola maintains that since the St. Nicholas predellas cannot have belonged to this altar-piece, and since Vasari says that he saw them in San Procolo, there must have been a second altar-piece in this same church showing St. Nicholas with

Plates 95, 96

episodes from his legend on the side panels, in which case the so-called St. Nicholas predellas would be the remains of this second altar-piece, and a second visit of Ambrogio to Florence would be assured[88]; it may be assumed that both these visits lasted several years. Ghiberti also mentions a chapel which the Sienese artist is supposed to have painted in San Procolo and speaks of some frescoes in the chapter hall of the Augustine friars in Santo Spirito. Very little has remained of all this work of Ambrogio's in the city of Giotto but its influence on Florentine painters of the period was considerable. We can see this influence in Iacopo del

Casentino, in Maso, and above all in Bernardo Daddi; but these are merely examples, for his influence and the sway of his models outlived the middle of the century by many years.

The discovery of the Madonna of Vico l'Abate becomes all the more important in view of the absence of any other picture by Ambrogio which can be placed in direct relationship with it. Between it and the Madonna in the seminary of San *Plate 92* Francesco a considerable number of years must certainly have elapsed. A mere external detail, the change in the technique of the haloes,[89] would be sufficient proof of this assertion, even if the whole picture did not reveal the riper stage of development to which Ambrogio had attained in the meantime. The half-recumbent Child is held more firmly by the Virgin, who leans back the better to support the weight of the heavy boy. The latter tucks up his leg as he drinks, turns his dark eyes towards the pious beholder, and goes on drinking, grasping the nourishing breast with his tiny hands. Round the edge of the painting the artist has inserted a dark band, which throws the group into greater relief against the background, giving living force to the figure of the Madonna despite the flowing draperies. The simplicity of the artistic means and the accuracy of observation, combined with full appreciation of the divine nature of the religious ideal, make this picture one of those which may be considered definite solutions of a problem.

IN THE Museo Bandini at Fiesole Perkins has discovered the two half-figures which were formerly the wing panels of the altar-piece in San Procolo, where St. Nicholas stood on the right and St. Proculus on the left of the half-figure Madonna and Child, the latter group being now, as we are told by De Nicola, in a private collection. The centre-piece is more beautiful and of better quality than the rather arid wing panels. The little figures of St. John the Baptist and St. John the Evangelist, painted in the spaces below the pinnacles, reveal the participation of the workshop still more clearly. The thinner outlines and the abundance of decoration on the episcopal garments go far beyond the limits which one would have expected. The saints are placed beneath flat Gothic arches and the technique of the gold groundwork shows frequent use of cut dies.[90]

The fact that Ambrogio did actually work for the church of San Procolo in Florence is thus established, although some doubt may remain as to the exactitude of the date given by Cinelli. The date of 1332 ascribed to the St. Nicholas *Plates 95, 96* predellas is probably correct, and in them we possess Ambrogio's first interiors and his first landscape. When we compare them with Pietro's Carmelite predellas *Plates 75, 76* we are struck by the decision with which Ambrogio tackles the various problems. Scenes such as that depicting St. Nicholas throwing the three bars of gold into the *Plate 96a* room may well be compared with the Dream of Sobac, but Ambrogio's spatial *Plate 75a* phantasy is far more concrete and more assured in the balcony-architecture and

47

in the representation of the upper storey and of the adjoining palace in the background. The narrow lane with benches before the doors, along which the saint has passed, the homely interior with the cupboards, the jug in the alcove of the wall and the towel on the rack, and the figures in perfect proportion to the size of the room, all are depicted with a masterly power of representation and narration.

Plate 96 b The architectural and spatial elements in the picture of St. Nicholas raising a strangled child from the dead are even more elaborate. On the balcony of the upper storey the father is entertaining his friends to dinner. The child, who has been helping to carry the dishes upstairs, is suddenly called away by a stranger, and we see him hurrying downstairs towards a pilgrim, who after making him all sorts of promises, leads him aside and strangles him, for the child in his innocence does not realize that the seemingly friendly pilgrim is none other than the devil. The mother wrings her hands and weeps over the stiff little corpse, but the father offers up a prayer to St. Nicholas and to his great astonishment the good man perceives the radiant figure of the saint through the window. The boy rises from the bed and the mother raises her arms to clasp her resuscitated child to her breast. Ambrogio has always depicted the child as a lively little being, giving him fresh warmth and naturalness. His deep humanity is clearly shown and it is perhaps for this reason that he has been so successful in this story of a child, which with its happy ending emphasizes the fact that St. Nicholas is the protector of children.

When the youthful Nicholas arrives in Myra to attend the early mass, ignoring *Plate 95 a* that in that self-same hour he was to be consecrated bishop, a dignified old man plucks him by the sleeve, and Ambrogio shows us the subsequent ceremony of consecration in strict conformity with the ritual. The small interior of the church produces a very natural effect with the receding pillars of the middle aisle which intersect the heads of the prelates. On the arch of the conch is a half-figure of God the Father with angels, similar to that in the more sumptuous church interior of the *Plate 106* Presentation. The painter originally intended to depict the back of the church as a simple apse on the lines of that in the Presentation, as is proved by the semi-circular lines which can be seen beneath the colour.[91] In the predella pictures we find Gothic arches in the side aisles and windows, while the Presentation reverts to round arches.

Ambrogio's spatial phantasy gives us such convincing interiors that we are unable at a first glance to detect any irregularities, but a closer examination reveals that while both ceiling and flooring are constructed on one vanishing point, the latter is different for each, so that the vanishing lines of the intervening spaces have no point of convergence. His conceptions of architecture, however, come to the rescue and compensate for these defects. The thought that houses are cut open in order that the spectator may see into the interior does not even enter our heads, *Plate 95 b* for these arched openings become a natural feature of the architecture.

The Miracle of the Corn gives us a particularly good idea of Ambrogio's talent

48

in the presentation of space, for in this seascape the eye is led by stages towards the background by the decreasing size of the figures and the ships until it reaches the lateen sails on the distant horizon. Ghiberti mentions a storm at sea as having been among Ambrogio's frescoes in the cloisters of the Franciscan monastery in Siena, and Vasari singles this seascape out for special praise. The Miracle of the Corn is yet another example of Ambrogio's power of narration; even to those who know nothing of the legend the picture shows how the saint rescued the famine-stricken town, and how the angels descended from Heaven to replace the corn which had been unlawfully disposed of.

SINCE Tizio, Ambrogio's pictures in San Francesco have generally been attributed to the year 1331. For the frescoes it is possible to admit a date round about the beginning or the middle of the fourth decade, for they are very close to the St. Nicholas predellas and were painted before the cycle in the Palazzo Pubblico. After his return from Florence Ambrogio appears to have remained a fairly long time in Siena. In 1335 the two brothers were working together on the frescoes at Santa Maria della Scala, and during the following years we find several references to payments made for those in the Palazzo Pubblico; the last, effected after the completion of the work, is dated May 29th 1339. In this and in the following year Ambrogio received remuneration for paintings in the Duomo and for the altarpiece of St. Crescentius, evidently a companion-piece to those painted for the altars of the other patron saints of the city, all of whom were in turn honoured by the greatest painters of Siena, St. Ansanus by Simone in 1333 and St. Savinus by Pietro in 1335. In the supplement to Angelo Tura's chronicle we read that in 1340 Ambrogio completed a Madonna for the loggia of the Palazzo Pubblico, a work which has come down to us, but in a sadly damaged and mutilated condition.

In 1857 Ambrogio's frescoes in San Francesco were transferred from the chapter-hall of the monastery to the Bandini Piccolomini chapel in the church[92] and their present condition shows obvious traces of this removal. Both of the frescoes have been cut down in size, as is clearly proved in the Martyrdom, where the feet are all that remains of the figure at the apex of the middle arch.[93] On either side *Plate 93* of the pasha, beneath the arches of the hall of judgement, we see his followers, knights from the East and from the West, showing marked contrasts of race and clothing. It is difficult to imagine how Ambrogio could have painted these types of the peoples of the Far East unless he had had an actual opportunity of seeing them. The facial expressions of the onlookers are varied and animated and the scene itself is depicted with a realism due more to a delight in the portrayal of nature than to a morbid pleasure in horrible details. The juxtaposition of the two executioners is very fine. In the foreground are some horrible figures of Mongol children throwing stones at the dead martyrs. This magnificent composition with

49

its animated contrasts must have been of special interest for the monks of the period, for it is a pictorial record of a contemporary episode in the history of the Franciscan missions to the heathen.

Plate 94 The Reception of St. Louis into the Order is modelled on Pietro's Carmelite predellas. The numerous rows of figures one behind the other combine with the different levels on which they stand to produce an effect of naturalness and ani-
Plate 75 c, d mation, in comparison with which Pietro's little pictures are almost insipid. The bare seat in the foreground, above which the heads of the cardinals protrude, gives the picture a curiously realistic aspect. The facial expressions are studied with special care, from the pensive concentration of King Robert to the varied degrees of interest shown by the prelates and spectators in the background. The attitude of the pope is beautifully depicted, while St. Louis kneels humbly before him in an atmosphere of renunciation which bores all the onlookers except the two page-boys in front, who are spellbound by the novelty, for them, of the ceremony.

Plate 87 If we compare the spatial representation in Ambrogio's paintings with Pietro's best work, we see at once that only Ambrogio could have painted an interior such as that described above. Not only the framework of the composition but also the types of figures repeatedly remind us of Pietro and we are once more faced with "the problem of the brothers Lorenzetti". Nevertheless it is possible to distinguish the types, however similar they may at first sight appear (a similarity due to the fact that Pietro was Ambrogio's teacher in his early years). While Pietro's old St. Anna seems to have something of Ambrogio's style, conversely Ambrogio's grey-haired Anna is very similar to Pietro's later types, though it is none the less curious how the two painters differ in their portrayal of old age. The explanation of this is that the characteristics common to the work of both the brothers derive from their earlier collaboration, which probably was not confined only to the painting of the frescoes in Santa Maria della Scala. In San Francesco at Siena we find their works side by side in the same room and probably painted at the same time, so that it is quite likely that they collaborated in other paintings in Siena. The "problem of the brothers Lorenzetti" does actually exist.

Plates 104, 105 AMBROGIO's altar-piece in San Procolo leads us directly to his Madonna in Massa Marittima, painted about the middle of the fourth decade, when he was beginning to show a tendency towards allegory. The work is still full of original ideas. Whereas Duccio was the first to raise painting to the sphere of a lofty and simple humanity, which Simone adorned with the conscious restraint of good breeding, it was left to Ambrogio to establish the definite formula by deepening the philosophical significance of his pictures and at the same time investing them with a dignified etherealism which has something of the joyousness of paradise. The Maestà is transformed into the Madonna in the Glory of Heaven.

50

As if deliberately returning to Duccio, Ambrogio depicts the figure of the Madonna in disproportionately large dimensions, but also in that pleasing attitude of maternal intimacy with the Child which had been beloved of the painters of the thirteenth century. Three steps lead up to her throne, symbolically inscribed with the names of the three theological virtues, Caritas, Spes and Fides, who are placed upon the steps in the shape of allegorical figures. The Virgin is seated on a cushion held by two kneeling angels whose wings stretch up behind her as if to form a support against which she may lean. Two other angels hover above the throne, waving garlands of roses and lilies to and fro as if to envelop the Virgin in the sweet scent of the flowers. All the angels wear chaplets of flowers in their hair. The saints are arranged round the throne in three large, crowded groups. Above are the Patriarchs and Prophets of the Old Testament, in the middle the Apostles and Evangelists of the New Testament, while the lowest row is reserved for those saints who were felt to be most intimately connected with the period in which the picture was painted. The Virgin thus appears with her Child, who nestles his cheek against *Plate 105* his mother's almost in an attitude of fear, in the midst of clouds of perfume and incense, while angels' voices join in chorus with the music of harps, and the saints stand wrapped in contemplation of the Madonna.

The composition of the groups in the form of a pyramid rising about the Madonna and the throne is grandiose in its conception. It would be a grave error of judgement to find fault with the crowded arrangement of these inmates of heaven, for we are supposed to imagine a series of different levels. The heads of the elect are all on the same level, and when considered as a whole the groups are depicted with a vigorous sense of space. Ambrogio has expended a great wealth of ornamentation upon this picture, especially on the raiment of the angels, and this reminds us of the altar-piece of San Procolo, the style of which is still visible in Massa Marittima, though in a more attenuated form. The Madonna, however, is of the heavy type to which Ambrogio adheres in his subsequent works. 94

I HAVE called Ambrogio an ingenious and original painter, and nowhere are these qualities more clearly displayed than in the frescoes in the Sala dei Nove, for the *Plates 97-103* magnitude of the task gave him ample opportunity to show his capabilities and aspirations in many directions.

Allegorical pictures of this type were a feature of the period. We know that Giotto received and executed a similar commission. The old antithesis between Virtues and Vices furnished certain general characteristics of the representation which are also the basis of Ambrogio's frescoes, and it was natural that in the allegorical transformation of the various conceptions he should make use of those forms and attributes which were universally known and understood, without, however, allowing them to hinder his freedom of invention in working out the details.

51

The frescoes are so impregnated with his spirit that he must certainly have had a share in planning the spiritual and philosophical composition. The old authorities speak of him as a learned and cultured man, and in his Madonna pictures he reveals a taste for philosophical renderings of religious sentiment.

This series of frescoes is related to Simone's Maestà, in which the exhortation to good government is depicted in its ethical and religious aspect, whereas Ambrogio attains his philosophical and moral aim by placing the pictures in the very hall in which the ruling powers held their sittings. The state of Siena was then enjoying a period of peace and it was in 1338 that the bold plan of reconstructing the Duomo was decided upon. The proud satisfaction in possessing so good and successful a government found its artistic expression in these frescoes, to which a great painter like Ambrogio, with his seriousness of purpose and strength of moral character, was able to give a fitting form.

Plate 97 The Allegory of the Good Regiment is nowise disfigured by the aridity of affected ideas. We see the Commonwealth (Il Comune) holding the sceptre in his right hand and a shield, on the boss of which is depicted a Madonna enthroned with two kneeling angels, in his left.[95] Round his bearded countenance are the initials of the city, C. S. C. V., and above him hover the three Virtues, Faith, Hope and Charity. On either side, seated on a long, draped bench, are other Virtues, in the *Plate 99* choice of whom Ambrogio shows great independence of spirit. Peace leans meditatively back upon a cushion, holding a branch of olive in her left hand and with a chaplet of olive-leaves in her hair; she resembles one of the old Roman representations of Pomona, and is lightly clad, with the trappings of war beneath her cushion and her bare feet resting upon a shield. Next to her is the armed Fortitude with the morning star and a large shield, followed by Prudence, an old woman, pointing to the three flames in her shell.[96] On the other side is Magnanimity, holding a crown, her left hand thrust into a plate full of gold. Temperance holds the hour-glass, while Justice rests the pommel of her raised sword on the severed head of a criminal and also holds a crown in her left hand. We find her again *Plate 98* on the left-hand side of the picture, in the same attitude as the Commonwealth, gazing steadily upwards towards the sky and holding the scales level with her thumbs while Wisdom supports them from above. About her head is the first verse of the Book of the Wisdom of Solomon. In the left scale is symbolized Justitia Distributiva, in the right Justitia Computativa. From the beam of the scales run red and white ribbons which join in the hands of Concord (who is at the feet of Justice) to form a cord; across her knees lies the great plane. Concord passes this cord on to the twenty-four members of the council, who two by two in solemn procession carry it to the throne of the Commonwealth, where it ends in the hand holding the sceptre. On either side are the military forces which protect the city. In front of the horsemen are prisoners of war, whose leaders prostrate themselves in token of submission.

52

At the feet of the Commonwealth the city's heraldic animal, the wolf, gives suck to the two naked children.

The composition of the picture is not sufficiently regular, but we are compensated for this defect by such magnificent figures as the Justice and Concord, the celebrated Peace, the Fortitude and the Prudence. The Virtues to the right of the Commonwealth were obviously restored by another hand in the fourteenth century; but although the participation of the workshop is visible, we can still see traces of Ambrogio's own hand in many places. The delightful Peace at once attracts our attention and the painter seems to have given intentional prominence to this charming symbol of the happy, peaceful years during which the picture was painted.[97]

The manner in which, in the Consequences of Good Regiment, Ambrogio connects and separates the two scenes by the walls and gate of the city, merits our admiration, for in this way the interdependence of town and country life is clearly and significantly shown. First he relates with a wealth of detail the everyday life as seen in the streets of the city, depicting with an astonishing sense of space houses and palaces, spacious squares and narrow lanes, towers and churches, with the campanile and dome of the cathedral of Siena towering above the whole; for this painted city is none other than his flourishing native town. A noble lady returns home from a ride accompanied by two cavaliers. In the foreground elegant young ladies, dressed in the latest French fashions, are joyously dancing a jig to the accompaniment of songs and a tambourine. The irregular construction of the architectural background gives a vivid idea of the gradual growth of the city and although it is clear at a first glance that this up-and-down setting is not constructed in accordance with the rules of perspective, Ambrogio has yet contrived to concentrate the scene in so skilful a manner, that the impression is one of reality, even from the spatial point of view. On the right-hand side of the picture the light comes from the left, on the left-hand side from the right. Possible gaps are carefully concealed by placing houses before them, and these with their broad surfaces help to restore the perspective basis. The view of the city is obtained from some lofty eminence, and is such as one could enjoy nowadays from the top of the façade of the Duomo.

Very similar is the manner in which Ambrogio has conceived the Sienese country-side, above which hovers Security holding a picture of a criminal hanging from the gallows, thus emphasizing the beneficent dominion of peace and justice. From the gate of the city, decorated with the she-wolf, a broad paved road runs down into the open country to the fruitful valley, where every kind of agricultural activity may proceed without fear of robbers or enemies. In the open fields the huntsman follows the quarry with his hounds. From the valley with its meadows and farms, symbols of the peaceful occupations of an industrious people, rise the hills, the slopes of which on the left are covered with carefully tended vineyards, while in the centre scattered pine-trees lead the eye towards the depths of the

Plates 100, 102

Plate 101

Plate 102

background, and on the right is seen an arm of the sea, with a fortified town and the inscription "Talamone". This is the harbour which the Sienese had conquered to assure an outlet for their commerce and as an expression of their policy of world-expansion, the butt of Dante's biting sarcasm. Further towards the background the landscape becomes more broken, dark woods insert themselves between the hills, while distant towns look down from the slopes, and castles and watch-towers crown the heights. In the foreground the road gives rise to the busy traffic to and fro between the city and the surrounding country.

Plate 103

In this picture Ambrogio has extended the conquests of his art to the outside world and has succeeded in giving real depth to a broad landscape. The picture is a striking proof of the natural strength of his genuinely constructive representation and his eye, so sure and receptive for all the manifestations of life, fills all these near and distant planes with the artistic results of the impressions he was able to draw from an autumn day spent in the country. The subject itself was not completely new, for the old tradition of symbolizing the months by the various occupations of the peasant had prepared the ground for an artistic representation of everyday life. In Ambrogio's frescoes these old symbolical representations receive new life from his accurate and immediate observation of nature, and it is thus to the Sienese love of realism that the new school of painting owes its first landscape.

Plate 110

Plate 110 b

These frescoes and the Miracle of the Corn in the St. Nicholas predellas are a sure foundation for the ascription to Ambrogio of the two landscapes in the Accademia at Siena. In these we can recognize in a manner which leaves no room for doubt Ambrogio's sense of space, and the little pictures will puzzle us no longer if we reflect that they are nothing but cleverly-separated fragments of a larger, and perhaps of the same, picture. The City by the Sea has a forerunner in Duccio's Kingdoms of the World (Temptation on the Mount), which is strikingly called to life again with the addition of Ambrogio's power of representation. On the blue sea a two-masted ship is sailing, two little boats lie off the watch-tower and another ship passes across the distant horizon. In Ambrogio's Good Regiment in the Country, we also find a seaside town, Talamone.[98] As regards date, the two landscapes cannot be far removed from the frescoes and were probably painted a little later.

In the Evil Regiment the allegory is similar in arrangement, but rather more regular than the Commonwealth on the opposite wall. Despite deterioration, Ambrogio's original spirit is still clearly visible. The whole cycle is fringed at the top and bottom by an ornamental frieze containing quatrefoils, the subjects of which follow the given antithesis. Except for Spring the Seasons are in a good state of preservation, and are broadly and animatedly painted. Winter is represented by the half-figure of a bearded man wearing a hat, standing in the midst of a whirlwind of snow-flakes and holding a snowball in his hand.

The frescoes in the Palazzo Pubblico are Ambrogio's masterpiece. Not only do

54

they show his great artistic ability, his close power of observation, his fertile and animated gift of invention, but they are also a proof of his intellectual qualities, his learning and his culture, never carried to extremes which would be to the detriment of his artistic discernment. Another striking feature is the development of his studies of the antique, as shown with especial clearness in the figures of Peace and Security. In these pictures Ambrogio shows himself far in advance of his time.[99]

AMBROGIO seems to have remained in Siena during the years which followed the execution of the frescoes in the Palazzo Pubblico. In 1341 he was painting in the chapel of the cemetery, and Tizio mentions under the date of 1344 a fresco on the façade of San Pietro in Castelvecchio and a panel for the high altar of the same church[100], as well as a map of the world in the Palazzo Pubblico of which Ghiberti also speaks. In 1347 we hear of him for the last time as a member of the city council.

The Presentation in the Temple, now in the Uffizi and formerly in the Ospedale di Monna Agnese at Siena, is obviously a ceremonial picture and must therefore have been painted for a very important church.[101] The architecture and perspective are a successful development of the Early Mass and show still greater maturity of composition. The vanishing lines run so decidedly towards an imaginary centre that we are astonished when a closer examination reveals that the charming pattern of the flooring has really no vanishing point. In this picture Ambrogio strove to depict the scene as a historical event and brought all his learning and archaeological knowledge into play to attain this end. He intends that we shall recognize the Temple of Solomon by its magnificence and by the statues of Moses and Joshua. In front of the Ark of the Covenant hangs a costly curtain. The high priest wears on his forehead the golden plate, on which a Hebrew inscription has been imitated. His ephod is adorned with the golden bells and from a chain is suspended the breastplate with the twelve precious stones symbolizing the twelve tribes of Israel. He stands before the altar of burnt offering, holding the doves which Joseph has brought *Plate 108* and the sacrificial knife. In contrast to the solemn dignity of the Virgin and her attendants and of all the grave figures in the foreground, is the struggling Child with his finger in his mouth, a new conception which shows once again Ambro- *Plate 107* gio's power of invention. The contrast is further heightened by the timid reverence of Simeon and the pointing finger of the grey-haired Anna.

A noteworthy feature of the picture is the Gothic frame with its comparatively rich decoration, a Gothic element which Ambrogio generally avoids, just as in the architecture of the temple, except for the cupola which had become traditional since the days of Duccio, he is less Gothic than in the Early Mass. In Ambrogio's later period, as in Pietro's, we see a return to the great Sienese traditions, and the irregular play of folds on Simeon's mantle reminds us more of Duccio than it does of Simone.[102]

The Annunciation is another case of a return to the round arch, and in the panel *Plate 109*

55

Plate 72

itself there are but few traces of Gothic as Simone conceived it. Ambrogio follows the formula which Pietro had established a quarter of a century earlier, but he does it with that independence which is so typical of all his work. Except for Gabriel's costly stole and the chaplet of olive-leaves in his hair there are scarcely any traces of the influence of Simone's Annunciation. The picture has unfortunately been obscured and much damaged by a dark varnish, but nevertheless it must be numbered among Ambrogio's most important panel-paintings. The outlines attain real volume; the Virgin is seated in a natural manner upon the original, inlaid throne, which in its foreshortening heightens the perspective effect, which is further helped by the pattern of the flooring constructed upon one vanishing point. The atmosphere of the scene is grave and imposing, the Virgin's humility is exquisite, and Gabriel's gesture, as he points with his thumb towards the sky, seems in harmony with his heavy outlines, which form such a striking contrast to the delicate figure of the Madonna. Gabriel is not uttering the "Greeting" but a later part of the text. Once more Ambrogio has given his own imprint to an oft-depicted theme.[103]

Plate 111
Plate 112

With the death of Ambrogio the great period of Sienese painting in the fourteenth century comes to an end. It is true that his followers produced important and beautiful pictures such as the Madonna enthroned in the Accademia and the polyptych from Santa Petronilla, but creative art had vanished from the decaying city of Duccio and was not to return until many decades had passed.

Ambrogio combined all the qualities which had gone to make the greatness of Sienese art. To him Simone must have seemed an artist who had strayed from the right path and betrayed the old native traditions. Ambrogio has been called the first humanist painter and celebrated as painter, poet and philosopher at one and the same time. He is perhaps the only one of the great Sienese masters who contrived to master completely the wealth of artistic and spiritual gifts which were the heritage of his race, and who could not be induced to prize beauty above truth. His attainments represent an advance in the history of painting which leaves Simone's European influence in the shade, for he made experiments which did not until a century later receive the acknowledgement which was their due.[104]

IT HAS been well said that the great Sienese school of painting ceased to exist in 1348, the year of the terrible plague. It appears that neither Pietro nor Ambrogio survived this year, while Simone had died abroad a few years before. Their heritage fell into the hands of mediocre artists who plundered it but had not the ability to exploit it in an effective manner. This collapse after so brilliant a period is not difficult to understand, for within the space of two generations Siena had produced four great painters, and it seems as if the creative forces of the race needed repose after this immense effort. The task of the lesser masters was limited to the preservation and transmission of the creations of their great predecessors.

Generally speaking it may be said that the influence of the two Lorenzetti continued immediately after their disappearance, while it was only at a later period that Simone again began to fascinate the painters of Siena. The explanation of this is not merely that Simone had worked a great deal away from Siena and died in France, but rather that painting degenerated more and more into mere decoration, and the artists, no longer capable of appreciating the true greatness of Pietro and Ambrogio, could reap an easy harvest from the work of Simone as they followed in the train of the ever-increasing Gothicization of art. They all made up for their lack of ability by their diligence, and Sienese painting thus assumed a professional, almost commercial form, which received further encouragement from the extraordinary demand for religious pictures which existed at that time.

A fine and attractive painter like Lippo Vanni, of whom we hear from 1341 to 1375, is typical in his eclectic development of the Sienese artists of the period.[105] As an illuminator he derives from the Lorenzetti and adapts Pietro's Nativity of the Virgin and Ambrogio's Presentation to the necessities of miniature decoration. The triptych in SS. Sisto e Domenico shows that the influence of Simone was *Plate 114* gradually gaining ground in Lippo's art, although the Eve still reminds us of Ambrogio. In the chapel of the seminary of San Francesco at Siena he imitates in fresco an elaborate Gothic polyptych, thus following in the steps of Simone. His St. Francis showing the stigmata is borrowed from Ambrogio's Madonna in Massa Marittima. The foundations laid by the Lorenzetti had now become common property, and even in panel-pictures full-length figures of saints are found on either side of the enthroned Madonna.

Andrea Vanni (1332?-1414?) is more interesting as a personality than as an artist. He played a considerable part in the politics of his native city, held diplomatic appointments, was a friend of St. Catherine of Siena and also occupied a post at the court of the Queen of Naples. In 1353 he opened a studio at Siena in partnership with Bartolo di Fredi. Simone was Andrea's guiding star, but traces of the other great Sienese masters can also be recognized in his work. His Madonna in San Francesco at Siena is clearly copied from Simone, but is, nevertheless, a good example of his best period and of his delicacy of feeling. He is frequently to Simone what Segna was to Duccio. In his polyptych in Santo Stefano we see the hard, *Plate 113* almost childish, style into which he degenerated in his old age.[106]

Niccolò di Buonaccorso (first heard of in 1348, died in 1388) is an attractive representative of the lesser masters. The technical usages of Simone's pupils, especially the lavishing of embroidered ornamentation on the garments of the saints, became his gospel, but under the influence of Bartolo di Fredi he manages to give us a very pleasing narration in his signed Marriage of the Virgin now in London.[107] Francesco di Vannuccio was a finer and more original artist, whom we hear of between 1355 and 1388. He too followed Simone's lead, but he has left us only one

signed picture, the delightful little portable panel, for use in processions, now in Berlin, representing the Crucifixion.[108]

Luca di Tommè (mentioned from 1355 to 1389) also remained true to the heritage of Simone, and Vasari calls him a disciple of Barna. Nevertheless he sometimes follows the Lorenzetti, especially Pietro, and the Ovile Master. In all these panel paintings we invariably find the same syncretism which borrows from every source and satisfies the demand for works of art by diligence and solid work. Considered on their own merits nearly all these pictures are pleasing and well painted. Luca's *Plate 116* polyptych of the Madonna and Child with St. Anna is an excellent, even if rather *Plate 115* arid, work and the Madonna in the Crucifixion at Pisa shows the solemn grandeur he was capable of attaining.[109]

Bartolo di Maestro Fredi, of whom we hear between 1353 and 1407, was a very productive painter who also attained prominence in politics on several occasions. The documentary information about him is comparatively plentiful and we find him working in collaboration first with Andrea Vanni and then with Luca di Tommè and his son Andrea. We should be doing him an injustice if we based our opinion of his work exclusively upon the 35 frescoes representing stories from the Old Testament in the left aisle of the Collegiata at San Gimignano, for he was obviously very young when he painted them and entrusted a large portion of the work to his pupils. Vasari has handed down to us the signature on these frescoes and the date, 1356. Even in these pictures we see that he took his share in the transmission of the Sienese traditions for although he too was an eclectic, the word when applied to him must be taken in a good sense. Originally he derived from the school of Simone, was then attracted by Barna and also understood the work of Ambrogio and Pietro, thus preserving and handing on the grand old narrative art of Siena. The manner in which he endeavours to solve the problem of space is not lacking in ability, as can be seen in the Presentation now in the Louvre, a picture which derives from Ambrogio's painting in the Uffizi. From the Adoration of the Magi in the Accademia at Siena (No. 104) it is a short step to Gentile da Fabriano. His frescoes in the chapel in the choir of Sant'Agostino at San Gimignano, representing episodes from the Life of the Virgin, are for the most part still concealed beneath whitewash and what has been brought to light has suffered in the process. *Plate 117* This Nativity of the Virgin is a successful adaptation of Pietro Lorenzetti's mas- *Plate 118* terpiece and the Coronation of the Virgin in Montalcino shows the beautiful uniformity of Bartolo's style, which is not lacking in charm and dignity.[110]

Bartolo is the most important among those artists who formed the link between the great masters and that generation which was born in the latter half of the Trecento and whose activity was for the most part exercised in the Quattrocento, even though the spirit of the new century could not prevail over the influence of the past. I shall not speak of Andrea di Bartolo,[111] the son of Bartolo di Fredi, nor of

58

Martino di Bartolommeo,[112] both of whom were painters of little importance. Taddeo di Bartolo, on the other hand, is deserving of mention. We first hear of him in 1386 and he died in 1422. Like Bartolo di Fredi he carried on the healthy tradition of the past and succeeded in rescuing much of the artistic heritage of Siena and transmitting it to his successors. Unlike most of the others he also worked outside his native town and we hear of him in Genoa.[113] In many of his paintings we can recognize traces of Simone, and among the best works he painted must be numbered the frescoes of the Legend of the Virgin in the chapel of the Palazzo Pubblico (1407-1408), in which he bases himself upon Duccio's version and contrives to relate the story with animation and a new attitude towards reality. His charming Adoration of the Shepherds, reproduced in the present volume, will *Plate 119* serve to give an idea of Taddeo's ability in panel-painting.

In conclusion, although he really belongs to the older generation, we will mention Paolo di Giovanni Fei[114] of whom we hear between 1372 and 1410. The Nativity of the Virgin, which may safely be attributed to him, is a return to Pietro's *Plate 120* version of the theme, depicted with freedom and animation. The narrative element is brisker, and the little Virgin reminds us of Ambrogio. The painter has attained greater depth of space and the outside world is here seen from the interior of the room. These rose-bushes peeping in at the window seem to symbolize the birth of the Quattrocento, and it will not be long before Sassetta in Asciano depicts the same story of the Nativity of the Virgin (also in the manner of Pietro), and the outside world streams in through wide-open doors as if painting had won for itself reality and life. Sassetta derives from the school of Paolo; he is the first great Sienese of the Quattrocento, and to speak of him is outside the province of the present volume.

NOTES

The following remarks are intended to supplement the references given in the notes and do not in any way claim to be complete.

As regards documentary evidence, of prime importance are the researches made among the archives by the indefatigable Milanesi. Gaetano Milanesi: Documenti per la storia dell'Arte Senese, 3 volumes, Siena 1854-55; and the continuation of this work by Borghesi and Banchi: Nuovi Documenti per la Storia dell'Arte Senese, Siena 1898. Further, Milanesi's edition of Vasari, Florence, Sansoni, 1878-82. Also Alessandro Lisini: Elenco dei pittori senesi vissuti nel secolo XIV, in Miscellanea Storica Sanese, Vol. LV, 1896; by the same author: Elenco dei pittori senesi vissuti nei secoli XIII e XIV, in La Diana, Vol. II, 1927, p. 295 ff. A. Liberati: Nuovi Documenti artistici dello Spedale di S. Maria della Scala in Siena, in Bull. Senese di Storia Patria, Vols. XXXIII-XXXIV, 1926-27, p. 147 ff. Of the older literature, Della Valle, Lettere Sanesi, 3 volumes, Rome 1786, is deserving of more attention than it usually receives. The excellent guide by William Heywood and Lucy Olcott: Guide to Siena, History and Art, especially in the fourth edition with additions by F. Mason Perkins, contains a number of valuable critical observations and also useful bibliographical data.

Among the comprehensive works, the various editions of Crowe and Cavalcaselle are indispensable, especially the more recent English version edited by Langton Douglas, Vol. III, London 1908. The same may be said of Bernard Berenson: Central Italian Painters, seventh edition, New York - London 1908. In Adolfo Venturi: Storia dell'Arte italiana, Vol. V, Milan 1904, there is a section devoted to Sienese painting in the Trecento, as also in Michel, Histoire de l'art, Vol. II-2, Paris 1906, p. 819, from the pen of André Pérat. Pietro Toesca: Storia dell'Arte italiana, Vol. I, Turin 1927, pp. 993 ff., only brings us as far as Duccio. Raymond Van Marle: Development of the Italian Schools of Painting, Vol. II: The Sienese School of the fourteenth century, The Hague, 1924, is good and abundantly illustrated. Monographs: Louis Gielly: Les primitifs siennois, Paris 1926, with 57 plates; Emilio Cecchi: Trecentisti Senesi, Rome 1928, with 256 plates. The four last-named works contain bibliographical summaries.

For an insight into the inner relationships and character of Sienese painting the following works are of special importance: Oskar Wulff: Zur Stilbildung der Trecento-Malerei, in Rep. f. Kunstwissenschaft, XXVI, 1904; Georg Graf Vitzthum: Von den Quellen des Stils im "Triumph des Todes", *ibid.*, XXVIII, 1905, p. 199 ff.; Friedrich Antal: Gedanken zur Entwicklung der Trecento- und Quattrocento-Malerei in Siena und Florenz, in the Jahrbuch für Kunstwissenschaft, Vol. II, 1924-1925, p. 207 ff. Abundant material may be found in the Sienese reviews: Bullettino Senese di Storia Patria, 32 volumes, from 1894 onwards; Rassegna d'arte senese, 19 volumes, 1905-1927, after 1927 under the title "La Balzana"; Vita d'Arte, 15 volumes, 1908-1922; La Diana, Rassegna d'Arte e Vita Senese, from 1926 onwards, 3 volumes.

The following catalogues are particularly noteworthy for the amount of information they contain on Sienese painting of the fourteenth century: Burlington Fine Arts Club, Exhibition of pictures of the School of Siena, London 1904; Catalogue of a Collection of paintings and some Art Objects, Vol. I: Italian paintings, by Bernard Berenson, John G. Johnson,

Philadelphia, 1913; A catalogue of early paintings exhibited at the Duveen Galleries, New York, April to May 1924, by W. R. Valentiner, New York 1926; Catalogue of the Collection of George and Florence Blumenthal, New York, compiled by Stella Rubinstein-Bloch, Vol. I, Paris 1926; The Philip Lehman Collection, New York: Paintings, text by Robert Lehman, Paris 1929.

1] The quotation at the commencement of the present work comes from the Breve dell'Arte of the Guild of Sienese painters 1355 and is found in Milanesi: Documenti per la Storia dell'arte senese, Vol. I, 1854, p. 1. Cf. also Antonio Medin: Nota illustrativa di talune storie dipinte nella Cappella degli Scrovegni, Atti e Memorie della R. Accademia in Padova, XLIII, 1927.

 In English the quotation reads as follows: "By the Grace of God we are for the simple people who can neither read nor write the interpreters of all the miracles which have been done through and for our Holy Religion".

 Thus we see that even in 1355 the artists were fully conscious of religious tradition as it had already been expressed in 787 before the second Nicene Council. Cf. Davidsohn, Geschichte von Florenz, IV, Frühzeit der Florentiner Kultur, Part III, 1927, p. 215.

2] The best collection of documentary evidence regarding the Rucellai question is still that contained in Karl Frey's large Vasari edition: Le Vite..., edited with critical notes by Karl Frey, Vol. I, Munich, 1911, p. 455 ff. The literature on Duccio and the Rucellai question will be found in my article on Duccio in Thieme-Becker, Allg. Künstlerlexikon, Vol. x, 1914, p. 29; to which may be added: O. Sirén: Toskanische Maler im XIII. Jahrhundert, Berlin 1922, p. 302 ff., in which the author comes to the conclusion that the Rucellai Madonna was begun by Duccio and finished by Cimabue. The same writer in Revue de l'Art, Vol. XLIX, 1926, p. 73, has attempted to explain the question of the *Gualino Madonna*. The first exponent of the theory of a "Master of the Rucellai Madonna" who was neither Cimabue nor Duccio but an artist of Duccio's school, was F. Mason Perkins (Giotto, London 1902, p. 27), who in later articles still maintains this opinion (Rass. d'Arte, XIII, 1913, p. 36, note 3). Berenson is also of this opinion. For the Gualino Madonna see Lionello Venturi: Catalogo della Collezione Gualino, Turin, 1926, plate 1, and the same author's: Alcune opere della Collezione Gualino esposte nella R. Pinacoteca di Torino, Milan-Rome, 1928, plate 6. The history of this picture is related in Venturi's catalogue, where it is ascribed to Cimabue, as is also the Rucellai Madonna. The picture had to be thoroughly restored for a sixteenth-century artist had painted a Madonna on top of it. Toesca: Storia dell'arte italiana, II, Il Medioevo, Turin 1927, p. 1010, ascribes the Rucellai Madonna to a successor of Cimabue and places with it, "*in vario grado*", the Gualino Madonna, the Madonna in *Mosciano*, and the Madonna in the church of the Servi at *Orvieto;* in the notes on p. 1040 ff. Toesca has done but little to correct this grouping. He gives in the same work a kind of brief summary of the Rucellai question. Offner: Italian primitives at Yale University, Comments and Revisions, New Haven, 1927, scarcely touches the question. In one place (p. 4) he says of this picture: "painted... by a nameless hand not impossibly Duccio's own", and further on (p. 14) "commissioned an altar-piece from Duccio, now hanging

in the Rucellai Chapel''. He thus appears to consider that the picture ordered from Duccio is the Rucellai Madonna, but seems to hesitate as to whether it may be attributed to Duccio's own hand. In any case he does not consider it as the work of a Florentine artist.

During the printing of the present volume there has been published: Gustave Soulier, Cimabue, Duccio et les premières écoles de Toscane à propos de la Madone Gualino, 10 plates, 45 pages, Paris 1929 (Bibl. de l'Institut Français de Florence: Collection d'opuscules de critique et d'histoire, second series, No. 4). The author of this work arrives at conclusions which differ considerably from those given above. One can scarcely agree with him in describing the Madonna in the *Louvre* as a free copy by Duccio of a work by Cimabue, or in attributing the Madonnas in the church of the Servi at *Bologna* and in San Remigio at *Florence* to the school of Duccio, while the Gualino Madonna is ascribed to Duccio himself. The critical basis of this study is not solid enough to justify such assertions.

3] The lines quoted are the beginning of a sonnet by Guittone d'Arezzo (*ob.* 1297).

4] On the decoration and ornamentation of haloes see my work in Art Studies, VI, 1928. Line-engraving in the decoration of nimbi first appears in the Duecento in the paintings of Giunta, then in those of his Umbrian followers, who perhaps transmitted it to Siena. It is not unknown among the followers of the Master of the Maddalena, and is found in that picture (*Florence*, Accademia), but in Tuscan paintings the stippling method is on the whole predominant. It is not until the school of Guido da Siena that the draughtsmanship becomes firm and sure. It is significant that Cimabue and his school are content to use an ornament resembling a rosette, to which, but only in pictures of a ceremonial character, were added a few not very skilfully depicted tendrils; I call this ornament here and subsequently ''the Cimabuesque rosette''. A list of the pictures of the Cimabue school in which it is found is instructive: *Arezzo*, San Domenico, Crucifix (Sirén, plate 8 ff.); *Florence*, Uffizi, Trinità Madonna; Santa Croce, Museum, Crucifix; Santo Stefano in *Paterno*, Crucifix; *Paris*, Louvre, Madonna; *Turin*, Gualino Collection, Madonna. Cimabue's Trinità Madonna, however, furnishes a noteworthy exception; the haloes of the two lowest angels on the right and left are executed in line-engraving with foliated *motifs*, which are found in very similar form in the Sienese haloes of the Rucellai Madonna, but in the Cimabue picture the form is poorer and the execution weaker. The line-engraving in this case is nothing but an addition to the previously stippled rows of points, while the ground is hatched in line-engraving. The work is so un-Sienese in its weakness that it is impossible to attribute to Cimabue a Sienese assistant; the work must have been done by a Florentine who had only heard speak of Sienese work of this kind. There are two further exceptions of an opposite nature. The Madonna in the Pinacoteca at Arezzo, a work of Guido's school, has haloes with rows of stippled points in the Florentine manner and an ornament of spiral form, very like the ornament in the halo of the middle angel on the right in the Rucellai Madonna (plate 4) but of less sure execution. In the centre of the spirals is the

Cimabuesque rosette, which is lacking in the angel-halo of the Rucellai Madonna, although the latter is executed in the Florentine manner. Still more surprising is the fact that the Cimabuesque rosette also appears in the top panel of Guido da Siena's Madonna in the Palazzo Pubblico at *Siena*, in the haloes of God and the two angels, but in this case in line-engraving.

5] The use of gold lines on a brown ground for the angels' wings derives from Byzantine icons. The stylization of the wings in outline and colour has a completely, different appearance in Cimabue's school. In Cimabuesque pictures painted under Sienese influence, on the contrary, the angels, like Duccio's, have brown edges to their wings. The Louvre Madonna has a green ground like the Gualino Madonna, while Cimabue always used a brown ground, perhaps a habit learnt in fresco-painting (Trinità Madonna). On the medallions of the frame, cf. my remarks in Duccio, p. 136, note. In *Florence* there is an interesting analogy in the frame-medallions of the St. Francis in the Bardi chapel in Santa Croce. Sirén: Toskanische Maler, p. 101 ff. (plate 24 ff.), attributes the picture to a "Barone Berlinghieri", no signed picture by whom is known, and dates it 1275.

6] For Duccio's colour-system, see Weigelt: Duccio, p. 65 ff. and p. 135. Since then I have again tested these observations but can only confirm and amplify them. The last round picture but one (from left to right) of the lower edge of the frame represents St. Peter Martyr, easily recognizable by the wound on his forehead and his dress, who died in 1252 and had already been canonized by 1253, the first martyr of the Dominican order. On the brotherhood, see I. Wood Brown: The Dominican Church of Santa Maria Novella, Edinburgh 1902, p. 127 ff.; also Davidsohn, Forschungen zur Geschichte von Florenz, IV, 1908, p. 429 ff. and p. 435 ff.

7] Sirén, *op. cit.*, p. 307, maintains that the ornament in the brocade on the back of the chair is decidedly Florentine, as also the ornamental strips between the medallions of the frame. In Florentine pictures of the Duecento a quadrangle standing on end is used as an ornament in the cloth on the backs of thrones, whereas in Siena a circular ornament containing an eagle is employed. In Florence we can only point to certain similarities with the Rucellai ornament but to nothing resembling it to such a degree as those seen in the Madonna in the *Badia a Isola* or the Madonna in the cathedral at *Massa Marittima* (plates 30, 33). Both these pictures are free renderings of Duccio's Maestà and consequently contain many traces of the Rucellai Madonna. Sirén's second remark does not carry us much further; the ornament in question is not infrequently found in Florentine pictures of the Duecento but also occurs on crucifixes at *Pisa* and *Lucca*, and further in the altar-piece dedicated to St. Francis in the sacristy of San Francesco at *Assisi* and in other pictures of St. Francis. It cannot, therefore, be called "decidedly" Florentine, but can only be said to be of the thirteenth century.

8] On the Gualino Madonna, cf. note 2, and also Weigelt: The Rucellai Madonna and the young Duccio, in Art in America, XVIII, 1929-30, pp. 3-24 and p. 43 ff.

9] Cf. Douglas in his edition of Crowe and Cavalcaselle: History of Painting in Italy, Vol. I, 1903, pp. 182, 187 ff. On this picture see also Frey in his edition of Vasari, cf.

notes 4 and 5. For a criticism of this edition see Schlosser: Die Kunstliteratur, Vienna, 1924, p. 297 ff.

10] A hitherto unnoticed remark of Baldinucci (La Veglia, Dialogo di Sincero Veri, Florence, Pietro Matini, 1890, p. 10; further, Opere di Fil. Baldinucci, ed. Maria Manni, Vol. xiv, Milan 1812, p. 280 ff.) appears to confirm Duccio's stay in Florence. Cf. Weigelt, The Rucellai Madonna and the young Duccio, in Art in America, xvii, 1929, which also contains remarks on the observations of detail; see also the authors's second article, *ibid.*, p. 43 ff.

11] On this Madonna see my article in Thieme-Becker, Allgemeines Künstlerlexikon Vol. xv, 1922, p. 280 ff.; with bibliography. While at that time I was inclined to date the inscription on the picture in the year 1221, I am now practically certain, as a result of a new examination of the question and especially in view of the general artistic development in Central Italy and particularly in Tuscany, that the picture dates from the middle of the century. I discussed this point in a recent article in Art Studies.

12] After ample opportunities for studying the Crevole Madonna in the original, I am convinced that the opinion I had previously formed (Duccio, p. 168) is no longer tenable, and that the picture belongs to a comparatively early period. Besides Suida (Jahrb. d. Preuss Kunstsamml., xxvi, 1905, p. 28 ff.), Wulff (*ibid.*, Vol. xxxvii, 1916, p. 68 ff.) and Van Marle (Development, Vol. ii, 1924, p. 10) assign the Crevole Madonna to the master of the Rucellai Madonna. Both the last-named writers identify this master with Duccio. Lusini (Rassegna d'Arte Senese, ix, 1913, p. 19 ff.) has tried to clear up the history of the Crevole Madonna and gives one or two probable grounds for believing that the creation of the picture has something to do with the Duccio family.

13] On the *Perugia* Madonna, which came from the church of San Domenico in that city, see Umberto Gnoli, Rassegna d'Arte Senese, xiii, 1920, p. 94 ff.

14] Cf. the Zenobio altar-piece in the crypt of the cathedral, another example of the gable-shaped Duecento picture without enlargement of the centre-piece (Poggi, Il Duomo di Firenze, Italienische Forschungen, herausgegeben vom Kunsthistorischen Institut in Florenz, Vol. ii, Berlin 1909, p. 10 ff.; Sirén, Giotto and some of his followers, Cambridge 1917, Vol. i, p. 123 ff.; Vol. ii, plate 107). The gable-shaped Duecento picture survived in *Florence* much longer than in Siena; Giotto's Madonna from the Ognissanti has still this shape, which is also adopted by the "Cecilia Master". The famous Cecilia altar-piece in the Uffizi is a pure Duecento *paliotto* despite the fact that it dates from the beginning of the fourteenth century.

15] The accounts for the payments to the musicians have been preserved, cf. Lisini, Boll. senese di storia patria, v, 1898, p. 22, note. The Sienese chroniclers give even later detailed descriptions of this festival; the great event must thus have been remembered for a long time. It is very probable that Vasari's legend of the bringing of the Rucellai Madonna from Cimabue's workshop to Santa Maria Novella is an echo of this date of June 9th 1311 and of its grandiose solemnity. It seems like an irony of art history that Vasari, unconsciously, thus brings Duccio into connection with the Rucellai Madonna.

65

Benkard, Das literarische Porträt des Cimabue, Munich 1917, p. 86 ff., believes "that in this case a real historical event has been handed down to us in an altered form". Cf. Vasari, Vite, first edition, 1550, p. 128; Kallab, Vasari-Studien, Vienna 1908, p. 184; Frey, Vasari, I, p. 60 ff.

16] The schematic plans reproduced on pages 68-69 represent the reconstruction of the entire altar-piece which I attempted to make in the Bollettino Senese di Storia Patria, Vol. XVI, 1909, p. 190 ff. Cf. Giacomo De Nicola in his article on my Duccio book in the same review, Vol. XVIII, 1911, p. 431 ff. The signature of the Maestà is as follows:

> *Mater sancta dei sis causa Senis requiei*
> *Sis Duccio vita te quia depinxit ita.*

The four predella pieces of the Maestà went to America as a result of the sale of the Benson collection in 1927. The winged altar-piece in the museum at *Pienza* confirms my later additions, as I did not know this picture when I undertook the reconstruction of the Maestà. The altar-piece dates from the latter part of the fourteenth century and narrates, in 49 small pictures very much akin to those of the Maestà, the history of Jesus from the Annunciation to his Ascension; it is, however, a rough, insignificant work. An interesting echo of Duccio's version of the Holy Scripture is provided by the Shrine of the Santissimo Corporale (the Shroud of Jesus) in the cathedral at *Orvieto* (Ugolino di Vieri da Siena and assistants, completed 1338). Cf. Fumi, Il Santuario del SS. Corporale, Rome 1896, p. 30 ff., recently discussed by August Schmarsow, and rendered easily accessible by good reproductions of the different pictures, Italienische Kunst im Zeitalter Dantes, Augsburg 1928, p. 179 ff., plates 132-153.

17] For the iconographic relationship to the *Maniera Bizantina*, to Byzantine, Western and Gothic art, cf. the article in the appendix to my Duccio book, where all the scenes in the history of Jesus have been examined to this end. A valuable supplement to this is the work by Grüneisen, Tradizione orientale bizantina, influssi locali ed ispirazione individuale nel ciclo cristologico della Maestà di Duccio, in Rassegna d'Arte Senese, VIII, 1912, pp. 14-51; see also Evelyn Sandberg-Vavalà, La croce dipinta italiana, Verona 1929. R. Van Marle extended a similar study to Giotto in Recherches sur l'iconographie de Giotto et de Duccio, Strasburg, 1920. É. Mâle has drawn attention to analogies with French illumination in L'Iconographie française et l'art italien au XIV. siècle et au commencement du XV., in Revue de l'art, Vol. XXXVII, 1920, p. 1 ff.

18] For Duccio's perspective see the excellent essay by Erwin Panofsky: Die Perspektive als "symbolische Form", in Vorträge der Bibliothek Warburg, Vol. IV, 1924-1925, Leipzig 1927, p. 277 ff. This fundamental study gives the older literature on the subject.

19] For Landscape and its connection with the antique see the authoritative work by Wolfgang Kallab: Die toskanische Landschaftsmalerei im 14. und 15. Jahrhundert, ihre Entstehung und Entwicklung, in Jahrb. d. Kunsthist. Sammlungen d. Allerh. Kaiserhauses, Vol. XXI, 1900. Johannes Guthmann: Die Landschaftsmalerei der toskanischen und umbrischen Kunst von Giotto bis Raphael, Leipzig 1902, also contains a quantity of sound observations.

66

20] Cf. my edition of Giotto's pictures in "Klassiker der Kunst", Vol. xxix, Stuttgart 1925, where an example of the original iconographic version is given in the text.

21] Cf. Grüneisen, *op. cit.*, p. 22 ff.

22] Giotto's unconscious Madonna in *Padua* has an immediate model in older art, in which connection it should be compared with the diptych by a successor of Bonaventura Berlinghieri in the Accademia at *Florence* (No. 175). Reproduction in Sirén, Toskanische Maler im xiii. Jahrhundert, fig. 19; see also Offner, Italian primitives at Yale University, p. 10, and Evelyn Sandberg-Vavalà, La croce dipinta italiana, Verona 1929.

23] On "continuous" representation see Wickhoff: Die Wiener Genesis, Supplement to Vols. xv and xvi of the Jahrbuch d. Kunstsamml. d. Allerh. Kaiserh., Vienna, 1895, pp. 59-61, 80-85, 90.

24] Cf. Sirén, Toskanische Maler, plates 47-49, Photo Alinari 9880, Photos Anderson 28624-28635 with separate photographs of all the scenes.

25] Cf. Weigelt, Giotto, p. xxi and note on page 222.

26] Cf. R. Schiff in L'Arte, xv, 1912, p. 366 ff.; Weigelt in Thieme-Becker under "Duccio"; Van Marle, Development... Vol. ii, 1924, p. 153, wrongly ascribes the picture to the school of Segna di Buonaventura.

27] On Meo (*ob.* 1333 or 1334) and the influence of Sienese painting in Perugia see Mario Salmi in L'Arte, xxiv, 1921, p. 160 ff.; the same author in Rass. d'arte senese, xvi, 1923, p. 77; Weigelt, Art in America, xv, 1927, p. 255 ff.; Van Marle, Development of Italian painting, Vol. v, 1925. p. 20 ff.

28] A good example from this workshop is the half-figure Madonna belonging to Countess Tadini-Buoninsegni in *Florence*, first mentioned by Pietro d'Achiardi (L'Arte, ix, 1906, p. 372) as an original Duccio. The mantle of the Madonna was repainted a long time ago and through this the hands have suffered. The head of the Child is weak and the best part of the picture is the face of the Virgin, which is well preserved, although the outlines have suffered through restoration. Pictures Nos. 28 and 47 in the Accademia at Siena are considerably nearer to Duccio, although it would be rash to hold them for works of the master. The very beautiful half-length Madonna (No. 538) in the Accademia at *Siena*, further removed from Duccio himself than No. 28 in the same gallery, is the work of a pupil, whose careful drawing represents a transition to the manner of Ugolino (plate and bibliography in Van Marle, Development of Italian Painting, Vol. ii, p. 72). The late triptych in *London* (Buckingham Palace; reproduced in Weigelt, Duccio, pl. 49; cf. Catalogue of the Italian Exhibition at Burlington House, London 1930, No. 1) can at the most be assigned to the workshop and is perhaps merely the work of one of Duccio's pupils. The fragment of a Coronation of the Virgin in the National Gallery at *Budapest* (see G. von Térey, Die Gemäldegalerie des Museums der bildenden Künste in Budapest, Berlin 1916, p. 26) corresponds to Duccio's later style and may well be termed an excellent example of his workshop; this may also be said of the Triptych (No. 35) in the Accademia at Siena, which has suffered much through the

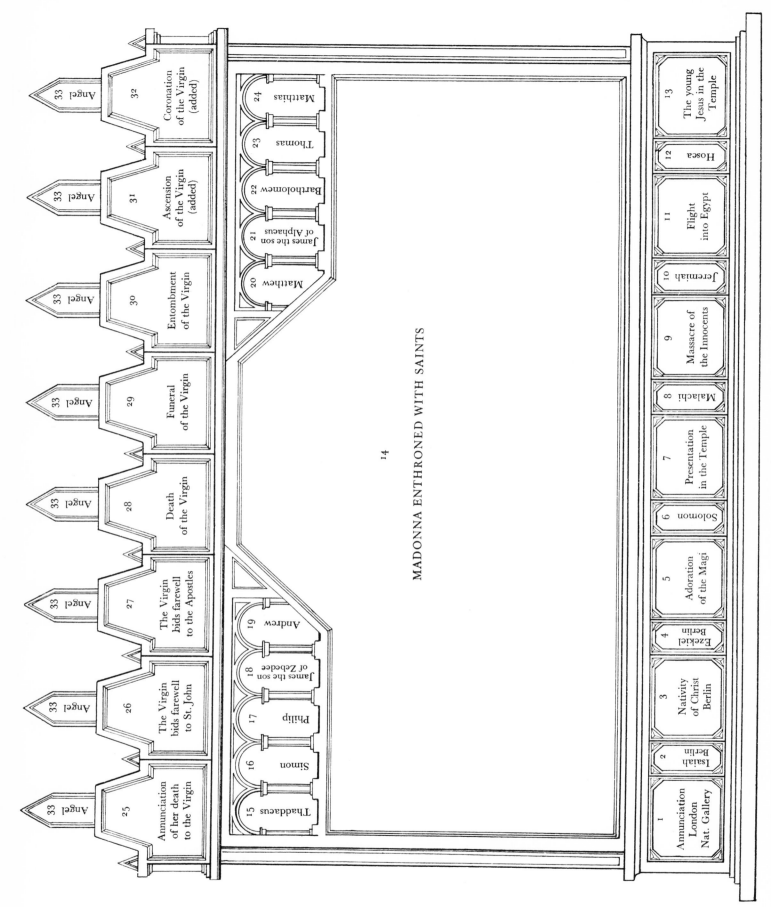

FRONT

	
1	Annunciation London Nat. Gallery
2	Isaiah Berlin
3	Nativity of Christ Berlin
4	Ezekiel Berlin
5	Adoration of the Magi
6	Solomon
7	Presentation in the Temple
8	Malachi
9	Massacre of the Innocents
10	Jeremiah
11	Flight into Egypt
12	Hosea
13	The young Jesus in the Temple
14	MADONNA ENTHRONED WITH SAINTS
15	Thaddaeus
16	Simon
17	Philip
18	James the son of Zebedee
19	Andrew
20	Matthew
21	James the son of Alphaeus
22	Bartholomew
23	Thomas
24	Matthias
25	Annunciation of her death to the Virgin
26	The Virgin bids farewell to St. John
27	The Virgin bids farewell to the Apostles
28	Death of the Virgin
29	Funeral of the Virgin
30	Entombment of the Virgin
31	Ascension of the Virgin (added)
32	Coronation of the Virgin (added)
33	Angel

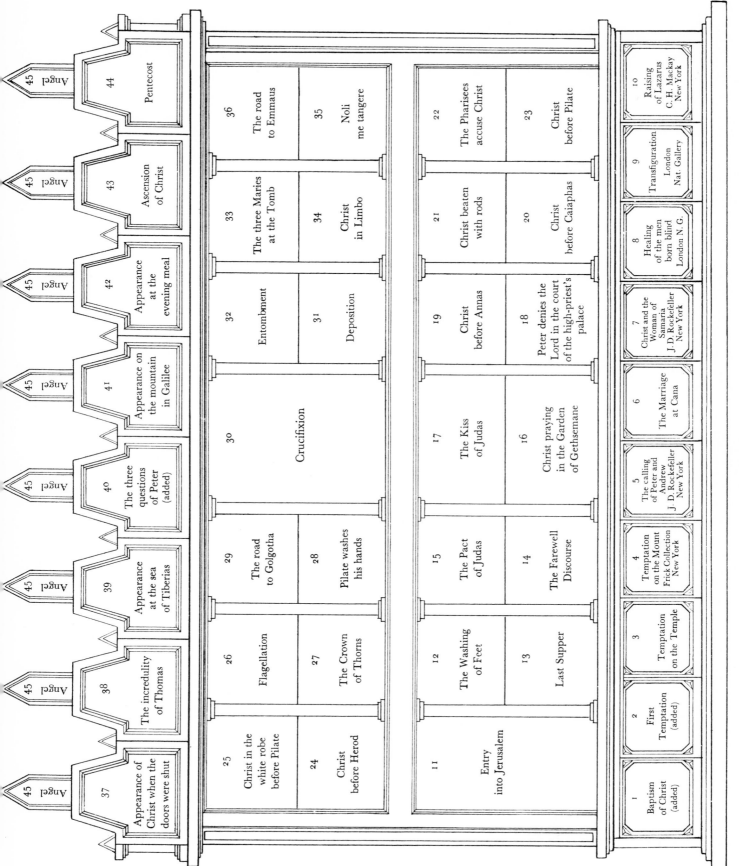

BACK

45 Angel	44 Pentecost	
45 Angel	43 Ascension of Christ	
45 Angel	42 Appearance at the evening meal	
45 Angel	41 Appearance on the mountain in Galilee	
45 Angel	40 The three questions of Peter (added)	
45 Angel	39 Appearance at the sea of Tiberias	
45 Angel	38 The incredulity of Thomas	
45 Angel	37 Appearance of Christ when the doors were shut	

36 The road to Emmaus	35 Noli me tangere
33 The three Maries at the Tomb	34 Christ in Limbo
32 Entombment	31 Deposition
30 Crucifixion	
29 The road to Golgotha	28 Pilate washes his hands
26 Flagellation	27 The Crown of Thorns
25 Christ in the white robe before Pilate	24 Christ before Herod

22 The Pharisees accuse Christ	23 Christ before Pilate
21 Christ beaten with rods	20 Christ before Caiaphas
19 Christ before Annas	18 Peter denies the Lord in the court of the high-priest's palace
17 The Kiss of Judas	16 Christ praying in the Garden of Gethsemane
15 The Pact of Judas	14 The Farewell Discourse
12 The Washing of Feet	13 Last Supper
11 Entry into Jerusalem	

10 Raising of Lazarus C. H. Mackay New York
9 Transfiguration London Nat. Gallery
8 Healing of the men born blind London N. G.
7 Christ and the Woman of Samaria J. D. Rockefeller New York
6 The Marriage at Cana
5 The calling of Peter and Andrew J. D. Rockefeller New York
4 Temptation on the Mount Frick Collection New York
3 Temptation on the Temple
2 First Temptation (added)
1 Baptism of Christ (added)

peeling of the colour on the contours of the figures; it is a little altar-piece painted for some royal prince, whose tiny figure kneels before the Virgin's throne. A follower of Duccio, who must have stood in close relationship to his workshop, painted the magnificent little triptych of the Blumenthal collection in *New York* (plate in Weigelt, Duccio, fig. 60). The strong Gothic tendency is noticeable in the figures of the centre-piece, while the scenes on the wings are copied from Duccio's Maestà. Among the material available there is no picture which can be assigned to the same artist. See Catalogue of the Collection of George and Florence Blumenthal, compiled by Stella Rubinstein-Bloch, Vol. I, 1926, plate XVI. A small and good Crucifixion with Mary and St. John (the upper part of an altar-piece, sold a short time ago by a Florentine antiquary to the Stoclet collection in *Brussels*) is also fairly near to Duccio's workshop; Van Marle wrongly attributed it to the so-called Ugolino Lorenzetti. Cf. Van Marle, Dipinti sconosciuti della scuola di Duccio, Rassegna d'Arte Senese, XIX, 1926, p. 4 ff. The fine little crucifixion formerly belonging to Prince Gagarin in Leningrad and now in the Hermitage there (reproduced in Weigelt, Duccio, plate 61) is harder in style but interesting on account of its connection with the Crucifixion in Duccio's Maestà, and its apparent relation to the Polyptych by the so-called Ugolino Lorenzetti in the museum of Santa Croce at *Florence*. I have to thank Professor Suida for drawing my attention to the little Madonna enthroned with the Child and angels in the Art Museum at Berne (31 x 23 cm; the Madonna with the three Franciscans at Siena measures 30 x 22 cm.), which has recently been published by Toesca in L'Arte, XXXIII (1930), p. 5 ff. This little picture, which has been damaged and darkened by varnish, must be very close to Duccio as far as can be judged from the reproduction. From an iconographic point of view it is interesting to note that this is the first picture closely related to Duccio in which the Child is represented with outstretched legs. I intend to deal with this picture, attributed by Toesca to Duccio himself, on another occasion, when I have had an opportunity of studying the original.

29] Van Marle, *op. cit.*, p. 77, plate, has rightly attributed to him a Madonna enthroned, which was formerly in the Argentieri Collection at *Spoleto*, and is very badly preserved. The type of Madonna-countenance found in Duccio's Maestà had a decisive influence on the development of the Sienese ideal of the Madonna, for in it Duccio rejected the Byzantine type with crooked nose.

30] The *œuvre* of the Master of Città di Castello was first brought together by F. Mason Perkins in Rassegna d'Arte Senese, IV, 1908, p. 51; cf. also Weigelt, Duccio, p. 195, and Van Marle, *op. cit.*, p. 81. The Madonna in *Copenhagen* was published as a work of Duccio by Adolfo Venturi in L'Arte, XXIV, 1921, p. 198 ff. Of the pictures mentioned, the Madonna from San Michele in Crevole has been much cut but is very well preserved; the other pictures have been damaged and partly painted over. De Nicola in the catalogue of the 1912 Duccio exhibition had already rightly attributed the four side pictures of a polyptych which was formerly in Santa Cecilia at Crevole (*Siena, Accademia*, Nos. 29-32) to the Master of Città di Castello (cf. Lusini in Rassegna d'Arte Senese, IX, 1913, p. 24); these pictures represent St. Peter, St. Anthony abbot, St. Au-

gustine and St. Paul. To this master's school must also belong the fine Crucifixion in *London* belonging to the Earl of Crawford. The frontal Madonna enthroned now in the Accademia at *Siena* (No. 18, originally in the church of San Pellegrino, Siena) is attributed by an unfounded tradition to a Maestro Gilio, who is proved to have existed about 1250. The beautiful picture has unfortunately been badly rubbed and cut. Even today I am still inclined to connect this picture with the Master of Città di Castello. Some time ago I had occasion to call attention to a certain relationship existing between it and the Madonna in *London* traditionally attributed to Cimabue (National Gallery No. 565; cf. my Duccio, p. 197) but I cannot even now agree with Van Marle (*op. cit.*, p. 87) in attributing the picture to this pseudo-master Gilio. In the London picture the influence of Pietro Lorenzetti is visible, or at any rate a first step towards his style. Until 1591 this Madonna hung upon a pillar in Santa Croce at Florence.

31] The front of the Madonna in *Massa Marittima* has been very much painted over and the back badly damaged. Whether the picture may be definitely assigned to Segna is by no means sure. Probably it was originally a large picture similar to Duccio's Maestà, with a series of scenes on the back, much shorter in comparison with Duccio's masterpiece, representing the story of the Passion. It is very possible that in consequence of the reduction of the picture to smaller proportions the angels and saints near the throne were sacrificed. The attribution to Segna is due to Giacomo De Nicola: Una copia di Segna di Tura della Maestà di Duccio, in L'Arte, xv, 1912, p. 21 ff.

32] For the Crucifix in *Moscow*, signed: HOC OPUS PINXIT SEGNA SENENSIS, see Burlington Magazine, Vol. XLVII, 1925, p. 151 ff., Vera Andreyeff, Some paintings of the Sienese school in the Museum of Fine Arts, Moscow. Lionello Venturi drew attention to the picture in 1912; cf. Giacomo De Nicola, L'Arte, xv, 1921, p. 21 ff., where the older literature on Segna is indicated. Mario Salmi, L'Arte, xv, 1921, p. 33 ff., and Weigelt, Duccio, pp. 188 ff. and 262 ff., give lists of pictures which nowadays are incomplete and inadequate. Hereafter only the best and most important pictures will be named, which can be ascribed to Segna (mentioned as having died in 1331) in addition to the already discussed, signed works.
Approximately to the same period as the Maestà in *Castiglion Fiorentino* belong the half-length Madonna in the Lehman collection at *New York* (originally in the Giuggioli collection in Siena), and the signed Triptych with the half-length Madonna and Saints Benedict and Silvester in the Metropolitan Museum at New York (Bulletin of the Metropolitan Museum, 1924, p. 191 ff.). The transition to Segna's mature period is seen in the badly preserved and mutilated half-length Madonna in the Chiesa dei Servi at Siena. To the master's middle period, that is to say nearer to the polyptych in the Accademia at *Siena* (No. 40) belongs the rather older half-length figure of St. Mary Magdalen (Alte Pinakothek, *Munich*, from the Charles Loeser collection in Florence; see Perkins, Rassegna d'Arte, 1913, p. 195 ff.). To the mature period belongs the Madonna, beautiful despite the restorations, in the Seminary of San Francesco at *Siena*. The name Segna has recently become a kind of collective designation for everything showing characteristics of the master or his school. Van Marle (Development, Vol II,

71

p. 125 ff.) went further than any in this direction, even though he makes a few not very successful attempts to eliminate and characterize certain individual artists. As in the present work it is not possible to mention, for every single picture, the first author who drew attention to it, I must limit myself to giving here a list of the most important works: Rassegna d'Arte Senese, Vol. VIII, 1912, dedicato a Duccio di Buoninsegna in occasione della mostra fatta il VI centenario della sua celebre Ancona; F. Mason Perkins: Appunti sulla mostra ducciana, Rassegna d'Arte, XIII, p. 5 ff.; Giacomo De Nicola: Duccio di Buoninsegna and his school at the Mostra, Burlington Magazine, XXII, 1912-13, p. 138; F. Mason Perkins: Some Sienese Paintings in American Collections, Art in America, VIII, 1920, p. 194 ff.; F. Mason Perkins: La pittura alla mostra d'arte di Montalcino, Rass. d'Arte Senese, XVIII, 1925, p. 50 ff. Very important, like everything this eminent connoisseur of Sienese art has written, Perkins: Alcuni appunti sulla Galleria delle Belle Arti di Siena, Rassegna d'Arte Senese, IV, 1908, p. 48 ff.; by the same author: Nuovi appunti etc., Balzana, II, 1928, p. 100 ff. and p. 143 ff. Further bibliographical indications in Van Marle, II, p. 1, note, and *passim*.

Here we must mention two groups of paintings which are generally connected with Segna. They are related by a special workshop tradition, but it cannot be maintained with certainty that they are due to the same creative hand. It is only natural that amongst the followers of Duccio, his most prominent pupil, Ugolino, should have exercised the strongest influence, and with him the Master of Città di Castello, as senior, and also Segna. The different stages of Duccio's development are partly preserved and transformed, and on the other hand the light of Duccio's great followers falls also on these second-rate artists. It would appear that there is a general tendency to date these pictures too early.

Another pupil of Duccio was the master of the half-length Madonna in the Collegiata at Asciano. To a later stage of development of the workshop belongs the half-length Madonna which was formerly in the Charles Loeser Collection and is commonly attributed to Segna (De Nicola: Niccolò di Segna, Burlington Magazine, XXII; plate in Van Marle, II, pl. 100). Closely related and perhaps even by the same hand is the Madonna in the Museum of Fine Arts at *Moscow*, also ascribed to Segna (reproduced in Burlington Magazine, XLVII, p. 1, *op. cit.*).

Another interesting and by no means unimportant pupil of Duccio painted the much-mutilated half-length St. Mary Magdalen in the museum at *Boston*. The artist reproduces to a certain extent the early manner of Duccio (Perkins, Art in America, VIII, 1920), but obviously had come under the influence of Ugolino. To this picture may very well be related the fine half-length of St. Catherine, which may possibly have belonged, together with the St. Mary Magdalen in Boston, to a polyptych (some years ago in the possession of Dr. Georg Martin Richter in *Munich*). In addition to this, two wing-pieces of a polyptych in the Otto O'Meara Collection (Catalogue of the auction sale of the Galerie Giroux in Brussels, October 15th-17th 1928, plate II), representing St. Mary Magdalen in half-length and St. Louis of Toulouse beneath a round arch in the exact style of the pictures of Duccio's workshop, may, as St. Louis of Toulouse is represented, be dated about 1320. Perkins, though with some hesitation, claimed

to recognize the enthroned Madonna del Latte in the Platt Collection at *Englewood* as an early work of the painter of the St. Mary Magdalen in Boston (Art in America, VIII). This seems to me impossible, although this important work (which was originally in the Monistero di Sant'Eugenio near Siena) undoubtedly belongs in a wider sense to this school.

For Segna's son Francesco, see Gaetano Milanesi: Sulla Storia dell'arte toscana, Scritti varii, Siena, 1870, p. 46; Lisini, *op. cit.;* documentary evidence concerning Niccolò from the year 1331 in Borghesi-Bianchi, *op. cit.*, p. 16; the latter gives Segna the elder as already dead in that year. For Niccolò see Perkins, Rassegna d'Arte, XIII, 1913, p. 35 ff., and Van Marle, *op. cit.*, II, p. 156. Some of the little pictures of saints in the sacristy of San Lucchese near *Poggibonsi*, attributed by Perkins to Niccolò, are very beautiful and well preserved. The attribution, however, does not appear very convincing.

33] Ugolino's high altar for Santa Croce can only be reconstructed in the imagination. In its construction (reproducing the form of the polyptych on plate 15 and coming from Duccio's workshop) it corresponds to the insignificant polyptych in the Collegiata at *Chianciano* in Val di Chiana (reproduced in Van Marle, *op. cit.*, II, p. 112), but the mediocre artist ruins Ugolino's model and descends to the coarse and the uncouth. Of the three other large side pictures with saints in half-figure, two have been lost except for the spandrel-pictures of angels. One of these is in *London* (National Gallery No. 3378), the other in the Cook collection at *Richmond* (cf. Catalogue of the paintings at Doughty House, Richmond, Vol. I, Italian Schools, by Tancred Borenius, Nos. 1-3). Two pairs of Apostles in small half-figures are in *London* (National Gallery, No. 3377 and 3473). On the trapeze-shaped, pointed upper sides of these pictures of the Apostles were pointed panels with Prophets and Patriarchs, of which Jacob is in *London* (No. 3376, National Gallery) Daniel in the Johnson collection at *Philadelphia* (cf. Berenson, Catalogue of a Collection of paintings, Vol. I, Philadelphia, 1913, p. 51, which shows the original size of the paintings); Moses and Aaron in *Richmond*. On the detached spandrel with the angels, now in Richmond, the Instruments of the Passion are depicted, a recent addition in order to fill up the surface. Other fragments of the altar are in private collections in England. Waagen saw in the Ottley collection four of the upper panels depicting Prophets, which are thus still extant today; cf. G. F. Waagen, Kunstwerke und Künstler in England und Paris, Berlin 1837, Vol. I, p. 393 ff., and also P. G. Konody, in Apollo, II, 1925, p. 187 f. For the signature of the picture see Della Valle, Lettere Sanesi, Vol. II, 1785, p. 201. To Ugolino himself may be ascribed the polyptych in the Accademia at *Siena*, No. 39; the head of St. John the Evangelist in the Lehman collection at *New York* (reproduced in Weigelt, Duccio, plate 50); two fragments of a polyptych with half-figures of St. Peter and St. Francis in the Misericordia at *San Casciano* near Florence, which De Nicola thought might belong to the altarpiece in Santa Maria Novella mentioned by Vasari (De Nicola, Ugolino e Simone a San Casciano, Val di Pesa, in L'Arte, XIX, 1916, p. 13 ff.). The Madonna enthroned with the Child and the little kneeling figure of a benefactor (cf. Rassegna d'Arte Senese, VIII, 1912, p. 52 ff., W. de Grüneisen), also in the Misericordia at *San Casciano* and attributed to Ugolino himself by De Nicola and also by Berenson (Essays in the

73

study of Sienese painting, New York 1918, p. 12, note), appears to me to be merely closely connected with the master. Two half-figures of saints, Peter and John the Baptist, in the Maitland Griggs collection, *New York*, were attributed by Van Marle (Rass. d'Arte Senese, xix, 1926, p. 4) to Ugolino, but more rightly by Offner to the Master of Città di Castello (Bulletin of the Associates in Fine Arts at Yale University, 1926, p. 5 ff.). Both are comparatively early pictures.

34] Pictures of Ugolino's school: one of the groups shows a workshop tradition which clearly leads from Duccio to Ugolino. First of all there is the impressive Madonna from Santa Maria dei Servi at *Montepulciano*, recently exhibited at the Uffizi (Perkins, Rass. d'Arte, xiii, 1913, p. 6, and Balzana, ii, 1928, p. 100 ff.), which is the work of a pupil of Duccio. More recent is the half-figure Madonna in the Lehman collection at *New York* (Perkins, Art in America, viii, 1920, p. 203, plate); to a still later period of development belongs the beautiful Madonna in the Platt collection at *Englewood* (Perkins, *ibid.*, p. 194, plate), while, finally, the polyptych with a half-figure Madonna, with saints on the side panels, at the *Castel Brolio* in Chianti (Ricasoli collection; De Nicola, L'Arte, xix, 1916, p. 13) is very close to Ugolino.

Related to this group is the Madonna enthroned in the Misericordia at *San Casciano*, mentioned in note 33, which Perkins rightly places with the triptych of the Pieve at *San Giovanni d'Asso*, formerly in San Pietro in Vincoli detto in Villore (see Rass. d'Arte, xiii, 1913, p. 8 plate, and Art in America, viii, 1920). Also closely related is the Madonna in half-figure in the *Boston* Museum (No. 60), wrongly assigned to Ugolino. The beautiful Madonna enthroned with the Child and the benefactress Monna Muccia Ciantara (*Lucignano* in Val di Chiana, Pinacoteca; cf. W. de Grüneisen, Rass. d'Arte Senese, viii, 1912, p. 52 ff.) is the work of a pupil of Duccio who is not very far removed from the Montepulciano group and shows strong traces of the influence of Ugolino. The finest and most attractive style in Ugolino's school is represented by a group of pictures, which Berenson baptized with the name of Ugolino-Lorenzetti Master, in order to designate the chief sources. These are partly pictures formerly attributed to Ugolino himself (Berenson, Essays in the study of Sienese painting, New York 1918, p. 136, ch. 1, "Ugolino Lorenzetti"). Perkins (Rass. d'Arte, xiii, 1913, p. 9, note 3) had already separated the most important of these pictures from Ugolino, while De Nicola showed the connection between the Madonna in *Fogliano* and the beautiful half-figures of St. Ansanus and St. Galganus (*Siena*, Accademia, Nos. 42 and 43; see De Nicola, Burlington Magazine, xxii, 1912-13, p. 46 ff., and the same author in Rass. d'Arte, N. S., vi, 1919, p. 95 ff.). See also Ernest T. Dewald, Art Studies, Vol. i, 1923, p. 45 ff.: The Master of the Ovile Madonna; Van Marle, *op. cit.*, Vol. ii, p. 113 ff. In addition to the triptych from Fogliano, we must assign to this master, whose activity must have extended beyond the middle of the century, the polyptych with a half-figure Madonna and four saints in the Museo dell'Opera at Santa Croce in *Florence* (No. 6), which is older than the triptych in Siena, and a Crucifixion in the *Louvre* (No. 1665). See also Offner in Art in America, vii, 1919, p. 189 ff.: a small, much-damaged triptych of the Madonna enthroned between St. Catherine and St. John the Baptist, with St. Michael and the Conversion of St. Paul on the wing panels, *New York*, Historical Society;

Perkins, *ibid.*, VIII, 1920, p. 282: a small Madonna dell' Umiltà, *New York*, Philip Lehman collection, Catalogue No. 30. Other works are also very near to the master, such as the Crucifixion in the Berenson collection at *Settignano*, a polyptych of the Ovile Master in the Bordonaro Chiaramonte collection at *Palermo* (from Sant'Agostino in San Gimignano), a very much deteriorated triptych with a Crucifixion as centre-piece in the Accademia at *Siena* (No. 54, from the convent of Santa Caterina a Radicondoli); cf. Van Marle in Boll. d'Arte, 1923, p. 565 etc. Nevertheless criticism has not yet said its last word on the relationship between the so-called Ugolino-Lorenzetti and the Ovile Master. In all these pictures, which in part are very finely executed, there is an artistic syncretism in play which leads from Duccio, through Ugolino, to Pietro Lorenzetti. An article has just appeared in the Burlington Magazine, LV, 1929, p. 232 f., by Philip Hendy, entitled: Ugolino Lorenzetti, some further attributions. These new ascriptions cannot be accepted; the only one which has any relationship to the so-called Ugolino Lorenzetti is the Birth of Christ in the Kaiser Friedrich Museum at Berlin (No. 1094 A) to which Berenson had already called attention.

35] Miss Jean Carlyle Graham (Rass. d'Arte Senese, V, 1909, p. 39 ff.) tried to prove that Simone was a pupil of his father-in-law Memmo di Filipuccio (Davidsohn, Forschungen zur Geschichte von Florenz, Vol. II, 1900, p. 311), who in 1317, in collaboration with his son Lippo di Memmo, executed paintings in the Council Chamber of the Palazzo Pubblico at *San Gimignano*, in the same hall in which Lippo signed the copy of Simone's Maestà in the year 1317. But we have no signed work by Memmo. Van Marle attributed to him a badly-preserved fresco in San Giacomo at *San Gimignano* (*op. cit.*, Vol. II, p. 167, plate), without giving any justification for this hypothesis. We hear of Memmo in 1305, 1306, 1310 and 1317 at San Gimignano, and in 1294, 1321 and 1326 at Siena. He must thus have resided at San Gimignano for a long time. That Lippo was Simone's brother-in-law and collaborator does not prove that Simone was Memmo's pupil. On Memmo see Van Marle in Rass. d'Arte Senese, XIII, 1920, p. 50 f.; Weigelt in Thieme-Becker, Künstlerlexikon, XXIV, 1930; on Simone, the still very useful work by Agnes Gosche, Simone Martini, Leipzig 1899, and Van Marle, Simone Martini et les peintres de son école, Strasburg 1920, with bibliography.

36] Ghiberti, Commentarii, first edition by Schlosser, Berlin 1912, Vol. I, p. 42, Vol. II, p. 147. Ghiberti's remarks, however, seem to indicate that he praised Ambrogio so highly either because he recognized his great learning, or because he saw how faithful Ambrogio remained to the antique.

37] The inscriptions on the steps have been renewed and the names of the archangels interchanged. Gabriel can be recognized by the lily and Michael by his raiment. The two crowned saints are St. Ursula, with her foot on an arrow, and St. Catherine with the wheel at her feet. The patron saints of the city kneel in the same order as in Duccio's work. The steps and the flooring with its fine inlaid intarsia-work are similar to those seen in the steps of the throne in the Naples picture (plate 39) and elsewhere. Despite the opposition to this opinion which has been raised (Toesca, Florentine Painting of the Trecento, Pegasus Press, Paris, 1929, note), I still hold that the relationship of

Giotto's Madonna from the Ognissanti with Simone's Maestà is certain (cf. Weigelt, Giotto, p. 230). The inscription on Simone's Maestà is given in Crowe and Cavalcaselle, Jordan edition, Vol. II, 1869, p. 233, and also in Milanesi, Documenti, I, p. 219.

38] Documentation in H. W. Schulz, Denkmäler der Kunst des Mittelalters in Unteritalien, Vol. III, 1860, p. 165 ff.; cf. Agnes Gosche, *op. cit.*, p. 34 ff.

39] The Predella contains five stories from the Legend of St. Louis (under round arcades; Photos Anderson, 5645-46, 26585-89), very much deteriorated. In the spandrels of the arcading is the fragmentary signature: SYMON DE SENIS ME PINXIT. Simone's picture of the Coronation, originally in Santa Chiara, the church founded by Robert, was removed at the end of the fourteenth century to San Lorenzo and is now in the Museo Nazionale. The technique of the engraving of the gold groundwork (plate 40) is very fine and accurate, stamped ornaments being little used, as except for the point and circle there are only a rosette and a roseleaf similar to those in the Maestà (plate 38); line-engraving predominates. On the other hand in the pictures at Pisa and Orvieto cut ornaments prevail. Although the number of different ornaments increases, we find only one ornament for all the haloes (as in the polyptych at Pisa). In Orvieto the pointed decoration running along the inner edge of the frame (plate 42) is stamped.

40] The data from the chronicle mentioned will be found in Bonaini, Memorie inedite alla vita e ai dipinti di Francesco Traini, Pisa 1846, p. 38; and also in Agnes Gosche, *op. cit.*, p. 19, note.

41] The whole picture has been provided with a new frame which is too rich in the single decorations. The correct order of reconstruction seems to me to be, from left to right: St. Dominic, St. Mary Magdalen, St. John the Evangelist, the Virgin, St. John the Baptist, St. Catherine, St. Peter Martyr; the names inscribed on the predellas contain common errors; St. Lucy, although she is holding the lamps, is wrongly taken for St. Mary Magdalen (as in all literature on the subject). The saint next to her (in the reconstruction of Nikolaus) is St. Jerome, who thus completes the series of Doctors of the Church; as in the frame of Simone's Maestà he wears the bishop's pluvial and is bareheaded. The total width of the restored altar is about 11 1/2 feet. The signature is beneath the centre picture and is worded as in the *Naples* picture. The damaged altarpiece must have been removed soon after the fire in 1651. Cf. Luigi Dami in Dedalo, III, 1922-23, p. 4 ff.

42] The notice in Crowe and Cavalcaselle, *op. cit.*, II, p. 240, is taken from a manuscript chronicle of the former Dominican convent in Orvieto, written by Fra Matteo del Caccia. According to information kindly supplied by Professor Pericle Perali, this was printed by the Dominican Fathers Viol and Girardin, Viterbo 1907. Unfortunately I was unable to consult this work in Florence. Crowe and Cavalcaselle considered the reading 1321 as possible, and Perali also places the creation of the picture in the same year (Pericle Perali, Orvieto, Note Storiche, Orvieto 1919, p. 99), while Berenson (Essays in the Study of Sienese Painting, New York, 1918, p. 21, note), claims to recognize traces of several letters at the end of the signature, but, on account of a difference of style from the Pisa picture which he has noticed, prefers to date it a few years later than 1320.

The signature, the wording of which is the same as that in Pisa, closes with the legible date M.CCCXX. Remains of letters after the last x are no longer perceptible. The signature and its position make a higher number improbable. The altar-piece must, as Agnes Gosche has rightly observed (*op. cit.*, p. 24), have been in seven parts. Trasmondo paid one hundred golden florins for it.

43] A little Madonna in the Opera del Duomo, coming from San Francesco in *Orvieto* (Alinari 25975-975a), with the Virgin in half-figure and the Child, an angel in each spandrel and Christ between two angels above, belongs to the workshop of Simone, and is ascribed by Van Marle to Lippo (Van Marle, Simone, p. 104; the same author, *op. cit.*, Vol. II, p. 254). Perkins considers the Madonna in the *Gardner collection* as a work of Lippo Memmi executed under the direction of Simone (Rass. d'Arte Senese, I, 1905, p. 75).

44] A series of pictures by Simone, which I cannot discuss here, belongs to about the beginning of the third decade of the century, viz. *Rome*, Vatican Gallery, No. 27, half-figure of Christ blessing (Guida della Pinacoteca Vaticana, Rome, 1913, p. 13); *Cambridge*, Fitzwilliam Museum, three wings of a polyptych with half-figures of the Archangel Michael and probably of the Fathers of the Church, St. Ambrose and St. Augustine (Perkins, Rass. d'Arte Senese, V, 1909, p. 3 ff.); *San Casciano* near Florence. Misericordia, Crucifix, with the Virgin and St. John on the side panels (cf. De Nicola, note 33); *Altenburg*, Lindenau Museum, St. John the Baptist enthroned (Schmarsow, in Festschrift zu Ehren des Kunsthistorischen Institutes zu Florenz, Leipzig 1897, p. 135); *Settignano* near Florence, Berenson collection, St. Lucy and St. Catherine, two wings of a polyptych, in which the half-figure of St. Lucy with the sword shows traces of the workshop (De Nicola, Boll. d'Arte, N. S., I, 1921, p. 342 f.; Adolfo Venturi, L'Arte, XXIV, 1921, p. 198).

Adolfo Venturi (Storia, V, 1907, p. 596) with some hesitation placed the beautiful Madonna and Child (half-figure) of the Borghese Gallery in *Rome* (now in Palazzo Venezia, cf. Hermanin, Il Palazzo Venezia, Descrizione e Catalogo, Bologna 1925, p. 30) in Simone's Neapolitan period; it must have been a late work, if only on account of the rich Gothic decoration of the gold groundwork. The picture should be eliminated from the list of Simone's works for it is evidently the work of an artist of his school, very close to the Madonna enthroned with Saints Michael and Gabriel in the Berenson collection at *Settignano* (generally attributed to Lippo Memmi). Cf. Weigelt in Thieme-Becker, Künstlerlexikon, XXIII, 1929, under Lippo Memmi.

45] The blue background has been renewed and the rest of the fresco much restored.

46] Both the saints on the wing pictures produce a weak effect, the flesh-colouring is duller, the statuesque element stronger, on which account these wings have been declared to be the work of Lippo, while the collaboration of the workshop in the side panels may be admitted. Many have tried to distinguish the work of the two artists in this picture and the last to do so, Leandro Ozzola, in Rass. d'Arte Senese, VIII, 1921, p. 117 ff., assigns Ansanus and Gabriel to Lippo, the Virgin and St. Julia to Simone, while others,

77

like Van Marle, attribute the wings to Lippo. A definite decision will scarcely be possible, as the state of preservation of the picture is not uniform and the middle panel has been much restored. It seems to me out of the question that the main picture can be by any other hand but Simone's.

47] Painted for the altar of St. Ansanus in the Duomo (Lusini, Il Duomo di Siena, 1911, p. 237), later in Sant'Ansano in Castelvecchio, exchanged by the Grand Duke in 1733 for other pictures. Cf. Guida storico-artistica del Duomo di Siena, Siena 1908, pp. 51, 61 ff. The frame is modern, and in the missing medallion in the middle there should be the half-figure of Christ blessing. On the hem of the sleeve is the name of the angel. The inscriptions on the stole are: on the breast, St. Luke, I, 30; under the sleeve, *idem*, v, 31; on the piece hanging down towards the front, from bottom to top, *idem*, v, 35. Prophets in the medallions, from left to right: Jeremiah (Jeremiah, xxxvi, 22), Ezekiel (*Vidi portam in domo domini clausam*, a reference to Ezekiel, xliv, 2), Isaiah (Isaiah, vii, 14), Daniel (Daniel, vii, 13). The inscription on Jeremiah's scroll is from Jeremiah, xxi, 22. These are the predictions of the prophets regarding the mystic conception and the virgin birth of Our Lord. The inscriptions bring into relief the whole wealth of religious and symbolical relationship. If such inscriptions received the attention which is their due, we should be spared many false assumptions, as, for example, regarding plate 59. On the prayer-book are the first words of Luke, ii, 48: *Fili quid fecisti nobis sic?* There can therefore be no discussion as to the spiritual meaning of the pictures, such as is found in Van Marle (*op. cit.*, ii, p. 237).

48] Thus Della Valle, and also Agnes Gosche, Langton Douglas and Berenson (Essays... of Sienese painting, 1908, p. 20). The frescoes are more impregnated with Gothic elements than any other picture by Simone prior to 1333, especially the architectural decoration on the intrados of the windows and entrance. Though the architectural features of the pictures remain faithful to round arches, the Obsequies of St. Martin (plate 55) contain highly developed and graceful Gothic triforia. A figure like that of St. Mary Magdalen (plate 57) reminds us in the Gothic profuseness of the raiment of the Joseph in the picture at *Liverpool* (plate 59), the figure of St. Julia in the Annunciation (plate 46), on the other hand, seems unpretentious by comparison. In the same way the greater predominance of the costume of the time, the importance attached to the fashions, as in the figures of St. Elizabeth or St. Louis or in the "histories" themselves (plates 51, 52) leave no doubt as to the late origin. The style, on the whole, has become heavier.

49] On the windows see Thode, Franz von Assisi, Berlin 1904, p. 620; on the two chapels *ibid.*, p. 290 ff. Further, for the windows in the St. Louis chapel, cf. P. Egidio M. Giusto, O. F. M., Le vetrate di San Francesco in Assisi, Milan 1911, p. 287 ff., with plates; also Beda Kleinschmidt, O. F. M., Die Basilika S. Francesco in Assisi, Vol. i, 1915, p. 228 ff., plates. The windows of the chapel of St. Martin evidently derive from cartoons by Simone, those of the chapel of St. Louis from a pupil of Simone. That Gentile left bequests to the church we know from the inventory of 1338, cf. Kleinschmidt, *op. cit.*, Vol. iii, Berlin, 1928, p. 30; on Gentile see also Vol. ii, index. In 1585 the roof of the chapel fell in and was subsequently restored.

50] On St. Agostino Novello (*ob.* May 19th, 1309), who had been living at San Leonardo al Lago near Siena since 1300, see A. Corrao, Vita del B. Agostino Novello, Rome, 1915; and the article on the saint in the splendid Enciclopedia Italiana which is now in course of publication (Vol. I, 1929, p. 931 f.). The arrangement of the scenes in the St. Martin chapel is as follows:

Left-hand wall		10	*Right-hand wall*		8
on entering:	5	9	*on entering:*	6	7
	1	2		3	4

In the literature on the subject some of the scenes are variously interpreted (cf. Agnes Gosche, *op. cit.*, and Van Marle). 1) The Division of the mantle. 2) The Lord appears to the saint in a dream. 3) St. Martin knighted. 4) The saint refuses to go to war. 5) St. Martin raises a child from the dead. 6) The Mass of St. Martin. 7) The Emperor Valentinian humbles himself before the saint. 8) The death of St. Martin. 9) St. Ambrose in a dream officiates at the obsequies of St. Martin. 10) The Obsequies of St. Martin in the presence of St. Ambrose. The interpretation presents no difficulties until we reach No. 9, which since Agnes Gosche has been wrongly explained as the Meditation of St. Martin. The *Legenda Aurea*, however, describes the dream of St. Ambrose in exactly the same manner as represented by Simone. A late Italian version of Voragine (in the attractive edition by Guido Battelli, Le più belle Leggende cristiane, Milan 1924, p. 538) gives further details; the combination of the two scenes is found in *Milan* in the mosaic of the apse of Sant'Ambrogio. There is one detail which leaves no room for doubt, viz. the presence of St. Ambrose in his sleep (plate 54). On his episcopal mitre there is a round ornament, as in the Obsequies (plate 55), which is lacking in all the figures of St. Martin. As Archbishop of Milan St. Ambrose wears the archiepiscopal pall. The standing monk-saint with his hood drawn over his head is not easily identified (St. Severinus of Cologne?) and is evidently the same person as the monk wringing his hands who is bending over St Martin in No. 8, although in this case he has no halo. For the liturgical and ritual elements cf. Beda Kleinschmidt, *op. cit.*, II, 1926, p. 243 ff., who also interprets No. 9 as the dream of St. Ambrose. The choice of the legends of St. Martin was certainly made by the donor, whose titular church was SS. Martino e Silvestro in Rome. In the documents he is called the Cardinale di San Martino. Gentile died on October 27th 1312 in Lucca, on his way from Perugia to Avignon, whither he was accompanying the papal treasure. Cf. Davidsohn, Geschichte von Florenz, Vol. III, 1912, p. 566. A short time ago the first Italian edition of the "Golden Legend" was published, the beautiful Italian version of the late Trecento, promoted by Arrigo Levasti: Beato Iacopo da Varagine, Leggenda Aurea, Volgarizzamento Toscano del Trecento a cura di A. L., Florence 1924-26, 3 volumes.

51] Christ and the saint are quite in the style of Simone, but the drawing of the angels is rather harder. Van Marle (Simone, p. 37 ff.) still attributes to Donato (Adolfo Venturi, Storia, V, p. 606, was the first to mention Donato's name as a collaborator) the angels with the saint's soul in the Death of St. Martin, the topmost saints in the entrance-archway and the half-figures of saints in the right transept of the lower church;

and also some panel paintings (cf. Van Marle, Apollo, IV, 1926, p. 161 ff., where the pictures given to Donato do not correspond to the style of the frescoes and differ widely from one another). Donato, first heard of in 1324, married in 1334 a certain Giovanna and received full powers for Avignon in 1339 at the same time as Simone. He accompanied his brother thither and returned to Siena after Simone's death. The childless Simone had appointed Donato's six children his heirs. According to Milanesi Donato was buried on August 16th 1347. Cf. also Lisini in La Diana, *op. cit.*, p. 30, and see the genealogical tree of Donato's descendants in Milanesi, Documenti, I, pp. 216, 244 ff., and Vasari-Milanesi, I. These notices permit us to assume a close connection between the two brothers, who also owned in common a house and a vineyard. A collaboration in painting can only be taken as certain for the time they spent in Avignon.

52] Reproduced in Beda Kleinschmidt, *op. cit.*, Vol. II, p. 260.

53] Vasari (Milanesi edition, I, p. 557) gives the number of figures correctly as eight. Although in his life of Simone he adds new and sometimes valuable observations to those of Ghiberti, whose notes form the nucleus of his "Vita di Simone", this biography is full of errors. To Vasari we owe the invention of "Simone Memmi" and the attribution of the frescoes in the chapel of St. Martin to Puccio Capanna. Unfortunately there is no longer any means of controlling the supposed frescoes in the chapter house of Santo Spirito in *Florence*, the remains of which, according to Vasari, were pulled down about 1560. The saints in the lower church, from left to right, are: 1) St. Francis, 2) St. Louis of Toulouse, 3) St. Elizabeth, 4) a woman saint, generally known as St. Clara, 5) a young saint in fine raiment, with a lily in his left hand, very similar to the saint in the intrados of the window in the chapel of St. Martin, whom Beda Kleinschmidt, II, p. 262, without any justification calls St. Martin. On the adjoining wall is a half-figure Madonna with the Child between St. Louis of France on the left (as in Vasari) and on the right a young saint with a crown. Both carry sceptres and imperial globes. Maria is also crowned (Photo Anderson 26927).

54] For Simone's Avignon period see Agnes Gosche, *op. cit.*, p. 88 ff., which contains the older bibliography; also Van Marle, *op. cit.* For his connection with the Cardinal see G. De Nicola, L'Affresco di Simone Martini ad Avignone, L'Arte, IX, 1906, p. 336. On the personality and life of Iacopo (*ob.* 23.6.1343 in Avignon), see Hösl, Kardinal Jacobus Gaietani Stefaneschi, Histor. Studien, Vol. LXI, Berlin 1908.

55] On the words in the Virgin's prayer-book cf. above, note 47, and Frizzoni in L'Arte, VII, 1904, p. 260. A particularly good reproduction of the picture is in the Illustrated Catalogue of Pictures of Siena, Burlington Fine Arts Club, 1904, plate XIII.

56] Both the pictures in *Antwerp* are in the original frame, signed beneath the Crucifixion SYMON, beneath the Deposition PINXIT, which must be the remains of a longer inscription. On these four pictures cf. Schubring Jahrb. d. Preuss. Kunstsamml., XXIII, 1902, p. 141 ff.; Frizzoni, *op. cit.*; Catalogue, Burlington Fine Arts Club, 1904, plates XIV-XV, p. 56. The romantic evening sky with red clouds against a deep blue ground in the Entombment is not original. Ever since the publication of the old catalogue of the

Antwerp Gallery (1857, p. 4) we find in the writings on the Crucifixion the interpretation of the S. P. (the first letters of S. P. Q. R.) as "Simone pinxit", although Simone has signed the picture in another place.

Such attempts at interpretation find no justification in the customs of the period; cf. W. von d. Schulenburg, Ein neues Porträt Petrarcas, Berne, 1918 p. 25 f. The Carrying of the Cross, has evidently been much restored. The youth with a hat, who helps to carry the Cross, and the face of the turbaned man must have been repainted. Count Erbach-Fürstenau (as he himself told me) has also noticed traces of renewal, and claims that the picture reminds him, even in its colouring, of one of the masters of the Très Riches Heures (*Chantilly*). Duccio's Woman of Samaria (Weigelt, Duccio, plate 30) served (together with the Entombment of the Virgin from his Maestà) as a model for the depicting of the city. The polygonal building on the right is the Temple of Solomon, though Schulenburg is not of this opinion, *op. cit.*, p. 27. The name of "special" relationships might be applied to such observations as that the man under the town gate resembles the Apostle Simon. In the Maestà of 1315, Simon the Apostle, the patron saint of the painter, bears one of the supports of the canopy. I have not been able to consult W. v. d. Schulenburg: Heraldisch-genealogische Probleme in den Werken des Malers Simone Martini, Herold, 1914. The *Antwerp* museum possesses two other panels of a very beautiful Annunciation, which are held to be the wings of the small altarpiece. A curious, strongly-Gothicized variant of the large Annunciation, which with its lively play of folds and lines leads us far beyond the *Liverpool* picture. De Nicola, *op. cit.*, (cf. note 54), thinks it possible that the kneeling bishop of the Deposition is Cardinal Iacopo. A comparison with the likeness of the patron in the St. George Codex confirms this on physiognomic grounds, in which case the picture cannot have been commissioned after the spring of 1343.

57] On the blind soldier, generally called, like the captain, Longinus, cf. Rudolf Hofmann, Das Leben Jesu nach den Apokryphen, Leipzig 1851, p. 381.

58] The two sonnets of Petrarch are the 49th and 50th. In the 86th Petrarch again mentions this portrait and places Simone above Zeuxis, Praxiteles and Phidias; notwithstanding which many writers, with no justification, dispute that this passage refers to Simone. On Simone's relationship with Petrarch see Pietro Rossi, Simone Martini e Petrarca, in Arte Antica Senese, I, 1904, pp. 160-182. On the St. George fresco see De Nicola, *op. cit.*, note 54.

59] The couplet runs as follows:

> *Mantua Virgilium qui talia carmina finxit,*
> *Sena tulit Symonem digito qui talia pinxit.*

For the literature thereon, see Müntz in Gaz. Archéol., 1887, p. 102 ff.; d'Esling and Müntz, Pétrarque, Paris 1902, p. 9 ff.; Pietro Rossi in Arte antica senese, I, 1904, *cit.;* Van Marle, *op. cit.;* and the proposed new interpretation of the figures in W. von der Schulenburg, *op. cit.* (see also note 56). Count Erbach also told me personally that he considered it a work of Simone, which was subsequently overlooked. For the Virgil

81

centenary the publication of a facsimile edition of the Codex with coloured reproductions in photogravure of the miniatures is announced under the title: Francisci Petrarcae Vergilianus Codex... praefatus est Johannes Galbiati... ascita etiam Achillis Ratti (nunc Pii XI Pont. Max.) de hoc Codice commentatione. Mediolani, Anno Natali MDCCCCXXX in aedibus Hoeplianis.

60] Further attributions to Simone: *Leningrad*, Hermitage, Madonna of the Annunciation, seated, formerly in the Stroganoff Collection, very badly preserved, probably to be ascribed to the workshop; see G. M. Richter, who assigns it to Paolo di Giovanni Fei (Burlington Magazine, LIV, 1929, p. 166 ff., and *ibid.*, p. 282), in which I cannot support him. *Cambridge* (U. S. A.), Fogg Museum, Crucifixion (formerly in the Bonnat Collection), imitated from the Christ on the Cross in the little altar-piece at Antwerp. *Brussels*, Stoclet Collection, Madonna of the Annunciation, seated, first noticed by Gielly (*op. cit.*, plate 28) as a work of Simone (cf. Van Marle, Apollo, IV, *op. cit.*, and G. M. Richter, *op. cit.*); although I have not seen the original, I am by no means convinced that the work is by Simone himself. The numerous lesser masters in the orbit of Simone, of whom we only know Naddo Ceccarelli by name (cf. Perkins, Rass. d'Arte Senese, V, 1909, p. 5 ff.; De Nicola, Boll. d'Arte, 1921, p. 243 ff.; Van Marle, *op. cit.*, p. 303 ff.) cannot be critically treated here. I have endeavoured (Thieme-Becker Lexikon, under Lippo Memmi) to establish a basis of distinction between them. Their pictures are attributed partly to Simone, but mostly to Lippo Memmi and Barna, both of whom have become generic conceptions, and to whom the most heterogeneous works are assigned. See also below, note 63. Naddo in his early period (polyptych in the Accademia, *Siena*, No. 115) bears the same relation to Simone as Segna does to Duccio.

61] Niccolò (*ob.* 1363) is frequently mentioned from 1357 onwards, cf. Milanesi, Doc. Senesi, I, p. 50. See also Perkins in Burlington Magazine, V, 1904, p. 581 ff.; Irène Vavasour Elder in Rass. d'Arte Senese, VI, 1910, p. 16 f.; Berenson in Gaz. d. Beaux-Arts, 1924, I, p. 266 ff.; Van Marle, Simone Martini, and Development, II, p. 600 ff.; and the same author in Apollo, IV, 1926, p. 214 ff.

62] The Berlin Miniatures (K. K., Nos. 1984-2000) were first correctly determined by De Nicola (L'Arte, XI, 1908, p. 385 f., App. di Viaggio); I was unaware of this in 1913 when I published the excerpts with figures (Amtl. Berichte aus den preuss. Kunstsammlungen, 1913, p. 105 ff.). See also: F. Hermanin, Il Miniatore del Codice di S. Giorgio, in Scritti varii di filologia a Ernesto Monaci, Rome 1901, p. 445 ff.; De Nicola in L'Arte, IX, 1906, p. 336 ff.; and XI, 1908, p. 385 ff.; Suida in Rep. f. Kunstw., 1908, p. 213; Perkins, Rass. d'Arte, XVII, 1917, p. 45 ff.; *ibid*, XVIII, 1918, p. 105 ff.; *idem*, Apollo, VI, 1927, p. 201 ff.; Van Marle, Simone Martini, p. 112 f.; *idem*, Development, II, p. 277 ff. Panel pictures: *Florence*, Bargello (Carrand collection), Noli me tangere, Coronation of the Virgin; belonging thereto, *New York*, John D. Rockefeller collection (formerly Benson collection; auctioned in 1927), Crucifixion, Pietà; *Paris*, Louvre (No. 1666), Madonna enthroned with angels, St. John the Baptist and St. John the Evangelist (kneeling); *Cracow*, Czartoryski Museum, Annunciation; *Florence*, Carmine, Madonna enthroned with St. John the Baptist and St. John the Evangelist (standing,

reliquary); *Brussels*, Stoclet collection, Madonna of the Annunciation (standing); pertaining thereto: Angel of the Annunciation (kneeling), formerly in Vicomte d'Hendecourt's collection, *London* (auctioned in 1929). In the large panel of a Madonna with Child (*Florence*, Santa Croce Museum), attributed to the master by Perkins, I fail to recognize his hand. Count Erbach-Fürstenau told me verbally that in the Berlin excerpts he had noticed technical differences in the under-painting as compared with the Codex in the Vatican, thus excluding the possibility of their being by the same hand. The connection with the workshop both in them and in the panel paintings he does not dispute.

63] Cf. Weigelt in Thieme-Becker, Lexikon, XXIII, 1929, under Lippo Memmi; also for the bibliography. With the signed pictures mentioned there is generally included the Madonna in the Opera del Duomo at *Orvieto*, signed: LIPPUS DE SENA NATUS NOS PINXIT AMENA, which is unusual for Memmi. The style does not agree with that of the other signed works. The following pictures may be admitted as certain attributions: *Boston*, Gardner collection, half-figure Madonna and Child; perhaps also *Rome*, Vatican Gallery, No. 28, small Crucifixion. Very near to Lippo are: *Siena*, Accademia, Nos. 48 and 49, St. Louis of Toulouse and St. Francis; *Florence*, Loeser collection, St. Dorothea; *New York*, Maitland F. Griggs collection, half-figure Madonna with John the Baptist and St. Francis; *Berlin*, Kaiser Friedrich Museum, No. 1072, Madonna suckling the Child. The objections to the attribution of the Assumption of the Madonna in *Munich* (Pinak. No. 671) were first made verbally by Count Erbach-Fürstenau and subsequently confirmed by A. Venturi (L'Arte, VII, 1904, p. 391). Beenken's attribution of the picture to Simone (Ztschr. f. bild. Kst., LXII, 1927, p. 73 ff.) cannot be accepted. The gold groundwork was completely restored in the nineteenth century; the picture is genuine, and although damaged in a few places shows but few traces of over-painting. On the beautiful Madonna enthroned with St. Michael and St. Gabriel in the Berenson collection at *Settignano* see above, note 44. As a part and an echo of Simone's Maestà the picture is particularly interesting. To this group belongs: *Siena*, Accademia, No. 108, Nuptials of St. Catherine (attributed by Edgell, in Art in America, XII, 1924, p. 43 ff., to Barna, like the very beautiful half-figures of saints, Nos. 85, 86, 93, 94, in the Accademia at *Siena;* Perkins in Rass. sen., IV, 1908, p. 55, had already remarked upon the connection between these five pictures, without committing himself to a definite attribution. I fail to see any connection between No. 108 and the half-figures or Barna, cf. Weigelt *op. cit.*). After Simone's death, Lippo went to *Avignon* and with his brother Tederigo painted in 1347 a Madonna for the Franciscan church there (De Nicola, L'Arte, IX, 1906, p. 340); we hear of him for the last time in November 1347 in Siena. For Tederigo see Lisini, Diana, II, 1927, p. 306. Van Marle (Development, II, p. 162 f.) gives the chief share in the Maestà of 1317 to Memmo, basing this view on the notice published by Davidsohn, a by no means convincing explanation; cf. above, note 35.

64] On Barna cf. De Nicola in Thieme-Becker, Lexikon, II, 1904, where the older bibliography will be found; Berenson, Essays in the study of Sienese painting, p. 32 f.; Crowe and Cavalcaselle, Douglas edition, III, p. 80 ff.; Van Marle, Development, II, p. 283 ff.; Pèleo Bacci (Balzana, II, 1927, p. 249 ff.) has found *graffiti* in several places on these

frescoes, written in characters of the latter half of the Trecento or of the beginning of the Quattrocento: LIPPO DA SIENA PINSI(T), which he interprets as the expression of a custom of the time. Naturally he does not think of Lippo Memmi but assumes on the basis of this discovery that Vasari's Barna is a legendary figure. As far as the period is concerned Milanesi's Barna Bertini would be both possible and acceptable.

65] The distinguishing of the work of Barna from that of Giov. d'Asciano has been attempted by Della Valle (*op. cit.*, II, p. 113) and the question has been reconsidered by Cesare Brandi (Balzana, II, 1928, p. 19 ff.), who makes some good observations. The frescoes of the story of Christ's Childhood in the lunettes, apart from the noteworthy Annunciation, betray a weak, that is to say a third, hand. Brandi's documentary information concerning a certain Giovanni d'Asciano does not quite convince me that he is the same person as Vasari's Giovanni. Despite the affinity of style of the second hand with Bartolo di Fredi Vasari's date is too late. It may rightly be maintained that part of the panel paintings attributed to Barna can be approached to the second hand, but not to the first. This is also true of the charming fresco of the Madonna walking with the Child in San Pietro at *San Gimignano*, and perhaps also of the Nuptials of St. Catherine in Boston. The Madonna in San Francesco at *Asciano* (Perkins in Rass. d'arte senese, XXII, 1920, p. 109 ff.) can scarcely be assigned to either. The Crucifixion in the Duomo at *Arezzo* has been irretrievably ruined through over-painting. The attributions of panel paintings to Barna need revising; see Van Marle, Rass. d'Arte Senese, XVIII, 1925, p. 43 ff.; *idem*, Balzana, I, 1927, p. 243 ff.; Edgell, *op. cit.;* cf. also note 63.

66] On the spread of Sienese style see the relative articles in Van Marle, Simone Martini, 1920. For Simone's Avignon period cf. note 54 above, and Van Marle, Development, II, p. 311, containing bibliography; on the frescoes in the Papal Palace R. André-Michel in Mélanges d'histoire et d'archéologie, 1920, p. 43 ff.; Dvořák, Die Illuminatoren des Johannes von Neumarkt, Jahrb. d. kunsthist. Samml. d. Allerh. Kaiserhauses, XXII, 1901, p. 35 ff.; Kurt Glaser, Italienische Bildmotive in der altdeutschen Malerei, Ztschr. f. bild. Kunst, N. F., Vol. 35, 1914, p. 145 ff.; on his influence in Spain see Sanpere y Miquel, La Pintura mig-eval catalana, 1906, II, pp. 40 ff., 179 ff.; more recently A. L. Mayer, Mittelalterliche Kunst in Spanien, 1928, p. 175 ff.; on the Pisan painters, Lavagnino, in L'Arte, XXVI, 1923, p. 43 ff.; on Florence, Toesca, Florentine Painting of the Trecento, Pegasus Press, Paris 1929; on Hungary, Béla Lázar, in Studien zur Kunstgeschichte, Vienna 1917.

67] As the picture must have been painted before 1320 and the influence of Duccio's Maestà is very clear, the date must be about 1311-15. Berenson, Essays on Sienese painting, p. 12 f., dates it in 1315. That Pietro made another stay in Cortona is proved by the large Crucifix in San Marco, very like that in the Bandinelli chapel in San Francesco at *Siena*, of which it may be considered the immediate forerunner. See below.

68] Documentation in Borghesi-Banchi, *op. cit.*, p. 10 f.; the signature runs: PETRUS LAURENTII HANC PINXIT DEXTRA SENENSIS. The predella has been lost. The edition of Vasari's "Life" with comments by F. Mason Perkins, Bemporad, Florence 1912, is impor-

tant (Vol. VII of the Lives). For Pietro and writings concerning him see Giulia Sini-baldi under Pietro Lorenzetti in Thieme-Becker, Lexikon, XXIII, 1929. Also Perkins, Balzana, II, *cit.* Dr. Giulia Sinibaldi is preparing a study on Pietro and Ambrogio. It was only after I had almost finished preparing the present volume for publication that I was able to consult the long-expected work by Ernest T. Dewald on Pietro Lo-renzetti (Art Studies, VII, 1929, pp. 131-166, 101 fig.). The most concrete result of this work is the disentanglement of the group of pictures connected with the Loeser Ma-donna, the best of which, I too (cf. note 70) have ascribed to other hands than Pietro's. Dewald calls them, after the first of the series, the triptych in Dijon (see note 82), the works of the Master of the Dijon Triptych, and approaches to them the little Madonna enthroned between St. Paul, St. John the Evangelist, St. John the Baptist and St. Peter in the Provincial Museum at Münster (Westphalia), Catalogue No. 354. Dewald's com-prehensive work, not lacking in valuable observations but curiously uneven from a critical point of view, forms an excellent basis for a subsequent biographer of Pietro.

69] Cf. Ernest T. Dewald in Art Studies, I, 1923, p. 45 ff., who gives a list of Sienese repre-sentations of the Assumption. As frescoes very similar to those of the Lorenzetti still exist on certain pillars of the church Vasari's date may be accepted. Vasari's descrip-tion of the Assumption seems to point to a late origin of the frescoes, as the compo-sition is advanced.

70] In this connection, cf. the badly-preserved Madonna enthroned, attributed to Ambro-gio, in the National Gallery at *Budapest*. See Suida in L'Arte, X, 1907, p. 179 ff. Re-lated to the Loeser Madonna are the small standing Madonna with the Child and donor in the Berenson collection at *Settignano*, and the considerably later Madonna between St. Agnes and St. Catherine in the Museo Poldi-Pezzoli at *Milan*.

71] See Dewald in American Journal of Archaeology, XXIV, 1920, pp. 73-76. The signature on the step of the throne runs: PETRUS LAURENTII DE SENIS ME PINXIT A. D. MCCCXXVIIII. Elijah, despite the inscription, has been turned into St. Anthony Abbot after the over-painting. The condition of the panel, which must formerly have been oblong in shape, is lamentable and in urgent need of restoration (cf. Milanesi, Doc. sen., I, 193). The four predella pieces are in the Accademia at *Siena* (Nos. 83-84). Elijah's father is called Sobac by Daniel a Virgine Maria in his Speculum Carmelitanum, Antwerpiae 1680, Tom. II, No. 66. It is also spelt Sabac and Sabacha, as for example in Acta SS. Bollandi, Tom. V, Julii, No. 25. For the bibliographical notices on the history of the Carmelite Order I am indebted to Father Redemptus vom Kreuz Weninger, Provincial of the Barefoot Carmelites in Ratisbon, and would refer the reader to his brief history of the Order (Linz, Verlag des Karmelitenklosters); see also Stanislao di Santa Teresa, Compendio della Storia dell'Ordine Carmelitano, Rome 1925.

72] *Siena*, Accademia, half-figures: No. 82, St. Bartholomew; No. 81, St. Cecilia; No. 79, St. John the Baptist. The remains of the signature are as follows: beneath 81: ... RUS LAURENTIUS (?DE SENIS?), beneath 79: CCXXXII HOC OPUS. The good quality of these pictures is spoilt by a thick layer of brown varnish. They originally formed an altar-piece in five parts. Cf. Perkins, Balzana, *cit.*, p. 146 f.

73] The Signature is given by Ugurgieri and Pecci: HOC OPUS FECIT PETRUS LAURENTII ET AMBROSIUS EIUS FRATER MCCCXXXV. The scenes mentioned by Ghiberti differ from those of Vasari. Della Valle saw the remains, which were only destroyed in 1720 when the roofing above them was removed. A predella piece now in the National Gallery in *London* represents a holy bishop, accompanied by a deacon and a monk, received in audience by a Roman emperor, who is cleverly depicted sitting high in the background. On the left is a heathen priest with an idol and another with a candle. The scene is interpreted as representing Savinus, and the type of bishop agrees with this theory. It is possible that it is a fragment of the Savinus altar-piece. The spacing and style would fit in with the date of the altar-piece (1335). The form was probably similar to that of the St. Humilitas altar-piece, plate 85. The Christ before Pilate in the *Vatican* Gallery (No. 9) also resembles it.

74] Simone uses a different and more elegant gesture of indication, *e. g.* the Virgin and the Christ in the *Pisan* polyptych or the Christ in the Appearance at the bedside of St. Martin (*Assisi*, Chapel of St. Martin), etc.

75] In the scenes from the Legend of St. John in the M. A. Ryerson collection in New York (formerly in the Aynard collection) reproduced in Schubring, Cassoni; cf. Emilio Cecchi, *op. cit.*, p. 138.

76] Beneath the Deposition four half-figures are still preserved, St. Rufinus, St. Catherine, St. Clara and St. Margaret, which are paintings of the workshop. On the whole the frescoes on this wall are tolerably well preserved, and only the blue background has been completely restored, during which process the ladder leaning against the cross was covered with varnish.

77] In the signature the form of the L in LAVRENTII is the same as that used in the last figure of the year, so that the latter must be read as XL; in PETRVS the uncial V (= the figure five) is used. The picture, recently restored in a rather rough manner, used to be in *Pistoia*, and is therefore identified with the Madonna in San Francesco mentioned by Vasari, who gives the signature as PETRUS LAURATI DE SENIS (which does not prove the identity of the painting) and mentions a predella.

78] Modern frame, date and inscription, probably copied from the altar-piece of the saints (cf. for the history of this picture Davidsohn, Geschichte von Florenz, Vol. IV, Part III, 1927, p. 56 f.). On account of the style it is impossible to accept the reading 1316, while the technique of the haloes corresponds to Pietro's later style. The general form of the frame and of the arrangement is probably correct, though this can hardly be the case with the order of the scenes.

79] The signature runs: PETRVS LAURENTII DE SENIS ME PINXIT A MCCCXLII. The picture has been damaged and neglected, but has not been painted over. The painting is of a remarkably fine character.

80] Barna's Crucifixion represents a version created in the orbit of Simone, as Lippo Memmi's little picture in the *Vatican* proves, but it is not impossible that he may have known Pietro's fresco. The second horseman from the right has evidently impressed

him. That "Barna" in this case did not rely on his own observations from life is shown by the slip which he makes by showing his horse pawing the ground simultaneously with both fore and hind left feet, a slip due to the fact that in Pietro's picture the feet are shown close together but belong to two different horses. The horseman striking at the legs of the wicked thief also appears to come from Pietro. In Duccio (plate 25) an old woman with a sharp profile is prominent and is repeated by the painters of his school: by Simone in three pictures of the little altar-piece in *Antwerp* (plates 60 a, 61 a and b) and also by Pietro, Barna, and other artists. It ought to be possible to give her a name.

81] Kurt Glaser, *op. cit.;* cf. note 66.

82] It seems certain that Pietro must have stayed for some time in Arezzo and also in Cortona. A tabernacle of his in Santo Spirito at *Florence*, which was seen by Bottari, is praised by Vasari "per la morbidezza delle teste e per la dolcezza che in esso si vede". To the signed pictures mentioned in the text must be added a small diptych representing the Madonna in half-figure with the Child in swaddling clothes and the Christ of the Passion (*Altenburg*, Lindenau Museum, Nos. 47, 48), a contrast of birth and redemption, signed: PETRVS LAURENTII DE SENIS ME PINXI(T).
Pietro depicts the edges of the garments with a short fringe, which appears for the first time in the Rucellai Madonna and is found in Ambrogio's Annunciation and Presentation in the Temple. It is only a clever conjecture of A. Venturi (Storia, v, p. 586) to assign to Pietro the Madonna enthroned in the Accademia at *Siena* (No. 18); cf. note 30. We may safely attribute to Pietro's later period the two standing figures of St. Agnes and St. Catherine in the same gallery (Nos. 578 and 579). Berenson and Perkins had previously assigned to Pietro the Allegory of the First Fall and the Redemption (*Siena*, Accademia, No. 92) which is most interesting for its subject and remarkable as a landscape; the condition of the picture, subsequently darkened and spoilt by varnish, renders a decision difficult. Berenson (Städel-Jahrbuch 1927) now opines for a successor of Ambrogio, and Perkins (Balzana, II, p. 150 f.) for Ambrogio himself. Perkins further attributed to Pietro the "five half-figures of praying Franciscans", a narrow fresco beneath Cimabue's Madonna in the right transept of the lower church of San Francesco at *Assisi*. In what is now the refectory of San Francesco at *Siena*, the former chapter hall of the convent in which Pietro's Crucifixion (plate 77) and Ambrogio's wall-paintings (plates 93-94) used to be, are two fragments of frescoes, which seem to betray Pietro's hand (Resurrection of Christ, half-figure with Prophets). A triptych in the museum at *Dijon*, with the Madonna enthroned between St. Peter and St. John the Baptist on the middle panel, has been attributed to Pietro by Roberto Longhi; cf. M. E. F. Mercier in L'Art et les Artistes, N. S., Vol. VI, 1922, p. 45 ff. The half-figures of St. Peter and St. Paul with the overleaning angels in the spandrels (*Rome*, Vatican Gallery, Nos. 2, 3; attribution in Van Marle) are at the most late and poor works of the school. The beautiful frescoes in *San Leonardo al Lago* (groups of angels in the vaulting, Nuptials of the Virgin in the choir) are the work of one of Pietro's successors. Pietro's traditions were carried on in Umbria by the mediocre Guiduccio Pal-

meruccio of Gubbio, cf. Gnoli in Rass. d'Arte Umbra, 1909, p. 86, 1910, p. 22; Van Marle, *ibid.*, 1921, p. 7, and also in Development, III, and Belvedere, XI, 1927, p. 140 f.; IV, 1923, Salmi. In 1926 Ugo Iandolo had in his possession at *Rome* a standing Madonna with Child by Palmeruccio. See also Perkins in Balzana, II, 1928, p. 112, on the polyptych in the Accademia at *Siena* (No. 50), by a mediocre successor of Pietro. For further attributions to Pietro see Giulia Sinibaldi, *op. cit.;* and Van Marle, Development, II, p. 270 note; for bibliography see Giulia Sinibaldi, *op. cit.*

83] On the Ovile Master see E. T. Dewald in Art Studies, I, 1923, p. 45 ff., "The Master of the Ovile Madonna". In addition to the pictures mentioned Dewald attributes the following paintings to the master: *Boston*, Fenway Court, Gardner Museum, Madonna enthroned with the Child and angels, between St. Mary Magdalen and St. Catherine, a tabernacle (Berenson, Ugolino Lorenzetti, *cit.*, p. 26); *Palermo*, Bordonaro-Chiaramonte collection, polyptych, formerly in S. Agostino at San Gimignano, showing on the central panel the Madonna in half-figure with the Child holding the Virgin's crown in his hands, and on the side panels St. Dominic, St. John the Baptist, St. Stephen (?), St. Catherine; cf. above, note 34; *Siena*, Accademia, No. 53, St. Gregory; *Cambridge* (U. S. A.), Fogg Museum, Nativity of Christ. See also Perkins in Balzana, II, 1928, p. 112 f., and the remarks on this subject by Andreas Péter in Balzana, I, 1927, p. 93.

84] Documentation in Milanesi, Docum. Senesi, I, p. 195, and Vasari-Milanesi, I, p. 521; corrections and additions will be found in the still important work by A. L. von Meyenburg, Ambrogio Lorenzetti, Zurich, 1903 (thesis). For the bibliography see Van Marle, Development, II, p. 377 ff., and more especially Giulia Sinibaldi in Thieme-Becker, Künstlerlexikon, Vol. XXII, 1929, under Ambrogio, where a critical selection of the literature on the subject is given. Cf. also Perkins, Balzana, II, 1928, *cit.* Professor George Rowley (Balzana, I, 1927, p. 211) announces the publication of a monograph on Ambrogio; as does also Dr. Andreas Péter.

85] Giacomo De Nicola, Il Soggiorno fiorentino di Ambrogio Lorenzetti, in Boll. d'Arte, N. S., I, 1922, p. 49 ff. The head of the Madonna, the Child in a wine-coloured dress, the hands of the Virgin, the stone-grey throne with inlays in black, red and white, are well preserved; the Virgin's mantle and red dress have been clumsily painted over.

86] The golden ear-pendants occur again in the Presentation in the Temple (plate 108) and in the Annunciation (plate 109).

87] George Rowley in Balzana, I, 1927, p. 219 f.

88] Cf. De Nicola, *op. cit.*, (note 85) and Perkins, Rass. d'Arte, XVIII, 1918, p. 106, f.; Cinelli, Bellezze della città di Firenze, 1677, p. 389; Richa, Le Chiese fiorentine, 1754, I, p. 239. According to Cinelli the signature ran: AMBROSIUS LAURENTII DE SENIS MCCCXXXII.

89] The line-engraving has given way to stippling. In place of hatching, the roughening of the surface is produced by means of points placed close together and deeply incised, thus forming a background from which the letters stand out. Ambrogio prefers to put scriptural texts or the names of the saintly personages in the haloes instead of decoration.

90] The side panels of the St. Proculus altar are reproduced in Perkins, *op. cit.* (note 88), and in Van Marle, Development, II, p. 392. The centre picture of the Madonna mentioned by De Nicola does not bear the signature given by Cinelli, and De Nicola refers the latter to the altar of St. Nicholas.

91] These *pentimenti* are clearly visible even in the photograph of the whole picture (Alinari 1592); Rowley, *op. cit.*, gives a detail photograph which shows them even more distinctly.

92] The comparatively exact descriptions of Ghiberti do not refer to these frescoes, but to another series, which was painted in the cloister of the convent and was probably damaged when the cloister was reconstructed in 1517. In 1750 the rest disappeared under the whitewash. Cf. Lusini, Storia della Basilica di San Francesco, 1894, p. 214 ff. A few fragments of fresco, transferred from San Francesco to the National Gallery in *London* (No. 1174) and representing the heads of four nuns, came from the chapter hall. This may also be the case with two other fragments (Nos. 3071, 3072), depicting the head of a crowned woman-saint and a half-figure Madonna of the Annunciation.

93] The piece reproduced in plate 93 (Anderson 21722) does not shows the pinnacles with the figures. The figures are important on account of their relationship to the antique. Of the seven, four female and two male figures have been preserved. The Virtues are modelled upon antique draped figures and accompanied by animals. From left to right: Justice (with her scales), Temperance (with her pitcher), Wisdom (an Athena with the Gorgon in her left hand) and Chastity (a Diana with bow and arrow and, in place of an animal, a winged putto). The male figures are in armour with helmets, and carry lances and shields; the left-hand one (Hercules) is accompanied by a lion, the right-hand (Mars), by a horse.

94] With the Madonna in *Massa Marittima* we may place three damaged pictures: the Madonna in SS. Pietro e Paolo at *Roccalbegna* (Berenson, *op. cit.*, p. 23), the Madonna in the State Gallery at *Budapest* (cf. note 80), and the Madonna in the Loggia of the Palazzo Pubblico (1340). All three have been mutilated; the Madonna in Roccalbegna has been much cut down and deprived of the side figures. In the Madonna in Budapest and that in the Loggia, the Child is holding a scroll in his hand, with the same text (St. John, XIII. 34) in each case. All three are similar in style, even in the poise of the child. Perkins called the picture in Massa Marittima Ambrogio's masterpiece (Burlington Magazine, v, 1904, p. 81 ff.), thereby rightly drawing attention to its importance. It is not "the" master-piece of Ambrogio, as the workshop also had a hand in it, the quality of the drawing and painting being very variable. In the raiment we recognize Duccio's serpentine borders, which produce a very piquant effect in the construction of the middle group. The position of the Virgin's hands is taken from Pietro's Madonna in Cortona (plate 70). To this group of pictures belongs the half-figure Madonna in the Lehman collection at *New York*, cf. Perkins, Art in America, VIII, 1920, p. 209 ff. The much-damaged and repainted half-figure Madonna with the Child holding a little bird (a favourite *motif* with Pietro) in the church at *Rapolano* (See photo

89

Alinari 18988) appears to be connected with Ambrogio, in the same way as the Loeser Madonna is with Pietro.

95] The half-obliterated inscription round the shield runs as follows: SALVET VIRGO SENAM VETEREM QUAM SIGNAT AMENAM. The same words are found beneath Simone's fresco. C. S. C. V. = Comune Senarum Civitas Virginis.

96] Inscription: PRETERIUM. PRESENS. FUTURUM.

97] The details cannot be gone into here; see Vasari-Milanesi, I, p. 527; Crowe and Cavalcaselle, Douglas edition, III, p. 110 ff.; P. Schubring, Das gute Regiment, in Zeitschrift f. bild. Kunst, 1902; Odoardo H. Giglioli, Emporium, XIX, 1904, p. 265 ff.

98] The "City by the sea" is sometimes said to be a picture of the harbour-town of Talamone.

99] The signature on the front wall runs: AMBROSIUS DE SENIS HIC PINXIT UTRINQUE. Rowley, (op. cit.) believes that the Charity (above the Commonwealth) and the Security were modelled on the fine antique relief of a Nike (Siena, Accademia). The figure of the Commonwealth without side figures, but with the she-wolf, occurs on the cover of a book of the Gabella dated 1344 (Siena, State Archives) and for this reason is held to be by Ambrogio (cf. Lisini, Le tavolette dipinte di Biccherna e di Gabella, Siena, 1902). The Allegory of the Bad Regiment shows Tyranny enthroned, with the vices sitting on either hand in threes; (from left to right) Cruelty, Treachery, Fraud, Anger, Dissension and War. Round the head of the leering, horned monster hover Avarice, Pride and Vanity. Before the throne lies ravished Justice, the beam of her scales broken and the scales themselves strewn upon the floor.

100] In the rectory some badly-preserved and mutilated fragments of an altar-piece are preserved, namely a standing Madonna with the Child, standing figures of St. Peter, St. Paul, St. Michael and a woman saint, and a small over-painted upper panel of Christ enthroned. See Perkins, Balzana, II, p. 3 ff., with reproductions. The pictures must be the work of a pupil.

101] Supposed to have been the centre-piece of the St. Crescentius altar, as the latter (according to a later notice) was signed and dated 1342, and had as centre panel the Presentation, with two-half figures of saints on each side panel. This is contradicted by the documentary evidence of payments made for the altar in 1339-40 (see Meyenburg, op. cit.). The ceremonial nature of the picture would agree with the supposition that it was painted for the cathedral as a kind of counterpart to Simone's Annunciation; the depth of religious feeling which inspires these two pictures, shown by quotations from the Scriptures, is a proof of the great care and attention bestowed upon the work. The signature runs: AMBROSIUS LAURENTII FECIT HOC OPUS ANNO DOMINI MCCCXLII.

102] Joshua is derived from the Hercules of the Martyrdom in San Francesco. The two prophets with scrolls are Moses and Malachi. The dragons on the middle arches are imitated from the drolleries of illumination. The picture is in a bad state of preservation, has been spoilt by varnish, and also restored.

103] The Annunciation in the Accademia (No. 88) was painted for the Palazzo Pubblico, as is clear from the inscription, which begins: ...XVII. DI. DICEMBRE. M. CCC. XLIIII.

90

FECE. AMBRVOGIO. LORENZI. QVESTA. TAVOLA. The upright wings of Gabriel are a recent addition. In the Virgin's halo is the angel's greeting.

104] For attributions to Ambrogio see Giulia Sinibaldi, *op. cit.*, and Van Marle, Development, II, p. 426 note. On the Holy Family attributed to Ambrogio in the Hamilton collection in *New York* see Offner, The Arts, V, 1924, p. 245, and Valentiner, Duveen Catalogue, *cit.*, No. 26.

Rowley, *op. cit.*, denies that the Madonna in the Accademia (No. 65), hitherto universally recognized as one of his masterpieces and of high artistic quality, is the work of Ambrogio (plate 111). One is bound to agree with him as many technical and artistic details of this remarkable little picture differ from Ambrogio's customary work. Rowley further denies Ambrogio's authorship for the polyptych from Santa Petronilla. The style of the latter picture (plate 112) is so very different from that of Ambrogio's signed works, that Rowley's judgement can scarcely be disputed. The remark also seems correct that the Madonna in the Platt collection in Englewood (from the Monistero di Sant'Eugenio near Siena) must be attributed to the Petronilla Master on account of its hard and stiff style. Rowley further attributes to this artist the frescoes in the Badia di Monte Siepi near San Galgano (Madonna enthroned with the Child and angels, with Eve before the throne; Annunciation; episodes from the life of St. Galganus), which are very badly preserved and have been painted over. It is certain that they are not the work of Ambrogio himself, cf. Crowe and Cavalcaselle, Douglas edition, III, p. 119, note 4. In conclusion Rowley places the Madonna in the middle arch of the triptych at the *Badia a Rofeno* with the four-panelled picture in the Opera del Duomo at Siena (half-figures of St. Catherine, St. Benedict, St. Francis, St. Mary Magdalen, with St. John the Evangelist, St. John the Baptist, St. Peter and St. Paul in the corresponding trefoils of the pinnacles), and attributes the works to a pupil of Ambrogio; which is justified by the empty style of the pictures. On Monte Siepi see also Perkins in La Diana, IV, 1929, p. 261 ff., and Rowley in Art Studies, VII, 1929, pp. 107-127, plate, "The Gothic frescoes at Monte Siepi".

105] For the bibliography on Lippo Vanni, cf. Weigelt in Thieme and Becker, Künstlerlexikon, vol. XXIII, 1929.

106] On Andrea see list of pictures in Berenson, Central Italian Painters, 1909, p. 261; De Nicola in Thieme and Becker, Künstlerlexikon, I, 1904; more recent bibliography in Van Marle, Development, II, p. 432 ff.

107] On Niccolò di Buonaccorso see bibliography in Van Marle, Development, II, p. 514 ff.

108] On Francesco di Vannuccio see Thieme and Becker, Künstlerlexikon, XII; Bode, Jahrb. der preuss. Kunstsamml., VI; Schubring in Ztschr. f. bild. Kst., XXV, 1912, p. 130. Francesco's charming little domestic altar-piece of a Madonna dell'Umiltà, which was formerly in the Von Kauffmann collection in Berlin, came into the possession of the antiquary A. S. Drey at *Munich* in 1927. In the F. A. von Kaulbach collection at *Munich* there was formerly a very delicate Crucifixion by this master, very similar to the one in the Johnson collection at *Philadelphia*, showing the Virgin and St. John,

the latter kneeling, St. Francis and another saint. See Helbing's Catalogue of Auction Sales, Munich, 29th-30th October, 1929, No. 155.

109] On Luca di Tommè see bibliography in Van Marle, Development, II, p. 465; see also Perkins in Balzana, I, 1927, p. 143 f.; for documentary evidence, unknown until recently, see Pèleo Bacci, Balzana, I, 1927, p. 51 ff. There is a comprehensive article, with a critical list of pictures, by Perkins in Thieme-Becker, Künstlerlexikon, XXIII, 1929. In the F. A. von Kaulbach collection at Munich (auctioned by Helbing October 29-30th 1929, No. 154, plate VI) there was a Crucifixion by Luca di Tommè, the former right wing of a diptych. The left panel, representing a very beautiful Madonna enthroned with St. Agnes, St. Catherine, John the Baptist and St. Nicholas is in a private collection in Munich.

110] On Bartolo di Maestro Fredi see list of pictures in Berenson, *op. cit.*, p. 139 ff.; Schubring in Thieme and Becker, Lexikon, II, p. 558 f. More recent bibliography in Van Marle, Development, p. 483 ff. Additions to Berenson's list of pictures: *ibid.*, p. 504, note. See also Perkins in Rass. d'Arte senese, XVIII, 1925, p. 58; and the same author in Apollo, VI, 1927, p. 203 f.

111] On Andrea di Bartolo see De Nicola in Thieme and Becker, Künstlerlexikon, I, 1904; the same author in Rass. d'Arte Senese, XIV, 1921, p. 12 ff.; Van Marle, Development, II, p. 572 f.; Rob. Longhi in Pinacoteca, I, 1928, p. 71 f. On Giorgio di Andrea di Bartolo see U. Gnoli in Thieme and Becker, XIV.

112] On Martino di Bartolommeo see Weigelt in Thieme-Becker's Künstlerlexikon, Vol. XXIV, 1930, with bibliography.

113] On Taddeo di Bartolo see list of pictures in Berenson, *op. cit.*, p. 255 ff.; Vasari, Vite; Milanesi, Docum. senesi, II; Van Marle, Development, II, p. 544 ff.; Sirén in Tidskrift för Konstvetenskap, II, 1917, p. 45 ff.; Bull. Art Institute Chicago, XX, 1926, p. 17 ff.; recently, in Balzana, I, 1927, p. 225 ff., Pèleo Bacci has published interesting documents which are important as regards Taddeo's methods.

114] On Paolo di Giovanni Fei see list of pictures in Berenson, *op. cit.*, p. 165 ff.; additions in Van Marle, Development, II, p. 356 note; bibliography, *ibid.*, p. 524. On Cola Petruccioli see Berenson, Essays..., p. 43 ff.

GEOGRAPHICAL INDEX

ALTENBURG

LINDENAU MUSEUM: Lippo Memmi, *Madonna enthroned* (signed), 32. - Simone Martini *St. John the Baptist enthroned*, note 44. - Pietro Lorenzetti, *Diptych, Madonna and Child and Christ* (signed), note 82.

ANTWERP

MUSEUM: Simone Martini, *Crucifixion* (signed), 29, 30; notes 56, 57, 80; plate 60b. *Deposition*, 29, 30, notes 56, 80; plate 61a. *Annunciation*, note 56.

AREZZO

PINACOTECA: School of Guido da Siena, *Madonna enthroned with child*, note 4.
CATHEDRAL: *Crucifixion*, fresco, note 65.
SAN DOMENICO: Workshop of Cimabue, *Painted Crucifix*, note 4.
BADIA SS. FIORA E LUCILLA: Segna di Buonaventura (?), *Painted Crucifix*, 17.
SANTA MARIA DELLA PIEVE: Pietro Lorenzetti, *Polyptych* (1320, signed), *The Madonna with the Child and Saints*, 34, 35, 37, 56; note 68; plates 72-74; Choir: Pietro Lorenzetti, *Frescoes of the Legend of the Virgin* (destroyed, a few remains on the pillars of the second transom), 35-36; note 69.

ASCIANO

COLLEGIATA: Stefano di Giovanni, called Sassetta, *Nativity of the Virgin*, 59. - Follower of Duccio (Master of Asciano), *Madonna and Child*, note 32.
SAN FRANCESCO: Follower of Simone Martini, *Madonna and Child*, note 65.

ASSISI

SAN FRANCESCO, LOWER CHURCH:
St. Martin's Chapel, left aisle: Simone Martini, *Frescoes of the Legend of St. Martin*, 24-28, 30; note 48; plates 51-56; *The Division of the Mantle*, 25; note 50. *Christ appears to St. Martin in a dream*, 25, 27; notes 50, 51, 74. *The Knighting of St. Martin*, 25; note 50; plates 51-52. *St. Martin refuses to go to war*, 25-26; note 50. *St. Martin raises a child from the dead*, 26; note 50. *The Mass of St. Martin*, 26; note 50. *The Emperor Valentinian humbling himself before St. Martin*, 25, 26; note 50; plate 53. *Death of St. Martin*, 26, 27; notes 50, 51. *The dream of St. Ambrose*, 26-27; note 50, plate 54. *The Obsequies of St. Martin*, 27; note 50; plates 55, 56. *Frescoes in the soffit of the entrance-archway*, 28; plate 57. *Portrait of the Founder*, 24, 28. *Gothic decoration of the chapel*, note 53. *Windows*, 24; note 49.
Chapel of St. Louis of France, right aisle: Pupils of Simone, *Windows*, 24; note 49.
Right Transept: Simone Martini, *Half-figures of Saints, Frescoes near the former Altar of St. Elizabeth*, 28; notes 51, 53; plate 58. - Pietro Lorenzetti (?), *Five half-figures of Franciscans praying*, note 82.
Left Transept, left-hand wall: Pietro Lorenzetti, *Crucifixion, Fresco*, 36, 42, 43; plates 83-84. *Madonna and Child with St. Francis and St. John the Evangelist, Fresco*, 36, 37; plate 81.

93

Orsini Chapel, Window wall: Pietro Lorenzetti, *Madonna between St. John the Baptist and St. Francis, Fresco*, 36, 37.

Orsini Chapel, Entrance wall: Pietro Lorenzetti, *Frescoes: Deposition*, 36, 39, 41; note 76; plate 82. *Entombment*, 36, 39. *Christ in Limbo*, 36, 39. *Resurrection*, 36, 39. Beneath the Deposition: School of Pietro Lorenzetti, *Four half-figures: St. Rufinus, St. Catherine, St. Clara and St. Margaret, frescoes*, note 76.

Left Transept, right-hand wall: Pietro Lorenzetti, *Fresco: The Death of Judas, St. Francis receiving the Stigmata*, 42-43.

Left Transept, Barrel-vaulting: Assistants and followers of Pietro Lorenzetti, *Frescoes of the Story of the Passion*, 36, 41. *Entry into Jerusalem*, 42, 43. *Washing of Feet*, 43. *Last Supper*, 43; plate 89. *Flagellation*, 43. *Bearing of the Cross*, 42, 43.

Sacristy: Followers of the Master of San Francesco, *St. Francis and Scenes from his Legend*, note 7.

AVIGNON

Notre-Dame-des-Doms: Simone Martini, *St. George slaying the dragon, fresco* (destroyed), 31.
Church of the Franciscans: Lippo Memmi and Tederigo di Memmo, *Madonna* (formerly), note 63.

BADIA A ISOLA (near Colle di Val d'Elsa)

Master of the Madonna of Badia a Isola, *Madonna enthroned with the Child and angels*, 16; note 7; plate 30.

BERLIN

Kaiser Friedrich Museum: No. 1062a, Duccio, *Nativity of Christ, with Isaiah and Ezekiel* (Predella from the front of the Maestà), 9. - No. 1062b, Francesco di Vannuccio, *Processional panel, front: Crucifixion; back: Madonna enthroned with Child*, 58. - No. 1070a, Simone Martini, *Entombment*, 29, 30; note 56; plate 61b. - No. 1072, School of Lippo Memmi *Madonna suckling the Child*, note 63. - No.1081, Lippo Memmi, *Madonna and Child* (signed), 32; plate 66. - No. 1094a, related to "Ugolino Lorenzetti", *Nativity of Christ*, note 34. - No. 1635, Ugolino da Siena, *St. Paul, St. Peter and St. John the Baptist*, like the following from the former high altar in Santa Croce at Florence, 18; plate 34. - No. 1635a, Ugolino da Siena, *Predella, Flagellation*, 18; plate 35a. - No. 1635b, Ugolino da Siena, *Predella, Entombment*, 18; plate 35b. - Pietro Lorenzetti, *Two panels from the St. Humilitas altar*, plate 86.

Print Room: Master of the St. George Codex, *Miniatures, Details* (Nos. 1984-2000), 31; note 62.

BERNE

Kunstmuseum: Duccio (?), *Madonna enthroned with Child (standing) and angels*, note 28.

BOLOGNA

Chiesa dei Servi: Cimabue, *Madonna enthroned with Child and angels*, note 2.

BOSTON (U.S.A.)

Museum: Pupil of Duccio (Master of the Boston Magdalen), *St. Mary Magdalen* (fragment), note 32. - Pupil of Duccio (related to the Master of Montepulciano), *Madonna and Child*, note 34. - School of Simone, *The mystic Marriage of St. Catherine*, note 65.
Fenway Court, Gardner Collection: Simone Martini and Assistants, *Madonna and Child with St. Paul, St. Lucy, St. Catherine and St. John the Baptist*, 22; note 43; plate 43. - Lippo Memmi, *Madonna and Child*, note 63. - Ovile Master, *Madonna enthroned with Child, Tabernacle*, note 83.

BRUSSELS

Galerie Giroux, formerly Otto O'Meara Collection (auctioned in 1929): Pupil of Duccio (Master of the Boston Magdalen), *Two wings of a polyptych, St. Mary Magdalen and St. Louis of Toulouse*, note 32.
Stoclet Collection: Duccio, *Madonna and Child*, 7, 8; plate 11. - Pupil of Duccio, *Crucifixion*, note 28. - Simone Martini (?), *Madonna of the Annunciation (seated)*, note 60. - Master of the St. George Codex, *Madonna of the Annunciation (standing)*, note 62.

BUDAPEST

National Gallery: School of Duccio, *Coronation of the Virgin* (fragment), note 28. - School of Ambrogio Lorenzetti, *Madonna enthroned with Child*, notes 70, 94.

CAMBRIDGE

Fitzwilliam Museum: Simone Martini, *Three wings of a polyptych, St. Michael, St. Ambrose (?), St. Augustine (?)*, note 44.

CAMBRIDGE (U.S.A.)

Fogg Museum: School of Simone Martini, *Crucifixion*, note 60. - Ovile Master, *Nativity*, note 83.

CASTEL BROLIO (Chianti)

Pupil of Duccio (Master of Montepulciano), *Polyptych, Madonna and Child with Saints*, note 34.

CASTIGLION FIORENTINO

Collegiata: Segna di Buonaventura, *Madonna enthroned with Child and angels*, 17-18, note 32.

CHANTILLY

Les très riches heures du Duc de Berry, note 56.

CHIANCIANO (Val di Chiana)

Collegiata (San Giovanni Battista): Follower of Ugolino da Siena, *Polyptych, Madonna and Child with Saints*, note 33.

95

CHICAGO

RYERSON COLLECTION: Giovanni di Paolo, *Six scenes from the Legend of St. John the Baptist*, 38; note 75.

CITTÀ DI CASTELLO

PINACOTECA: Master of the Madonna in Città di Castello, *Madonna enthroned with Child and Angels*, 17.

COPENHAGEN

NY CARLSBERG GLYPTOTHEK: Master of the Madonna in Città di Castello, *Madonna and Child*, 17; note 30.

CORTONA

CATHEDRAL: Pietro Lorenzetti, *Madonna enthroned with Child and angels*, 34; notes 67, 94; plate 70.
SAN MARCO: Pietro Lorenzetti, *Painted Crucifix*, note 67.

CRACOW

CZARTORYSKI MUSEUM: Master of the St. George Codex, *Annunciation*, note 62.

DIJON

MUSEUM: School of Pietro Lorenzetti (Master of the Dijon Triptych), *Madonna enthroned between St. Peter and St. John the Baptist*, notes 68, 82.

ENGLEWOOD (U.S.A.)

PLATT COLLECTION: Pupil of Duccio (Workshop of the Master of the Boston Magdalen), *Madonna enthroned, suckling the Child*, note 32. - Pupil of Duccio (Master of Montepulciano), *Madonna and Child*, note 34. - Workshop of Ambrogio Lorenzetti, *Madonna and Child*, note 104.

FIESOLE

MUSEO BANDINI: Ambrogio Lorenzetti, *Two wing panels of the St. Proculus Altar-piece* (about 1332), *St. Nicholas and St. Proculus*, 46, 47, 50, 51; notes 88, 90.

FLORENCE

ACCADEMIA: Master of the Maddalena, *St. Mary Magdalen with scenes from her Legend*, 5, 7; note 4. - Follower of Buonaventura Berlinghieri, *Diptych, Madonna and Child, The Crucifixion*, note 22.
MUSEO NAZIONALE (BARGELLO), Carrand Collection: Master of the St. George Codex, *Noli me tangere, Coronation of the Virgin*, note 62.
UFFIZI: Cimabue, *Madonna enthroned with the Child and Angels* (from Santa Trinità), 5; notes 4, 5. - Pupil of Duccio (Master of Montepulciano), *Madonna and Child* (fragment from Santa Maria dei Servi at Montepulciano), note 34. - Giotto, *Madonna* (from the

GROSSETO

CATHEDRAL: Ovile Master, *Madonna enthroned with the Child*, note 83.

LENINGRAD

HERMITAGE: " Ugolino Lorenzetti " (?), *Crucifixion*, note 28. - Workshop of Simone Martini, *Madonna of the Annunciation*, note 60.

LIVERPOOL

ART INSTITUTE: Simone Martini, *Jesus reproved by his anxious parents after his return from the Temple* (signed), 29; notes 47, 48, 55, 56; plate 59.

LONDON

NATIONAL GALLERY: No. 565, School of the Master of the Madonna in Città di Castello, *Madonna enthroned with the Child and angels*, note 30. - No. 566, Duccio, *Triptych, Madonna and Child, with angels; on the wings St. Agnes and St. Dominic*, 7, plate 12. - No. 1109, Niccolò di Buonaccorso, *Nuptials of the Virgin*, 57. - No. 1113, Pietro Lorenzetti, *A holy Bishop in the presence of the Roman Emperor* (from the St. Savinus altar?), note 73. - No. 1139, Duccio, *Annunciation* (Predella from the front of the Maestà), 9. - No. 1140, Duccio, *Healing of the Blind Men* (Predella from the back of the Maestà), 12, 13, 25. - No. 1174, Ambrogio Lorenzetti (?), *Heads of four Nuns* (fragments of a fresco from the chapter hall of San Francesco in Siena), note 92. - No. 1188, Ugolino da Siena, *Predella, The Arrest of Christ* (like the following from the former high altar in S. Croce, Florence), 18. No. 1189, Ugolino da Siena, *Predella, Bearing of the Cross*, 18. Ugolino da Siena, *Predella, Resurrection of Christ*, 18. - No. 1330, Duccio, *Transfiguration* (Predella from the back of the Maestà), 9. - Nos. 3071, 3072, Ambrogio Lorenzetti (?), *Head of a crowned Saint, Half-figure of a Madonna of the Annunciation* (fragments of a fresco from the chapter hall of San Francesco in Siena ?), note 92. - No. 3375, Ugolino da Siena, *Predella, Deposition*, 18. - No. 3376, Ugolino da Siena, *The patriarch Jacob*, 18; note 33. - Nos. 3377, 3473, Ugolino da Siena, *Four Apostles*, 18; note 33. - No. 3378, Ugolino da Siena, *Two angels* (fragment of a larger side panel), 18; note 33.

Buckingham Palace: Workshop or Pupils of Duccio, *Triptych, Christ on the Cross, with the Virgin and St. John; on the wings, left: Annunciation and Madonna enthroned; right: St. Francis receiving the stigmata and Christ with the Virgin enthroned*, note 28.

BENSON COLLECTION (auctioned in 1927): Lippo Memmi, *Madonna and Child*, 32.

PRIVATE COLLECTION OF THE EARL OF CRAWFORD: School of the Master of the Madonna in Città di Castello, *Crucifixion*, note 30.

PRIVATE COLLECTION OF VISCOUNT D'HENDECOURT (auctioned in 1928): Master of the St. George Codex, *Kneeling angel of the Annunciation*, note 62.

DOUGHTY HOUSE, RICHMOND, COOK COLLECTION: Ugolino da Siena, *Fragments of a side panel, two angels* (from the former high altar in Santa Croce), 18; note 33; *The Prophets Moses and Aaron*, 18; note 33.

LUCIGNANO (Val di Chiana)

Pinacoteca: Pupil of Duccio (related to the Master of Montepulciano), *Madonna enthroned with the Child and Founder*, note 34.

MASSA MARITTIMA

Cathedral: Segna di Buonaventura (?), *Madonna delle Grazie;* on the back: *Scenes from the Passion*, 17; notes 7, 11; plate 33.

Municipio: Ambrogio Lorenzetti, *Madonna enthroned, with saints and angels*, 50-51, 57; plates 104, 105.

MILAN

Biblioteca Ambrosiana: Virgil Manuscript with a miniature by Simone Martini, *Servius Honoratus reveals Virgil*, 30, 31; note 59.

Museo Poldi-Pezzoli: Workshop of Pietro Lorenzetti (Master of the Dijon Triptych), *Madonna with the Child, St. Agnes and St. Catherine*, note 70.

Sant'Ambrogio: *Mosaic in the apse*, note 50.

MONTALCINO

Palazzo Comunale: Bartolo di Fredi, *Coronation of the Virgin*, 58; plate 118.

MONTEPULCIANO

Santa Maria dei Servi: Pupil of Duccio (Master of Montepulciano), *Madonna and Child* (see under Florence, Uffizi).

MONTE SIEPI, see under San Galgano.

MOSCIANO

Pieve (Sant'Andrea): Florentine Master of the end of the Duecento, *Madonna enthroned*, note 2.

MOSCOW

Russian Historical Museum: Segna di Buonaventura, *Painted Crucifix* (signed), 17; note 32. - Pupil of Duccio (Master of Asciano), *Madonna and Child*, note 32.

MUNICH

Alte Pinakothek: No. 671, Sienese Master of the late Trecento, *Assumption of the Virgin*, note 63. - No. 9038, Segna di Buonaventura, *St. Mary Magdalen*, note 32.

A. S. Drey Collection (1927): Francesco di Vannuccio, *Madonna dell' Umiltà*, domestic altar-piece, note 108.

F. A. von Kaulbach Collection (auctioned 1929): Francesco di Vannuccio, *Crucifixion*, note 108. Luca di Tommè, *Crucifixion* (right wing of a diptych), note 109.

Private Collection: Luca di Tommè, *Madonna enthroned, with St. Agnes, St. Catherine, St. John the Baptist and St. Nicholas* (left wing of the preceding), note 109.

Formerly in the possession of Dr. G. M. Richter: Pupil of Duccio (Master of the Boston Magdalen), *St. Catherine*, note 32.

MÜNSTER

PROVINCIAL MUSEUM: No. 354, Workshop of Pietro Lorenzetti (Master of the Dijon Triptych), *Madonna enthroned, with St. Paul, St. John the Evangelist, St. John the Baptist and St. Peter*, note 68.

NAPLES

MUSEO NAZIONALE: Simone Martini (signed), *St. Louis of Toulouse crowning King Robert of Naples*, 20-21; notes 37, 39, 41; plates 39, 40. - *Predella of the above with Scenes from the life of St. Louis of Toulouse*, 24, 35.

SANTA CHIARA: Tomb of Robert of Anjou, 21.

NEW YORK

METROPOLITAN MUSEUM: Segna di Buonaventura, *Triptych, Madonna and Child between St. Benedict and St. Silvester* (signed), 17; note 32.

HISTORICAL SOCIETY: "Ugolino Lorenzetti" (?), *Triptych, Madonna enthroned between St. Catherine and St. John the Baptist*, note 34.

BLUMENTHAL COLLECTION: Pupil of Duccio, *Triptych, Crucifixion and "Histories"*, note 28.

MAITLAND F. GRIGGS COLLECTION: Master of the Madonna in Città di Castello, *Two wing pictures of a polyptych: St. Peter and St. John the Baptist*, note 33. - School of Lippo Memmi, *Madonna and Child, with St. John the Baptist and St. Francis*, note 63.

HAMILTON COLLECTION: Ambrogio Lorenzetti (?), *Holy Family*, note 104.

PHILIP LEHMAN COLLECTION: No. XVI, Pupil of Duccio (Master of Montepulciano), *Madonna and Child*, note 34. - No. XVII, Ugolino da Siena, *Bust of St. John the Evangelist* (fragment), note 32. - No. XXIX, Ambrogio Lorenzetti, *Madonna and Child*, note 94. - No. XXX, "Ugolino Lorenzetti" (?), *Madonna dell'Umiltà*, note 34.

CLARENCE H. MACKAY COLLECTION: Duccio, *The Raising of Lazarus* (Predella from the back of the Maestà), 9.

JOHN D. ROCKEFELLER COLLECTION: Duccio (Predellas from the back of the Maestà), *The Woman of Samaria at the well*, 13; note 56. *The Calling of Peter and Andrew*, 9. - Master of the St. George Codex, *Crucifixion, Mourning for Christ*, note 62.

In the possession of MISS FRICK: Duccio, *Temptation on the Mount* (Predella from the back of the Maestà), 12, 54.

ORVIETO

OPERA DEL DUOMO: Simone Martini, *Polyptych* (1320), originally in seven parts, from left to right: *St. Dominic, St. Peter, St. Mary Magdalen, the Madonna*, (missing: *St. Catherine*), *St. Paul*, (missing: *St. Peter Martyr*), 22; notes 39, 42; plate 42. - Workshop of Simone Martini, *Madonna and Child* (from San Francesco), note 43. - Lippo Memmi (?), *Madonna* (signed), note 63.

CATHEDRAL: Ugolino di Vieri and assistants, *Silver Reliquary of the Holy Shroud*, note 16.

CHURCH OF THE SERVI: School of Coppo di Marcovaldo, *Madonna enthroned with the Child and Angels*, note 12.

PADUA

CAPPELLA DELL'ARENA: Giotto, *Frescoes: Annunciation to St. Anna*, 32; *Last Supper*, 36; *Crucifixion*, 39.

PALERMO

BORDONARO CHIARAMONTE COLLECTION: Ovile Master, *Polyptych, Madonna and Child, with St. Dominic, St. John the Baptist, St. Stephen* (?) *and St. Catherine*, notes 34, 83.

PARIS

LOUVRE: No. 1151, Bartolo di Fredi, *Presentation in the Temple*, 58. - No. 1260, Follower of Cimabue, *Madonna enthroned with the Child and Angels* (from San Francesco at Pisa), 5; notes 2, 4, 5. - No. 1383, Simone Martini, *Bearing of the Cross*, 29; notes 56, 80; plate 60a. - No. 1665, "Ugolino Lorenzetti", *Crucifixion*, note 34. - No. 1666, Master of the St. George Codex, *Madonna enthroned with the Child and Angels, St. John the Baptist and St. John the Evangelist*, note 62.

PATERNO

SANTO STEFANO: Follower of Cimabue, *Painted Crucifix*, note 4.

PERUGIA

PINACOTECA: Duccio, *Madonna with the Child and Angels* (in the spandrels), 7, 8; note 13; plate 13.

PHILADELPHIA

JOHNSON COLLECTION: Ugolino da Siena, *The Prophet Daniel* (from the former high altar of Santa Croce in Florence), note 33. - Francesco di Vannuccio, *Crucifixion*, note 108.

PIENZA

MUSEUM: Sienese Master of the latter half of the Trecento, *Winged altar-piece depicting the History of Christ*, note 16.

PISA

MUSEO CIVICO: Pisan Master of the end of the Duecento, *Madonna enthroned with the Child, and scenes from her Legend* (from San Martino ?), 14; note 24. - Simone Martini, *Parts of the Polyptych from Santa Caterina*, Wing-picture: *St. John the Baptist;* Predella of the centre panel: *Christ between the Virgin and St. Mark;* Predellas of the side panels: *St. Stephen and St. Apollonia, St. Gregory and St. Luke, St. Jerome and St. Lucy, St. Agnes and St. Ambrose, St. Thomas Aquinas* and *St. Augustine, St. Ursula and St. Lawrence*, 21-22; plate 41. - Luca di Tommè, *Crucifixion, Christ with the Virgin and St. John* (1366), 58; plate 115.
SANTA CATERINA: Simone Martini, *Polyptych* (1320, signed), panels: *St. Dominic, St. Mary Magdalen, St. John the Evangelist, the Virgin, St. Catherine, St. Peter Martyr*, 21; notes 39, 41, 42, 74.
SCHIFF COLLECTION: Workshop of Duccio, *Madonna and Child* (from San Francesco at Lucca), 16; note 26.

PISTOIA

SAN FRANCESCO: Pietro Lorenzetti, *Madonna* (perhaps identical with the Madonna enthroned in the Uffizi, mentioned by Vasari), note 77.

POGGIBONSI

SAN LUCCHESE, Sacristy: Follower of Duccio, *Small pictures of saints in the panelling of a cupboard*, note 32.

RAPOLANO

PIEVE: Workshop of Ambrogio Lorenzetti, *Madonna and Child*, note 94.

ROCCALBEGNA

SS. PIETRO E PAOLO: Ambrogio Lorenzetti, *Madonna and Child*, note 94.

ROFENO

BADIA: Pupil of Ambrogio Lorenzetti, *Central pinnacle of a triptych*, *Madonna and Child* (cf. under Siena, Opera del Duomo), note 104.

ROME

BIBLIOTECA VATICANA: Missorium libri et sancti Georgii Martyris historia, manuscript with *Miniatures* by the Master of the St. George Codex, 31; note 62.

PINACOTECA VATICANA: Nos. 2, 3, School of Pietro Lorenzetti, *Two side panels of a polyptych*, *St. Peter and St. Paul*, note 82. - No. 9, Pietro Lorenzetti, *Christ before Pilate*, *Predella*, note 73. - No. 26, Simone Martini, *Half-figure of Christ blessing*, note 44. - No. 28, Lippo Memmi (?), *Crucifixion*, notes 63, 80.

PALAZZO VENEZIA: Follower of Simone Martini (Master of the Madonna in Palazzo Venezia), *Madonna and Child*, note 44.

CAPPELLA SISTINA: Michelangelo Buonarroti, *Frescoes*, *The Prophet Jeremiah*, 27.

SS. SISTO E DOMENICO (monastery): Lippo Vanni, *Triptych* (1358, signed), *Madonna enthroned with the Child and Saints, and scenes from her Legend*, 57; plate 114.

UGO IANDOLO COLLECTION: Guiduccio Palmeruccio, *Madonna and Child (standing)*, note 82.

SAN CASCIANO

MISERICORDIA: Ugolino da Siena, *Side panels of a polyptych*, *St. Peter and St. Francis*, note 33. - Follower of Ugolino da Siena, *Madonna and Child, with the Founder*, notes 33, 34. - Simone Martini, *Painted Crucifix*, note 44.

SAN GALGANO

BADIA DI MONTE SIEPI: Follower of Ambrogio Lorenzetti, *Frescoes*, *Madonna enthroned with the Child and Angels, Annunciation, Legend of St. Galganus*, note 104.

SAN GIMIGNANO

PALAZZO PUBBLICO: Lippo Memmi, *Maestà* (1317), 31; notes 35, 63; plates 63, 64.

SANT'AGOSTINO: Bartolo di Fredi, *Frescoes of scenes from the Legend of the Virgin*, 58; plate 117. - Ovile Master, *Madonna with the Child and saints* (see under Palermo).

COLLEGIATA: Barna, Frescoes, *Scenes from the Life of Christ*, 32-33; notes 64, 65; plates 67-69. - Bartolo di Fredi, *Frescoes, Stories from the Old Testament*, 58.
SANT'IACOPO: Sienese Master of the end of the Duecento, *Madonna enthroned with the Child and saints, Fresco*, note 35.
SAN PIETRO: School of Simone Martini, *The Madonna walking with the Child, Fresco*, note 65.

SAN GIOVANNI D'ASSO

PIEVE: Pupil of Duccio (related to the Master of Montepulciano), *Polyptych, Madonna with the Child and saints*, note 34.

SAN LEONARDO AL LAGO

Follower of Pietro Lorenzetti, *Frescoes:* on the vaulting: *Groups of angels;* in the choir: *Annunciation*, note 82.

SANT'ANSANO A DOFANA

Pietro Lorenzetti, *Madonna enthroned with angels, St. Nicholas and Elijah* (1329, signed), centre panel of the Carmelite altar-piece in Siena, 35; note 71.

SETTIGNANO

BERENSON COLLECTION: Related to "Ugolino Lorenzetti", *Crucifixion*, note 34. - Workshop of Simone Martini, *Two side panels of a polyptych: St. Lucy and St. Catherine*, note 44. - Master of the Madonna in Palazzo Venezia, *Madonna enthroned with the Child and Angels, between the Archangels Michael and Gabriel*, notes 44, 63. Workshop of Pietro Lorenzetti (Master of the Dijon Triptych), *Madonna (standing) with the Child and Founder*, note 70.

SIENA

ACCADEMIA: No. 4, School of Guido da Siena, *Martyrdom of St. Bartholomew*, 2. - No. 8, School of Guido da Siena, *Antependium, Entry into Jerusalem*, 2, 12. - No. 15, Guido da Siena (?), *St. Peter enthroned, with "histories"*, 10. - No. 18, School of the Master of the Madonna in Città di Castello, *Madonna enthroned with the Child*, notes 30, 82. - No. 20, Duccio, *Madonna with the three Franciscans*, 6; note 28; plate 10. - No. 28, Workshop of Duccio, *Polyptych, Madonna and Child, with St. Augustine, St. Paul, St. Peter and St. Dominic*, 7, 8; note 28; plate 14. - Nos. 29 and 32, Master of the Madonna in Città di Castello, *Four side panels of a polyptych, St. Peter, St. Anthony abbot, St. Augustine, St. Paul*, note 30. - No. 33, Master of the Madonna in Città di Castello, *Polyptych, Madonna and Child, with St. John the Evangelist, St. Francis, St. Stephen and St. Clara*, 17. - No. 35, Pupil of Duccio, *Triptych, Madonna enthroned with the Child, Saints, and "Histories"*, note 28. - No. 39, Ugolino da Siena, *Polyptych, Madonna with the Child and Saints*, notes 33, 34. - No. 40, Segna di Buonaventura, *Four panels of a polyptych, St. Paul, the Virgin (Crucifixion, or Christ, missing), St. John the Evangelist, St. Benedict*, 17; note 32; plate 32. - Nos. 42 and 43, "Ugolino Lorenzetti", *St. Ansanus and St. Galganus*, note 34. - No. 46, Niccolò di Segna di Buonaventura, *Painted Crucifix* (1345, signed), 18. - No. 47, Workshop of Duccio, *Polyptych* (from Santa Maria della Scala), *Madonna and Child, with St. Agnes, St. John the Evangelist, St. John*

the Baptist and St. Mary Magdalen, 8, 21; notes 28, 33; plate 15. - Nos. 48 and 49, School of Lippo Memmi, *Two side panels of a polyptych, St. Louis of Toulouse and St. Francis*, note 63. - No. 50, Follower of Pietro Lorenzetti, *Polyptych, Madonna with the Child and saints*, note 82. - No. 53, Ovile Master, *St. Gregory*, note 83. - No. 54, related to "Ugolino Lorenzetti", *Crucifixion, with saints on the side panels*, note 34. - No. 61, Ovile Master, *Assumption of the Virgin*, 35, 45. - No. 65, Workshop of Ambrogio Lorenzetti, *Madonna enthroned with the Child, angels and Fathers of the Church*, 56; note 104; plate 111. - No. 70, Ambrogio Lorenzetti, *Seascape*, 54; plate 110a. - No. 71, Ambrogio Lorenzetti, *The City by the sea*, 54; note 98; plate 110b. - No. 76, Ovile Master, *Madonna enthroned with the Child and angels*, 44-45. - No. 77, Workshop of Ambrogio Lorenzetti, *Polyptych* (from Santa Petronilla), *Madonna and Child, with St. Mary Magdalen, St. John the Evangelist, St. Dorothea and St. John the Baptist*, 56; note 104; plate 112. - Nos. 79, 81 and 82, Pietro Lorenzetti, *Polyptych* (1332, from Santa Cecilia in Crevole), *St. John the Baptist, St. Cecilia, St. Bartholomew*, 36; note 72. - No. 80, Ovile Master, *Madonna enthroned with the Child and angels*, 45. - Nos. 83 and 84, Pietro Lorenzetti, *Four scenes from the predella of the Carmelite altar-piece* (1329), 35, 36, 40, 47, 50; note 71: *The Dream of Sobac*, 35, 36, 47; note 71; plate 75a; *Hermit life of the Carmelites*, plate 75b; *Honorius III confirms the rules of the Order*, 36; plates 75c, 76; *Innocent IV invests the Carmelites with a new monastic garb*, 36; plate 75d. - Nos. 85, 86, 93, 94, School of Master of the Madonna in Pal. Venezia, *St. John the Baptist, St. Catherine, St. Paul, St. John the Evangelist*, note 63. - No. 88, Ambrogio Lorenzetti, *Annunciation* (1344, signed), 55-56; notes 82, 86, 103; plate 109. - No. 92, Pietro Lorenzetti (?), *Allegory of the first Fall and the Redemption*, note 82. - No. 104, Bartolo di Fredi, *Adoration of the Magi*, 58. - No. 108, Master of the Madonna in Palazzo Venezia, *Mystic nuptials of St. Catherine*, note 63. - No. 109, Luca di Tommè, *Polyptych, Madonna and Child with St. Anna and other saints* (1367), 58; plate 116. - No. 115, Naddo Ceccarelli, *Polyptych, The Virgin and Child, with St. Anthony abbot, the Archangel Michael, St. John the Evangelist and St. Stephen*, note 60. - No. 116, Paolo di Giovanni Fei, *Nativity of the Virgin*, 59; plate 120. - No. 538, Pupil of Duccio, *Madonna and Child*, note 28. - Nos. 578 and 579, Pietro Lorenzetti, *Side panels of a polyptych, Full-length figures of St. Agnes and St. Catherine*, note 82. - No. 595, Lippo Memmi, *Madonna and Child* (from Montepulciano), 32. - Ancient relief of a Nike, note 99.

ARCHIVIO DI STATO: Niccolò di Ser Sozzo Tegliacci, Caleffo d'Assunta, Manuscript with *Miniature of the Assumption of the Virgin*, 31; plate 62. - Ambrogio Lorenzetti (?), Cover of the book of the Gabella, *The Commonwealth enthroned, with the she-wolf*, note 99.

OPERA DEL DUOMO: Duccio, *Maestà*, Front: *Central picture*, 5, 6, 8, 9, 10, 34; notes 15, 16, 29, 31; plates 6a, 16-20, figure on page 68. Predella, *Flight into Egypt*, 12, 14; *Adoration of the Magi*, 14. Top pictures: *Annunciation of her death to the Virgin*, 11; *Entombment of the Virgin*, note 56. - Back: *Central picture*, notes 16, 28; plate 21, figure on page 69. Predella: *Marriage at Cana*, 11. Top pictures: *Pentecost*, 16. "Histories" of the principal picture: *Entry into Jerusalem*, 12, 13, 15; plate 22; *The Washing of Feet*, 10, 11; *Last Supper*, 11, 15, 36; *Christ's farewell address*, 11; *The pact of Judas*, 10, 14, 15; *Christ praying in the Garden of Gethsemane*, 12, 14, 15; plate 23; *Arrest of Christ*, 15; *Peter denies the Lord in the courtyard*, 10, 12, 13, 15, 25; *The second denial*, 14, 15; plate 26; *The third denial*, 15; *Christ before Annas*, 11, 15, 16; *Christ before Caiaphas*, 11, 15; *Christ before Pilate*, 15; *Christ before Herod*, 11, 15;

Christ in the white robe before Pilate, 11; *Flagellation*, 15; *The Crown of Thorns*, 15; *Pilate washes his hands*, 14, 16; *Bearing of the Cross*, 15; *Crucifixion*, 13, 14, 15; note 28; plates 24, 25; *Deposition*, 14, 15; plate 27; *The three Maries at the tomb*, 10, 14, 15; plate 28; *Noli me tangere*, 13, 14; plate 29; *The road to Emmaus*, 15. - Duccio, *Madonna* (from Santa Cecilia in Crevole), 6, 7, 8; plates 7-9. - Master of the Madonna in Città di Castello, *Madonna and Child* (from San Michele in Crevole), 17; notes 12, 30; plate 31. - Pietro Lorenzetti, *Nativity of the Virgin, Triptych* (1342, signed), 36, 40, 41, 50, 57; note 79; plates 87, 88. - Pupil of Ambrogio Lorenzetti, *Four side panels of a polyptych, half-figures of St. Catherine, St. Benedict, St. Francis and St. Mary Magdalen*, note 104.

PALAZZO PUBBLICO:

Sala del Gran Consiglio (del Mappamondo): Guido da Siena, *Madonna enthroned with the Child and angels*, 6; notes 4, 11. - Simone Martini, *Maestà* (of 1315), *Fresco*, 9, 19-20, 21, 22, 51; notes 35, 37, 39, 41, 63; plates 36-38. - Simone Martini, *The Condottiero Guidoriccio de' Fogliani*, *Fresco* (1328, signed), 22-23; plates 44, 45.

Sala dei Nove: Ambrogio Lorenzetti, *Frescoes* (signed), 20, 25, 37, 49, 51-55; note 99. *Allegory of the Good Regiment*, 51-54; notes 95, 96, 97; plates 97-99. *Life in the City*, 53; plates 100, 101. *Life in the Country*, 53-54; plates 102, 103. *Allegory of the Evil Regiment*, 53; note 99. *Quatrefoils of the decoration of the frame*, 54.

Chapel: Taddeo di Bartolo, *Frescoes* (1407-8, signed), *Scenes from the Legend of the Virgin*, 59.

Loggia: Ambrogio Lorenzetti, *Madonna enthroned with the Child*, note 94.

SANT'AGOSTINO: Simone Martini, *St. Agostino Novello with four scenes from his Legend*, 24-25; plates 49, 50.

CATHEDRAL (SANTA MARIA DELL'ASSUNTA), Cappella delle Grazie: School of Guido da Siena, *Madonna del Voto*, 7.

SAN DOMENICO, Cloister (Scuola Tecnica): Lippo Memmi. *Madonna enthroned with the Child and angels* (fragment of a fresco), 32.

SAN FRANCESCO, Cappella Bandinelli: Pietro Lorenzetti, *Fresco, Crucifixion*, 36, 37, 38, 39, 42; notes 67, 82; plate 77. - Cappella Bandini-Piccolomini: Ambrogio Lorenzetti, *Frescoes*, 49, 50; notes 82, 92, 93. *Martyrdom of the Franciscans*, 49-50; note 102; plate 93. *Reception of St. Louis into the Franciscan Order*, 50; plate 94. - Chapel on the right of the choir: Andrea Vanni, *Madonna enthroned with the Child*, 57. - Seminary: Segna di Buonaventura, *Madonna and Child*, note 32. - Seminary Chapel: Ambrogio Lorenzetti, *Madonna suckling the Child*, 47; plate 92. - Lippo Vanni, *Polyptych, Fresco, Madonna enthroned with the Child, St. Francis, St. John the Baptist, St. Catherine and St. Anthony*, 57. - Refectory (former chapter-house) of the Seminary: Pietro Lorenzetti (?), *Fragments of fresco, Resurrection of Christ, Half-Figure, Prophets*, note 82.

SAN PIETRO IN CASTELVECCHIO: Ambrogio Lorenzetti, *Fresco on the façade*, according to Tizio (lost), 55. High altar: Ambrogio Lorenzetti, *Panel painting*, according to Tizio (lost), 55. Rectory: Follower of Ambrogio Lorenzetti, *Fragments of a polyptych, Madonna (standing) with the Child, St. Peter, St. Paul, the Archangel Michael and another saint*, note 100.

SAN PIETRO A OVILE: Ovile Master, *Madonna enthroned with the Child and angels*, 44-45.

SANTA MARIA DEI SERVI: Lippo Memmi, *Madonna del Popolo*, 32; plate 65. - Pietro Lorenzetti and pupils, *Frescoes: The Massacre of the Innocents*, 38; plate 78. *Dance of Salome*,

INDEX OF NAMES

PLATES 1-120

I

DUCCIO
Rucellai Madonna. 1285.
FLORENCE. SANTA MARIA NOVELLA
Photo Brogi

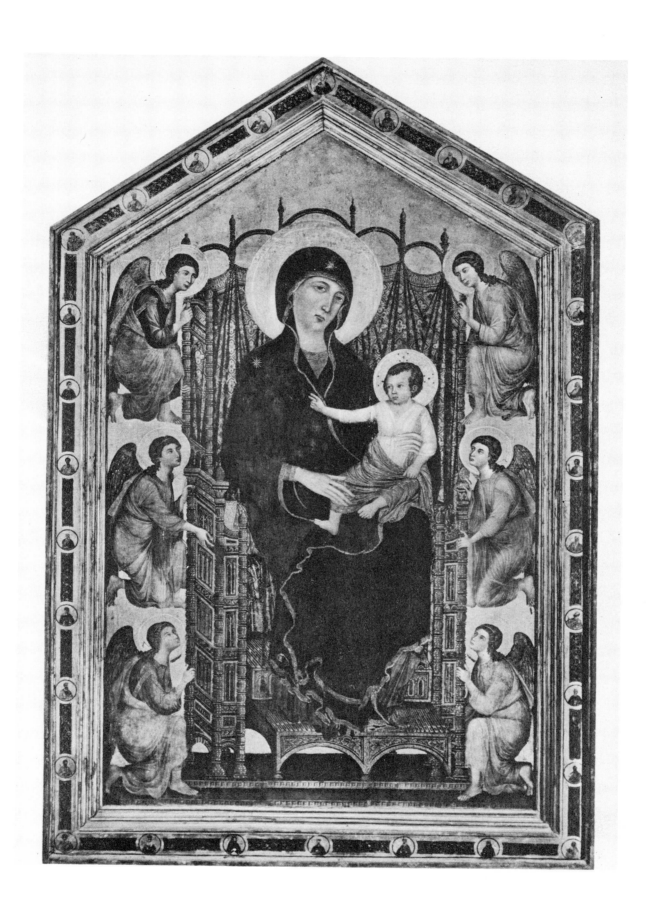

2

DUCCIO
Rucellai Madonna.
Detail: Head of the Madonna.
FLORENCE. SANTA MARIA NOVELLA
Photo Brogi

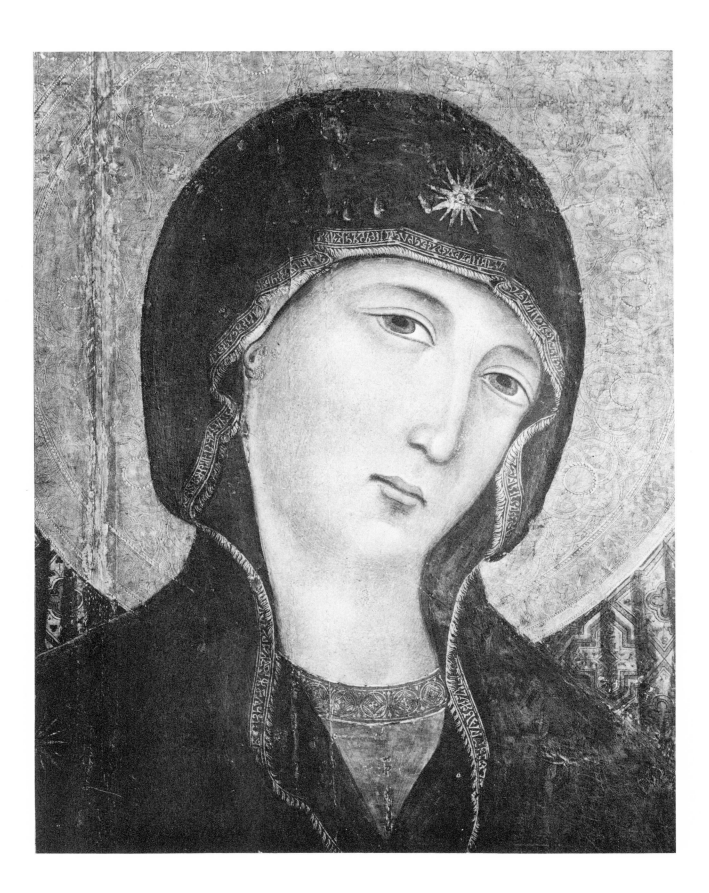

3

DUCCIO
Rucellai Madonna.
Detail: Head of the Child Jesus.
FLORENCE. SANTA MARIA NOVELLA

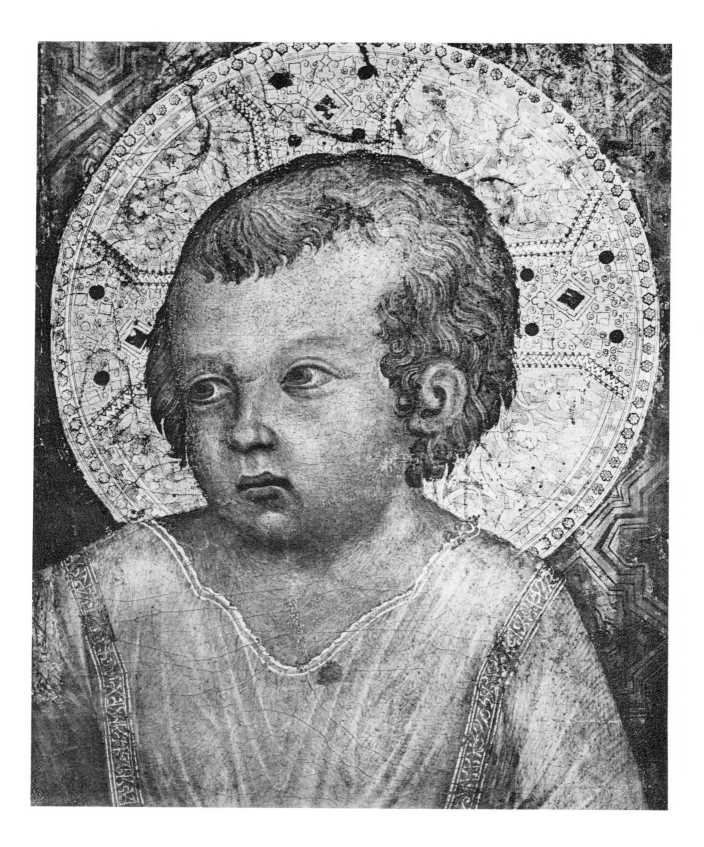

4

DUCCIO
Rucellai Madonna.
Detail: Head of the lowest Angel on the right.
Florence. Santa Maria Novella
Photo Brogi

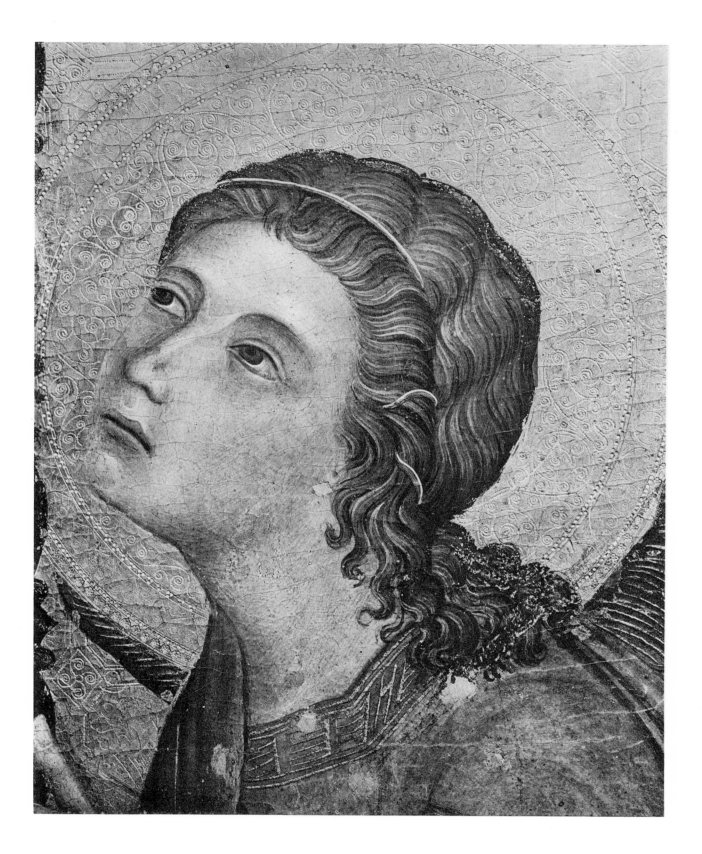

5

DUCCIO
Rucellai Madonna.
Detail: Head of the middle Angel on the left.
FLORENCE. SANTA MARIA NOVELLA

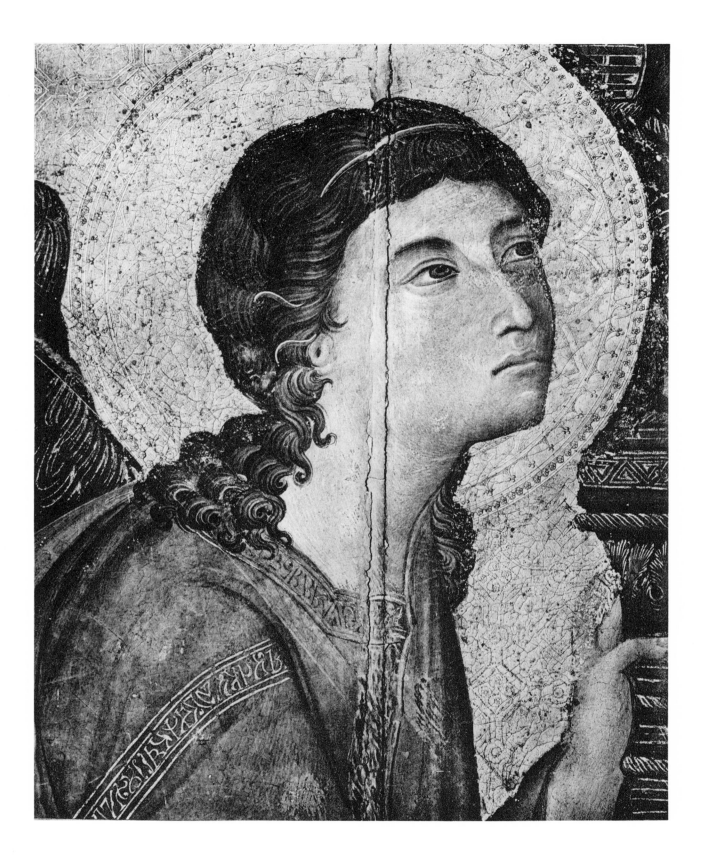

6

DUCCIO

A. Rucellai Madonna.
Detail: Head of the topmost Angel on the right.
FLORENCE. SANTA MARIA NOVELLA

B. Maestà.
Detail: Front; second Angel on the right of the Madonna,
top row.
SIENA. OPERA DEL DUOMO

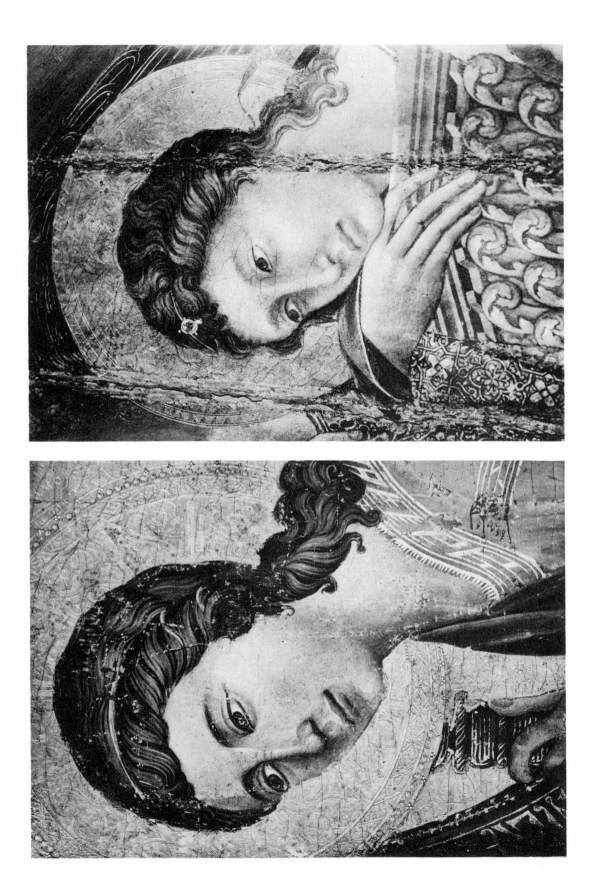

7

DUCCIO
Madonna from Santa Cecilia in Crevole.
Siena. Opera del Duomo
Photo Alinari

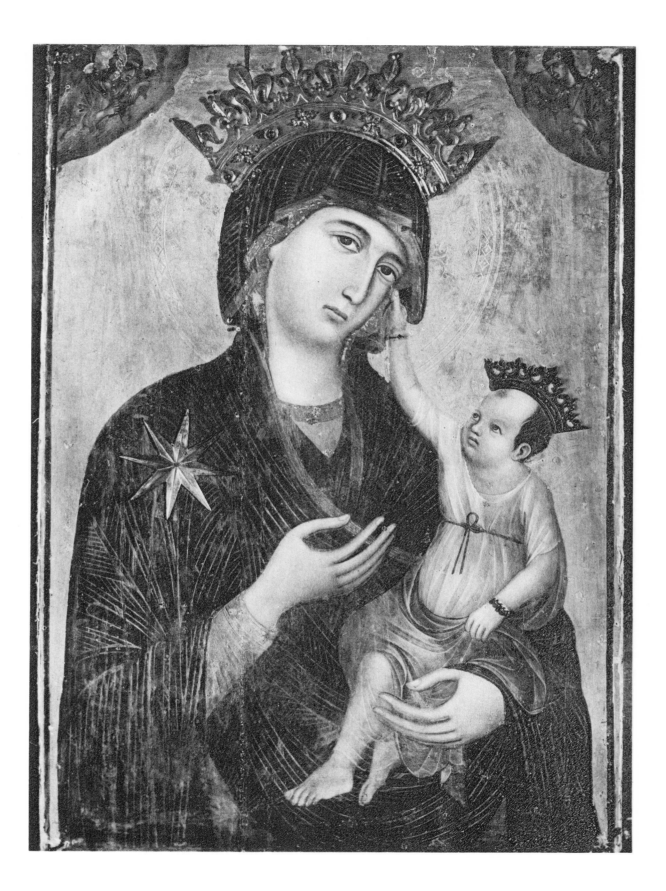

8

DUCCIO
Madonna from Santa Cecilia in Crevole.
Detail: Head of the Madonna.
SIENA. OPERA DEL DUOMO

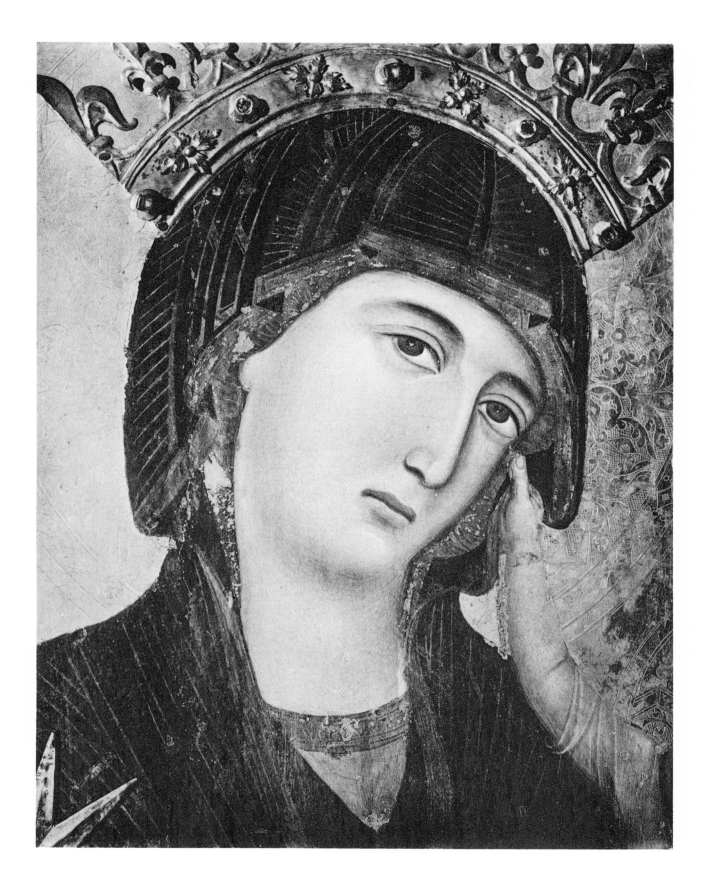

9

DUCCIO
Madonna from Santa Cecilia in Crevole.
Detail: The Child Jesus.
SIENA. OPERA DEL DUOMO

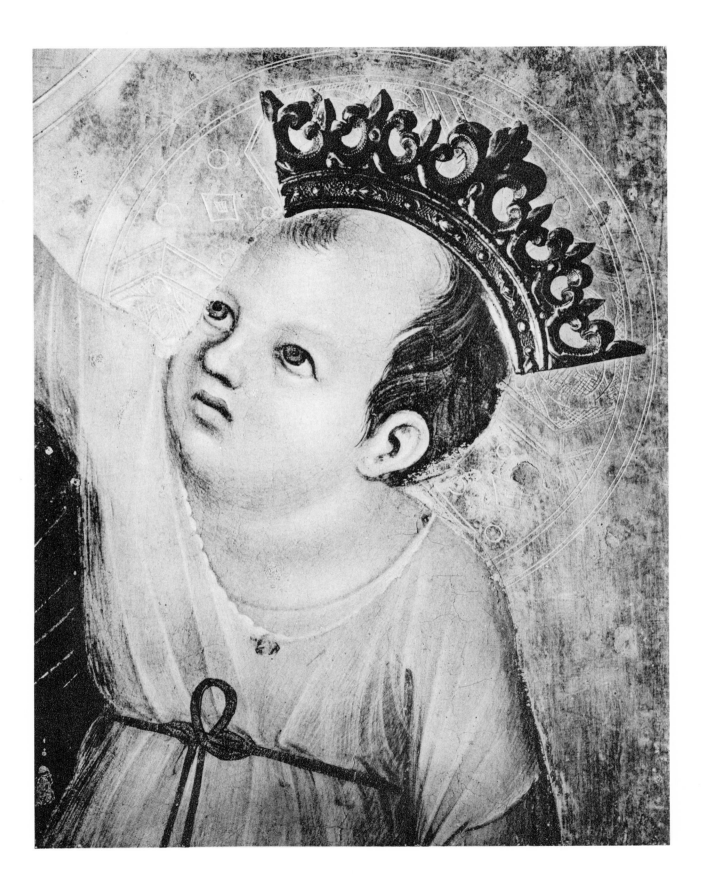

10

DUCCIO
Madonna with the three Franciscans.
SIENA. ACCADEMIA
Photo Anderson

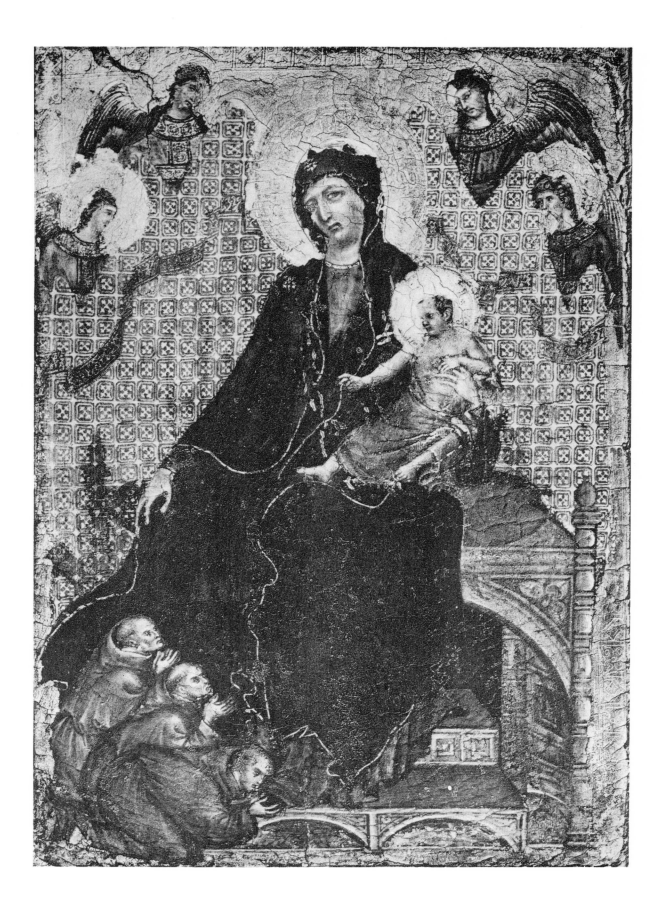

II

DUCCIO
Madonna and Child.
BRUSSELS. STOCLET COLLECTION

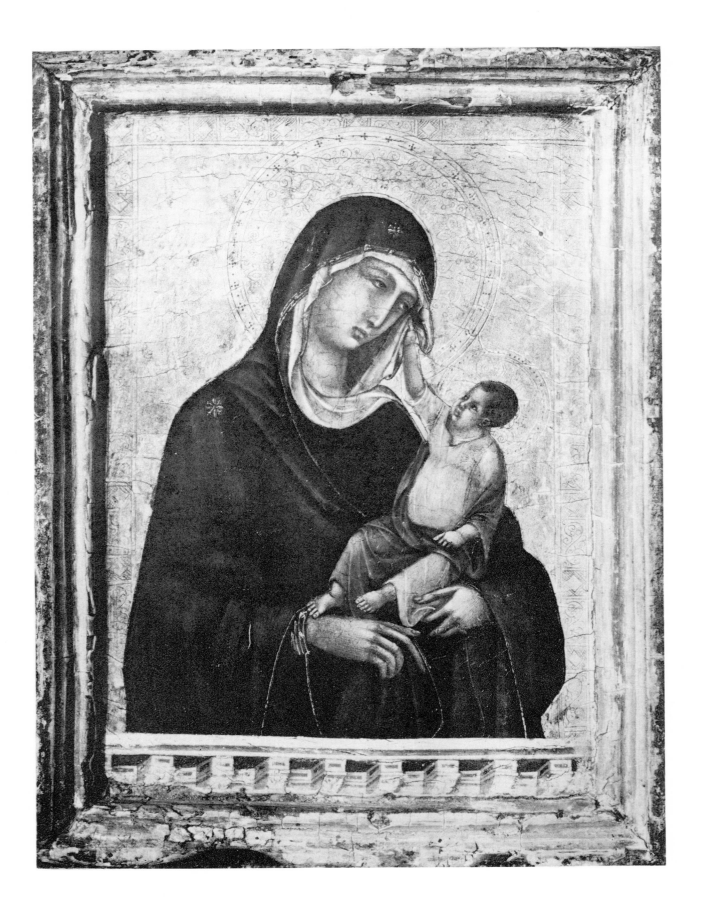

12

DUCCIO
Triptych: Madonna and Child.
On the wing-panels: St. Dominic and St. Agnes.
LONDON. NATIONAL GALLERY
Photo Hanfstaengl

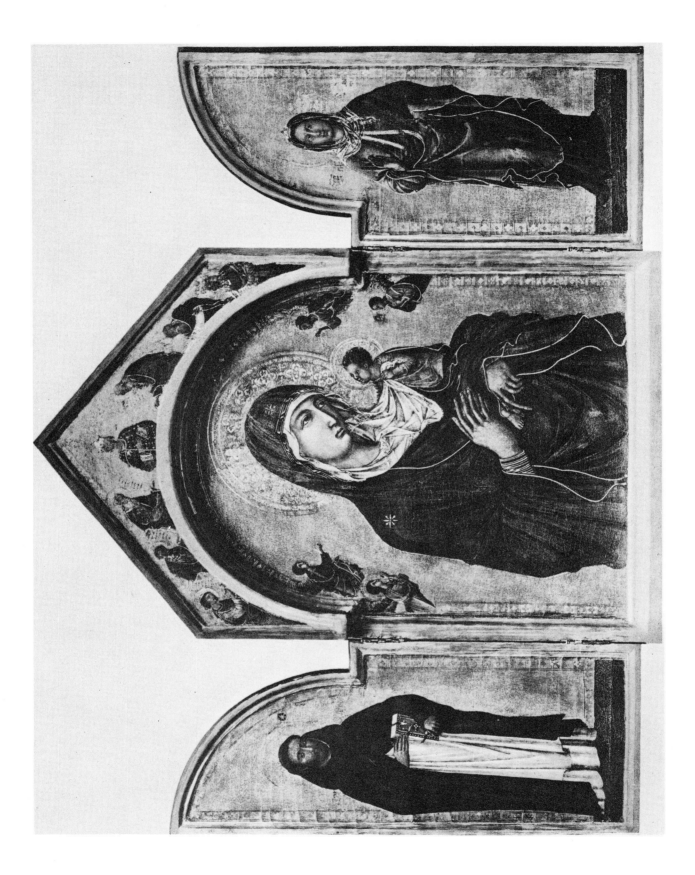

13
DUCCIO
Madonna and Child.
PERUGIA. PINACOTECA
Photo Alinari

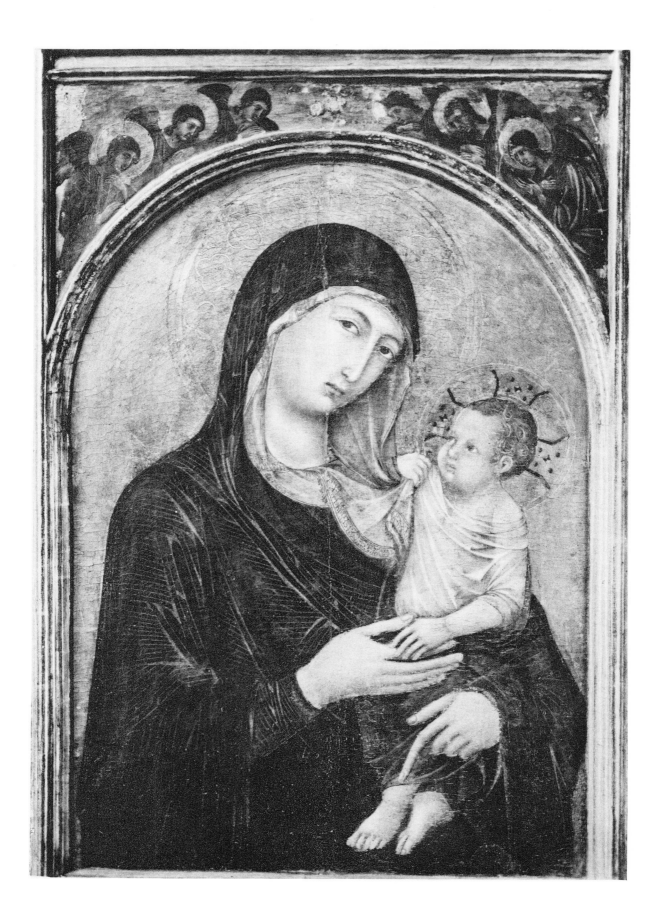

14

DUCCIO
Polyptych: Madonna and Child,
with St. Augustine, St. Paul, St. Peter and St. Dominic.
SIENA. ACCADEMIA (No. 28)
Photo Anderson

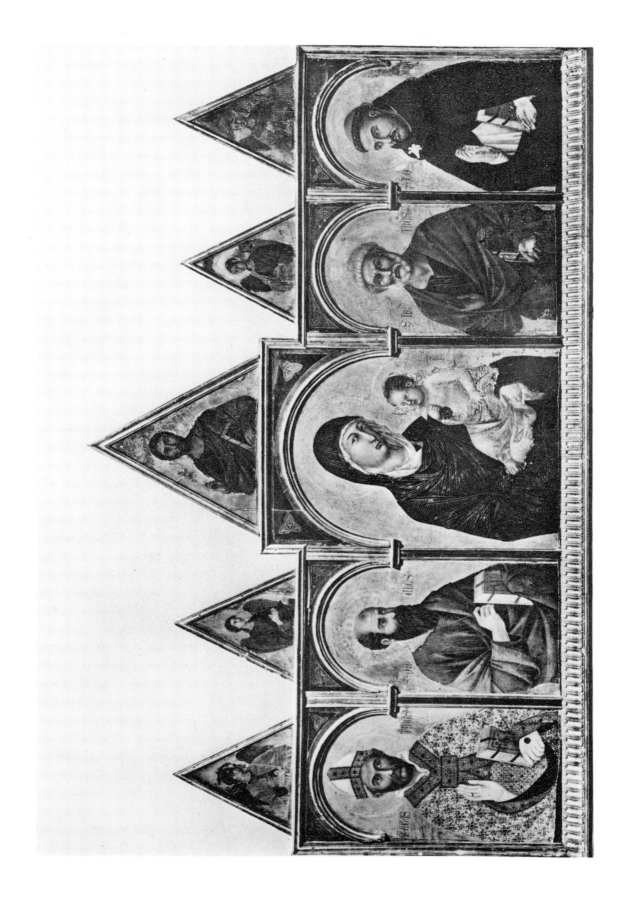

15

DUCCIO

Polyptych: Madonna and Child, with St. Agnes, St. John the
Evangelist, St. John the Baptist and St. Mary Magdalen.
Detail: St. Agnes and St. John the Evangelist.
SIENA. ACCADEMIA (No. 47)
Photo Anderson

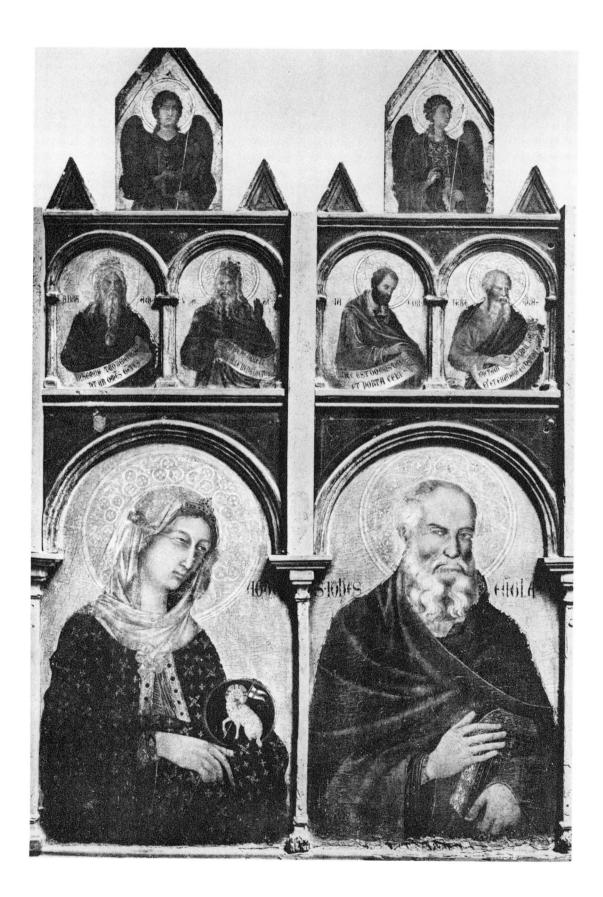

16

DUCCIO
Maestà, 1308-1311. Front.
Siena. Opera del Duomo
Photo Anderson

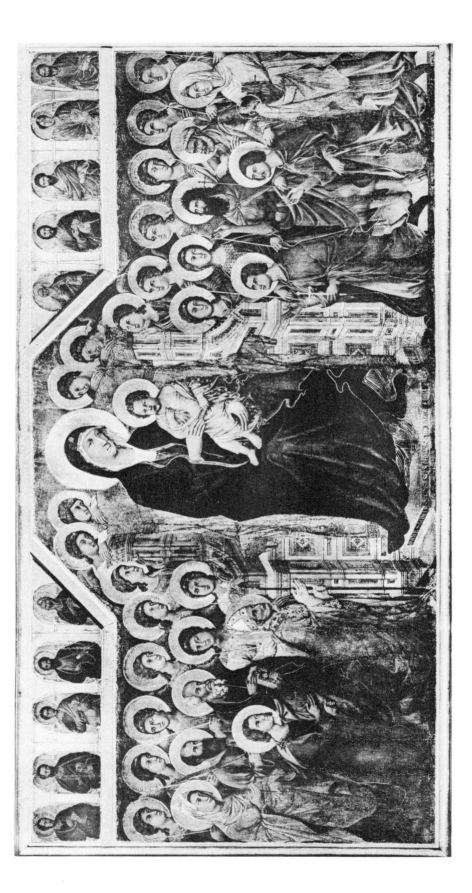

17

DUCCIO
Maestà, 1308-1311. Front.
Centre-piece: The Madonna Enthroned.
SIENA. OPERA DEL DUOMO
Photo Brogi

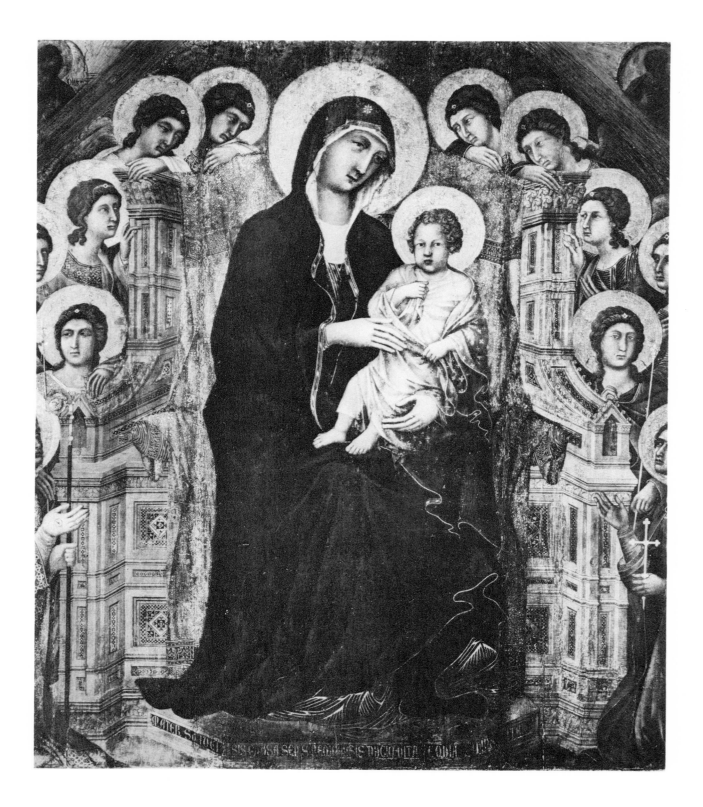

18

DUCCIO
Maestà, 1308-1311. Front.
Detail of left side.
SIENA. OPERA DEL DUOMO
Photo Anderson

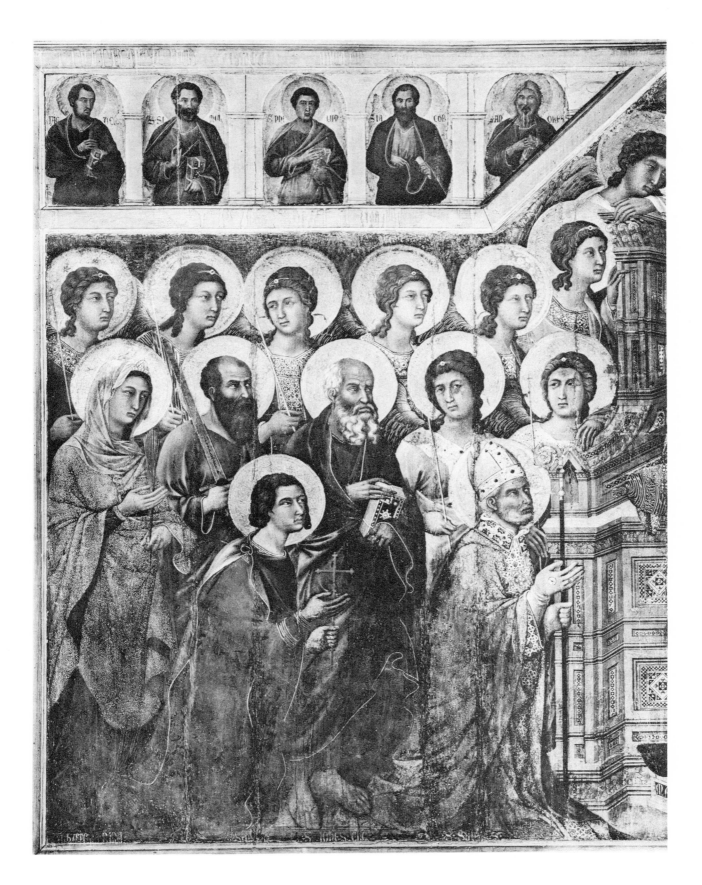

19

DUCCIO
Maestà, 1308-1311. Front.
Detail of right side.
SIENA. OPERA DEL DUOMO
Photo Anderson

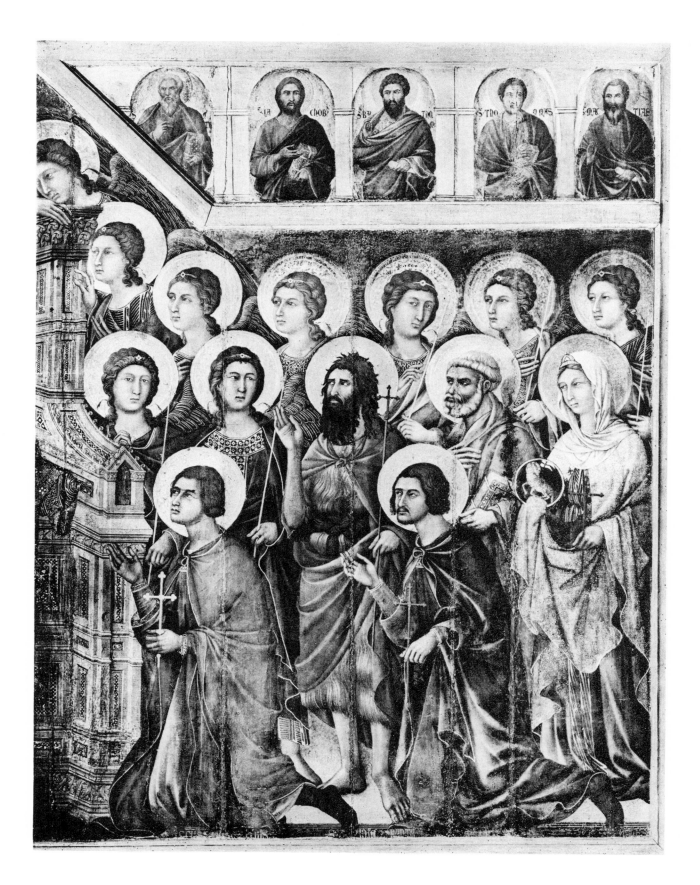

20

DUCCIO
Maestà, 1308-1311. Front.
Detail: Head of St. Catherine.
SIENA. OPERA DEL DUOMO
Photo Anderson

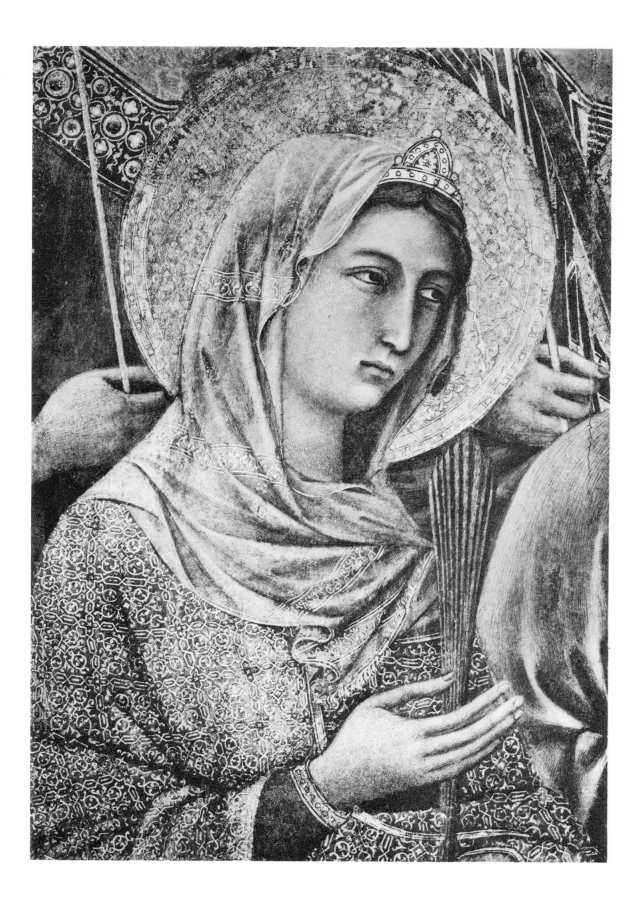

21

DUCCIO
Maestà, 1308-1311. Back.
Siena. Opera del Duomo
Photo Anderson

22

DUCCIO
Maestà, 1308-1311. Back.
Detail: The Entry into Jerusalem.
SIENA. OPERA DEL DUOMO
Photo Anderson

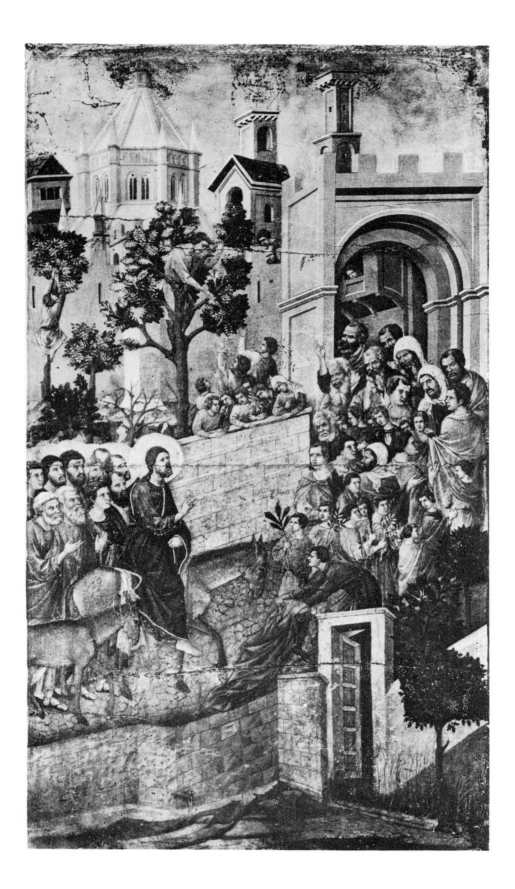

23

DUCCIO
Maestà, 1308-1311. Back.
Christ's Agony in the Garden of Gethsemane.
Detail: Jesus speaks to Peter, James and John.
SIENA. OPERA DEL DUOMO

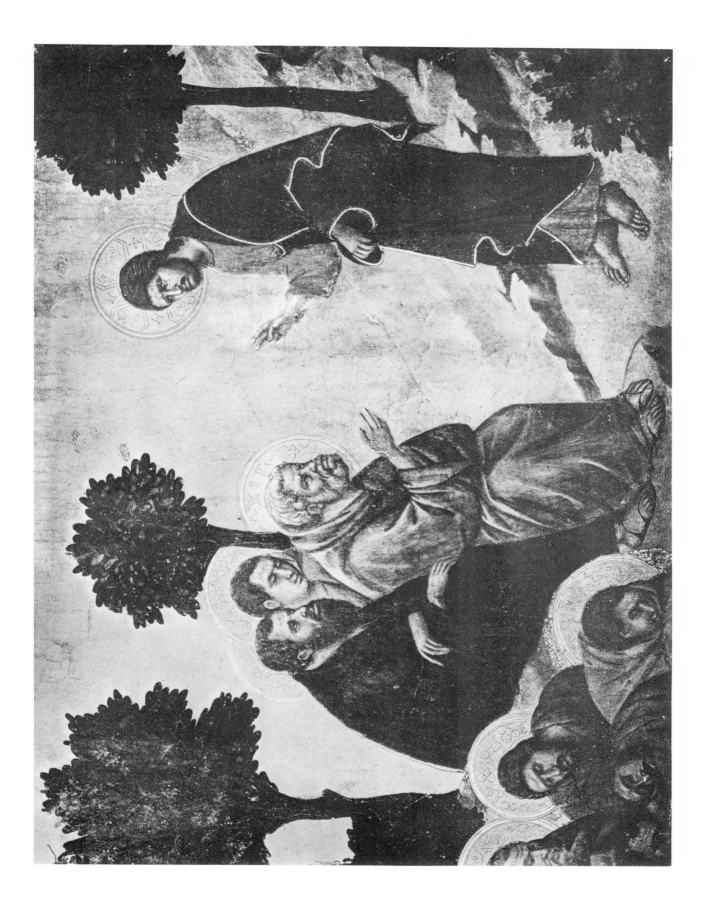

24

DUCCIO
Maestà, 1308-1311. Back.
The Crucifixion.
Detail: Christ on the Cross with the mourning Angels.
SIENA. OPERA DEL DUOMO
Photo Anderson

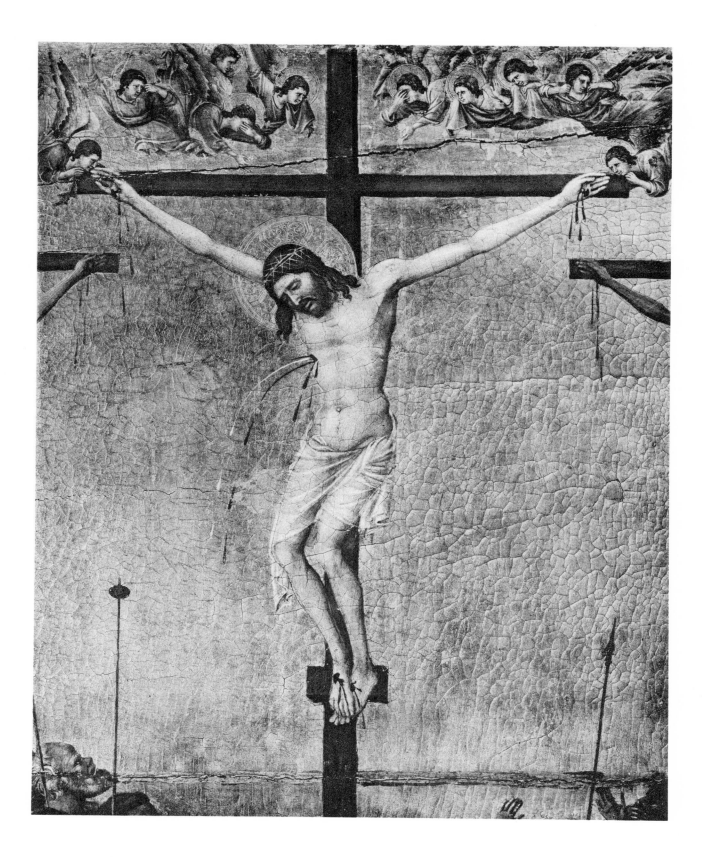

25

DUCCIO
Maestà, 1308-1311. Back.
The Crucifixion.
Detail: The Virgin falling into a swoon.
SIENA. OPERA DEL DUOMO
Photo Anderson

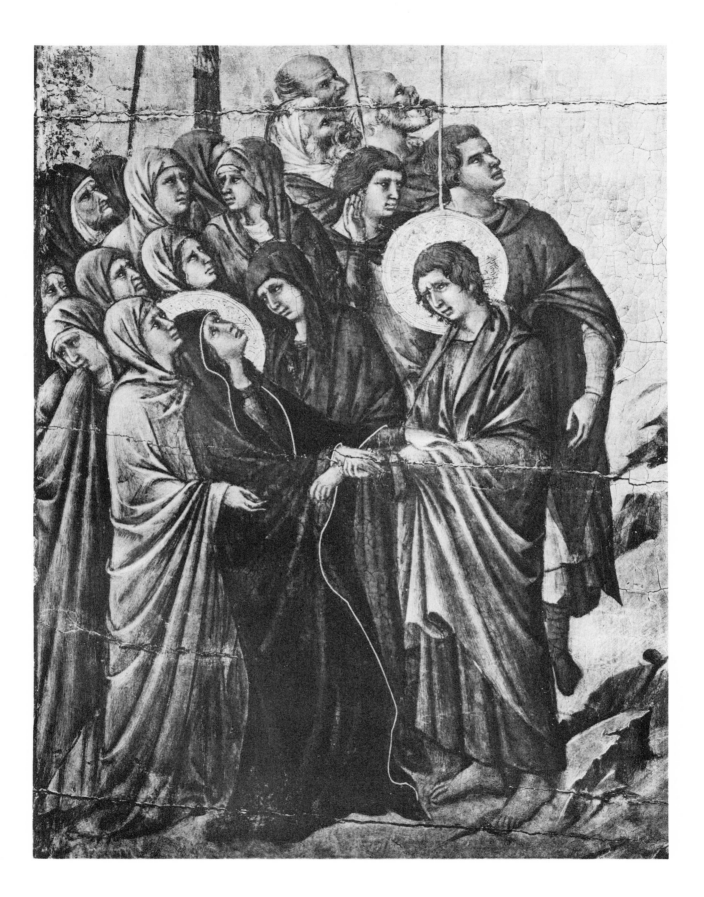

26

DUCCIO
Maestà, 1308-1311. Back.
Jesus before Caiaphas.
Detail: Peter denies the Lord for the second time.
SIENA. OPERA DEL DUOMO

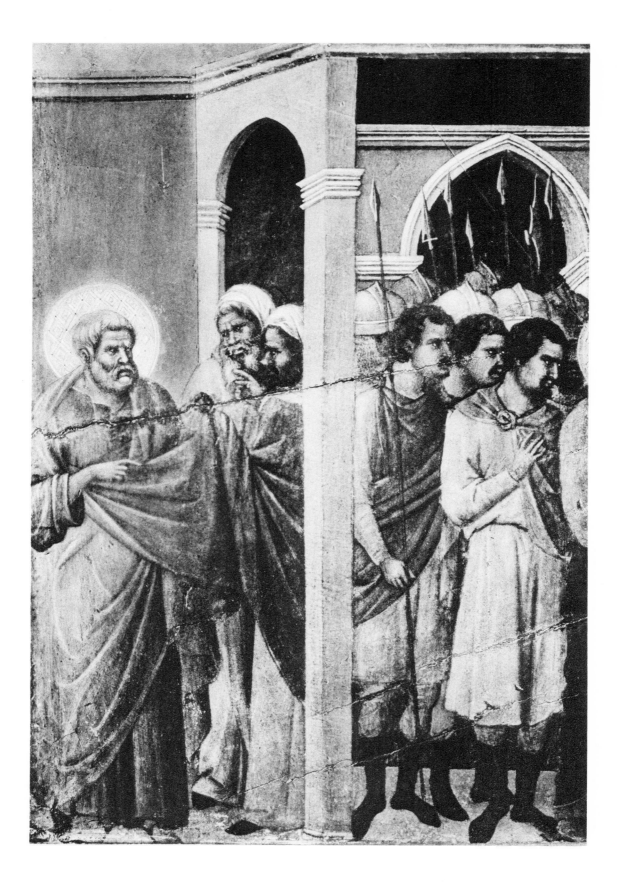

27

DUCCIO
Maestà, 1308-1311. Back.
The Deposition.
Detail: The Virgin kisses the head of the Lord.
SIENA. OPERA DEL DUOMO

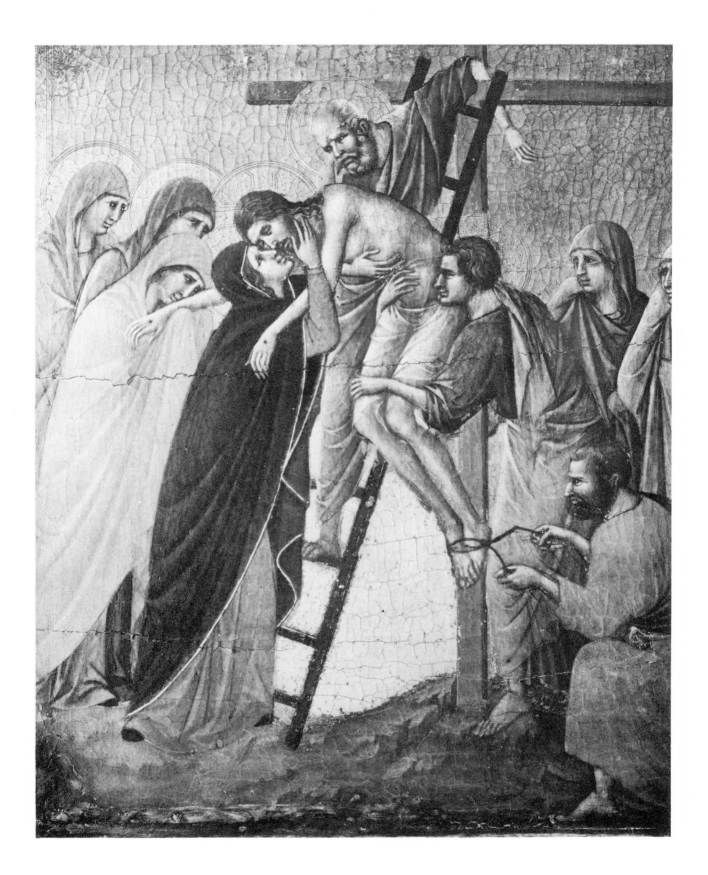

28

DUCCIO
Maestà, 1308-1311. Back.
The Holy Women and the Angel at the Tomb.
Detail: The three Maries.
SIENA. OPERA DEL DUOMO
Photo Anderson

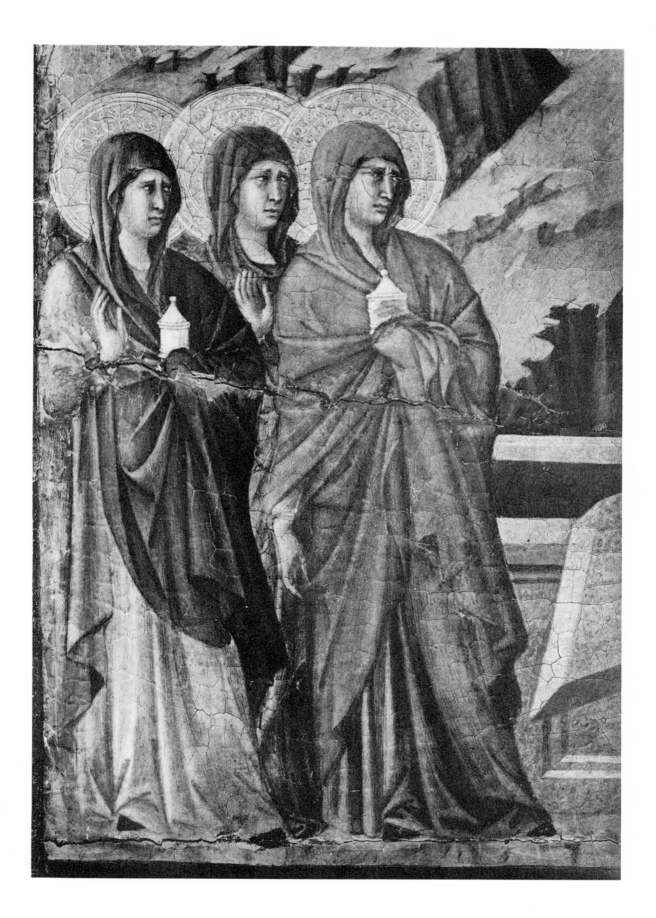

29

DUCCIO
Maestà, 1308-1311. Back.
Noli me tangere.
SIENA. OPERA DEL DUOMO
Photo Anderson

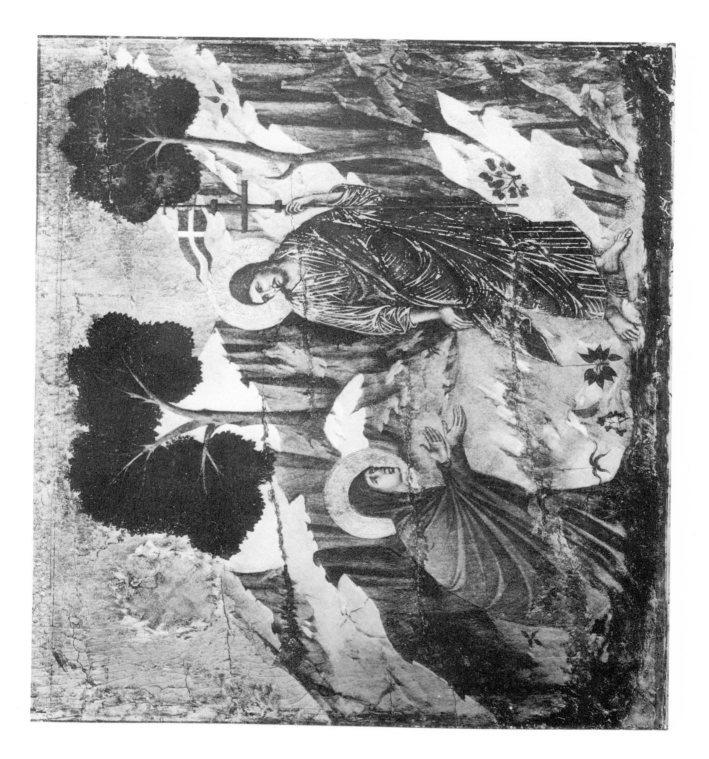

30

MASTER OF THE MADONNA OF BADIA A ISOLA
Madonna enthroned, with the Child and Angels.
BADIA A ISOLA. COLLE DI VAL D'ELSA
Photo Brogi

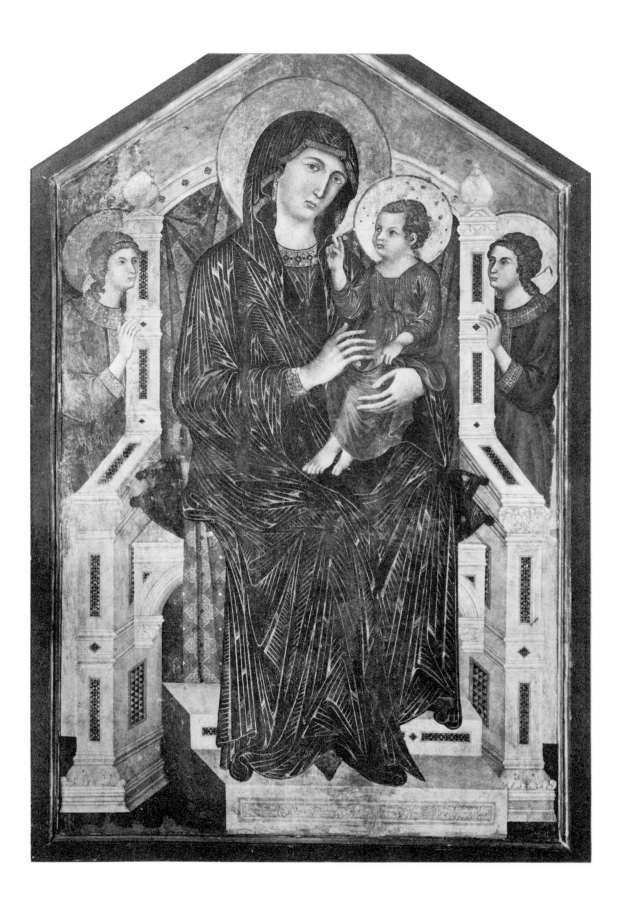

31

MASTER OF THE MADONNA OF CITTÀ DI CASTELLO
Madonna from San Michele in Crevole.
SIENA. OPERA DEL DUOMO
Photo Alinari

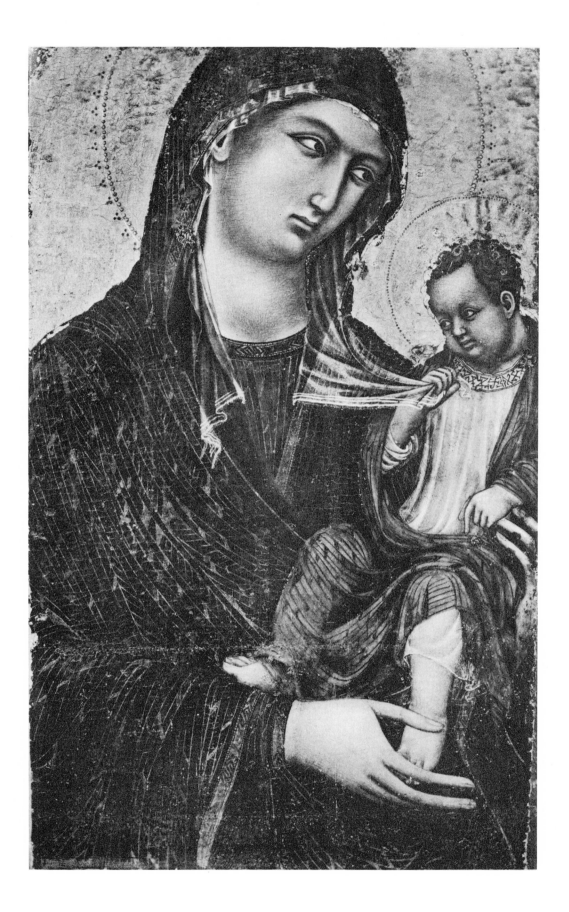

32
SEGNA DI BUONAVENTURA
St. Paul, the Virgin, St. John and St. Benedict.
SIENA. ACCADEMIA
Photo Anderson

33

SEGNA DI BUONAVENTURA (?)
The Madonna enthroned (completed after 1316).
MASSA MARITTIMA. CATHEDRAL
Photo Alinari

34

UGOLINO DA SIENA
St. Peter and St. Paul
(from the former high altar in Santa Croce at Florence).
BERLIN. KAISER FRIEDRICH MUSEUM
Photo Kaiser Friedrich Museum

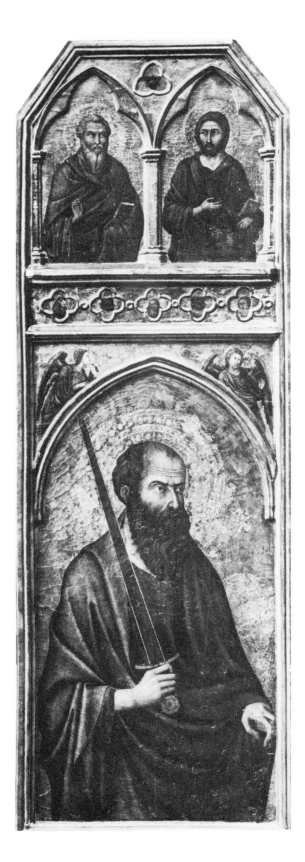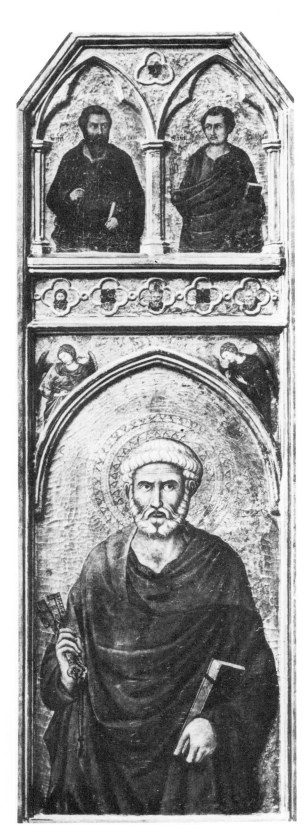

35

UGOLINO DA SIENA
Predella
(from the former high altar in Santa Croce at Florence).
A. The Flagellation.
B. The Entombment.
BERLIN. KAISER FRIEDRICH MUSEUM
Photo Kaiser Friedrich Museum

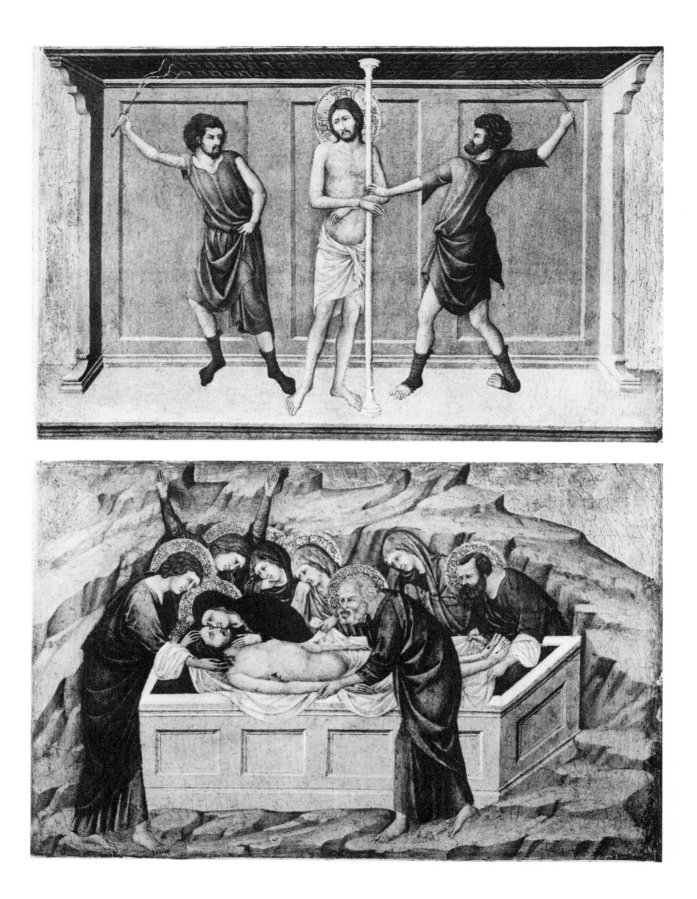

36

SIMONE MARTINI
The Madonna enthroned with Saints, 1315, Fresco.
SIENA. PALAZZO PUBBLICO, HALL OF THE GRAND COUNCIL
Photo Anderson

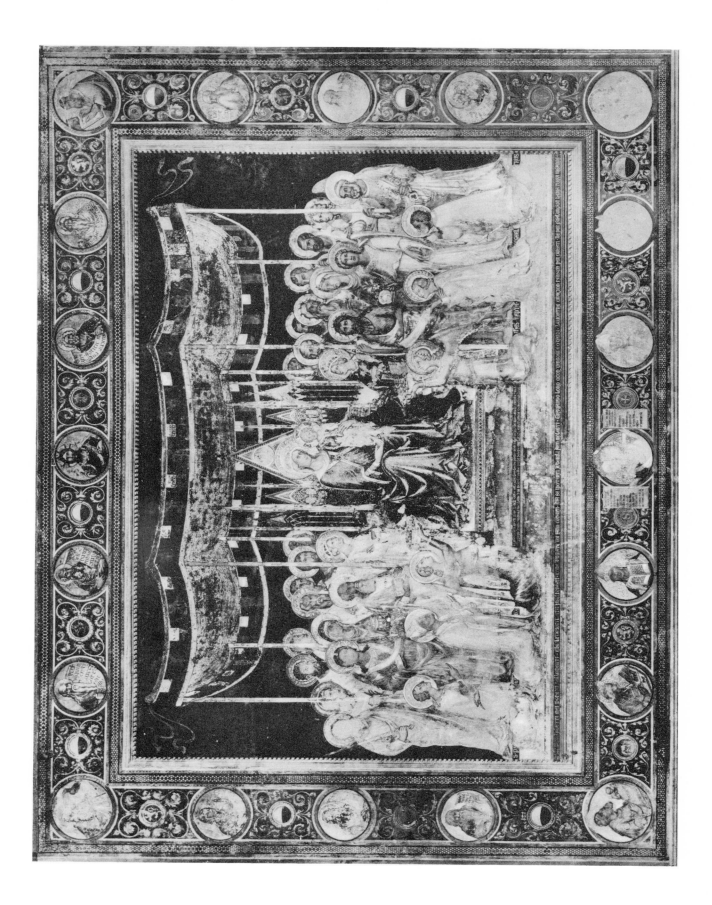

37

SIMONE MARTINI
The Madonna enthroned with Saints, 1315, Fresco.
Detail: The Madonna.
SIENA. PALAZZO PUBBLICO, HALL OF THE GRAND COUNCIL
Photo Anderson

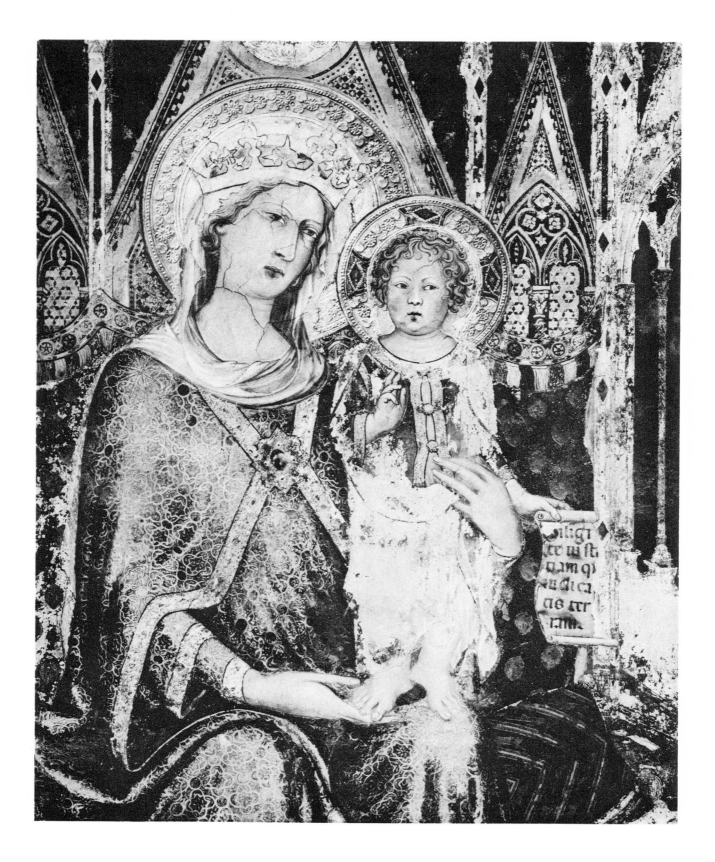

38
SIMONE MARTINI
The Madonna enthroned with Saints, 1315, Fresco.
Detail: Head of St. Catherine.
SIENA. PALAZZO PUBBLICO, HALL OF THE GRAND COUNCIL
Photo Anderson

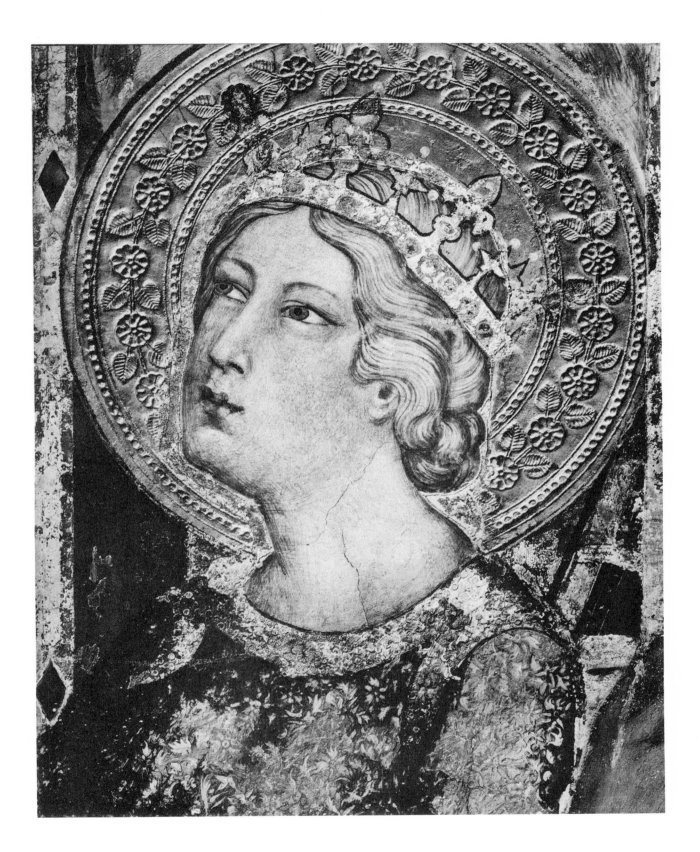

39

SIMONE MARTINI
St. Louis of Toulouse crowning King Robert of Naples
(painted in 1317 or 1318).
NAPLES. MUSEO NAZIONALE
Photo Anderson

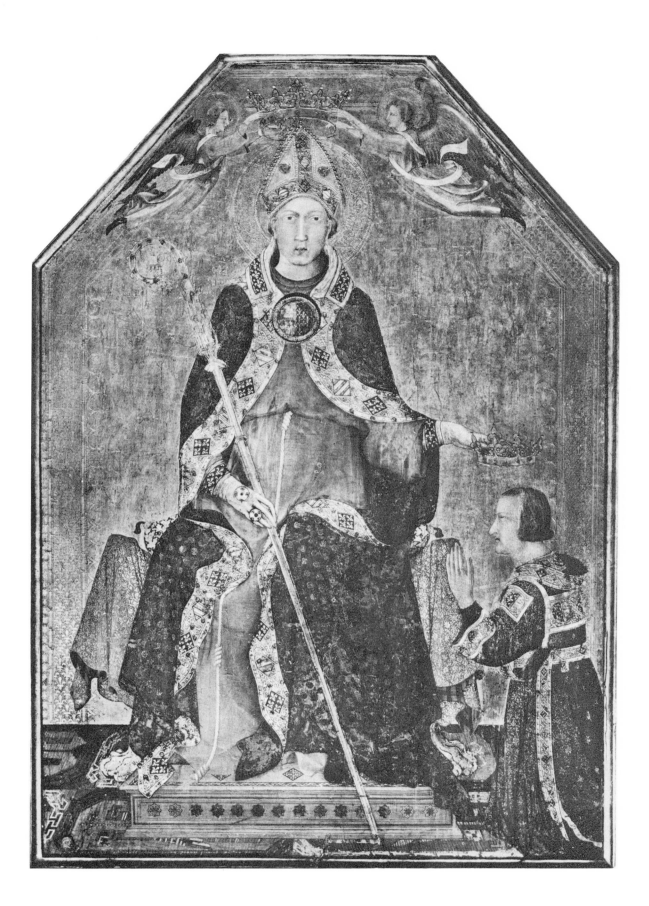

SIMONE MARTINI
St. Louis of Toulouse crowning King Robert of Naples,
(painted in 1317 or 1318)
Detail: Head of St. Louis.
NAPLES. MUSEO NAZIONALE
Photo Anderson

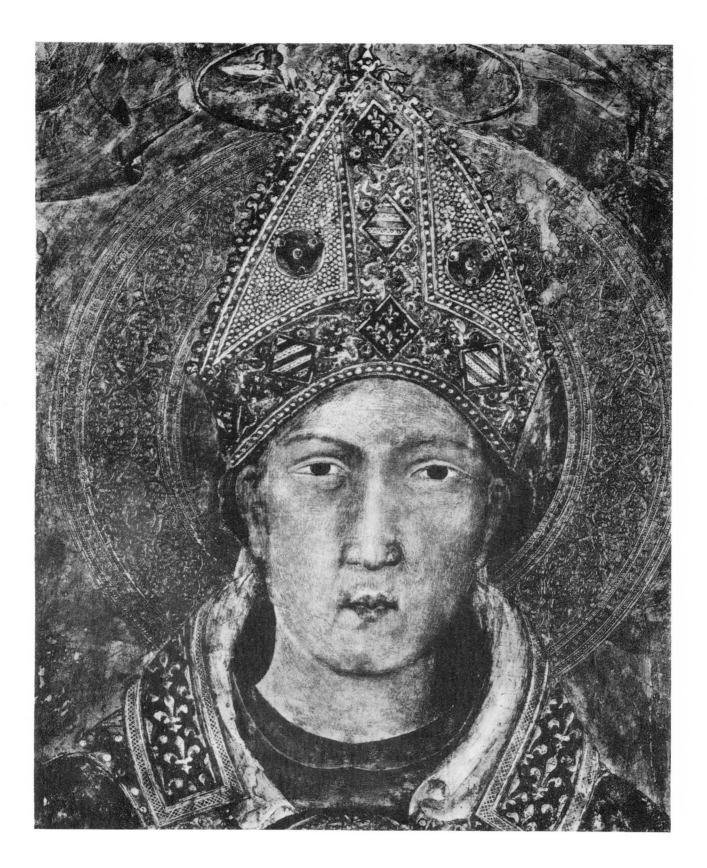

41

SIMONE MARTINI
Polyptych of 1320, Predella. Details:
A. St. Thomas Aquinus and St. Augustine.
B. St. Jerome and St. Lucy.
PISA. MUSEO CIVICO
Photo Anderson

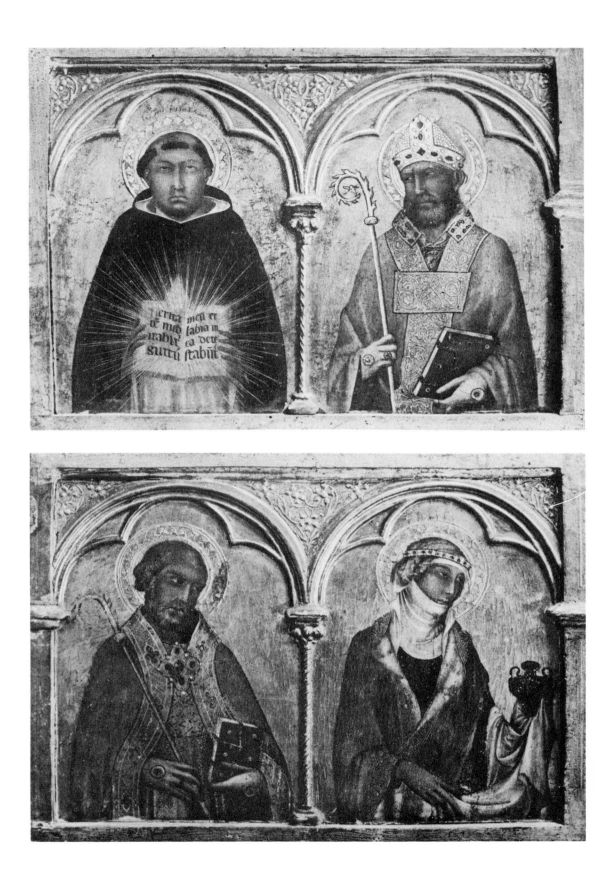

42

SIMONE MARTINI
Polyptych of 1320,
Centre-piece: The Madonna.
ORVIETO. OPERA DEL DUOMO
Photo Alinari

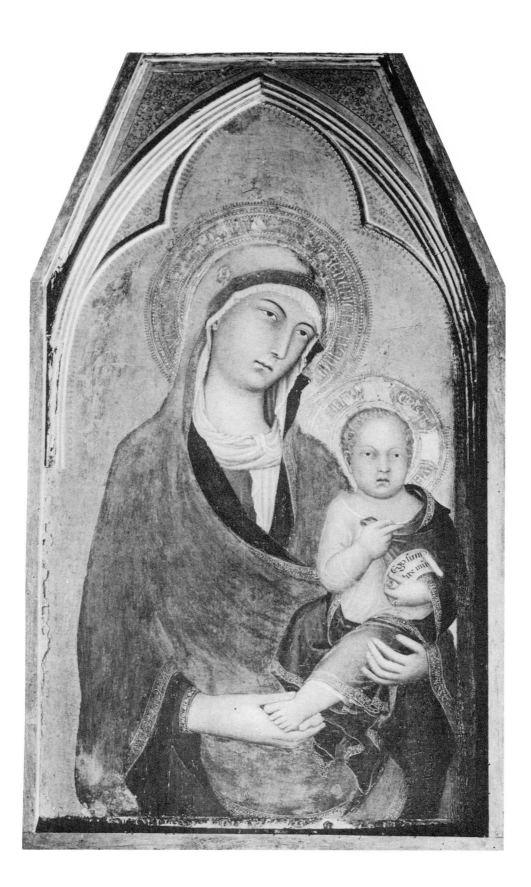

43

SIMONE MARTINI
Madonna between St. Lucy and St. Catherine.
FENWAY COURT NEAR BOSTON. GARDNER COLLECTION
Photo Anderson

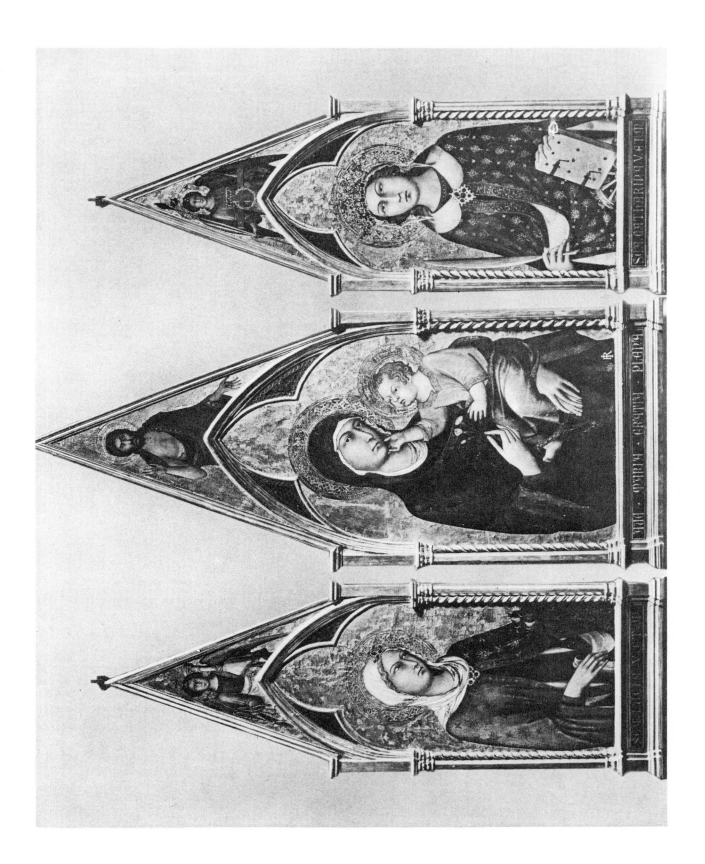

44

SIMONE MARTINI
Portrait of the Condottiero Guidoriccio de' Fogliani. 1328.
SIENA. PALAZZO PUBBLICO, HALL OF THE GRAND COUNCIL
Photo Alinari

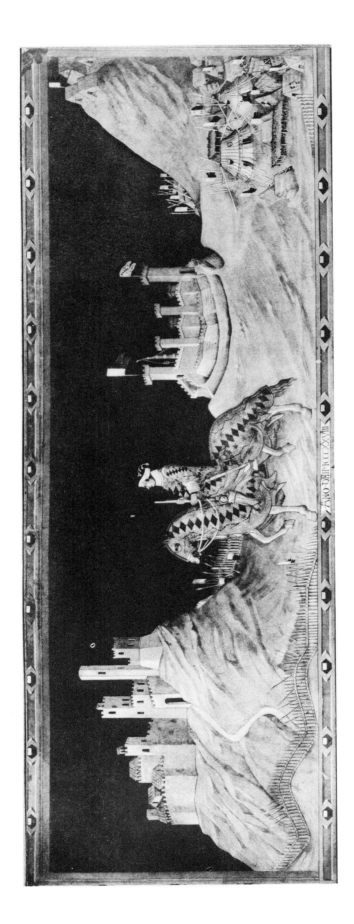

45

SIMONE MARTINI
Portrait of the Condottiero Guidoriccio de' Fogliani. 1328.
Detail.
SIENA. PALAZZO PUBBLICO, HALL OF THE GRAND COUNCIL
Photo Anderson

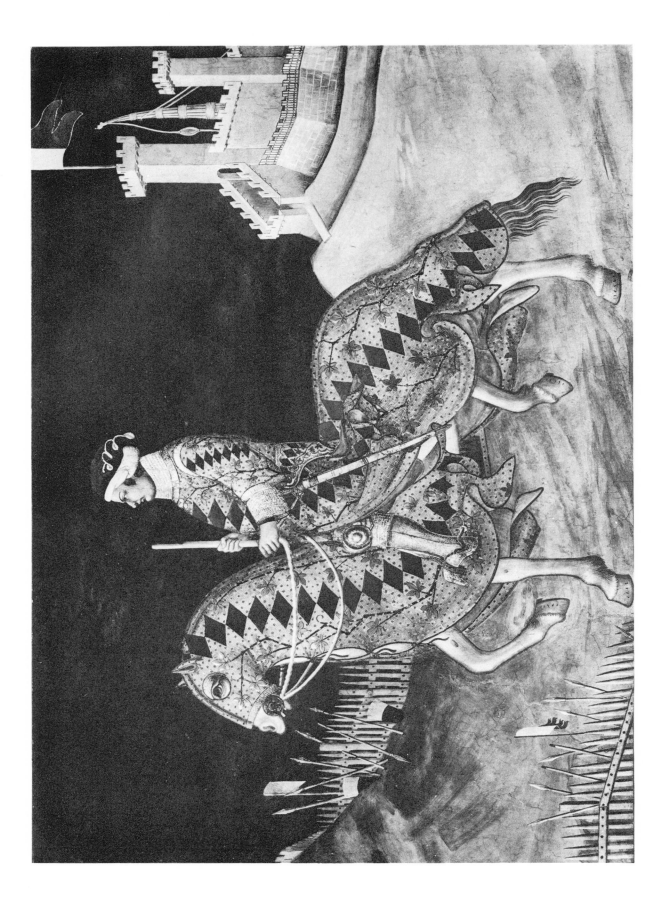

46

SIMONE MARTINI (AND LIPPO MEMMI)
The Annunciation, with St. Ansanus and St. Julia. 1333.
FLORENCE. UFFIZI
Photo Brogi

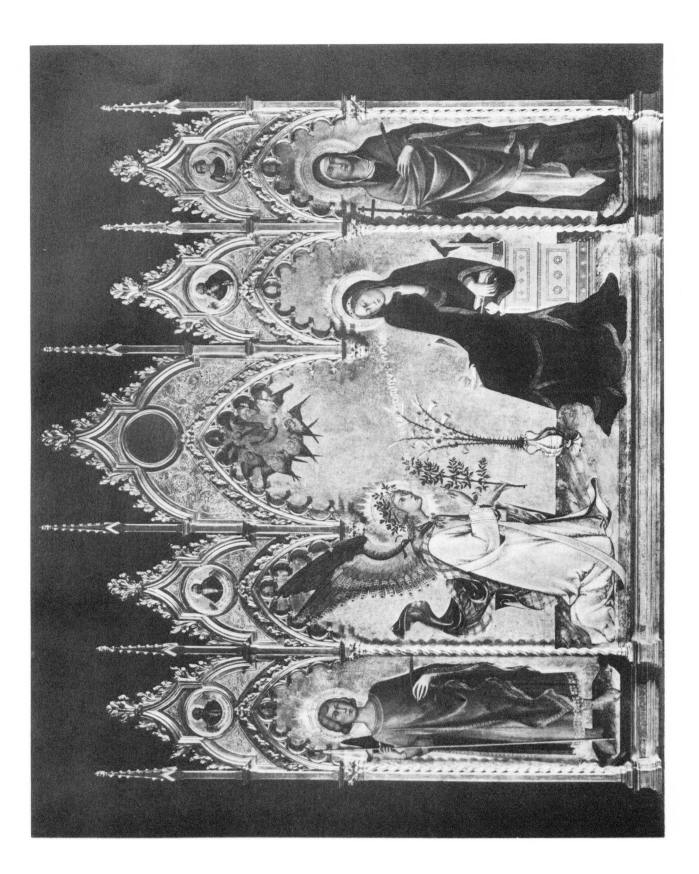

47

SIMONE MARTINI (AND LIPPO MEMMI)
The Annunciation, with St. Ansanus and St. Julia. 1333.
Detail: The Virgin.
FLORENCE. UFFIZI
Photo Brogi

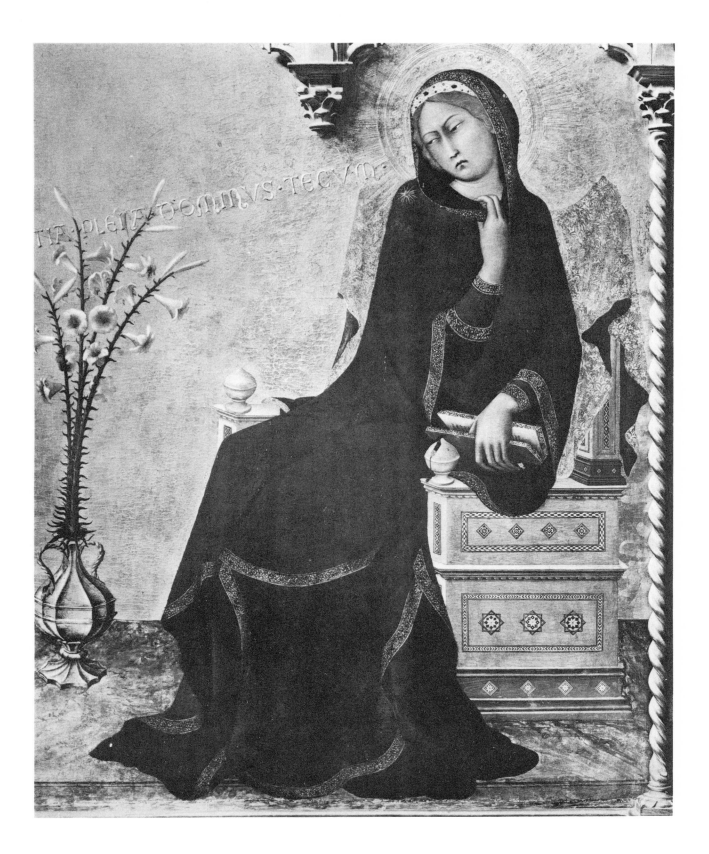

48

SIMONE MARTINI (AND LIPPO MEMMI)
The Annunciation, with St. Ansanus and St. Julia. 1333.
Detail: Head of the Virgin.
FLORENCE, UFFIZI
Photo Brogi

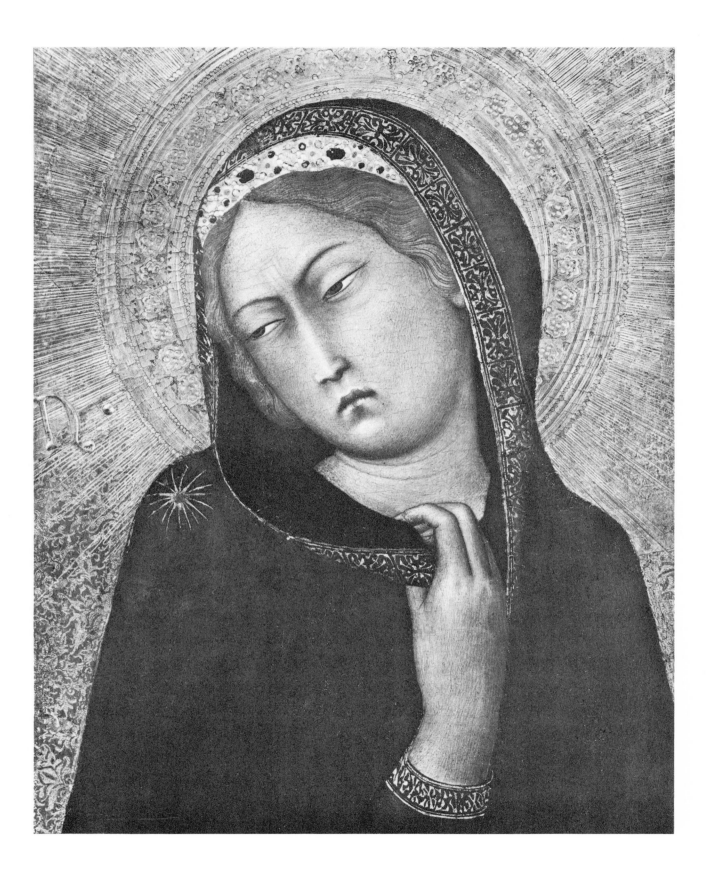

49

SIMONE MARTINI
Sant'Agostino Novello, with Scenes from his Legend.
SIENA. SANT'AGOSTINO
Photo Anderson

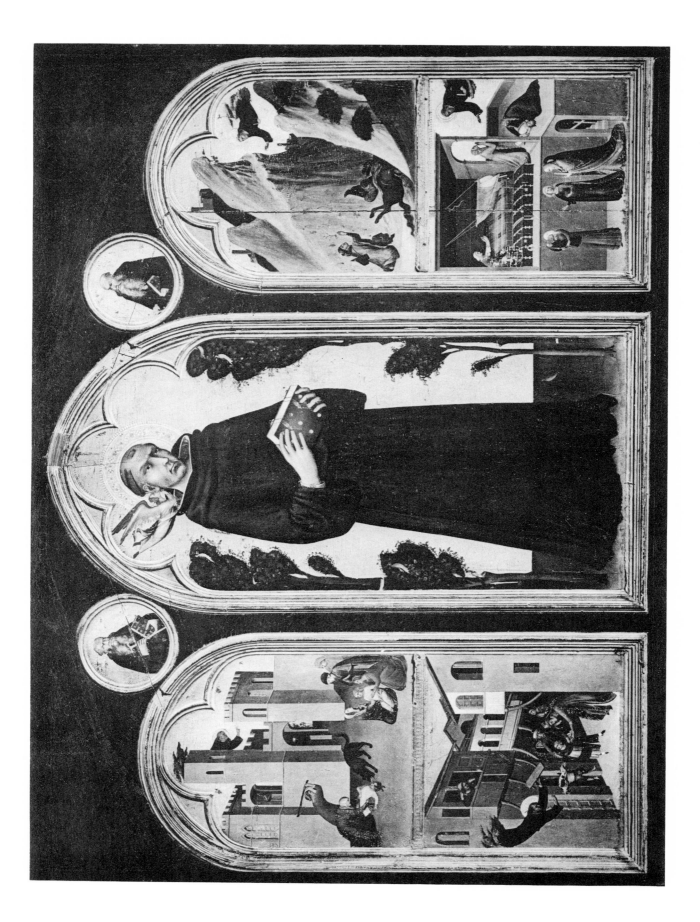

50

SIMONE MARTINI
Sant'Agostino Novello, with Scenes from his Legend.
Detail: The mother carries her resuscitated child to the church.
SIENA. SANT'AGOSTINO
Photo Alinari

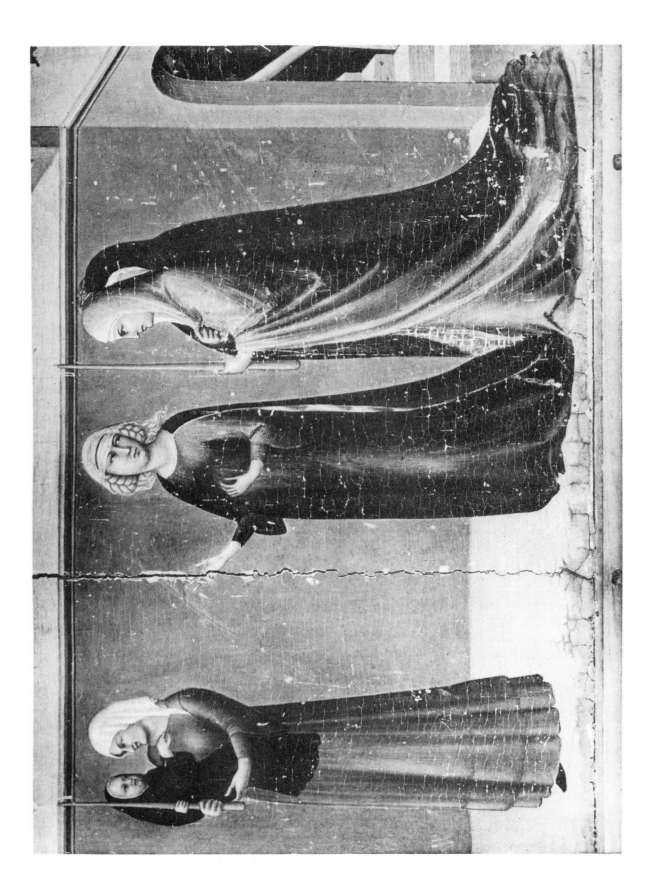

51
SIMONE MARTINI
St. Martin knighted by the Emperor Julian, Fresco.
ASSISI. SAN FRANCESCO, LOWER CHURCH, ST. MARTIN'S CHAPEL
Photo Anderson

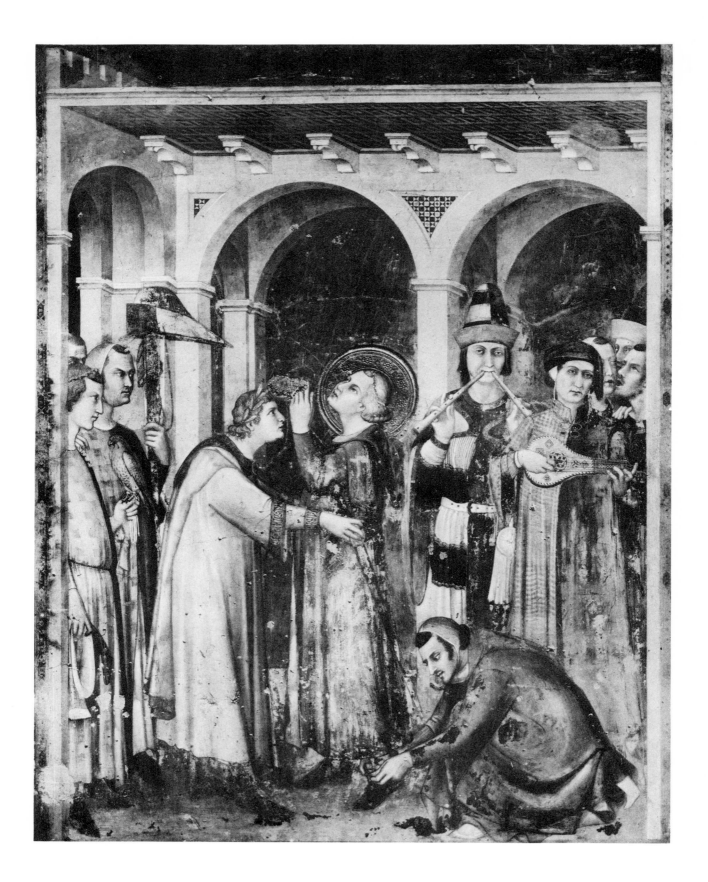

52

SIMONE MARTINI
St. Martin knighted by the Emperor Julian, Fresco.
Detail: The Musicians.
ASSISI. SAN FRANCESCO, LOWER CHURCH, ST. MARTIN'S CHAPEL
Photo Anderson

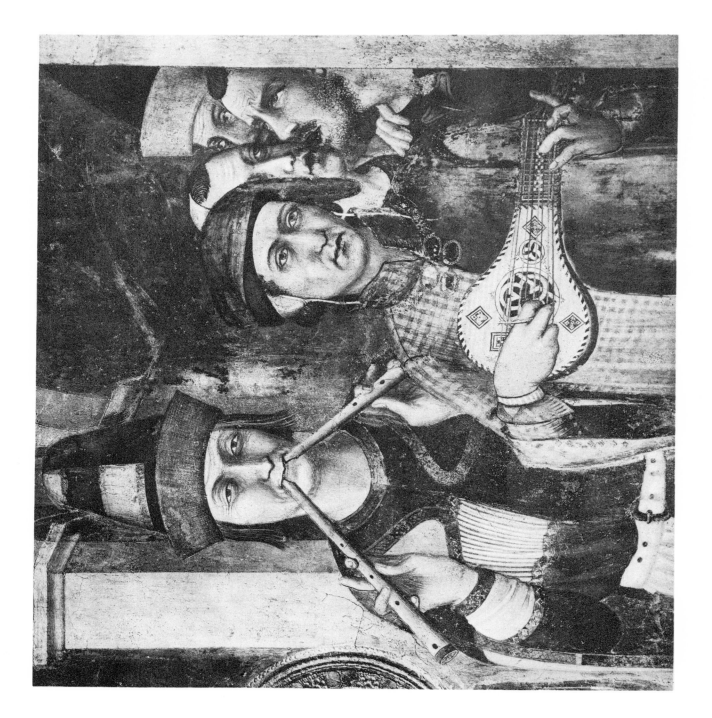

53

SIMONE MARTINI
The Emperor Valentinian humbling himself before St. Martin,
Fresco.
ASSISI. SAN FRANCESCO, LOWER CHURCH, ST. MARTIN'S CHAPEL
Photo Anderson

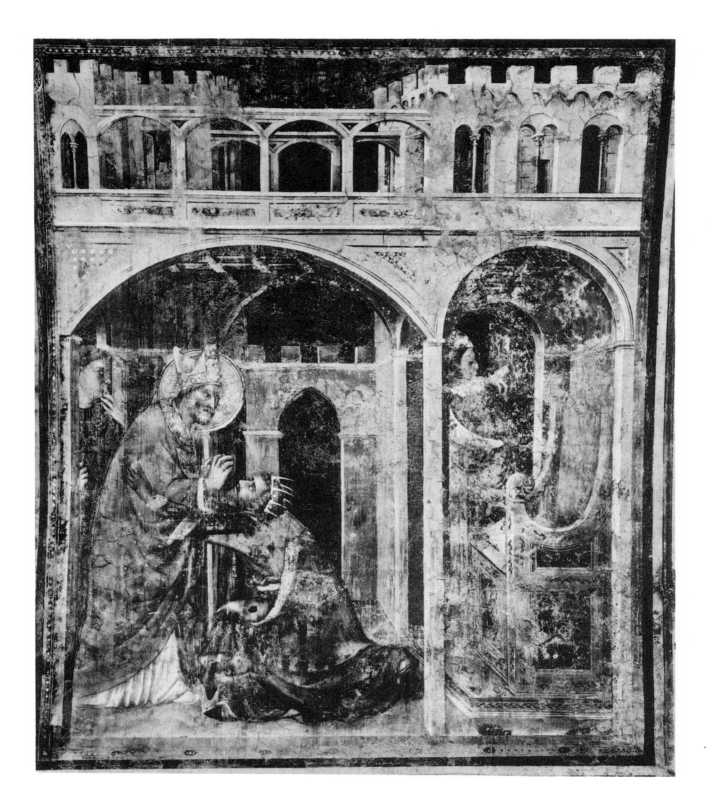

54

SIMONE MARTINI
St. Ambrose falls asleep during Mass and dreams that he is
present at the Obsequies of St. Martin, Fresco.
Assisi. San Francesco, Lower Church, St. Martin's Chapel
Photo Anderson

55

SIMONE MARTINI
The Obsequies of St. Martin, Fresco.
ASSISI. SAN FRANCESCO, LOWER CHURCH, ST. MARTIN'S CHAPEL
Photo Anderson

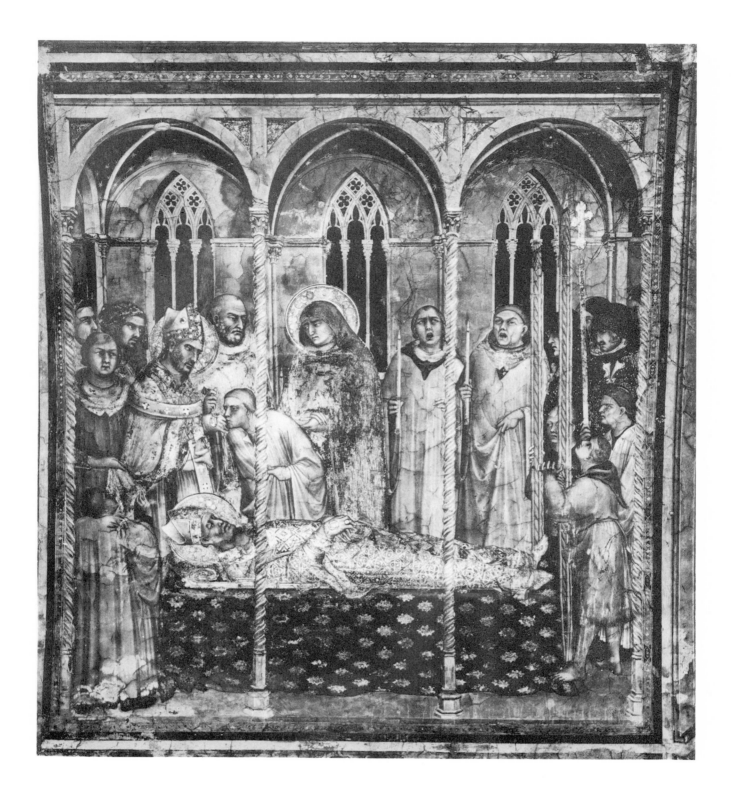

56

SIMONE MARTINI
The Obsequies of St. Martin, Fresco.
Detail: The singing Clerics.
ASSISI. SAN FRANCESCO, LOWER CHURCH, ST. MARTIN'S CHAPEL
Photo Anderson

57

SIMONE MARTINI
St. Mary Magdalen and St. Catherine, Fresco.
Assisi, San Francesco, Lower Church, Soffit of the
Entrance-Archway to the Chapel of St. Martin
Photo Anderson

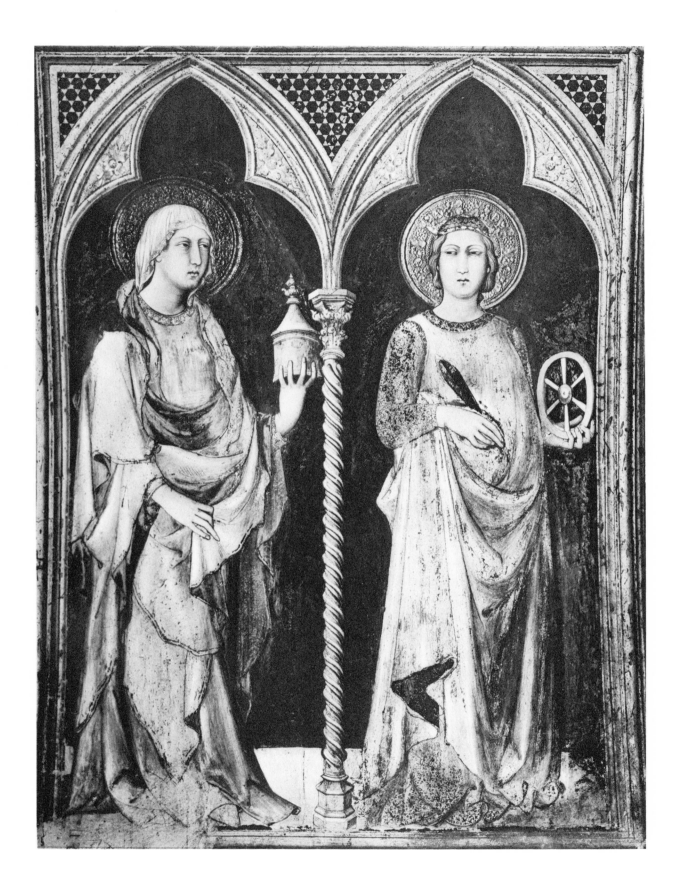

58

SIMONE MARTINI
Half Figure of a female Saint, Fresco.
ASSISI. SAN FRANCESCO, LOWER CHURCH, RIGHT TRANSEPT
Photo Alinari

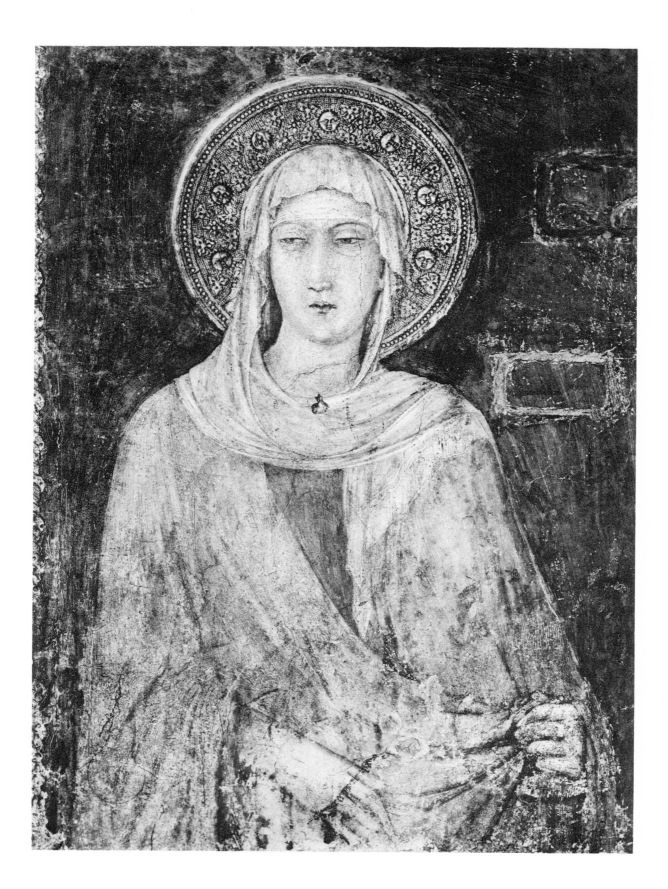

59

SIMONE MARTINI
Jesus reproved by his anxious parents after his return from
the Temple. 1342.
LIVERPOOL, ROYAL INSTITUTE OF ARTS
Photo Mansell, London

60

SIMONE MARTINI
A. The Bearing of the Cross.
PARIS. LOUVRE

B. The Crucifixion.
ANTWERP. MUSEUM
Photo Alinari

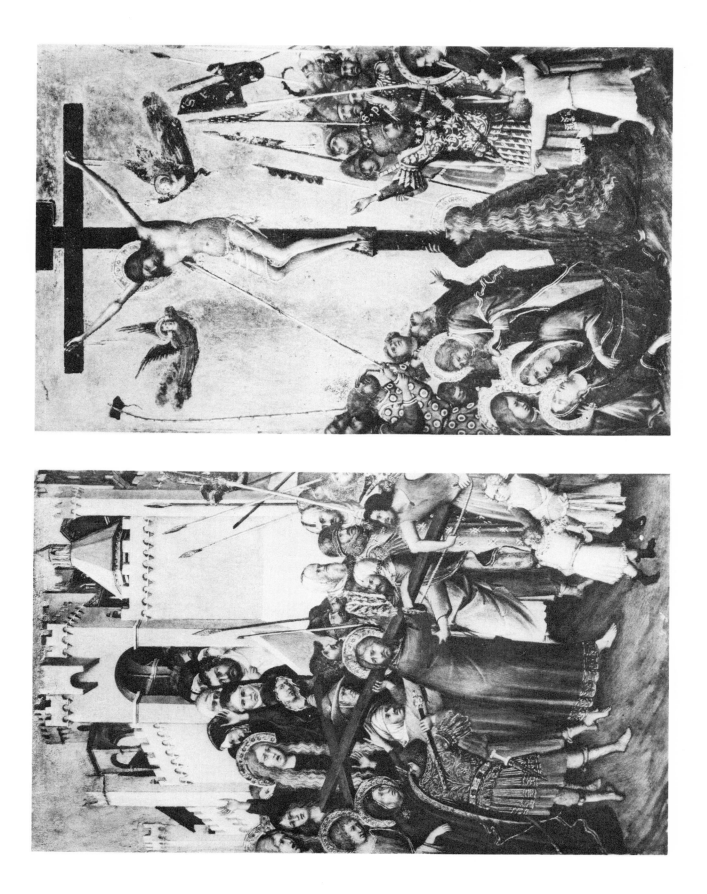

61

SIMONE MARTINI
A. The Deposition.
ANTWERP. MUSEUM

B. The Entombment.
BERLIN. KAISER FRIEDRICH MUSEUM
Photo Kaiser Friedrich Museum

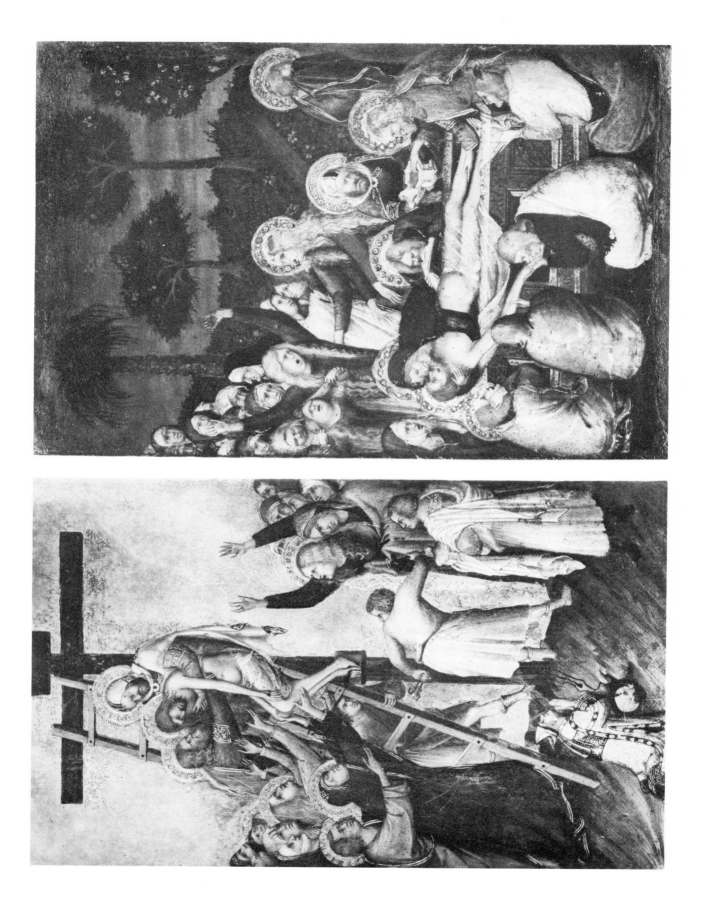

62

NICCOLÒ DI SER SOZZO TEGLIACCI
Caleffo dell'Assunta, 1332. Miniature on the title-page of
a manuscript.
Detail: The Ascension of the Virgin.
SIENA. STATE ARCHIVES
Photo Anderson

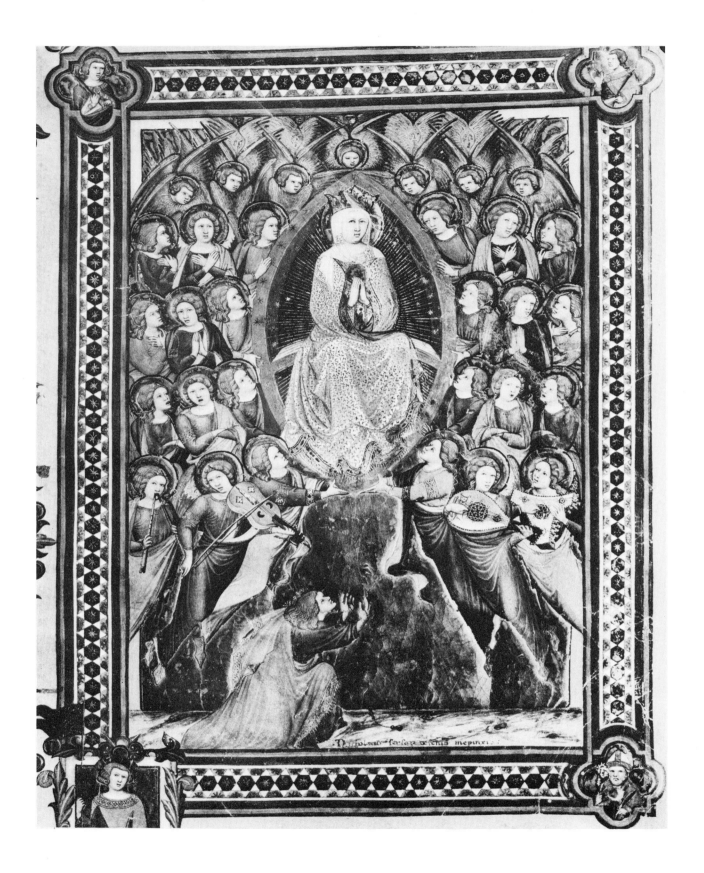

63

LIPPO MEMMI
Maestà, Fresco. 1317.
San Gimignano. Palazzo Pubblico
Photo Alinari

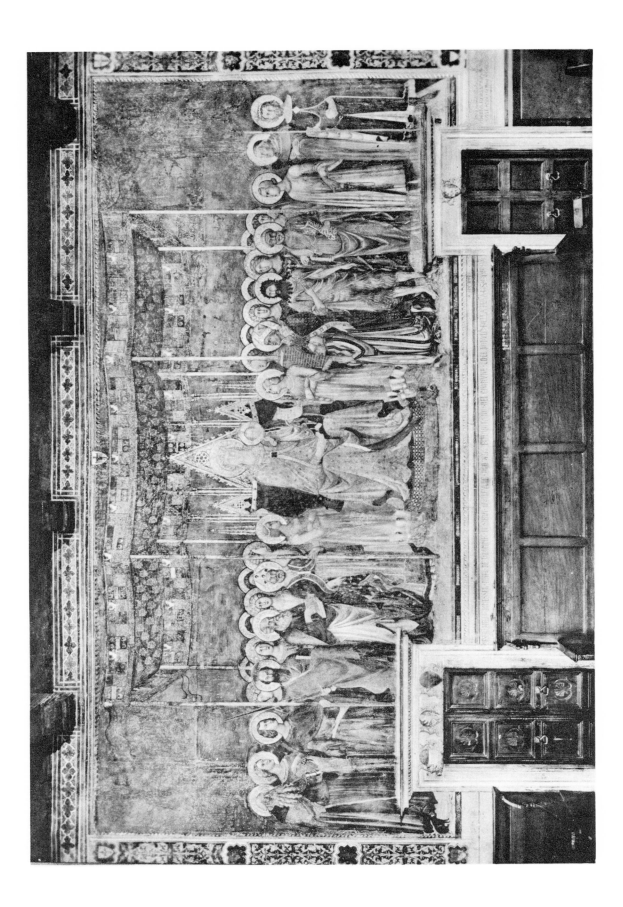

64

LIPPO MEMMI
Maestà, Fresco. 1317. Details:
A. St. John the Baptist.
B. St. John the Evangelist.
SAN GIMIGNANO. PALAZZO PUBBLICO
Photo Alinari

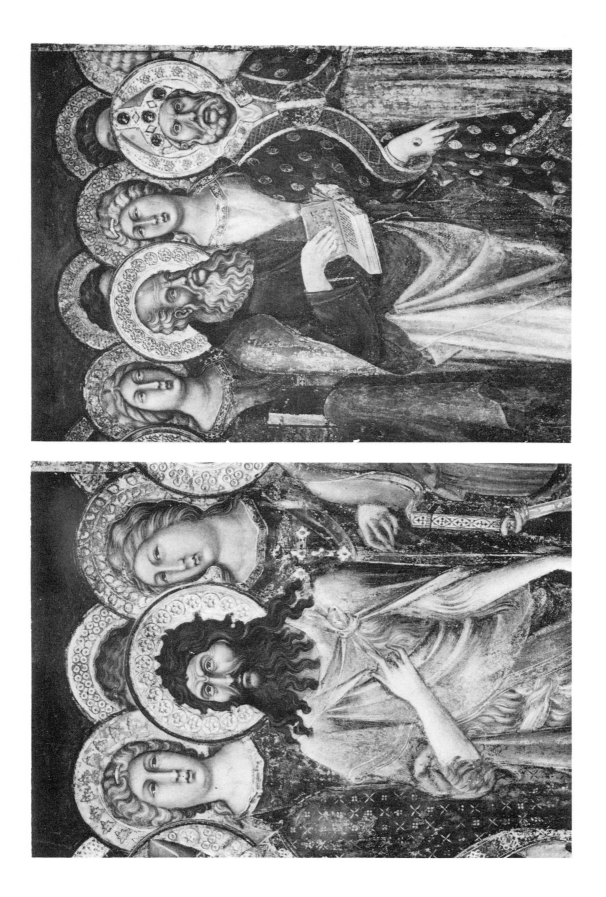

65

LIPPO MEMMI
Madonna del Popolo.
SIENA. CHURCH OF THE SERVI
Photo Anderson

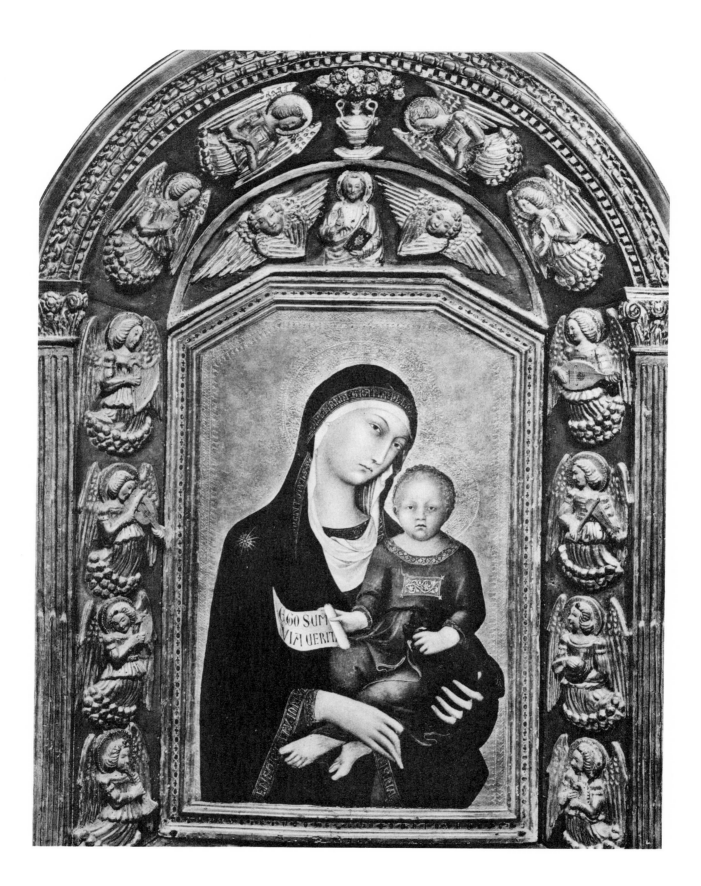

66

LIPPO MEMMI
Madonna and Child.
BERLIN. KAISER FRIEDRICH MUSEUM

67

BARNA
The Marriage at Cana, Fresco.
SAN GIMIGNANO. COLLEGIATA
Photo Alinari

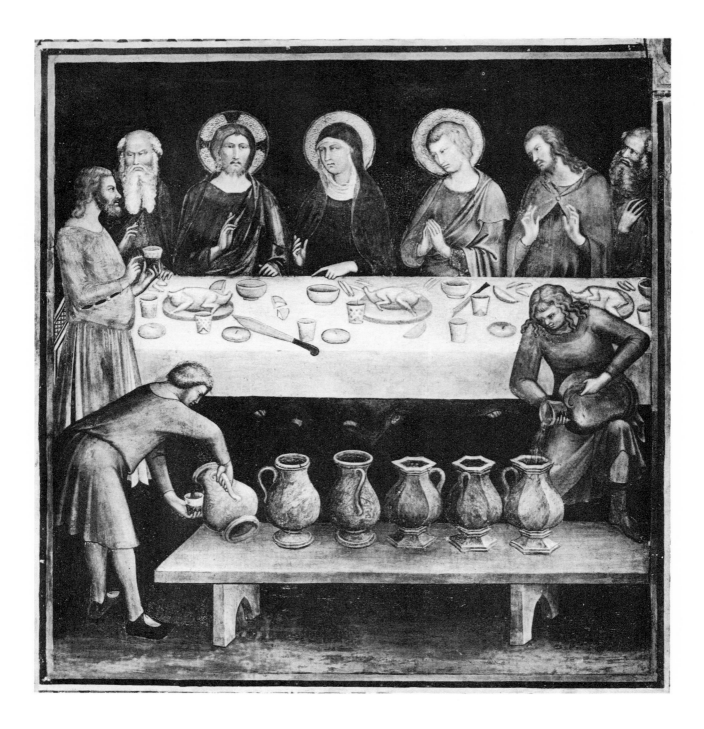

68

BARNA
The Bearing of the Cross, Fresco.
San Gimignano. Collegiata
Photo Alinari

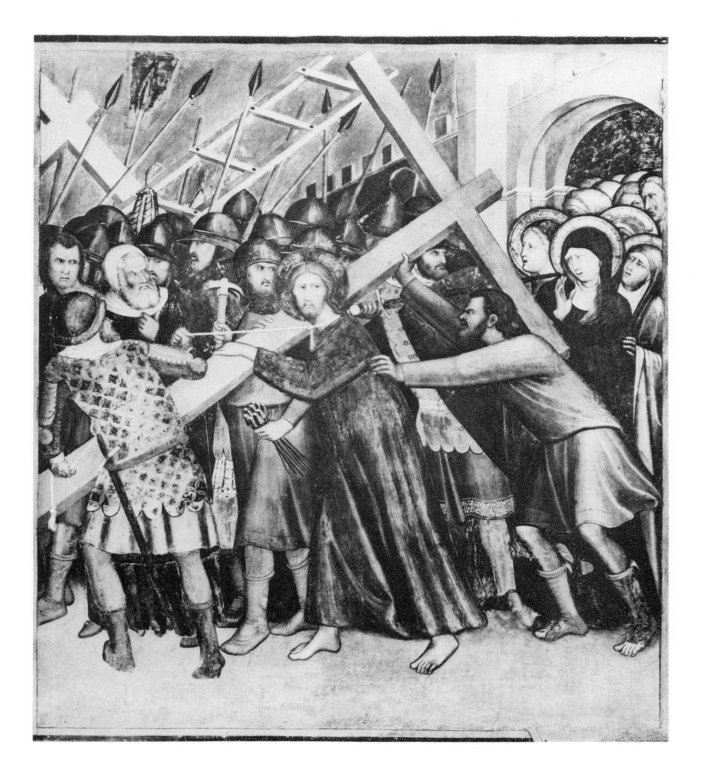

69

BARNA
The Crucifixion, Fresco.
Detail: The Virgin falls into a swoon.
SAN GIMIGNANO. COLLEGIATA
Photo Alinari

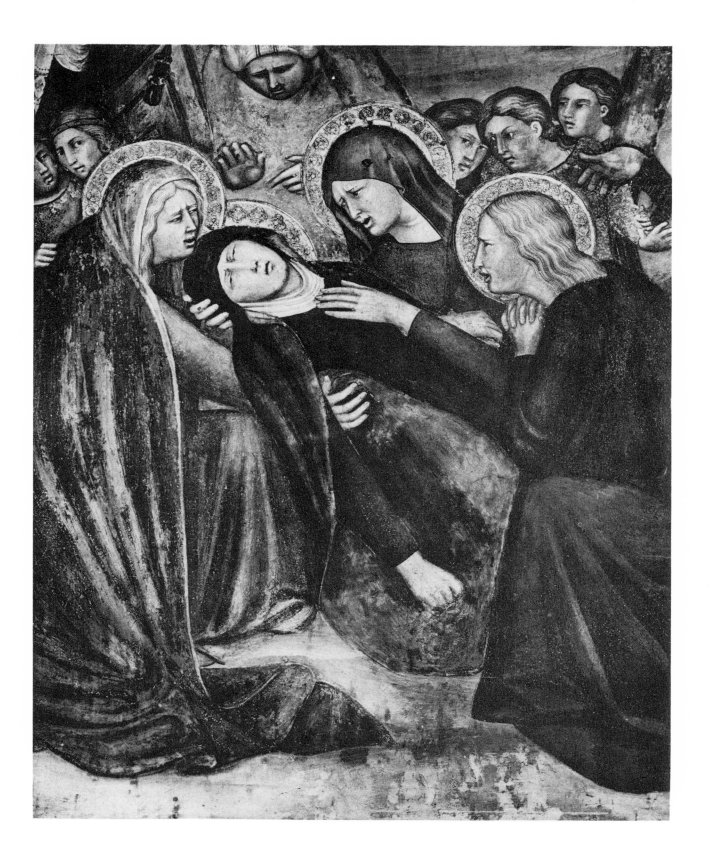

70
PIETRO LORENZETTI
Madonna with Child and Angels.
CORTONA. CATHEDRAL
Photo Alinari

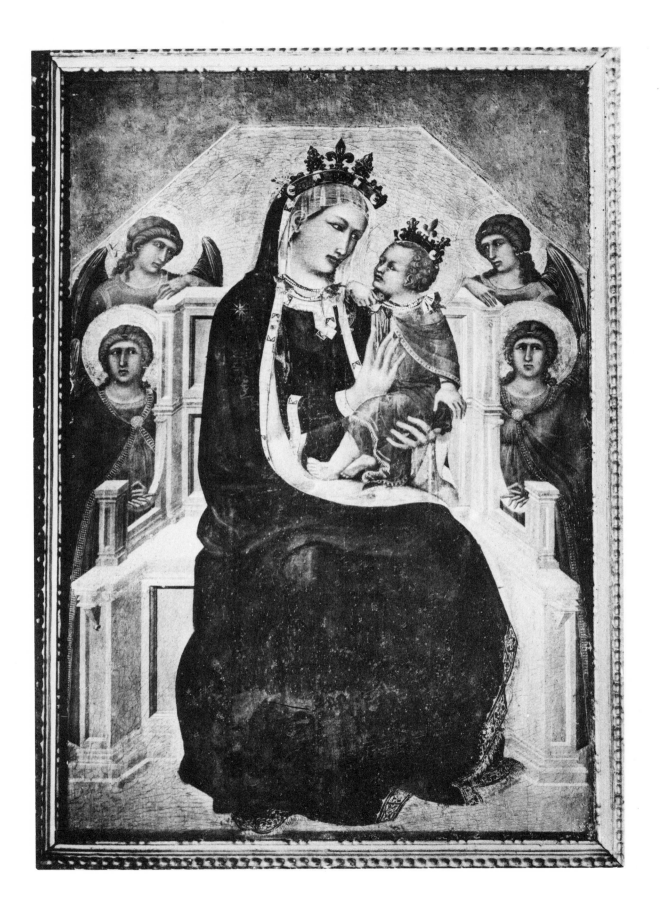

71

SCHOOL OF PIETRO LORENZETTI
Half Figure of the Madonna with Child.
FLORENCE. CHARLES LOESER COLLECTION
Photo Brogi

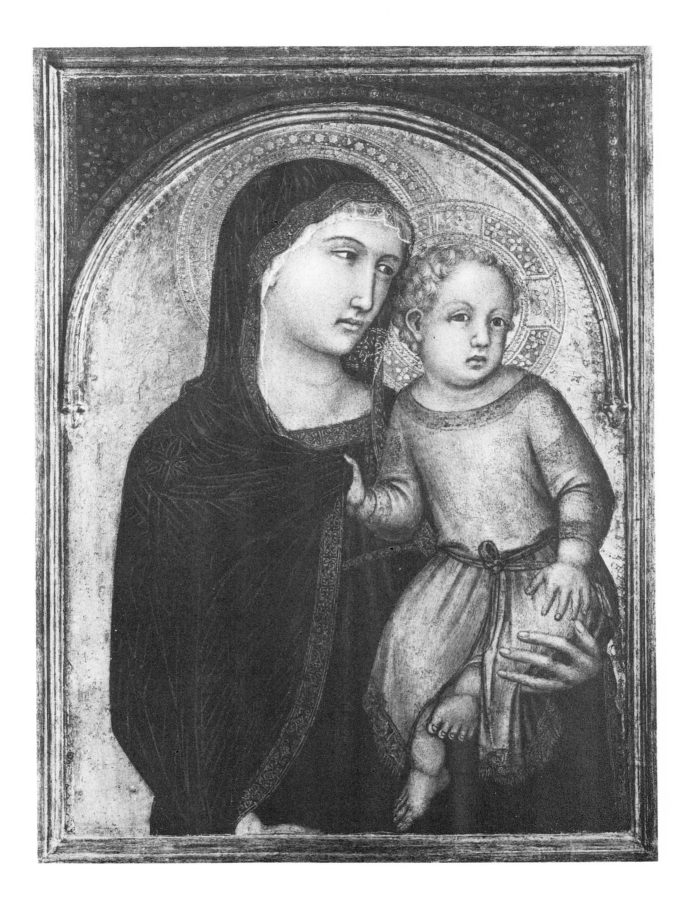

72

PIETRO LORENZETTI

Polyptych: Madonna and Child, with St. Donatus, St. John
the Evangelist, St. John the Baptist and St. Matthew, 1320.
AREZZO. SANTA MARIA DELLA PIEVE

73

PIETRO LORENZETTI
Polyptych: Madonna and Child with St. Donatus, St. John
the Evangelist, St. John the Baptist and St. Matthew, 1320.
Detail: The Madonna and Child.
AREZZO. SANTA MARIA DELLA PIEVE

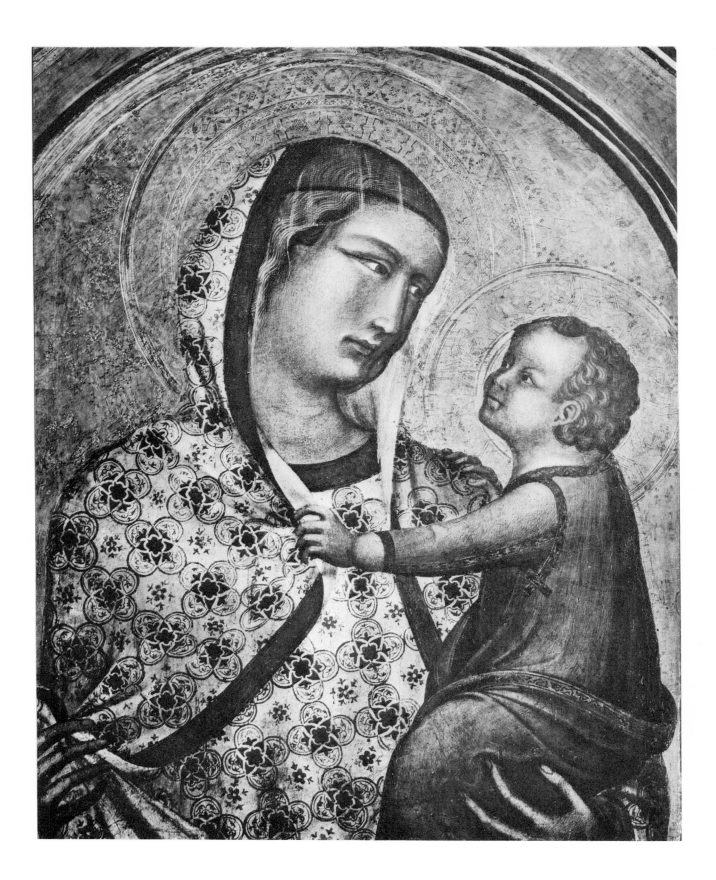

74

PIETRO LORENZETTI
Polyptych: Madonna and Child with St. Donatus, St. John
the Evangelist, St. John the Baptist and St. Matthew, 1320.
Detail: St. John the Evangelist.
Arezzo. Santa Maria della Pieve

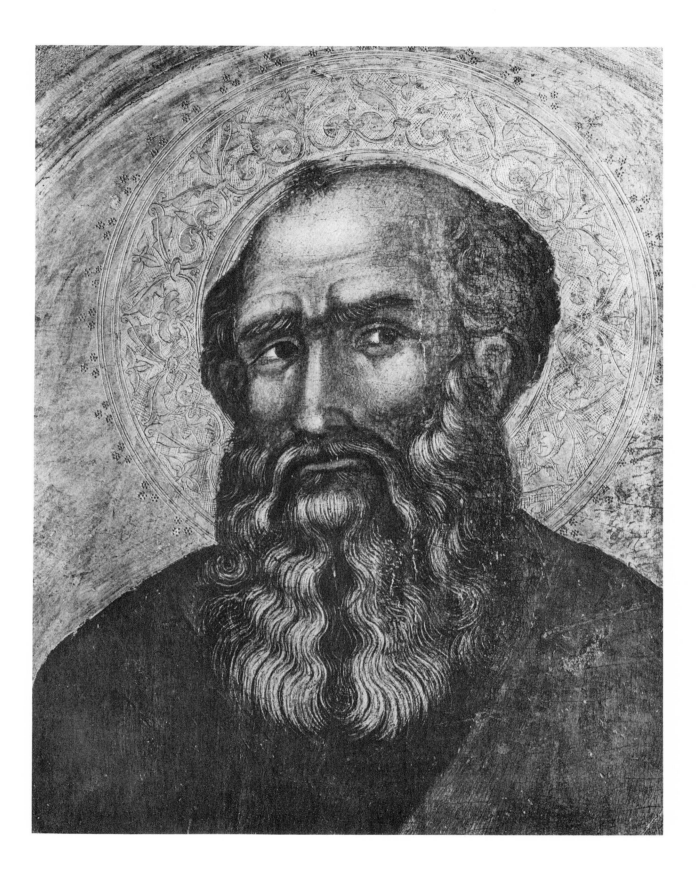

75

PIETRO LORENZETTI
Four predella-pieces with scenes from the history of the
Carmelite Order, 1329:
A. The Angel appears to Sobac in a dream and informs him
that his son Elijah will found the Carmelite Order.
B. Hermit Life of the Carmelite Monks at the well of Elijah.
C. Pope Honorius III confirms the rules of the Carmelite
Order in 1227.
D. Pope Innocent IV invests the Carmelites with a new monastic
garb in 1245.
SIENA. ACCADEMIA
Photo Alinari

76

PIETRO LORENZETTI
Predella: Pope Honorius III confirms the rules of the Carmelite
Order.
SIENA. ACCADEMIA
Photo Anderson

77

PIETRO LORENZETTI
The Crucifixion, Fresco.
SIENA. SAN FRANCESCO
Photo Anderson

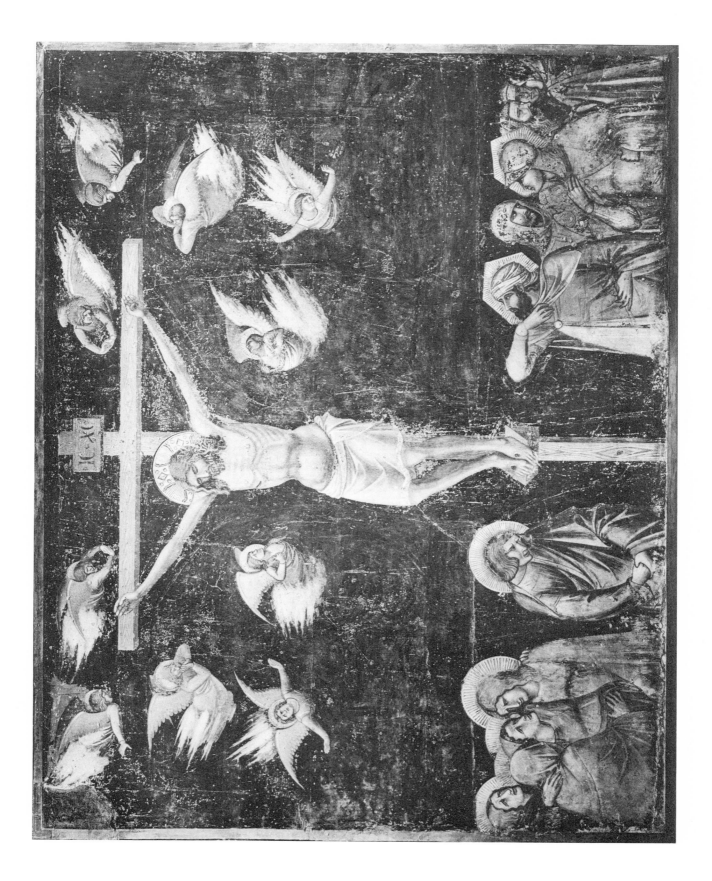

PIETRO LORENZETTI
The Massacre of the Innocents, Fresco.
SIENA. CHURCH OF THE SERVI
Photo Anderson

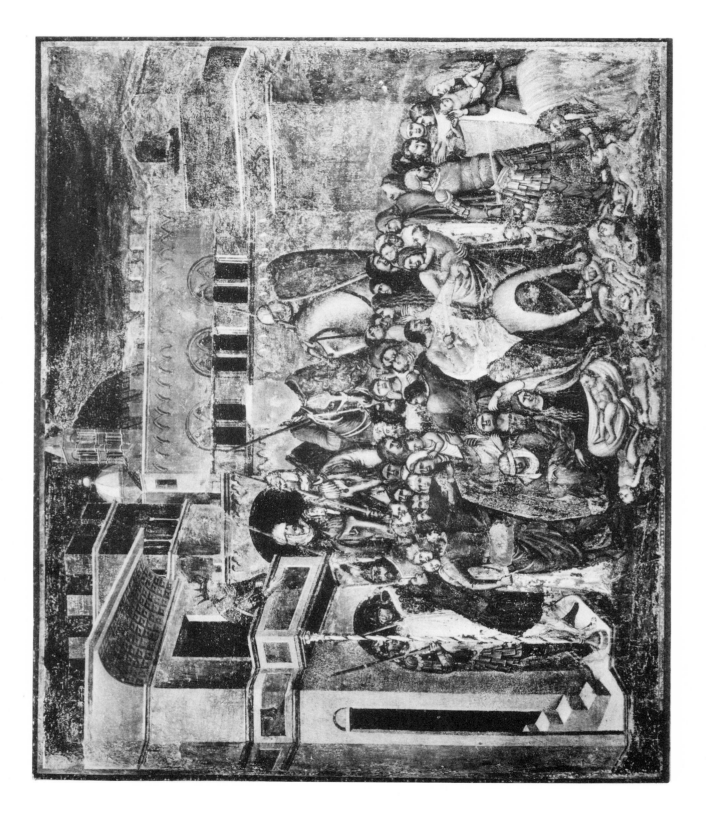

79

PIETRO LORENZETTI
The Beheading of John the Baptist and the Dance of Salome,
Fresco.
Siena. Church of the Servi
Photo Anderson

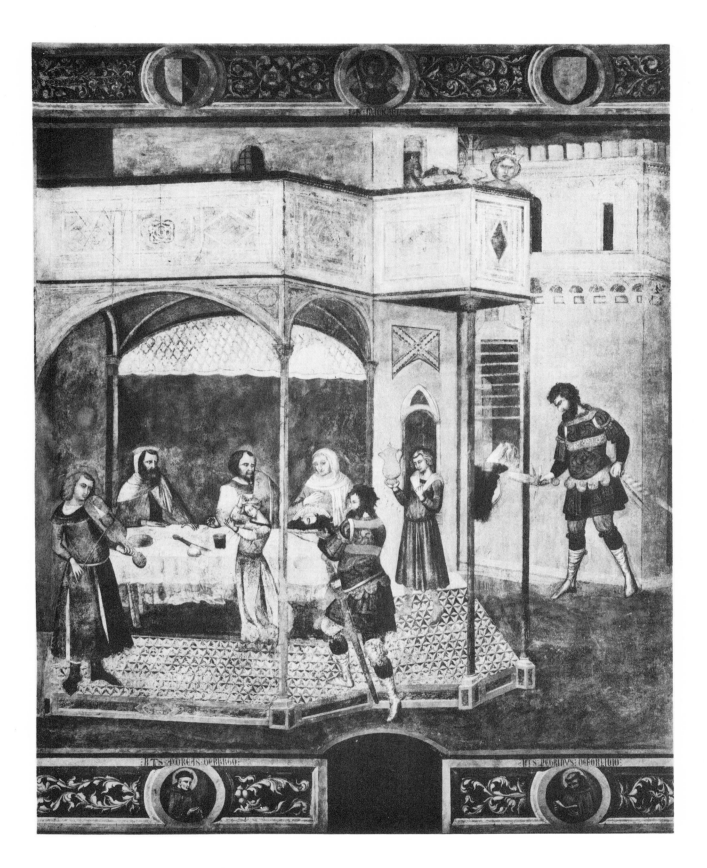

80

PIETRO LORENZETTI
Ascension of St. John the Evangelist, Fresco.
SIENA. CHURCH OF THE SERVI
Photo Alinari

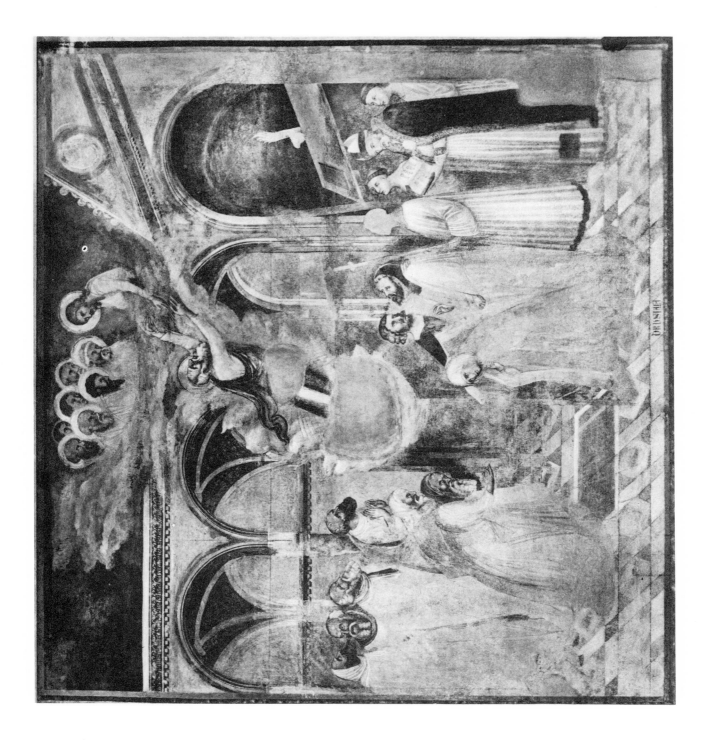

81

PIETRO LORENZETTI
The Madonna between St. Francis and St. John the Evangelist,
Fresco.
ASSISI. SAN FRANCESCO, LOWER CHURCH, LEFT TRANSEPT
Photo Anderson

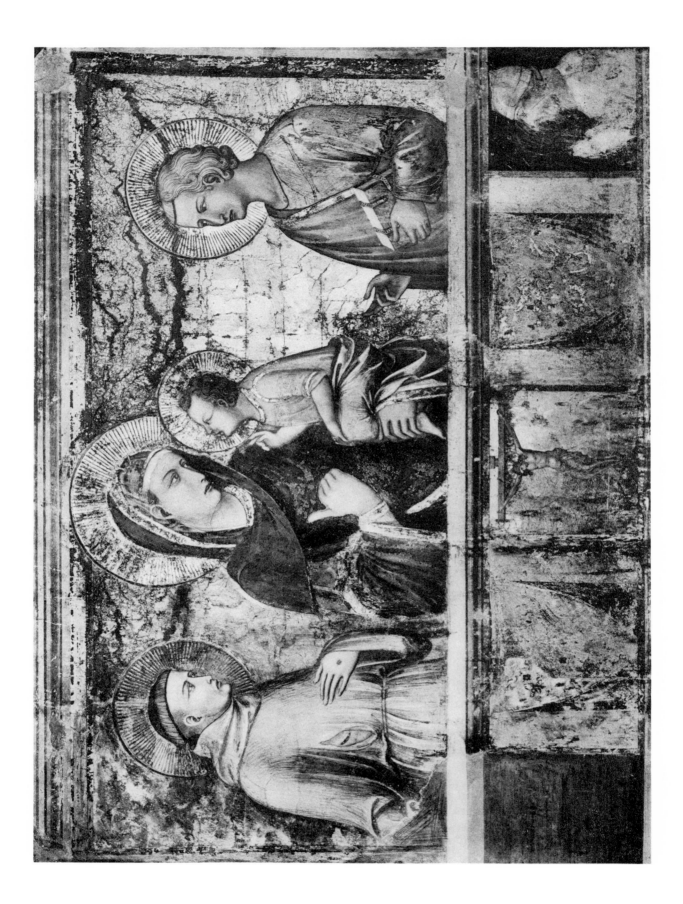

82

PIETRO LORENZETTI
The Deposition, Fresco.
ASSISI. SAN FRANCESCO, LOWER CHURCH, LEFT TRANSEPT
Photo Anderson

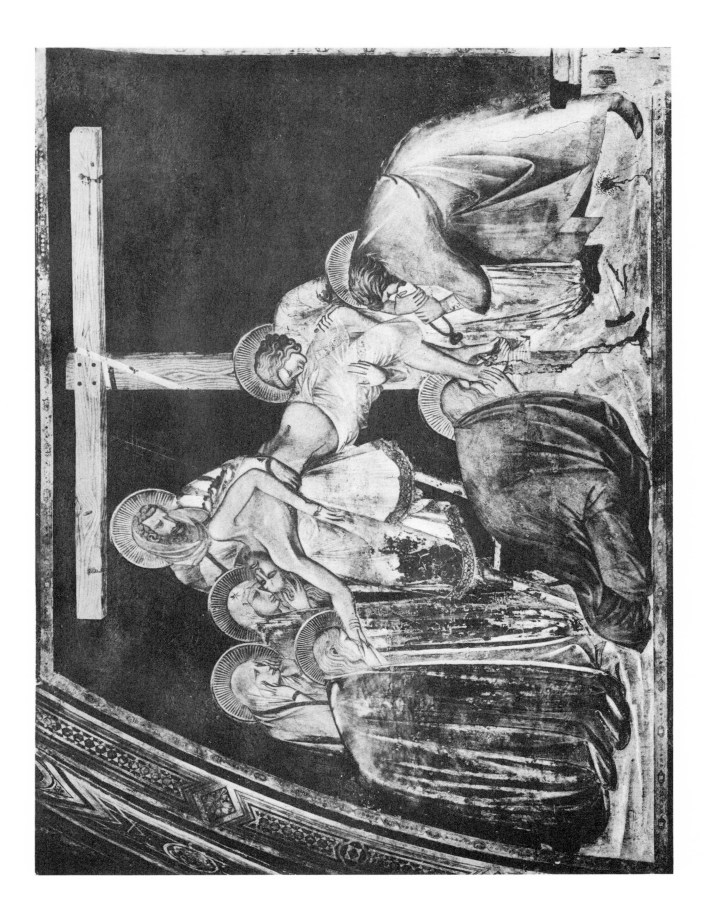

83

PIETRO LORENZETTI
The Crucifixion, Fresco.
ASSISI. SAN FRANCESCO, LOWER CHURCH, LEFT TRANSEPT
Photo Anderson

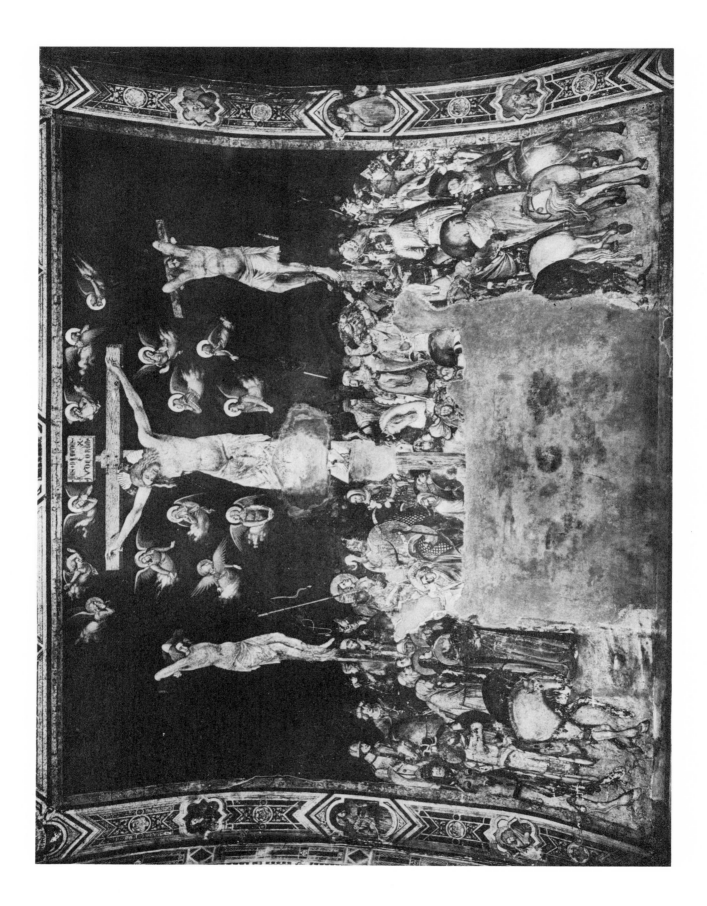

84

PIETRO LORENZETTI
The Crucifixion, Fresco.
Detail: Christ on the Cross, with the mourning Angels.
ASSISI. SAN FRANCESCO, LOWER CHURCH, LEFT TRANSEPT
Photo Anderson

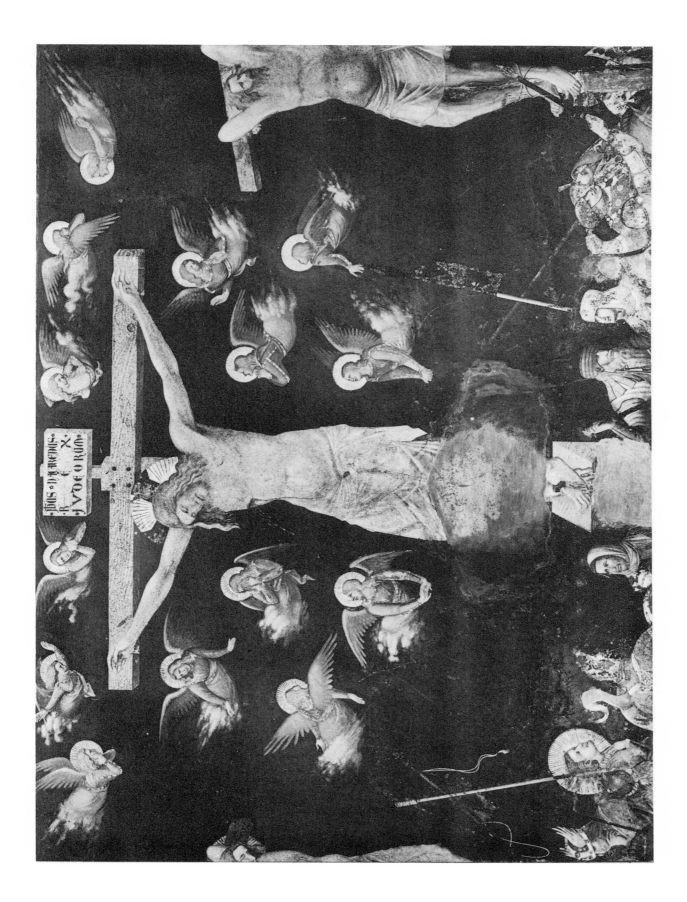

85

PIETRO LORENZETTI
St. Humilitas of Faenza, with scenes from her Legend, 1341.
FLORENCE. UFFIZI
Photo Alinari

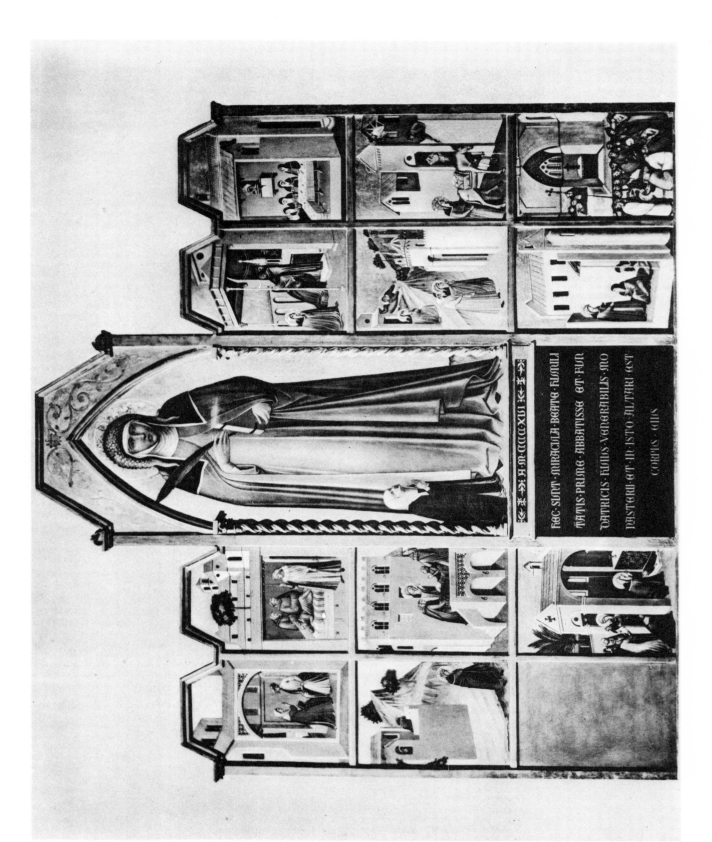

HEC · SUNT · MIRACULA · BEATE · HUMILI
TATIS · PRIME · ABBATISSE · ET · FUN
DATRICIS · HUIUS · VENERABILIS · MO
NASTERII · ET · IN · ISTO · ALTARI · EST
CORPUS · EIUS

86

PIETRO LORENZETTI
St. Humilitas of Faenza, with scenes from her Legend, 1341.
Details:
A. The Death of St. Humilitas.
B. St. Humilitas healing a nun.
BERLIN. KAISER FRIEDRICH MUSEUM

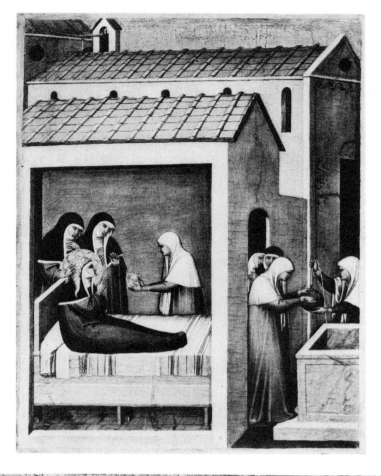

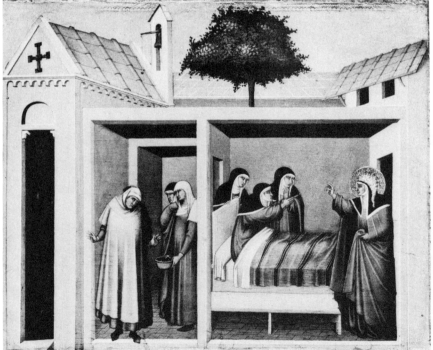

87

PIETRO LORENZETTI
Triptych: The Nativity of the Virgin, 1342.
SIENA. OPERA DEL DUOMO
Photo Anderson

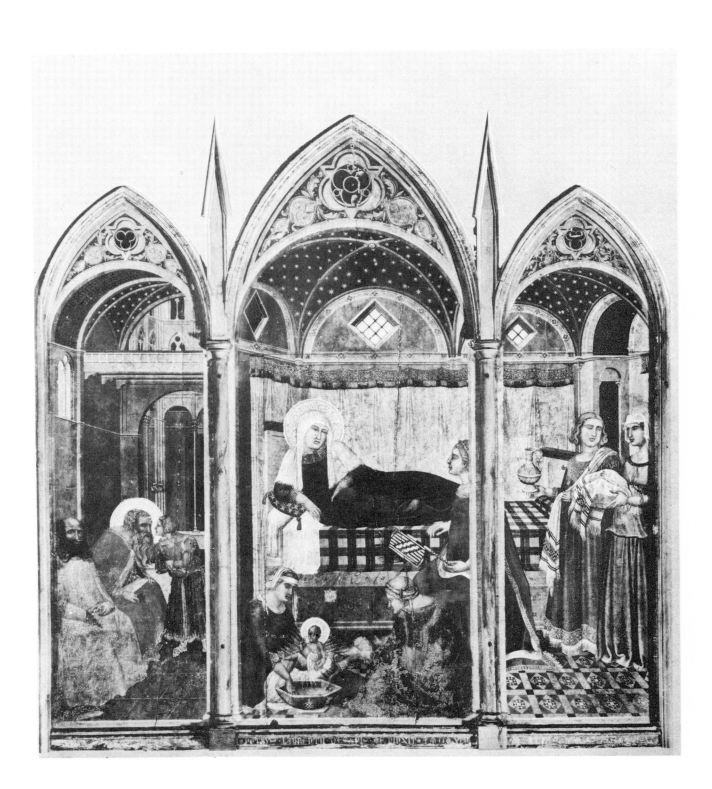

88

PIETRO LORENZETTI
Triptych: The Nativity of the Virgin, 1342.
Detail: The page brings Joachim the news of the birth
of the Virgin.
Siena. Opera del Duomo

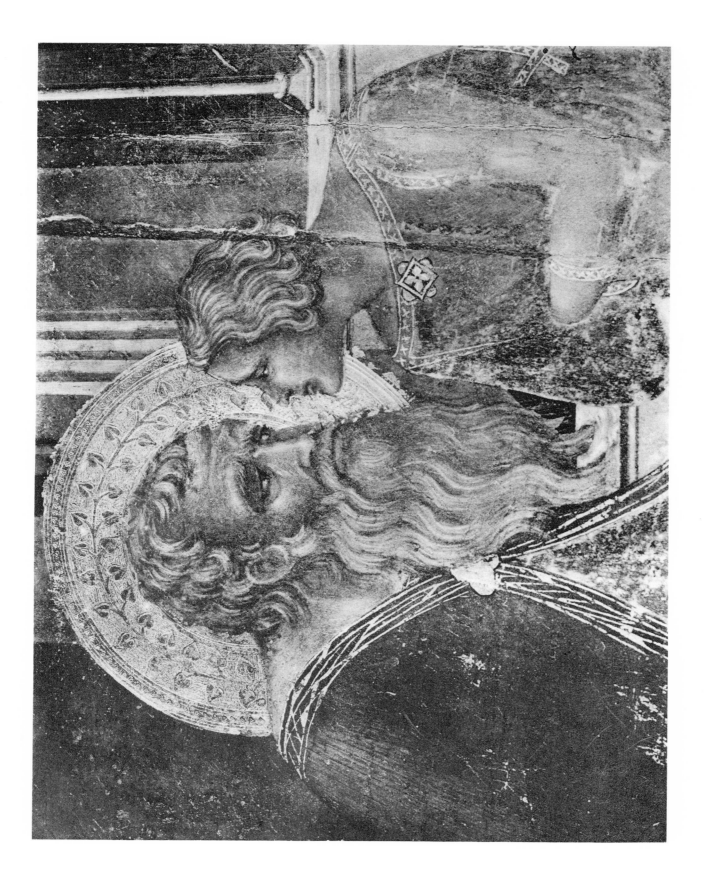

89

SCHOOL OF PIETRO LORENZETTI
The Last Supper, Fresco.
ASSISI. SAN FRANCESCO, LEFT TRANSEPT
Photo Alinari

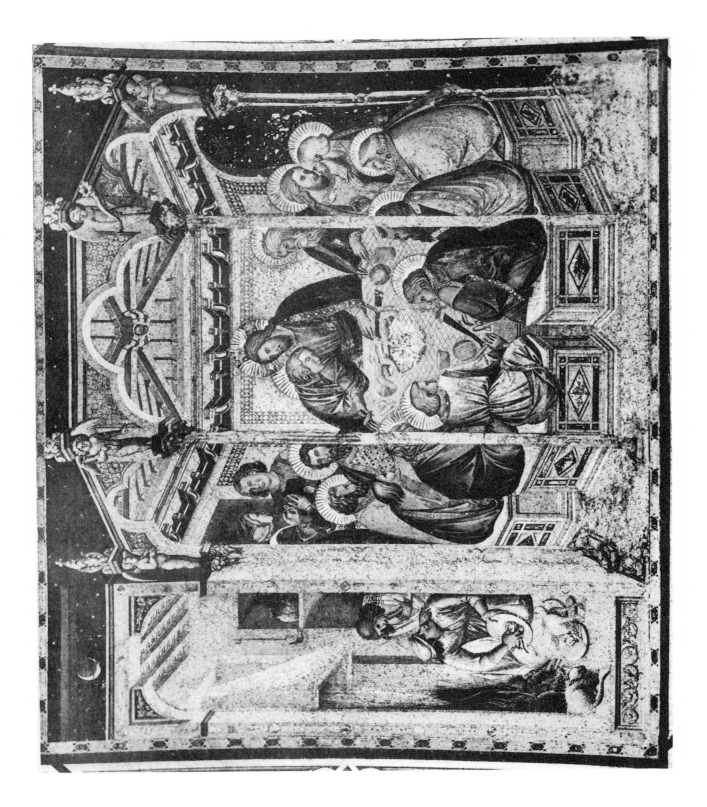

90

AMBROGIO LORENZETTI
Madonna enthroned with Child, 1319.
Vico l'Abate near Florence. Sant'Angelo
Photo Reali

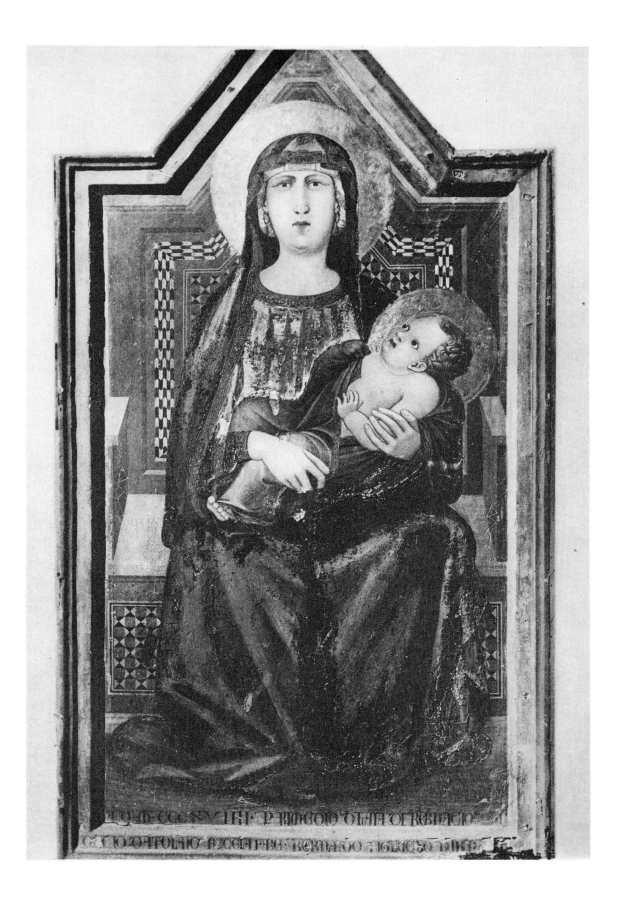

91

AMBROGIO LORENZETTI
Madonna enthroned with Child, 1319.
Detail: Head of the Madonna.
Vico l'Abate near Florence. Sant'Angelo
Photo Reali

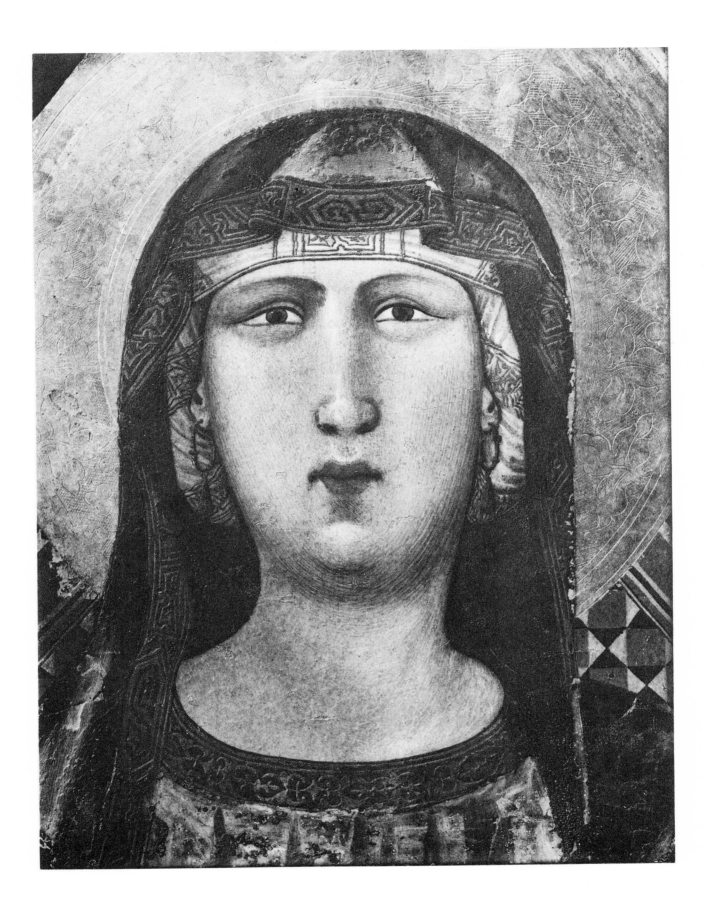

92

AMBROGIO LORENZETTI
Madonna and Child.
SIENA. SAN FRANCESCO, SEMINARY
Photo Anderson

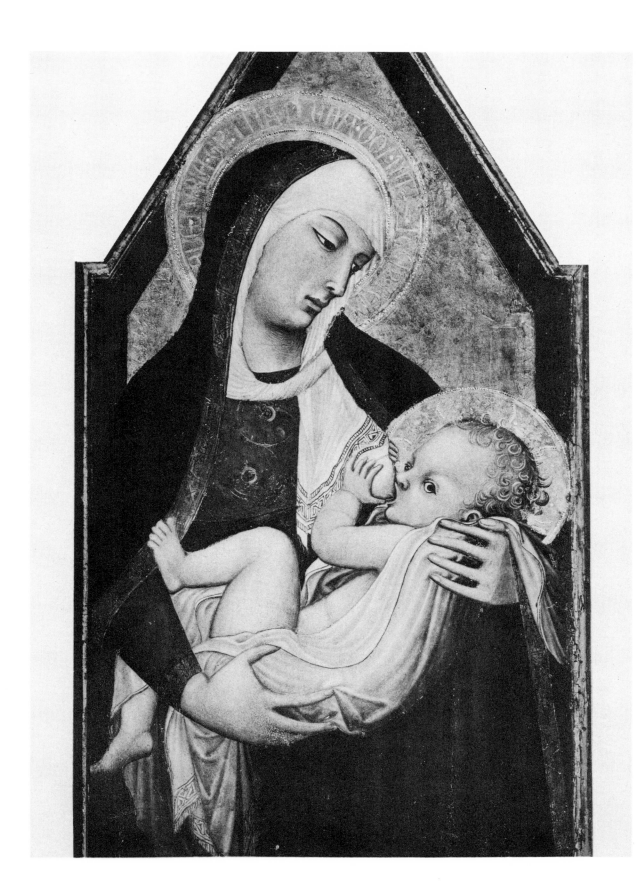

93

AMBROGIO LORENZETTI
Martyrdom of the Franciscans at Ceuta, Fresco.
SIENA. SAN FRANCESCO
Photo Anderson

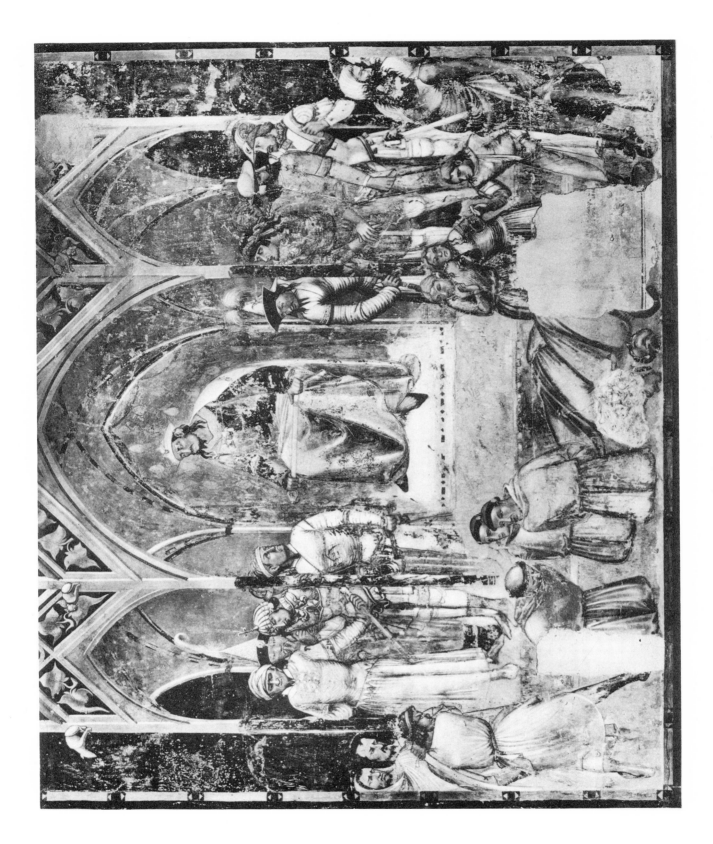

94

AMBROGIO LORENZETTI
St. Louis received by Boniface VIII as a Novice in
the Franciscan Order.
SIENA. SAN FRANCESCO
Photo Anderson

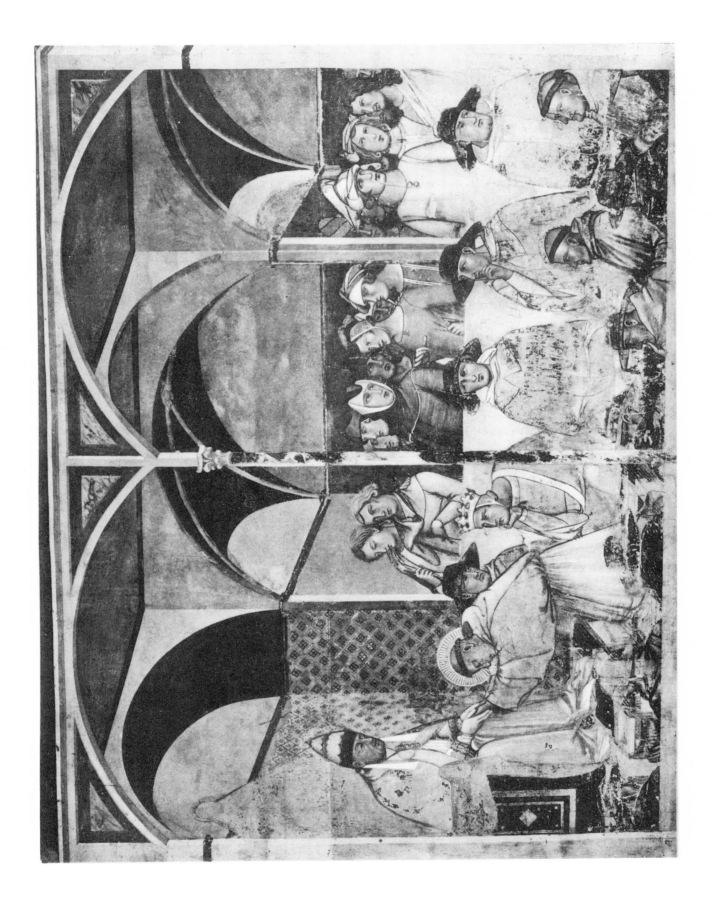

95

AMBROGIO LORENZETTI
St. Nicholas Predellas.
A. St. Nicholas comes to the early Mass and is consecrated
Bishop of Myra.
B. The Miracle of the Corn.
FLORENCE. UFFIZI
Photo Brogi

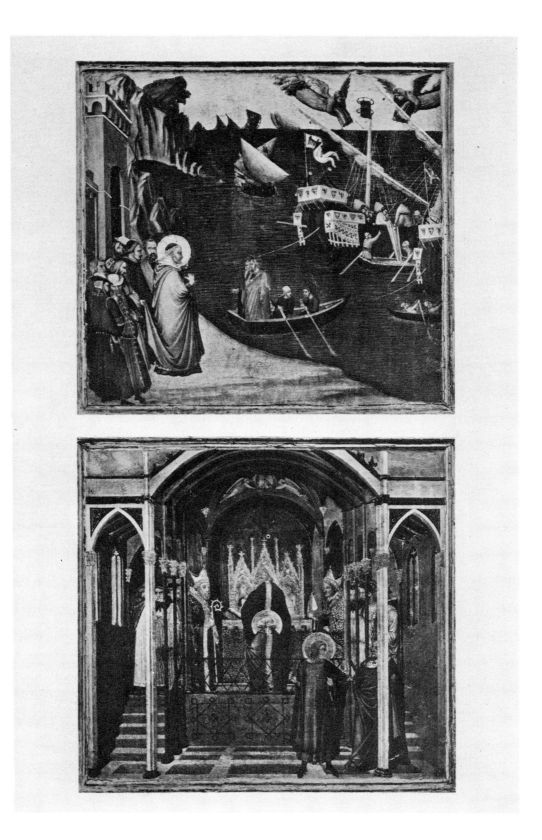

96

AMBROGIO LORENZETTI
St. Nicholas Predellas.
A. St. Nicholas succours the three daughters of the impoverished knight.
B. St. Nicholas raises a strangled child from the dead.
FLORENCE. UFFIZI
Photo Brogi

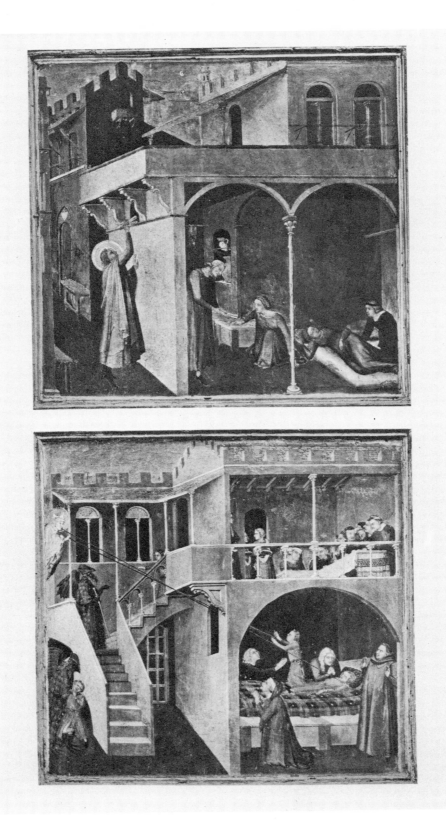

97

AMBROGIO LORENZETTI
Allegory of the Good Regiment. 1337-1339. Fresco.
Siena. Palazzo Pubblico, Sala dei Nove
Photo Alinari

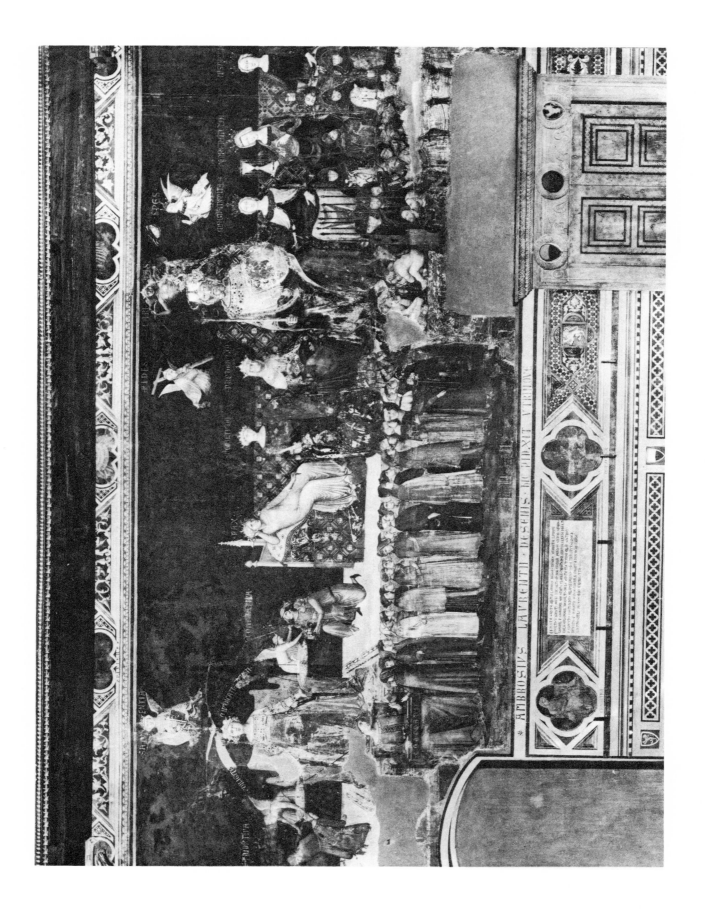

98

AMBROGIO LORENZETTI
Allegory of the Good Regiment. 1337-1339. Fresco.
Detail: Justice.
SIENA. PALAZZO PUBBLICO, SALA DEI NOVE
Photo Anderson

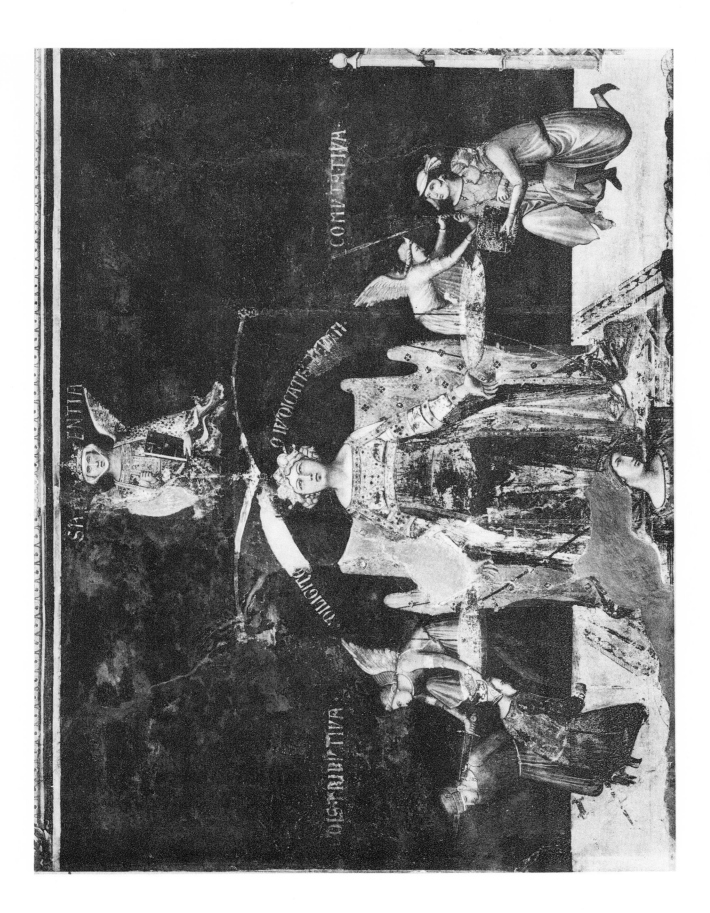

99

AMBROGIO LORENZETTI
Allegory of the Good Regiment. 1337-1339. Fresco.
Detail: Three Virtues.
SIENA. PALAZZO PUBBLICO, SALA DEI NOVE
Photo Anderson

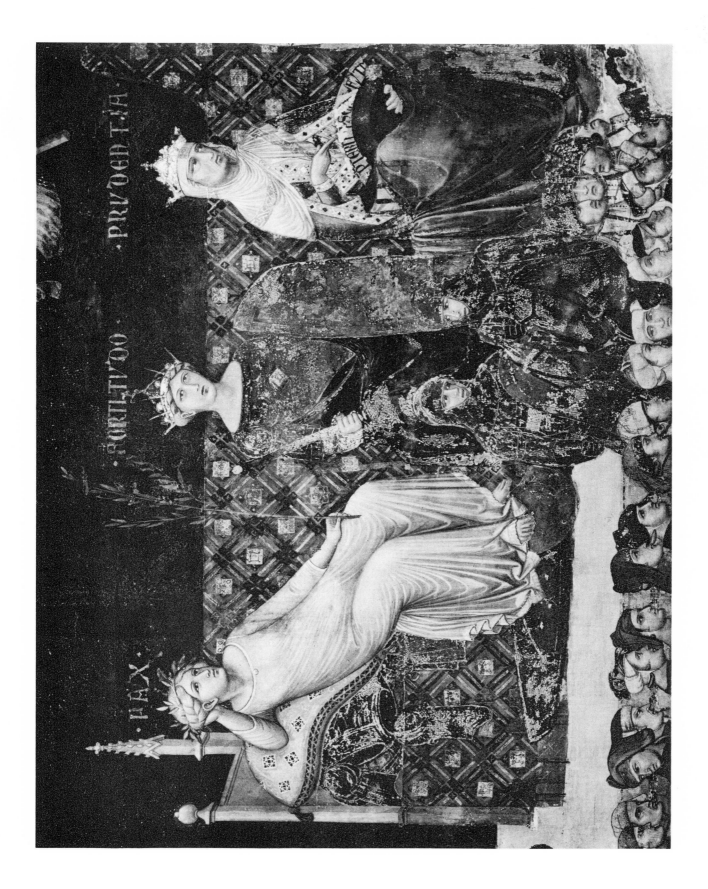

100

AMBROGIO LORENZETTI
Allegory of the Good Regiment. 1337-1339. Fresco.
Life in the City.
SIENA. PALAZZO PUBBLICO, SALA DEI NOVE
Photo Anderson

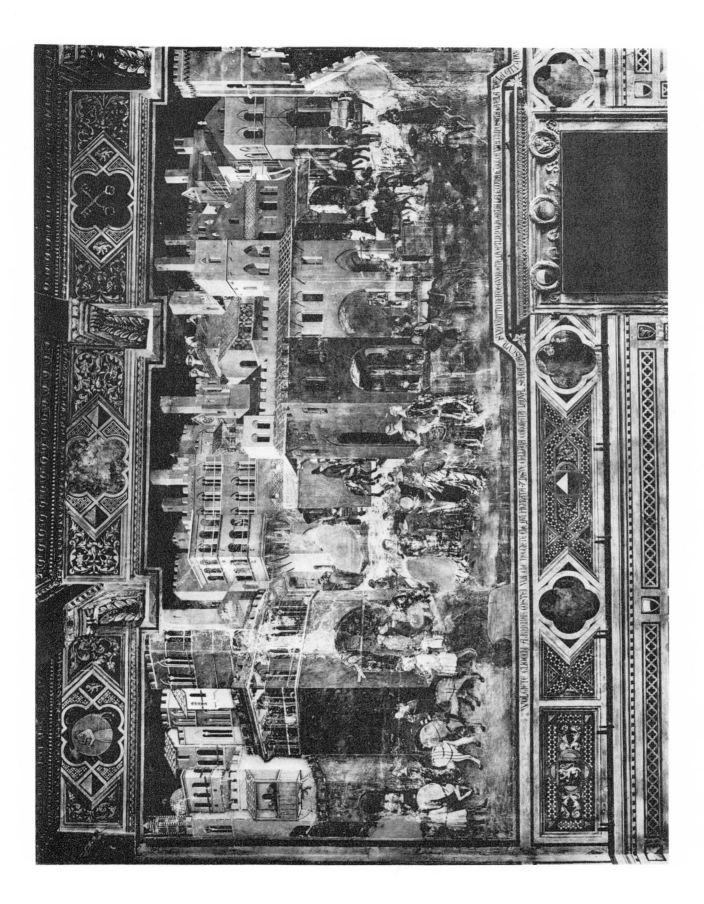

101

AMBROGIO LORENZETTI
Allegory of the Good Regiment. 1337-1339. Fresco.
Life in the City: A noble lady returning home from a ride.
SIENA. PALAZZO PUBBLICO, SALA DEI NOVE
Photo Anderson

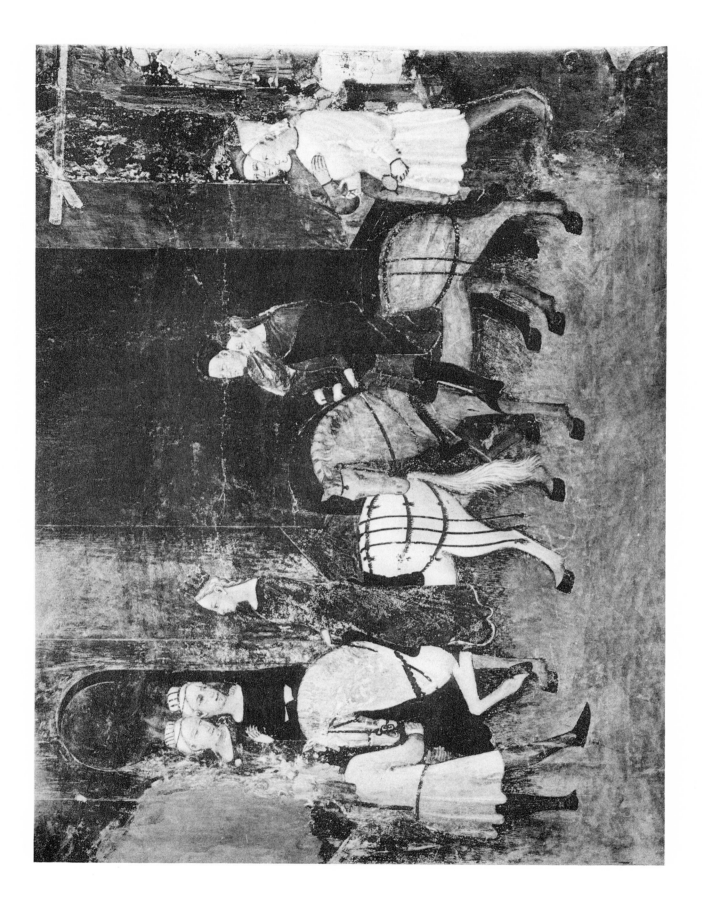

102

AMBROGIO LORENZETTI
Allegory of the Good Regiment. 1337-1339. Fresco.
Life in the Country.
SIENA. PALAZZO PUBBLICO, SALA DEI NOVE
Photo Anderson

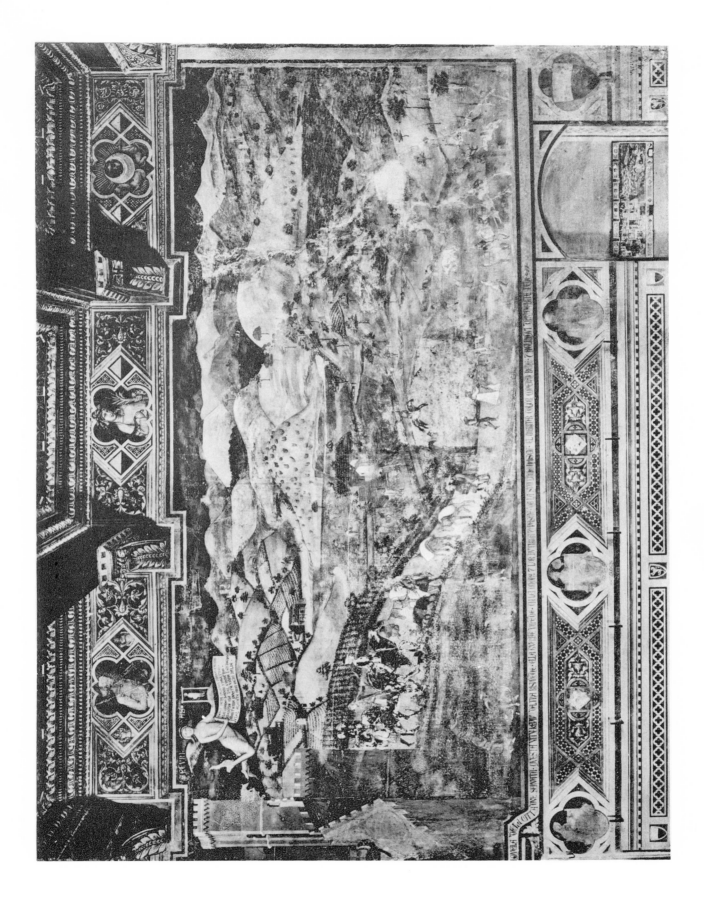

103

AMBROGIO LORENZETTI
Allegory of the Good Regiment. 1337-1339. Fresco.
Life in the Country, Detail: A noble lady riding to the chase
with a falcon.
SIENA. PALAZZO PUBBLICO, SALA DEI NOVE
Photo Anderson

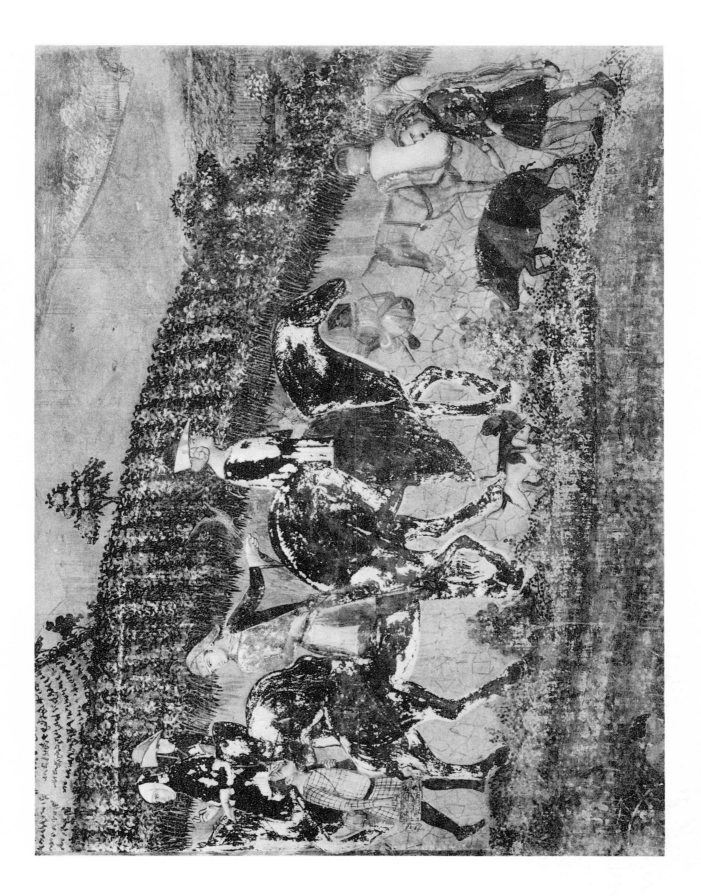

104

AMBROGIO LORENZETTI
Madonna enthroned with Saints and Angels.
MASSA MARITTIMA. MUNICIPIO
Photo Alinari

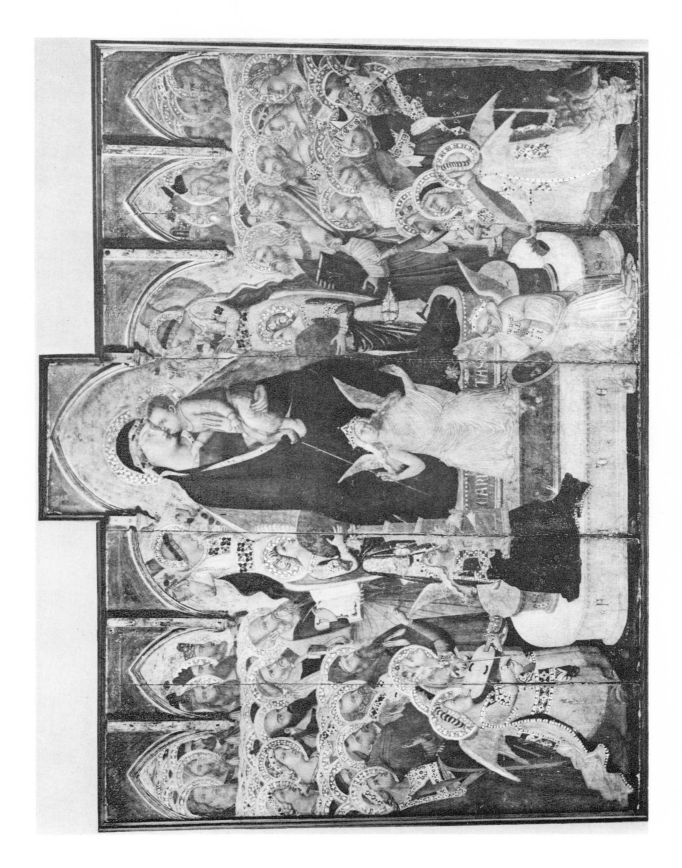

105

AMBROGIO LORENZETTI
Madonna enthroned with Saints and Angels.
Detail: The Madonna.
Massa Marittima. Municipio

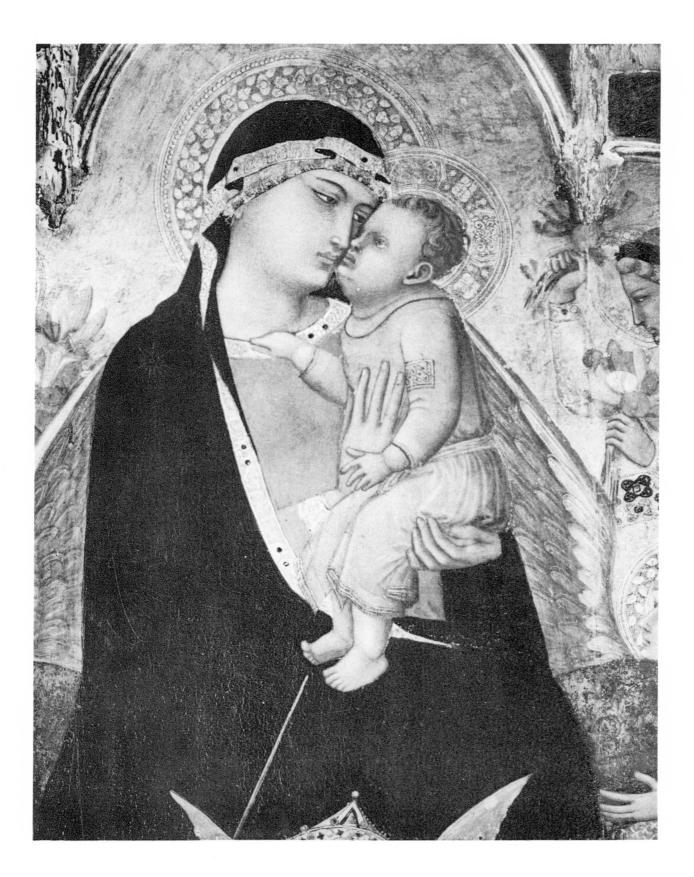

106

AMBROGIO LORENZETTI
The Presentation in the Temple, 1342.
FLORENCE. UFFIZI
Photo Anderson

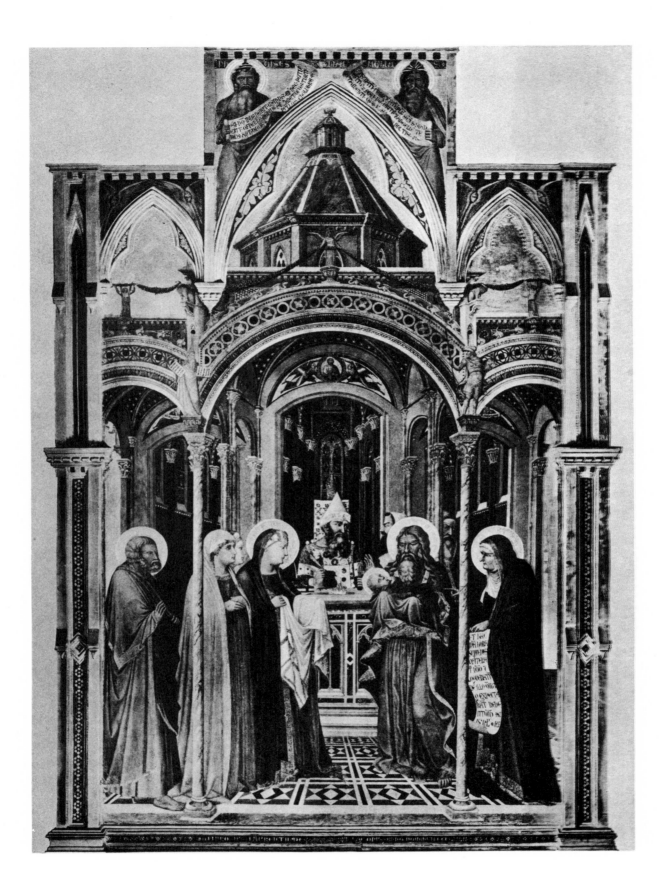

107

AMBROGIO LORENZETTI
The Presentation in the Temple, 1342.
Detail: The Child Jesus.
FLORENCE. UFFIZI

108

AMBROGIO LORENZETTI
The Presentation in the Temple, 1342.
Detail: Head of the Virgin.
FLORENCE. UFFIZI
Photo Alinari

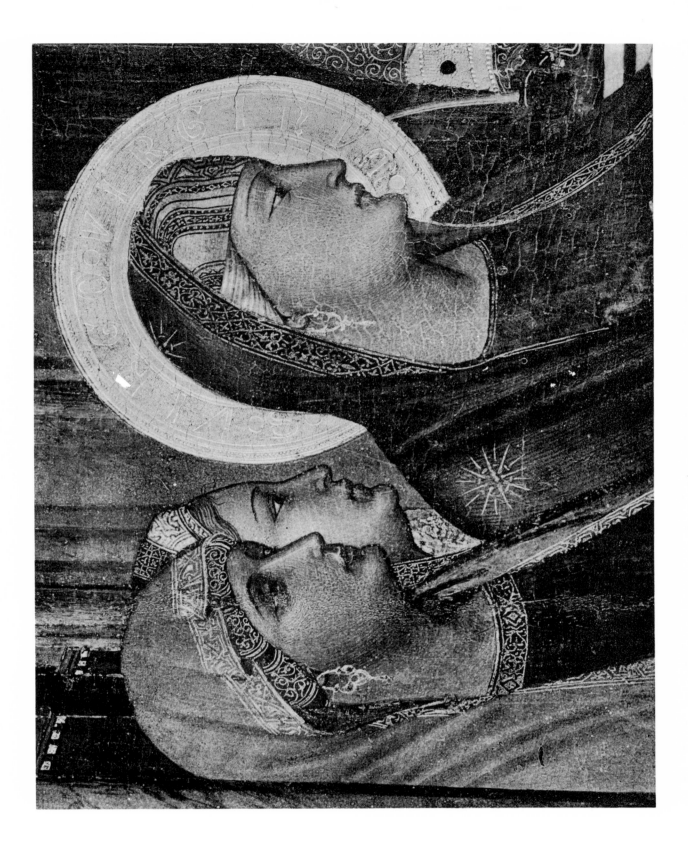

109

AMBROGIO LORENZETTI
The Annunciation, 1344.
SIENA. ACCADEMIA
Photo Anderson

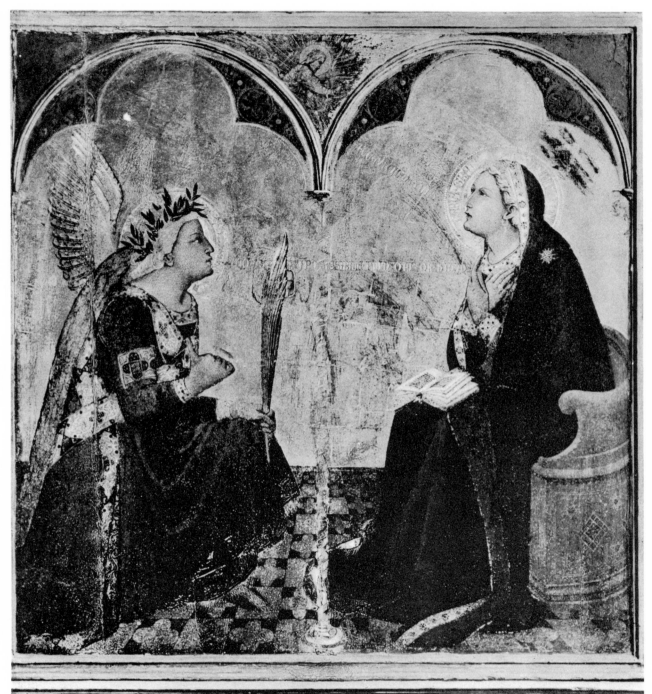

110

AMBROGIO LORENZETTI
Predella Pieces, two Landscapes.
A. Seascape.
B. The City by the Sea.
SIENA. ACCADEMIA
Photo Anderson

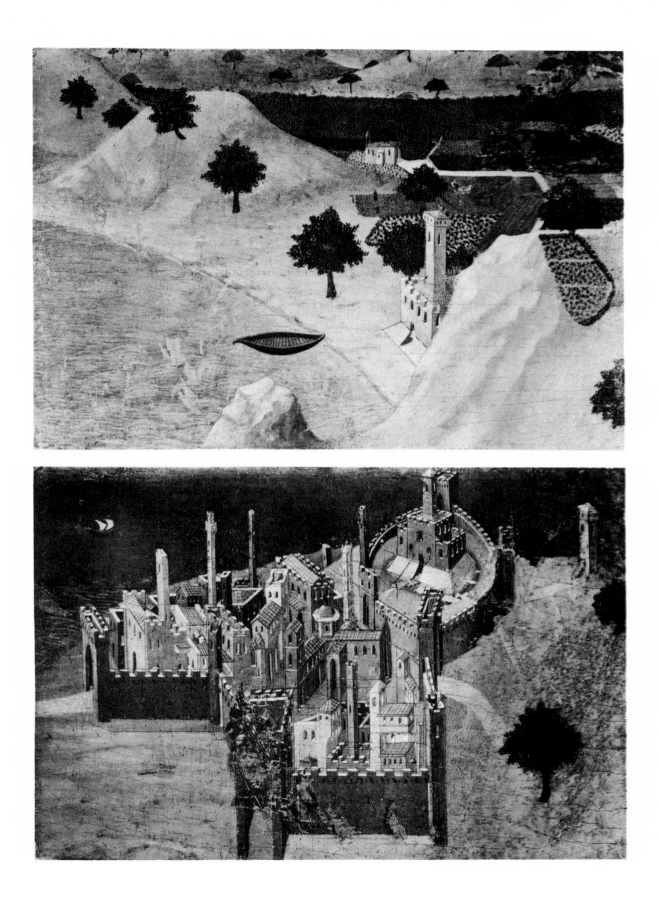

III

AMBROGIO LORENZETTI (?)
Madonna enthroned with Saints and Angels.
SIENA. ACCADEMIA
Photo Anderson

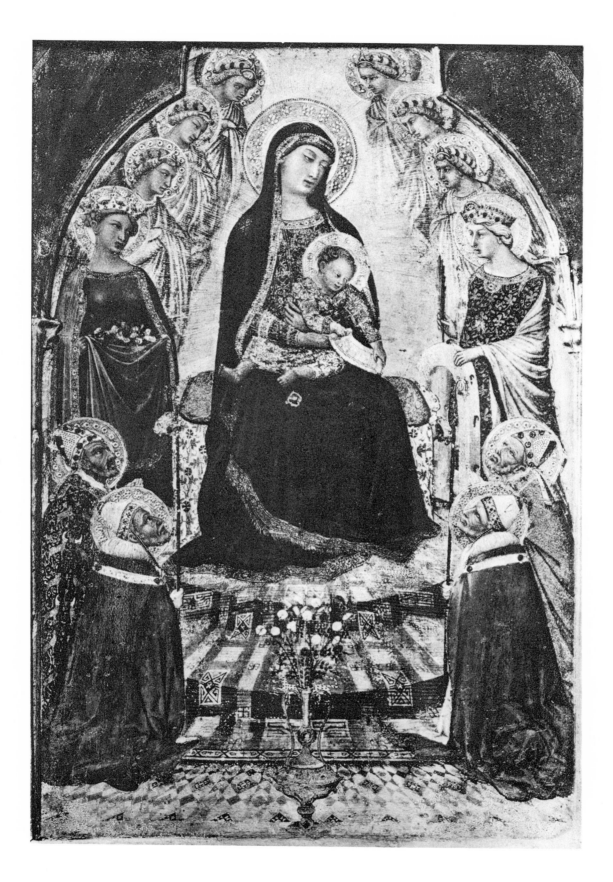

112

AMBROGIO LORENZETTI (?)
Polyptych.
Detail: The Madonna between St. Mary Magdalen and
St. Dorothea.
SIENA. ACCADEMIA
Photo Anderson

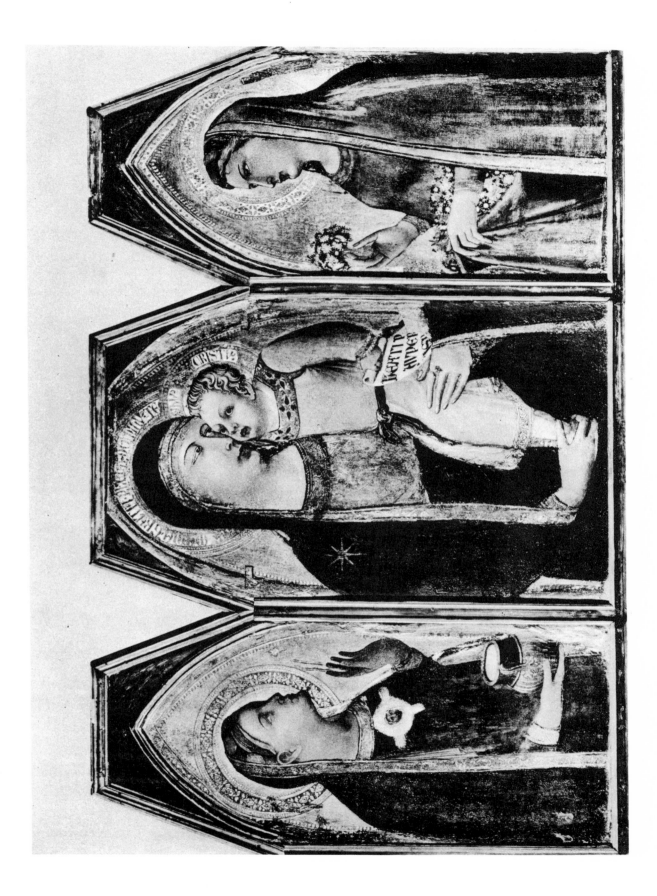

113
ANDREA VANNI
Polyptych: The Madonna enthroned with Child
and Saints, 1400.
Detail: The Madonna and Child.
SIENA. SANTO STEFANO ALLA LIZZA
Photo Alinari

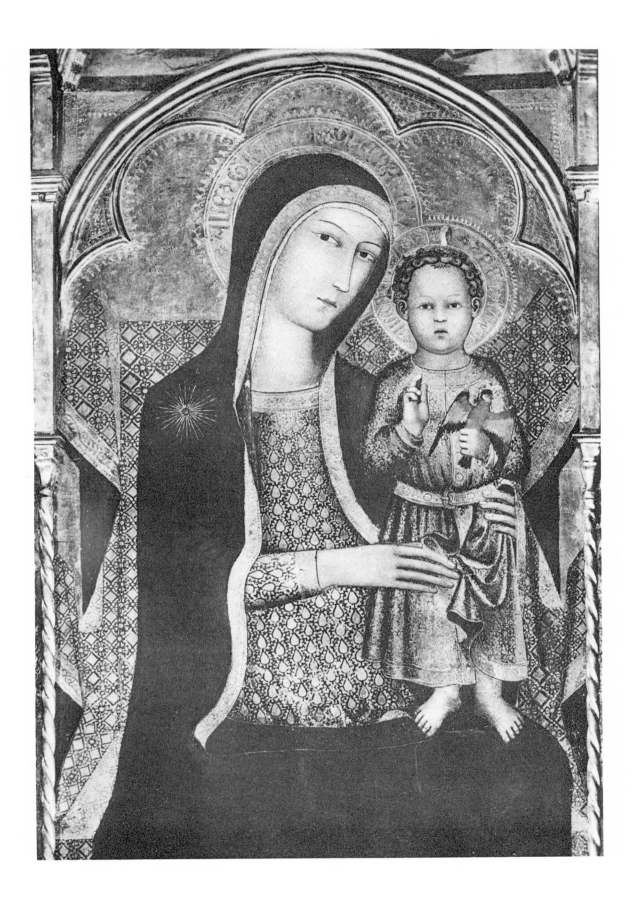

114

LIPPO VANNI

Triptych: The Madonna enthroned with Saints, and Scenes
from her Legend, 1358.
Rome. SS. Sisto e Domenico
Photo Luce

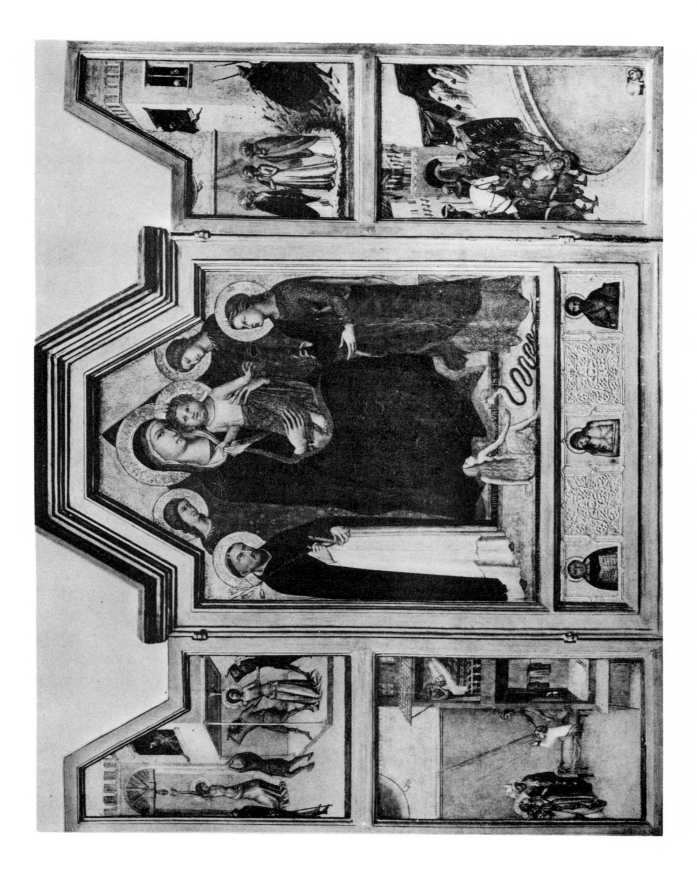

115

LUCA DI TOMMÈ
The Crucifixion, 1366.
Detail: Head of the Virgin.
PISA. MUSEO CIVICO
Photo Anderson

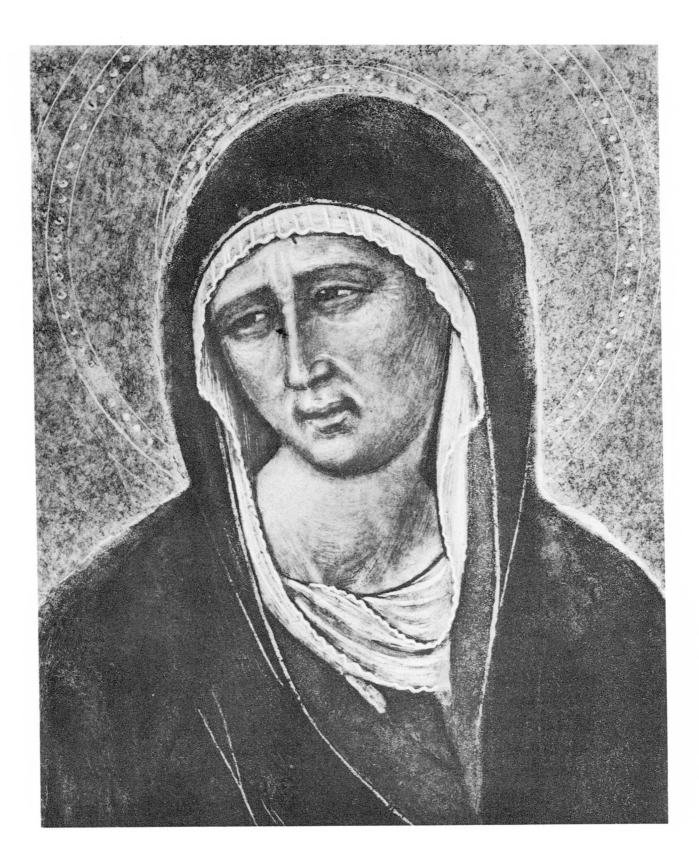

116

LUCA DI TOMMÈ
Polyptych: Madonna and Child, with
St. Anna and other Saints, 1367.
SIENA. ACCADEMIA
Photo Anderson

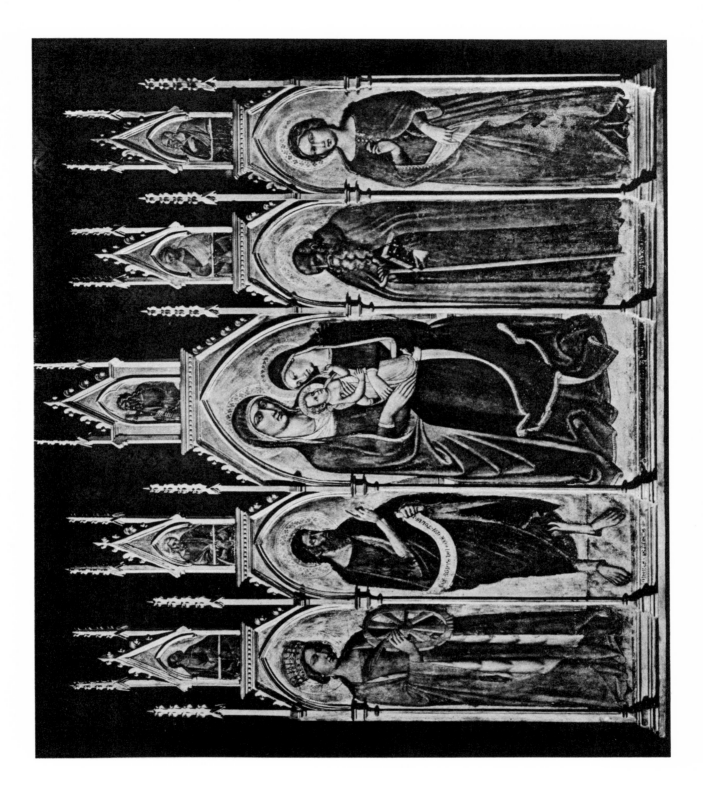

117

BARTOLO DI FREDI
The Nativity of the Virgin, Fresco.
SAN GIMIGNANO. SANT'AGOSTINO
Photo Alinari

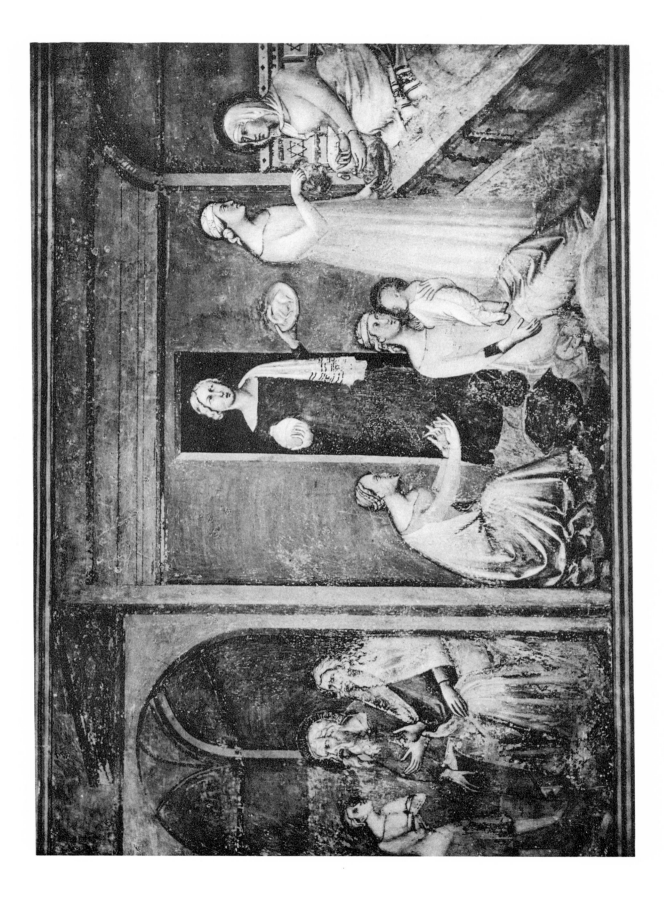

118

BARTOLO DI FREDI
The Coronation of the Virgin, 1388.
MONTALCINO. PALAZZO COMUNALE
Photo Brogi

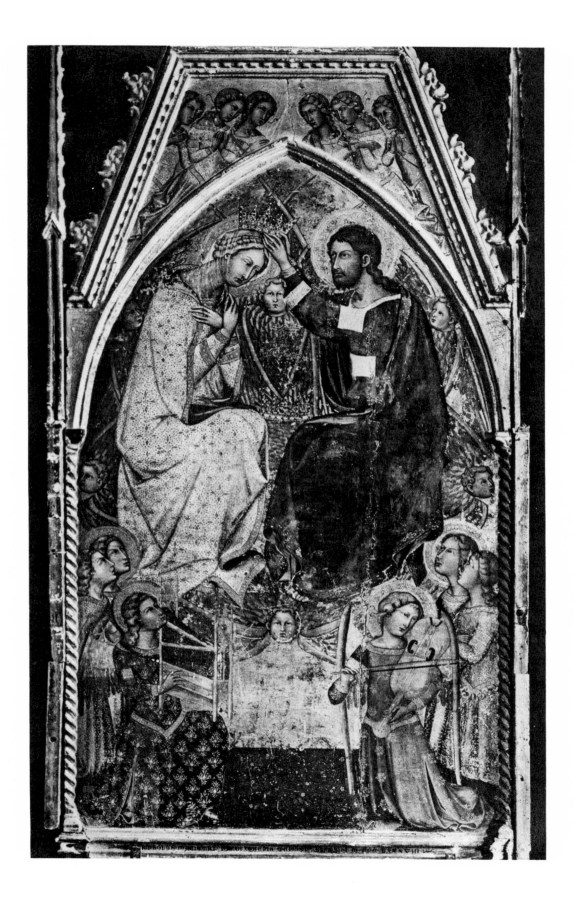

119

TADDEO DI BARTOLO
The Adoration of the Shepherds.
SIENA. CHURCH OF THE SERVI
Photo Anderson

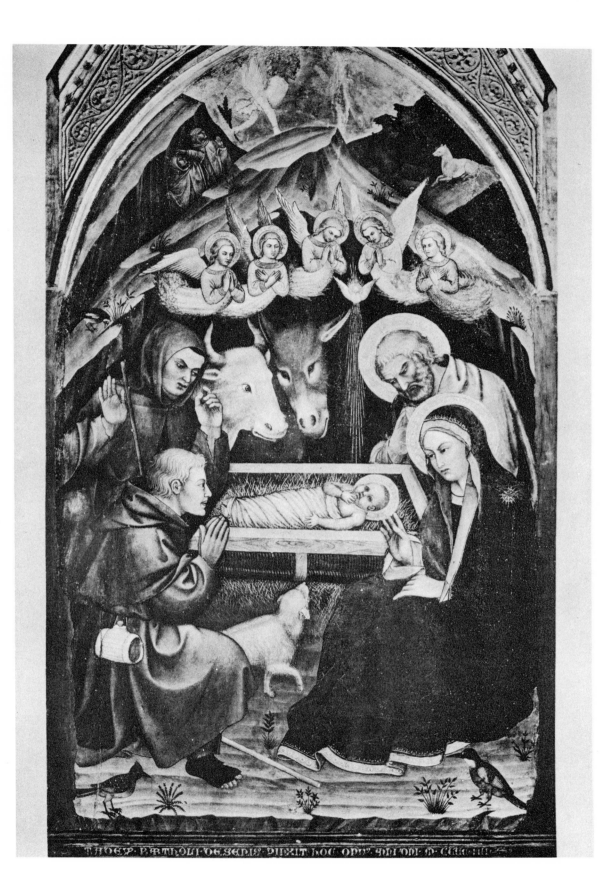

120

PAOLO DI GIOVANNI FEI
The Nativity of the Virgin.
SIENA. ACCADEMIA
Photo Anderson

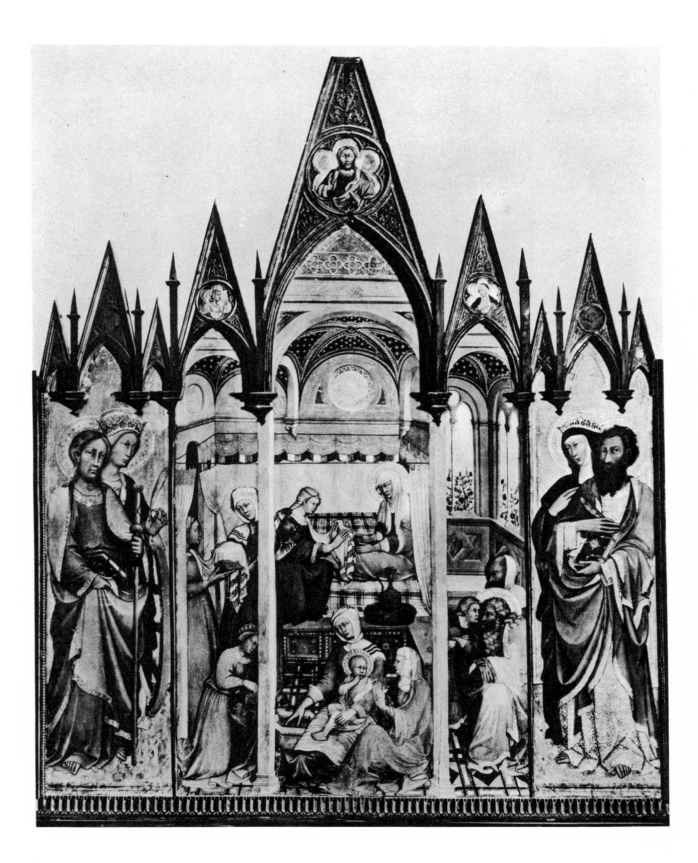

Printed in U.S.A. by
NOBLE OFFSET PRINTERS, INC.
New York, N.Y. 10003